LINLEY SAMBOURNE

Illustrator and *Punch* Cartoonist

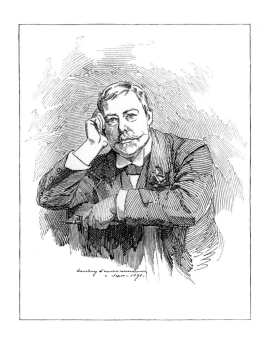

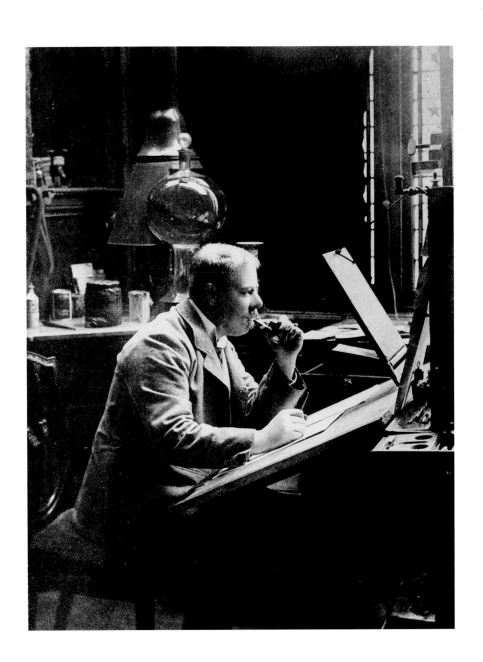

LINLEY SAMBOURNE

Illustrator and *Punch* Cartoonist

by

Leonee Ormond

Paul Holberton publishing 2010

First published 2010

© 2010 Paul Holberton publishing

Text © 2010 the author

ISBN 978 1 907372 03 2

British Library Cataloguing in Publication Data
A catalogue record of this book is available from the British Library

Produced by Paul Holberton publishing
89 Borough High Street, London, SE1 1NL
www.paul-holberton.net

Photography Katharine Forgan
Design by Laura Parker
Printed by E-Graphic in Verona, Italy

Jacket: Linley Sambourne, *The Diploma for the International Fisheries Exhibitions,* 1883–84, see fig. 55
Frontispiece: Linley Sambourne at his desk

Punch articles and Sambourne's diary entries are indicated in brackets with their dates: (P. 1.12.89) and (D. 1.12.89), for example.

Photographic Credits

Aberdeen Art Gallery and Museums Collections: figs. 50, 51

Author: fig. 4

Catherine Barne: figs. 41, 59–62, 65–68, 102

Katharine Forgan: front cover, figs. 5–6, 8–13, 16–17, 20–22, 26–35, 37–38, 43–48, 52, 54–58, 63–64, 69, 71–83, 88, 92–99, 101, 103, 105–09, 111–12, 114, 116

Linley Sambourne House, The Royal Borough of Kensington and Chelsea Libraries and Arts Service: frontispiece, figs. 1–3, 7, 14–15, 18–19, 23–25, 36, 39–40, 42, 49, 53, 70, 84–87, 89–91, 100, 104, 110, 113, 115, 117 (I am grateful to Linely Sambourne House for granting permission to reproduce 16–17, 37–38, 44, 55–58, 98–99, 109)

CONTENTS

This book is dedicated to my son, Marcus.

Acknowledgements

This has been a long-running project and many people have given me assistance without which it would never have been completed. Among them are Kate Allison, David Campbell, Clarinda Chan, Amanda-Jane Doran, Carolyn Dorée, Sophie Forgan, Mark Girouard, Mary Ann Goley, Rebecca Graham, the late Ian Grant, Alan and Joy Griffin, Sean Hackett, Hermione Hobhouse, Simon Jervis, the late Stephen Jones, Kedrun Laurie, Juliet McMaster, Philippa Martin, Victoria Messel, Frankie Morris, Daniel Robbins, Peter Shaw, Robin Simon, Roger Simpson, Peyton Skipwith, Teresa Sladen, Liza Verity, Alyson Wilson, the late Christopher Wood and Angus Wrenn. Bevis Hillier and John Stokes have been particularly kind in sharing their knowledge and in sending me relevant material.

Thanks are due to the staff of a number of libraries, the London Library, the British Library, the Bodleian Library, Richmond upon Thames Libraries, the Pierpont Morgan Library, the New York Public Library, the Folger Shakespeare Library, the Library of the National Gallery of Art in Washington and the Library of Congress. Above all, I am grateful to the staff of the Local Studies section in the Kensington Public Library, where the Sambourne archive is now housed, and to Reena Suleman, curator of Linley Sambourne House, who has accompanied me on many visits to the archive and who has been unstinting in giving her time and help.

Katharine Forgan has been a brilliant photographer and a pleasure to work with. The late Catherine Barne took some of the earlier photographs, and thanks are due to her son, Andrew Norman, for permission to reproduce these. Mark White of London Camera Exchange gave great help with some of the plates.

Shirley Nicholson has been exceptionally kind and I am deeply grateful for the way in which she has always shared her extensive knowledge with me. Shirley's excellent transcription of Linley Sambourne's diary has been an invaluable resource, as has her friendship.

I gratefully acknowledge the grants towards publication made by the Paul Mellon Centre for the Study of British Art and by Lord Phillimore's Charitable Trust.

I owe a special thank you to the late Countess of Rosse, Sambourne's grand-daughter, whose generosity with her time and whose encouragement were there from the outset. I am also grateful to her son and daughter-in-law, the Earl and Countess of Rosse, for their welcome on my visit to the archive at Birr Castle.

My husband Richard has, as always, been a tower of strength. Finally, I acknowledge the help of my son, Marcus, who has solved genealogical problems for me and has given help with the index.

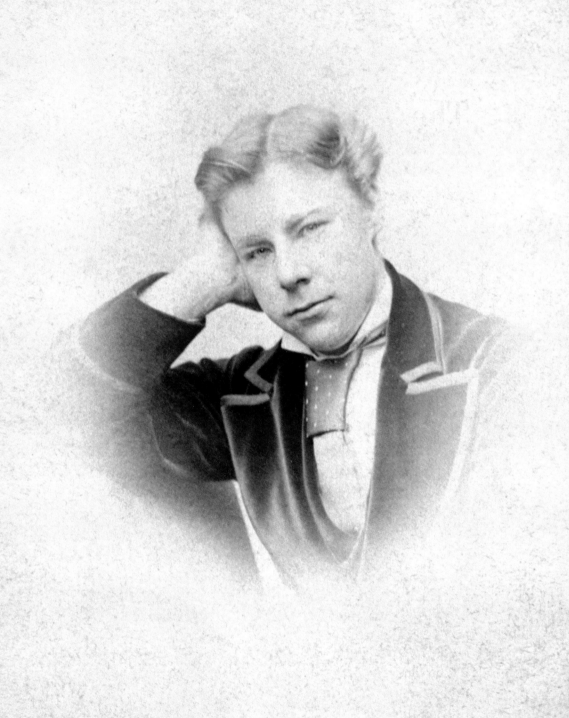

CHAPTER 1

The Young Draughtsman

When Linley Sambourne died in 1910, a host of obituaries paid tribute to his long career as a cartoonist and his contribution to late Victorian and Edwardian political satire. For more than forty years he had been a draughtsman for the comic magazine *Punch*, rising to the position of 'First Cartoonist' in his final decade. To his many friends Sambourne was a natural humourist, a teller of comic tales, a lively and cheerful companion. Something of a *bon viveur*, he became a frequent guest of the rich and successful, but his origins were very different. Sambourne rose in the world through a blend of talent and hard work. He is remembered for his imaginative and stylized cartoons, often reproduced as illustrations to studies of the social and political mores of his time. Sambourne's name, however, is chiefly known today through the special qualities of his home, 18 Stafford Terrace, Kensington, now a museum, Linley Sambourne House.

Sambourne set up home in Stafford Terrace in 1875, when he was thirty-one years old and a recently married man. He earned his living from *Punch* and, in his spare time, he was an illustrator of books. Neither occupation paid outstandingly well, and it was Sambourne's wife Mary Ann, or 'Marion' as she was widely known, who funded the couple's relatively high standard of living. Marion was the daughter of a prosperous stockbroker, Spencer Herapath, and her father paid £1000 towards the purchase of an eighty-nine-year lease from the Phillimore Estate, at a time when many illustrators and cartoonists were living in rented accommodation.

By the 1870s artists, in the van of fashion, were moving westwards. In the early Victorian period the artists' quarter of London had centred on Newman and

Fig. 1 Linley Sambourne aged 22, 1866

Berners Streets, north of Oxford Street. In 1862 the Pre-Raphaelite painter John Everett Millais was among the first to settle in South Kensington, moving his family from Scotland to 7 Cromwell Place. Sixteen years later Millais completed a sizeable mansion at 2 Palace Gate. Frederic Leighton and Valentine Cameron Prinsep began building houses on the former Holland Park Estate in West Kensington in the 1860s, to be followed in the next decade by William Burges, George Frederic Watts, Marcus Stone, Hamo Thornycroft, Colin Hunter and Luke Fildes. Edward Poynter lived close by in Addison Road. A few years later, the art world continued its westward movement when James Whistler set up a studio in Chelsea, destined to be the artists' quarter of the early twentieth century.

Artists rose steadily in the social scale throughout the Victorian period. By the later years of the century they were welcome guests in the homes of the well-born and wealthy. This phenomenon is demonstrated in the diaries which Linley and Marion Sambourne began to keep in the 1880s, documenting country-house visits, shooting holidays, yacht cruises and grand dinner-parties.

Family background

At the time of Linley Sambourne's birth in 1844, his father Edward Mott Sambourne was working from premises in the very heart of the City of London, at 39 Old Change, close to St Paul's. A short humorous poem of 1827 implies that he was working with others:

> Edwd Mott Sambourne Esqr
> Whom you will find if you enquire
> at no 39 Old Change,
> Leaf Son & Coles or else 'tis strange.[1]

Later he carried on a "wholesale furrier's business",[2] importing furs from America, at 30 St Paul's Churchyard, the street which encircles the Cathedral. Linley Sambourne described his father as a "merchant or in strict terms a warehouseman".[3] Sambourne and Bell, furriers, are listed in a street directory of 1851.

Interviewed by the *Illustrated London News* in 1893, Sambourne firmly declared: "I was … the only child of an English middle-class family".[4] It was a proud and accurate assertion. Edward Sambourne wrote 'Esq' after his name in the street directory, but his occupation would not have marked him out as a gentleman. From

the later years of the eighteenth century dramatists and novelists had joked about the 'cits', those who lived and worked in the City of London, by no means a fashionable address. In Jane Austen's *Pride and Prejudice*, published in 1813, Elizabeth Bennet's aunt and uncle are initially scorned by the landed proprietor Fitzwilliam Darcy because they live in Gracechurch Street, near the Monument.

Edward Sambourne was a rather unusual City dweller. Born in Pennsylvania, he was the son of Thomas Sambourne, a lawyer who had emigrated to the United States from Sheffield in South Yorkshire. Described as "a fashionable and accomplished young lawyer",[5] Thomas Sambourne was Deputy Clerk of the Peace for the West Riding and a large-scale property developer. The Sambournes claimed roots in Wiltshire, Berkshire and Hampshire, and were said to have moved north to Sheffield from the West of England. In the 1790s, when Sheffield was emerging as the capital of the English steel industry, synonymous with the manufacture of knives and cutlery, Thomas Sambourne laid out Sambourne Square with three-story brick houses. Photographs of the square (now demolished) show a typical Northern working-class area, with back-to-back houses, narrow pavements, public privies and children playing in the street.[6]

Thomas's wife Elizabeth Linley, whom he married in 1793, came from a Sheffield family, trading from 1772 as manufacturers of scythes. A later advertisement for the firm, then under the management of Linley Sambourne's uncles Samuel and Robert Linley, states that they made agricultural scythes, together with "Strickles, Scythe Shafts & Stones, Horse Nails, Files, Rasps, Bellows, Anvils, Vices &c., &c". With a playful family piety, their descendant Linley Sambourne would insert the Linley trademark 'Old O' onto the scythe of 'Old Father Time' in his annual *Punch* calendars.

The Sheffield Linleys were distantly related to a famous musical family, the Linleys of Bath, and Linley Sambourne's daughter Maud was fascinated by this connection. Thomas Linley of Bath was well known as a musician and composer in the second half of the eighteenth century. His daughters, famed for their talent and beauty, were painted by Thomas Gainsborough, and a double portrait of them hangs in the Dulwich Picture Gallery. Elizabeth Ann eloped with the playwright Richard Brinsley Sheridan and married him in 1773.

Thomas Sambourne's speculations in the property market proved to be his undoing. According to a friend, the Radical newspaper owner Joseph Gales, "it

unfortunately happened for him that from the Wars which grew out of the French Revolution, and from other causes, the value of Real Property sunk greatly in value, so that he, instead of gaining any thing by his purchase, was likely to be a great loser, and that his loss would prove his ruin".[7] Following in the footsteps of Gales, who had faced arrest for treason, Sambourne made his escape to America, leaving Elizabeth behind. Once he had established himself as a Pennsylvania surveyor Elizabeth followed and their son, Edward Mott, was born in Easton in 1802. Sambourne's frequent absences on business distressed Elizabeth so much that she returned to her family in Sheffield. Gales reports, however, that "after remaining there for some time, she became uneasy, and wished to come back to her husband. Mr. S., pleased that his wife had become convinced that it was her duty to be where he was, encouraged her to return and furnished her the means of doing so."[8] Both Sambournes were talented musicians and they now decided to earn their living as music teachers.

Joseph Gales had left Philadelphia for Raleigh, North Carolina, and, in 1807, Thomas Sambourne enquired whether he would be wise to join him there. Gales pointed out that the society of North Carolina was relatively simple, but explained that an Academy of young ladies was being established in Raleigh and that parents were increasingly prepared to fund piano lessons for their daughters. The Sambournes therefore moved south, advertising themselves as instructors for the piano and violin, French, Italian, embroidery, needlework and drawing. Elizabeth Sambourne later added singing and painting to her portfolio.

Not long after their arrival in Raleigh, Thomas Sambourne died suddenly from "Gout at his Stomach".[9] Left with three children to support, Elizabeth Sambourne continued on her own as a music teacher, at first privately and then at the New Bern and Raleigh Academies. Joseph and Winifred Gales had advised her that she would be able to keep her family in this way until funds were forwarded to pay for their fare home. Kim Tolley has shown that this was a propitious moment for a woman to enter upon such a career.[10] The growing demand for girls to display 'accomplishments' meant that their teachers could enjoy substantial financial rewards. Elizabeth Sambourne, evidently good at her job, was promoted to head of the female department of Raleigh Academy between 1810 and 1813.

A surviving letter from Elizabeth to her daughter Jane (who became Linley Sambourne's much loved aunt and benefactor) was written from Lexington, North

Carolina, in 1815. She was attempting to persuade Jane to stay at her school in Fayetteville, a larger town south of Raleigh. This establishment was, her mother believed, far better than any nearer home. This must have been the Fayetteville Academy to which Elizabeth herself moved in 1813, joining a former colleague from Raleigh. It would appear that she subsequently moved to a post in Lexington. Gales states that Elizabeth's relatives persuaded her to return to England. By that time, she had amassed one thousand dollars, more than enough to pay for their passage across the Atlantic.

The exact date of the Sambourne family's return home is not yet known, but the evidence suggests that Elizabeth's elder son, Edward Mott, was still a teenager. His decision to enter the fur trade may have resulted from his time in North Carolina, where trappers sold furs from further west.

A hint of Edward Mott Sambourne's character comes from a bequest made to him in 1844, a collection of books left by Barbara Hofland, a seventy-four-year-old novelist and the widow of a landscape and topographical painter, Thomas Christopher Hofland. Among the volumes were an edition of Isaac Walton's *Compleat Angler* and a copy of *A Visit to London* of 1814, written by Mrs Hofland herself. The nature of the relationship between Barbara Hofland and Edward Sambourne is not clear, but she must have thought him a fitting legatee for her books, and one can assume from this that he was well educated and well read.

Edward Sambourne's wife Frances Linley, whom he married in 1837, was a second cousin on his mother's side. Born in 1811, and so nine years younger than her husband, she was the daughter of Peter Linley, who followed the family business of scythe manufacture. Her home, in the hamlet of Bolehill, Norton, then on the outskirts of Sheffield, survives on high ground overlooking the city. Frances came

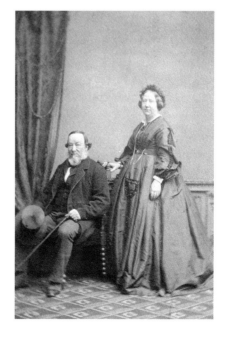

Fig. 2 Edward Mott and Frances Sambourne

from a large family, and her many sisters were to be a feature of Linley Sambourne's early life. When Frances gave birth to a son, at 4.45 a.m. on 4 January 1844, it was natural that the boy should be dubbed Linley, although his first name was that of his father Edward. The couple had already lost two still-born sons, in 1840 and 1842, and a third was born about an hour after Edward Linley. From the evidence of his diary, Sambourne rarely, if ever, talked of his dead twin, and he barely mentions his sister Fanny, who was born when he was four and died at the age of two and a half. She is buried in Highgate Cemetery. There was a fourth still-born boy between Edward Linley and Fanny – a tally of five lost children. In a letter of 1907 Linley Sambourne explained that he had been consulting the Sambourne family Bible, a volume in which the details of these early deaths are written, and their story must therefore have been known to him.

Growing up

Edward Linley was baptized at St Philip's Church, Clerkenwell, on 3 February 1844. One godfather was James Ackers, a Member of Parliament, and a wealthy Manchester businessman. The second, James Barr, a jeweller, was the husband of Edward Sambourne's sister Jane. Sarah Linley, his mother's younger sister, was the boy's godmother. At an early stage in his life, his first name Edward was dropped in favour of the more romantic Linley.

Edward Linley was born at the family home, 15 Lloyd Square in Pentonville, north of the City of London (fig. 4). The square was part of the Lloyd Baker Estate, on the borders of Pentonville and Clerkenwell, then known as a well-to-do residential area convenient to the City and with glimpses of the dome of St Paul's and the spires of Christopher Wren's churches. The estate had been developed from 1819 by the Lloyd Baker family, and had steep streets that ran down to the now covered Fleet

River. The elegant two-story houses in Lloyd Square, with their striking pediments, were the work of John, William and Joseph Booth. An earlier owner of the estate lands had conveyed a small area to the New River Company, responsible for the seventeenth-century canal which still brings fresh water into the capital from the King's Meads between Hertford and Ware. Linley Sambourne grew up close to the New River Head, and, half a century later, looking round the area, he found the New River bell which he remembered his mother's sister Ann pulling in the late 1840s.

By coincidence, another future *Punch* cartoonist, George Du Maurier, also lived on the Lloyd Baker Estate in the early 1850s and the two artists sometimes shared their memories of the area. Born in France and having spent a happy childhood in Passy, a suburb of Paris, Du Maurier was seventeen when he moved to 44 Wharton Street with his French father, English mother and brother and sister. In his first novel *Peter Ibbetson*, written when he was in his fifties and published in 1891, Du Maurier makes a forthright autobiographical statement: "I disliked Pentonville, which, although clean, virtuous, and respectable, left much to be desired on the score of shape, colour, romantic tradition, and local charm".[11] By the time that he wrote this, the whole area had gone down in the world and, in Du Maurier's tiny illustration of Wharton Street, drawn from Lloyd Square, a street pedlar and a smoking factory-chimney undermine the charming effect of the houses.

Du Maurier's childhood is well documented in two of his three novels. By contrast, regrettably little is known of Linley Sambourne's earliest years. As the only

ABOVE LEFT
Fig. 3 Linley Sambourne as a boy

RIGHT
Fig. 4 Lloyd Square, Pentonville (the Sambourne's house is in the middle)

surviving child of his parents, he must surely have been treasured. A beautifully written letter to his father shows that, at the age of seven, the boy was spending some time away from home. His sister had died earlier in the same year and his mother was ill.

> Dear Papa,
> I received that kind note you sent me yesterday evening. I thank you for sending me that nice fur. I will take great care of it. I have written a letter to Aunty Barr but I do not know her direction so will you please give it to her. I hope Mamma is quite well now. I send my love to you and her.
> I am my dear Papa, your affectionate Son, Edward Linley Sambourne
> Tottenham
> Nov 20 1851.[12]

A note for her son, written by Frances Sambourne, records how much the affectionate father valued such letters.

Edward Mott Sambourne clearly had a gift for friendship. Many years after his death, Ellen Rayne Garnett recalled that he was the only "intimate friend in London" of her mother Rayne Garnett, née Wreaks. Rayne's husband Revd Richard Garnett became Assistant Keeper of printed books at the British Museum in 1838. Both families came from Yorkshire, and Ellen Garnett notes that her grandparents, like Linley Sambourne's, lived in Norton. Linley, she says, "was about the only child I knew … he must have begun to draw as soon as he could hold a pencil, and his productions were certainly remarked for so young a child".[13] Linley can only have been six when, on the death of her father, Ellen Garnett left London. The families did not entirely lose touch, however, for Ellen's brother Richard (who followed his father into the British Museum, as Keeper of printed books), recalled the long family acquaintance and the "lifelong friendship of your mother and mine" in a letter to Linley Sambourne of 1903.[14]

Another childhood friend who remembered the talented little boy was Georgiana Eckstein. At the time of Linley Sambourne's silver wedding in 1899, she sent her congratulations, recalling how he would cut out "in paper, the most beautiful little animals – which so pleased my little sister who died".[15] She included good wishes from a surviving sister, Sarah, telling Sambourne that their brother, Fred, had died the year before.

Talking to an interviewer many years later, Sambourne recalled: "My parents, though gratified at my early taste for drawing, did not take any particular steps to further it".[16] It was his aunt Jane Barr, herself an amateur watercolourist, who gave the boy his first lessons in art. In the 1840s the Barrs were living at No. 4 Mountfort Terrace, off Barnsbury Square in Islington, close enough to the Sambournes to have an influence on Linley. A number of Jane Barr's landscapes, evidence of a considerable talent, hang in the drawing room at 18 Stafford Terrace, a testament of her nephew's affection.

Later, in 1852, when Linley was eight, there was a move to Sheffield. The boy is known to have spent about two years with his aunt and godmother Sarah Linley at Jordanthorpe House in Norton, a substantial building with a small portico. Sarah had moved to Norton after marrying Arthur Linley, a manufacturer of railway lamps, who seems not to have been a close relation. The imposing tomb of the sculptor Sir Francis Chantrey, born in Norton in 1781, is still a feature of the churchyard, and Chantrey's rise in the world – from carpenter's son and grocer's boy to Royal Academician – would have set an example for any child with artistic ambitions. Linley must have heard that his grandfather had been a pall-bearer at Chantrey's funeral. In November 1852 he acquired a copy of a large print by John Gilbert of the funeral procession of the Duke of Wellington as it passed through London, which he kept at 18 Stafford Terrace, carefully folded away with the *Illustrated London News* for the same date.

Aunt Sarah's mother and brother remained in Bolehill and Linley visited them there. An early Sambourne drawing is an accomplished and detailed rendering of a cottage, a former home of the family, which still stands there today (fig. 5). In May 1901, when visiting Norton, Bolehill and Jordanthorpe with his wife, Sambourne found them largely unchanged.

Linley returned to London and was a pupil at the City of London School for a brief period when he was ten or eleven. By 1857 he was at school in Sheffield. This school, at 3 Sandon Place, may have been "Adams's old school", which Sambourne noted was "altered" on a visit to Sheffield in 1902 (D. 29.3.02). A group of letters to his father, written in February 1857, tell of his achievements in coming top of the class in arithmetic and drawing, of his attempts to learn to skate and of visits to friends and relatives. Later he told an interviewer that he "formed only a poor opinion" of the education at the school.[17] One letter home tells of the "rubbishy"

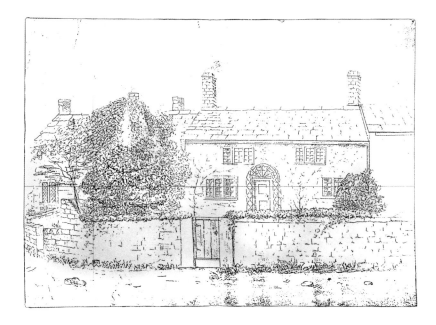

Fig. 5 Peter Linley's House at Bolehill, Sheffield, as drawn by Edward Linley Sambourne when a boy

lecture on electricity.[18] Two sessions on galvanism and magnetism were promised, and Linley sent his father a small coloured sketch of the class under the influence of galvanism, some leaping into the air. Other pictures are of soldiers in uniform or riding and of a scene in the mountains (said, fancifully, to be in the vicinity of Sheffield). Some show Linley being punished for various misdemeanours. He was made to write thirty lines of French as a penalty for being the last to get out of bed in the morning or for going out of the schoolroom without permission. A letter sent from Jordanthorpe House recounts his pleasure in fishing. Linley had formed a friendship with Manby Johnson, a fortunate boy who owned a black Shetland pony capable of great speed and of leaping a five-barred gate.

Frances Sambourne was clearly in Sheffield in early February 1857. Her son reported that she was well, "but she says she has not any thing to tell you or else she would write".[19] A fortnight later Frances was back in London, and her son was expressing dismay at his father's serious illness: "I trust that God will restore & keep you in good health till I shall be able to help you which I am sure I will do to my utmost strength, I *shall* always think how kind & thoughtful you have been towords [sic] me & I will try to repay you in every way I can".[20] From an undated

letter it is clear that Edward Mott had broken his leg badly in two places. The circumstances of Edward Sambourne's later years are difficult to interpret. In 1851 he was sufficiently wealthy to commission a watercolour portrait of himself, but four years later, in 1855, he was investigating the possibility of manufacturing liquid blacking and polish, hoping to sell these to the army for use on soldiers' boots. This suggests that the fur business was in difficulties.

From later 1857 to 1860 Linley Sambourne was enrolled at a new school, the Chester Training College, where the principal, Dr Rigg, encouraged him to pursue his talent for drawing. The college, set up by William Gladstone in 1839, was a foundation for the education of future teachers. It had a forward-looking reputation and was renowned for its emphasis on science and design. Alan Cole, the son of Henry Cole (later Sir Henry and first Director of the South Kensington Museum, now the Victoria and Albert Museum) was a fellow pupil. Alan Cole was to follow in his father's wake, studying at the Government Design Schools at South Kensington and then becoming Assistant Secretary there. Linley Sambourne and he remained friends and continued to meet in later life.

It was probably at the Chester Training College that Sambourne met James Creswick, thought to be a brilliant pupil with a splendid future ahead of him. Creswick would ask Sambourne why he wasted his time making sketches, but he himself rose no higher than a clerkship in the Admiralty Office. An eager draughtsman, as this criticism implies, the young Sambourne already demonstrated a marked gift for invention. He later explained that he had loved "mechanics, and was devoted to model ships and model engines". His father, now happy to encourage the interest, gave him "a lathe and other tools, it was a little surprising what I managed to turn out with the appliances at my command".[21] Looking back, he tried to describe himself:

> I was seized with an unconquerable longing to try and draw anything and everybody I encountered. It was, in short, the ruling passion with me, and in all probability all the Queen's horses and all the Queen's men could not have dragged me from my one cherished pastime.[22]

The boy was back in London on 18 May 1860, when he was confirmed by Dr Tate, the Bishop of London, at Christ Church, Newgate Street, a fine Wren building used by Christ's Hospital School. The church was gutted in 1940 but its tower

survives. In the same year, now sixteen, Linley spent two or three months at the South Kensington School of Art, joining Alan Cole, whose father was the principal. Like many art students at the time, he was set the task of copying casts of antique sculpture, the *Laocoön* and the *Apollo* Belvedere, an exercise which frankly bored him. Sambourne's complaint was not a unique one: the school had a reputation for dullness and a lack of imaginative teaching. In theory it should have provided training for those seeking to work in industrial design, but Sambourne can have learnt little of practical use there. Fees were high, and this may help to explain his rapid departure. Apart from a very brief spell later in the 1860s, when he attended a life class held in Langham Place, this frustrating time as a student at South Kensington was his only period of formal artistic training.

In 1861 Sambourne was apprenticed to John Penn & Son, marine engineers of Greenwich. Penn's had been set up in 1800 and the firm had begun to manufacture marine steam engines by 1825. Sambourne worked under the founder's son, John Penn the younger, whose propeller shafts were renowned worldwide. Sambourne recalled his time in the Blackheath Road factory with some pleasure: "I was first employed in the pattern fitters' and other shops, in close and, to me, far from uncongenial companionship with many whirling lathes. I was not discontented, and made the best of my lot."[23] Photographs taken at Penn's at the time when Sambourne was apprenticed there show huge pieces of machinery, dwarfing the workers beside them. Later, his employer having discovered his talent as a draughtsman, he was moved to the drawing office. When George Gissing chose to make the hero of his novel *Eve's Ransom* of 1895 a mechanical draughtsman, he assumed, without direct personal knowledge, that the job was a dull one, a straitjacket for an intending architect. Sambourne, on the contrary, wrote that: "Here at last I found myself in a more genial atmosphere, although it was not quite the style of drawing which appealed most strongly to me".[24] By the time he was twenty-two, he was earning £3.00 a week.

The young man spent his spare time sketching caricatures. The tale that a fanciful engineering drawing by Sambourne was actually carried out, with disastrous results, is presumably apocryphal, but it must soon have become clear that this was not to be his vocation. "I am afraid," he told a journalist, "I should have made an indifferent engineer."[25] In his career as a cartoonist his "knowledge of engineering" made him "very careful in drawing any machinery", but "otherwise has not

materially benefited me – as yet".[26] A story from these early days tells how Sambourne nailed the brim of a hat, belonging to a young French draughtsman, to a desk. The drawing-office staff waited with bated breath for the moment when the unfortunate left for lunch, only to see, with astonishment, that he took his hat and left. Sambourne had unwittingly nailed down his own hat.

The Penn family were well disposed towards their young draughtsman: "Mr John Penn took a kindly interest in my sketches when he saw me, and at certain garden parties given by him at 'The Cedars' I occasionally got a glimpse of the great artists of that day. I recollect meeting in this way Sir Edwin Landseer, Elmore (whom afterwards I knew intimately), and others."[27] In later life Sambourne saw a good deal of his former employer's son, another John Penn, who became the Member of Parliament for Lewisham. This continuing friendship reveals that there were no hard feelings when the young man left the firm, after six years, to seek his fortune elsewhere.

In 1861, the year that Linley joined Penn's, the Sambournes had moved from Lloyd Square. They were now in nearby Barnsbury, at 14 Upper Park Street (now Bewdley Street), living in the house of the seventy-nine-year-old Sarah Linley, who was Frances Sambourne's aunt on her father's side. Edward Sambourne's business was no longer listed in St Paul's Churchyard, and he may have retired from trade on grounds of ill health.

Details of Linley Sambourne's life at this time are very few and fragmentary. A tantalizing diary entry from many years later refers to his having been "assaulted" at Sandgate in Kent in 1864 (D. 31.8.98). Documents reveal that he became a Druid and a Freemason in 1871 and 1872, but there is no further reference to this. Intelligent and eager to learn, he studied the work of the great graphic artists Albrecht Dürer, Hans Burgkmair and their sixteenth-century German contemporaries, together with Hogarth and the English eighteenth-century masters. A hint of his historical interests comes from a book which he purchased in Greenwich on 19 February 1864. This was George Hooper's *Waterloo: The Downfall of the First Napoleon. A History of the Campaign of 1815*, published in 1862. Sambourne was later to acquire (and hang on the wall) a photograph of Ernest Meissonier's famous *Retreat from Moscow (The Campaign of France, 1814)* of 1864 (Louvre). Napoleon and his military campaigns were a lifelong passion and he introduced the figure of the Emperor into his cartoons whenever a chance presented itself. One example of

1899 shows the defeated Liberal leader Lord Rosebery as Napoleon, gazing into the fire after his own battle of Waterloo (P. 13.8.95).

Sambourne's father died on 2 February 1866, at the age of sixty-three, and was buried in Highgate Cemetery. The cause of death given on his death certificate is "apoplexy". Edward Sambourne was intestate and this may have caused problems for his widow and son. For a time, before January 1867, Linley Sambourne was living at 107 Devonshire Road, off Seven Sisters' Road, Upper Holloway, with his aunt Jane, now a widow. Later, when the census was taken in 1871, he and his mother were still with Jane, but now at Guildford Villas in rural Uxbridge, west of London.

It is tempting to speculate whether the absence of the father made it possible for the son to change direction, to leave the safe career chosen for him and risk his future as an illustrator. Once again there are parallels with the life of Sambourne's future *Punch* colleague George Du Maurier, who was only able to give up his work as a research scientist and become an artist in 1856 on the death of his father, who had always cherished the idea of having a scientist son.

Starting at *Punch*

There are two versions of the story of Sambourne's introduction to *Punch*, both emanating from Sambourne himself. One, which appeared in a letter to the press after his death, was that, while drawing a caricature of John Penn, his employer came up behind him and, instead of sacking the young man, decided to send the sketch to his friend, the legendary first editor of *Punch* Mark Lemon. Lemon needed to replace the artist Charles Bennett, who had died earlier in the year.[28] The second story is that a friend and fellow employee at Penn's, Alfred German Reed, showed a Sambourne sketch to his father, the musician and theatrical impresario Thomas German Reed. At his son's urging, German Reed passed it on to Lemon, who liked it enough to write and ask for more.[29]

There are, once again, alternative accounts of what happened next. Sambourne says that he responded to Lemon's request by putting "some [drawings] on wood without any previous knowledge & they appeared at once".[30] More modestly, he told an interviewer, "Mr Lemon saw some promise in them, I suppose, with the result that my first sketch appeared in *Punch*".[31] Telling Sambourne that his work was not without merit, Lemon suggested that he take lessons, consult the engraver Joseph Swain about drawing on wood and return to him in three months.[32] He

PROS AND CONS.

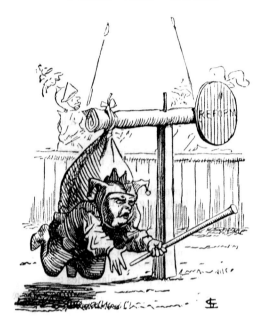

Fig. 6 Sambourne's first cartoon: initial
letter 'T', John Bright at the quintain
Punch, 247April 1967

asked Swain to send the young artist some woodblocks. Pleased with the results,
Lemon then published one drawing on 27 April 1867. This was an initial letter 'T'
showing the Radical politician John Bright charging at a medieval quintain (a post
with a sandbag for practising tilting; fig. 6). Sambourne did not realise that his
drawing had been accepted until he saw it in *Punch*. He was later to claim, with jus-
tifiable pride, that he had rarely been out of the paper after his first appearance.

Among the fanciful drawings of politicians which Sambourne sent to Lemon
was a sketch of Bright as a moth flying into the flame of a candle marked *Reform*.
In another, Benjamin Disraeli kneels in Elizabethan costume, with a rolled manu-
script, again marked *Reform*, held out on a platter before him. 1867 was the year
when Disraeli, then the Tory Chancellor of the Exchequer, brought in the Second
Reform Act, considerably extending the franchise. Sambourne placed these re-
jected drawings into an album "as a collective protest against editorial whims and
mis-selection".[33]

The *Punch* historian Marion Harry Spielmann was in the habit of expressing
admiration for Lemon's ability to detect Sambourne's talent from the somewhat
laboured drawings which the young man sent in:

> Few, indeed, who saw Mr Linley Sambourne's early work ... would
> have imagined that behind those woodcuts, clever though they were,
> lay power and even genius It was a lucky accident it was not to
> another than Mark Lemon that the sketch was shown.[34]

Taking Lemon's advice, Sambourne now began to attend evening life-classes in Langham Chambers, Portland Place, formerly the Clipstone Street Sketching Club. Working without a teacher, the students drew from a draped model in one week, and an undraped one the next. At ten o'clock they would assemble in order to comment on each other's work. This must have been better than drawing from casts of antique sculpture, but Sambourne soon left the class. A drawing of a seated nude model survives, revealing, in Alison Smith's view, "a lack of confidence in draughtsmanship. The proportions and modelling are awkward and static, testifying to difficulties in working direct from a living motif."[35]

For the first year or so Lemon employed Sambourne casually, generally asking him to supply the decorated initial letters which were a feature of Victorian journals (fig. 7). These stood at the head of articles, stories and poems, incorporating the first letter into a fanciful design. Sambourne contributed about three hundred and fifty initial letters to *Punch* between 1867 and 1874, the number steadily rising year by year, until it reached over sixty (more than one a week) between 1871 and 1873. From 1874 the number of initial letters began to decline as Sambourne shouldered a greater share in the production of larger drawings for the magazine. The initial letters, on a small scale, gave an outlet to Sambourne's ingenuity. His particular gift was for the grotesque, and he often introduced animals or men and women with animal qualities into his drawings and initial letters. Policemen are recurrent features of these initials. They regularly turn up in all shapes and guises, even on occasion as policewomen. A large proportion of the designs do not relate, or only very slightly, to the article or story for which they provide the heading or tailpiece. The fun lies in the drawing itself, not in its bearing on the subject of the illustration. Since there was no demand for realism on the part of the artist, his designs could sometimes be highly imaginative. His early work was complex and fantastic, but it lacked the solid draughtsmanship which was a hallmark of the best-known illustrators of the 1860s.

The 1860s was a great era of English book illustration. From the late 1840s artists of the Pre-Raphaelite Brotherhood began to experiment with the wood-

Fig. 7 Some early initials by Sambourne from *Punch*, 1874

block, and the art attracted outstanding practitioners, many of whom, like John Millais and Frederick Sandys, were painters exercising a second skill. Most of the finest nineteenth-century illustrations were wood engravings. Some artists drew directly onto the woodblock, others worked on paper and skilled engravers then transferred the design onto a block of wood (often the exceptionally hard boxwood). The 'negative' aspects of the design would be cut out, and the 'positive' left as they were, so that gradations of light and shade could be distinguished with remarkable intricacy. A number of firms of skilled engravers grew to deal with the demand, and their names – Dalziel, Linton, Swain – can often be seen on the illustrations. Joseph Swain, working with six to eight assistants, was head of the *Punch* engraving department when Sambourne began work for the paper. Sambourne was among the beneficiaries of a revolution in printing techniques which made it possible to produce large runs of illustrated books and magazines. Being of the same thickness, the block with the wood engraving could be combined with the type for ease of reproduction.

Punch benefited from a pool of talented artists working in this medium. From the start the weekly journal had a gift for attracting outstanding contributors. Founded in 1841, the magazine had survived when rival publications foundered. The good-humoured and Falstaffian Mark Lemon was its first editor and his staff included William Makepeace Thackeray and the artists Richard Doyle and John Leech. *Punch* had just celebrated its 'silver jubilee' when Sambourne began to contribute in 1867. Part of its appeal came from its unique blend of verbal and visual satire, its mixture of articles and cartoon drawings.

At the outset *Punch* throve on a radical and iconoclastic brand of humour, ridiculing pomposity, hypocrisy and cant. In its early days the paper's sharply satirical approach represented a modified version of the late eighteenth-century and Regency tradition, when draughtsmen like James Gillray and Thomas Rowlandson lampooned members of the royal family, statesmen and aristocrats. In the twenty-first century such outspoken accusations of corruption and sexual immorality would bring down libel suits. The radical quality was never entirely lost, but, during the span of Sambourne's career, the tone gradually became more conservative and gentlemanly. This was the Victorian age, and, by the time that Sambourne joined it, *Punch* was a family magazine. In the 1860s and 1870s the paper's political position shifted towards the right. The *Punch* staff were, however, still convivial Fleet Street men, old fashioned 'Bohemians'.

Throughout Sambourne's time on the paper, *Punch* was regarded as an institution, rather than simply as a comic magazine. Copies were to be found on bookstalls, in clubs and private households and in hotels in continental Europe. Bound volumes of the journal graced many a private and municipal library. Later in the century foreign monarchs censored unfavourable cartoons, something of which Sambourne was to have first-hand experience.

Each week the contributors would meet and dine together with the owners and publishers. By the time of Sambourne's arrival William H. Bradbury and Fred Evans, the sons of the founders, were regular diners. The subject of the main political cartoon would be decided by committee at this Wednesday dinner, a very different practice from that in newspapers today. Some flavour of the conversation comes from the diary the writer Henry Silver began to keep in 1858. There was a good deal of racy gossip, in keeping with the hearty masculine bonhomie of the period.

In 1867 three regular cartoonists dined at the *Punch* table. Two of them, John Tenniel and George Du Maurier, had trained as painters, but each had switched to illustration following the loss of an eye. Tenniel, who had executed an oil painting for the new Palace of Westminster, was an artist in the Germanic style, a manner exemplified by his classical female figures and his formal designs. When Sambourne joined the magazine, and for many years afterwards, Tenniel contributed the large weekly political cartoon, becoming a national institution in the process. Du Maurier was the social cartoonist, sending in one or two weekly drawings satirizing upper- and middle-class life. His work falls within the realist mode

initiated by John Millais and carried on by Frederick Sandys and Fred Walker. Sambourne could never have worked within this tradition. His instincts did not lead him in that direction, and, had they done so, his lack of training would have been a serious impediment. By contrast with Du Maurier and Tenniel, Charles Keene, the third cartoonist, had not trained as a painter, but had spent five years as an apprentice to the wood engraver J.W. Whymper. Keene's drawings were usually of low-life characters, including street urchins and tramps.

Sambourne's early *Punch* drawings suggest that he set out cheerfully enough, feeling able to vent his imagination and enjoying the exercise of his skill. He was still a young man and he had no specific role at *Punch*. His task was to fill in gaps, and to cover for the absences of the regular contributors. It is by no means surprising that some work of this period seems trivial and shows little of his true quality. He experimented with different styles, sometimes attempting broad caricature, sometimes adopting a more sophisticated and imaginative manner which reflected the abundance of his own humour.

From time to time Sambourne was asked to contribute a small social cartoon. The first, on 7 March 1868, was *A Hint to Hair-Dressers*. The presence of two attractive female hairdressers has encouraged a young man called Spooneigh to "go as long as his hair held out". Spooneigh, shown with a spiky hairstyle somewhat in the twentieth-century 'punk' mode, is by no means the last Sambourne character to prefigure later fashions. The idea, presumably Sambourne's own, is clever enough, but the execution is somewhat harsh.

Sambourne was more at home with decorative headpieces than with social cartoons. At the end of 1867, Charles Keene being unexpectedly absent, he was commissioned to illustrate the Preface for Volume 53 of *Punch*. He submitted a drawing of a Punch and Judy show, with Punch wielding a threatening stick, surrounded by the jumbled and battered puppet heads of politicians, including Disraeli (*Punch*'s regular butt), Napoleon III, the Pope and a woman with a mass of false hair. Sambourne was clearly fascinated by women and their appearance, hitting his stride as a *Punch* artist with a wonderful series of drawings satirizing contemporary fashions. This began on 12 October 1867 with *Coming to the Point: The Next Sweet Thing à la Porcupine*, a drawing of a woman with a spiked dress, hat and parasol. The idea was to present beautiful women in supremely elegant dresses, hats and hairstyles, each of them resembling an animal or a bird.

Having discovered the theme, Sambourne followed it up with two satires on the craze for the chignon, the wound plait or coil of hair at the back of the head, the hair rarely being the woman's own. *Next Hideous 'Sensation Chignon'*, with a gigantic spider as a head ornament, is aimed not only at fashionable hairstyles, but also at the 'sensation' fiction of the 1860s (P. 30.11.67). In *The Christmas Chignon* a woman sports a Christmas pudding and a bunch of mistletoe on the back of her head (P. 28.12.67). The formula was repeated over a period of years. Peacocks, doves, a duck, a bird of paradise, 'a bee in a bonnet', a mermaid, a giant prawn, fish of all kinds, beetles, a wasp, a silkworm, a butterfly, a snail, a hedgehog, a pineapple, false hair and military uniforms, all were transformed into stylish costumes.

Sambourne's dress cartoons, frequently introducing the whole animal into the drawing, reflect the popularity of animal products in contemporary fashion. Sambourne, it should be remembered, was the son of an importer of furs. On 28 March 1868, for example, when swansdown was a sought-after accessory, he drew a woman dressed as a swan, its beak and long neck curved over her head, its breast a bodice for her dress, and its webbed feet hanging down from her waist.[36] Later in his career, Sambourne was to draw cartoons supporting the bird preservation movement, and these early drawings, showing women in dresses or trains made of feathers or with whole birds in their hats, could have been adapted for that purpose.

The grotesquerie sometimes comes close to overwhelming the elegance, as in the aptly titled *Horrible Idea,* with a huge snake coiled on a woman's head in the style of a chignon (P. 11.1.1868; fig. 8). Generally the subjects are women, but from time to time a dandified man appears in an outrageous waistcoat, butterfly collar or hat. These drawings, given the general title of 'Mr Punch's Designs from [or after] Nature', may mock female fashion, but they certainly do not present women as weak or vulnerable. Helmeted with outsize insects, they are visibly metamorphosing from crinolined young girls into the substance of a Victorian male nightmare. In the animal world the male is usually more gorgeous than the female, but, in Sambourne's cartoons, women often take on male plumage. His designs also reflect a growing popular interest in the study of insect life, reminiscent of the collections of specimens found in museums and country houses.

An ingenious anthropomorphism was a hallmark of the early Sambourne. Like a number of artists of the period, including his friends Henry Stacy Marks and Briton Riviere, he was an habitué of the London Zoo. The anthropomorphic

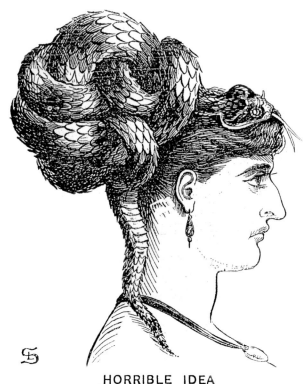

Fig. 8 *Horrible Idea,*
Punch, 11 January 1868

HORRIBLE IDEA

SUGGESTED BY THE TWISTED CHIGNON.

tradition, which goes back to ancient times, has been a continuous thread in Western art. In the nineteenth century it flourished in caricature and in animal painting. In his *Punch* cartoons John Tenniel frequently presented the nations as animals, the Russian bear and the British lion for example. Tenniel, however, followed a formula and, unlike Sambourne, he neither redrew his animal images nor ranged widely among different species.

An important influence on anthropomorphism came from an older painter, Sir Edwin Landseer, whom Sambourne had met briefly at John Penn's garden party. Landseer was a serious animal artist and, in his tragic later paintings of hunted animals, he touches a string far beyond the scope of satirical anthropomorphism. However, in earlier paintings like *Dignity and Impudence* (1839, Tate Gallery) the noble bloodhound and the tiny fox terrier, looking out of the bloodhound's kennel, provide a skit on relations between the great and the cheeky. Sambourne used this Landseer painting as the basis for a political satire of 22 January 1876, with Benjamin Disraeli as the bloodhound and Sir William Harcourt as the terrier.

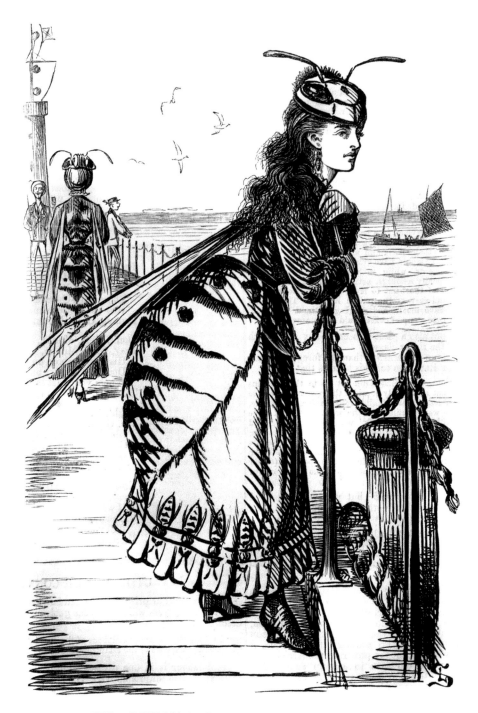

MR. PUNCH'S DESIGNS AFTER NATURE.

MIGHT NOT *WASP-WAISTED* YOUNG LADIES ADOPT THIS WITH ADVANTAGE?

Fig. 9 *Mr. Punch's Designs after Nature, Punch*, 16 October 1869

The evolutionary theories on the relation between animals and human beings published in Charles Darwin's *Origin of Species* of 1859 had a marked effect on Sambourne's animal drawings. Darwin's work led to a new strain in anthropomorphism. As Alex Potts has expressed it, "What could not be stated openly about the violence of social being in bourgeois society was displaced onto figurations of the animal world".[37] Sarah Burns has shown how American satirists used images of massed bears and bulls as a metaphor for the battles waged between rival tycoons and stockbrokers on later nineteenth-century Wall Street.[38] Sambourne's art was not of this kind, but he was aware of the work of Darwin as a naturalist, read his books, and carried this knowledge into his cartoon drawings. The fashion cartoons, 'Mr Punch's Designs after Nature', suggest a comic reversion of Darwin's theory of evolution, as human beings, far from evolving into higher forms, return to animal shapes once more (fig. 9). By implication, his contemporaries, whether politicians or fashionable women, retained the qualities of their forbears in the evolutionary chain.

Sambourne was not the only anthropormorphic draughtsman trying to get a footing on *Punch*. Ernest Griset, two years older than Sambourne, had begun his career in 1860, working for *Fun,* a rival journal. Griset's first drawings for *Punch* date from 1867, the same year as Sambourne's. Employed, like Sambourne, to draw initial letters at the outset, the experienced Griset was given far more cartoon work than the younger man. He seems, however, to have been a misfit on the *Punch* staff and had all but left the magazine by 1869. The *Punch* careers of Sambourne and Griset are oddly balanced. As Griset's stock fell, Sambourne's correspondingly rose.

An artist more regularly employed than Griset was Georgina Bowers, one of the few women illustrators to work on the mid-Victorian *Punch*. Bowers, who contributed cartoons, mainly of hunting scenes, was also a prolific designer of initial letters. She was popular with the public but would never, of course, have been invited to the weekly dinner, nor was she fully recognized as part of the team.

Although Mark Lemon had given Sambourne his original opening on *Punch,* and a chance to submit his splendidly grotesque fashion cartoons, he made no move to appoint him to the regular staff. Possibly Lemon saw the artist as a talented amateur rather than a full-time professional. He clearly liked the young man, and they occasionally met socially. Sambourne recalled "dancing in a set of quadrilles" in 1868 with Lemon, the actor Edward Askew Sothern, famous as Lord Dundreary

in Tom Taylor's *Our American Cousin*, and George Cruikshank, a comic and polemical artist whose graphic work Sambourne greatly admired.[39]

Sambourne was involved as an actor when Mark Lemon played Falstaff in various scenes from Shakespeare's history plays. It is not clear what part he took. These performances opened in London in 1868, first at Thomas German Reed's theatre in Regent Street, the Gallery of Illustration, and then at St George's Hall, Langham Place. Such was the success of the production that the Prince and Princess of Wales asked to see it and were accorded a special performance. In the following year, Lemon took to the road, with engagements in Cheltenham, Glasgow, Edinburgh, Birmingham, Manchester, Liverpool and a number of other towns and cities. Sambourne, who had not greatly enjoyed the experience in London, elected not to follow Lemon to the provinces. The strain of travelling, the heavy expenses (which were never covered), told on Lemon's health, and he died on 23 May 1870.

Lemon's deputy in all but name, Charles William Shirley Brooks, succeeded him. Shirley Brooks had been destined, like a number of members of the *Punch* staff, for a legal career. A writer of humorous verse and prose, he first contributed to *Punch* in 1851, after working for a rival magazine, *The Man in the Moon*, and as a parliamentary reporter for the *Morning Chronicle*. Brooks's good humour and his care for his young colleagues were as legendary as his professionalism, and the new editor promptly promoted Sambourne to the *Punch* table as second political cartoonist. It does not appear that party politics were ever an important personal concern for Sambourne, but this promotion was to involve him in national affairs for the rest of his working life. As time went on, he found his true métier in the more imaginative designs for special numbers, title pages and end-pieces and for the annual *Punch* Almanack.

Sambourne first attended the *Punch* dinner on 3 June 1871, but only as a special favour to mark the inauguration of the new dining room at 10 Bouverie Street. He had already been vetted as a colleague, and had clearly passed the test. On 18 December 1869 Shirley Brooks wrote in his diary that he had dined at the Bedford Hotel, a regular *Punch* haunt, with Mark Lemon, Fred [Evans], F.C. Burnand and "Sambo (this is Lindley [sic] Sambourne, the clever young *Punch* artist, who has been and will be very useful)".[40] On 13 September 1871 Brooks writes of Sambourne's full acceptance as a regular member of the staff: "Sambourne d[ined] and will do so for the future."[41] Sambourne treasured his invitation to this

dinner. Drawn by George Du Maurier, it shows Mr Punch ringing a bell, with Shirley Brooks on his head. The staff all appear, flying with only heads, wings and birds' feet. At twenty-seven, Sambourne was the youngest member of the team.

This was the dinner at which the plans for the annual *Punch* 'Almanack' were first drawn up. Among Sambourne's earliest major contributions to the magazine were his title pages for this publication, often including a calendar within the design. The first example appeared in 1869. The 'Almanack', almost entirely made up of drawings, was published separately in mid December and, as a result, it is not always to be found in bound volumes of *Punch*. This is regrettable, as the artists worked long and hard on the more complex cartoons and studies which were required, and the standard of draughtsmanship is high.

Once Sambourne had joined the staff, Brooks wanted him to work regularly on 'The Essence of Parliament', a satirical commentary about recent political events, written by Brooks himself or, in his occasional absences, by Henry Silver. Brooks had begun the series in 1854 and was to carry it on for twenty years. A number of artists, including Charles Bennett, worked on the column, but during the 1860s the 'Essence' frequently appeared without decorative initial letters. Bennett's early death in 1867 left a space open for Sambourne, who contributed his first initial letter to the column on 30 November 1867. A second followed rapidly on 7 December and two more appeared in June and July 1870. From 1871 Brooks asked Sambourne for further initial letters, and these drawings began to increase in size until many of them covered a quarter of a page or more. Brooks greatly admired the three-quarter page 'T', showing Mr Punch swimming, in the number of 2 September 1871.

Sambourne had to study the faces of the politicians whom he needed to caricature in his initials. Following his particular bent, he often presented them as animals, birds or insects. The leader of the Tory party Benjamin Disraeli, with his distinctive curly black hair, was a constant target for the Liberal magazine's humour and Sambourne, like John Tenniel, presented him in many guises, as a character from Shakespeare, a camel, a bee, Mercury and a hairdresser.

Sambourne did not always represent the politicians who featured in the 'Essence' articles, often falling back on images related to current political issues. On 1 March 1873, for example, he showed Disraeli, the leader of the opposition, and the Liberal Prime Minister, Gladstone, as octopuses (fig. 10). This was a large

PUNCH'S ESSENCE OF PARLIAMENT.

Fig. 10 Initial letter 'T', *Punch*, 1 March 1873. Disraeli (above) and Gladstone (below) as octopuses

design based upon a letter 'T'. On 15 March 1873 an initial letter 'P' covered the whole page, with the heads of prominent politicians hanging down like grapes, Liberals on the left and Tories on the right. Mr Punch, as a winemaker, stands between them. His dog, Toby, sleeping with his back against the wine racks, forms the rounded part of the 'P'. If the features of Disraeli and Gladstone are still familiar today, those of contemporary politicians, once famous, are now unknown to all but historians of the period. As a result, the thrust of these drawings has often been lost.

Sambourne retained his interest in women's fashion and a number of his cartoons are essentially satires on the latest crazes. Hats, appearing as a design feature in Sambourne's initials and cartoons of the period, were a favourite. George Du Maurier believed that Sambourne could draw hats better than anyone else. He also became involved with Frank Burnand's series, 'More Happy Thoughts' (a successor to the highly successful 'Happy Thoughts', begun in 1866), which had no running theme and called for a variety of drawings to illustrate the narrator's good ideas, dreamt up for unhappy or comic predicaments.

Between 1869 and 1883 Sambourne contributed to *Punch's Pocket Book*, a publication which ran until the 1880s. This was a small diary with pages of useful

information about such matters as taxation levels, costs of postage, theatres and museums, together with lists of judges, Members of Parliament, senior civil servants, the royal household and other notables. At the back were a number of short articles. These were interspersed with a series of humorous drawings, caricaturing political figures and very much in the style of 'The Essence of Parliament'. A Sambourne drawing for the 1878 Pocket Book shows a householder as a rat, with five young on its back, each named after a particular tax – income, vestry, Queen's, property, poor rate (fig. 11). This drawing faces a list of taxes which a citizen might expect to pay.

Sambourne's regular contributions to the magazine and appearances at the weekly *Punch* dinners provided a framework to his career which was to last until nearly the end of his life. The magazine staff were good friends as well as working associates. A staff outing on 18 June 1873 took them to Gravesend, a once popular resort on the lower Thames. On 17 June 1874 they were at the Royal Hotel, Purfleet in Essex, looking out over the sea and the Chichester Training Ship. There were regular summer expeditions to the Trafalgar Tavern, Greenwich, where the *Punch* team enjoyed the famous whitebait dinners.

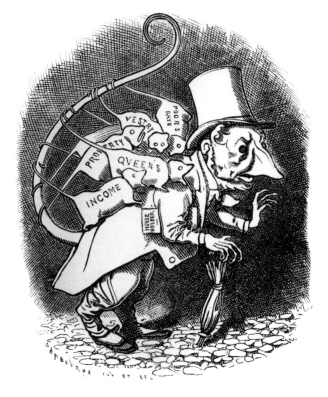

Fig. 11 Illustration to *Punch's Pocket Book* for 1878

In September 1871 and 1872 Brooks sent Sambourne to Aldershot to draw cartoons based on the annual autumn military manoeuvres. Among the young officers was Arthur à Beckett, formerly a civil servant attached to the War Office, the son of the *Punch* founder and writer Gilbert Abbott à Beckett. Arthur à Beckett was the commander of his own territorial company, the Prince Consort's Own Rifle Brigade, known as the Tower Hamlets Militia. He gives a glimpse of Sambourne as he appeared to a contemporary:

> I managed to get away with a brother officer to dine with my future *Punch* colleague at a local inn. Truth to tell, as we were in the enemies' country, if we had been taken prisoners we should have been liable to all sorts of imaginary punishments. When we bade our host good-bye we had to run the enemies' sentries.
>
> 'Who goes there?' said one of these guardians.
>
> 'A friend!'
>
> 'Pass friend and give the countersign.'
>
> 'Don't know it,' returned my comrade, imagining that our next moment would be our last of liberty! Don't know it!'
>
> 'But I do!' replied the sentry, a volunteer, 'it's "Windsor!"'[42]

The first book Sambourne was commissioned to illustrate was *Military Men I have Known* by E. Dyke Fenton, published by Tinsley in 1872. He contributed a number of comic vignettes to the volume, a joky account of the Army. The extra money was important to him, and *Punch* had no objection to his taking on other work, as long as he kept to his contract with the magazine.

Francis Cowley Burnand

Sambourne remained living in Uxbridge until the time of his marriage in 1874, riding into London when he needed to attend *Punch* dinners or to arrange his illustration work. He now lived at Pen Close, presumably with his mother and his widowed aunt, Jane Barr. Sambourne's social life at this time centred on the musical parties given by the German Reed family. Alfred Reed's mother had been a well-known child actress, Priscilla Horton. Now established as a contralto, she was the star of Mr and Mrs Reed's 'entertainments', musical and dramatic evenings which were inaugurated in 1855. The 'entertainments', together with his New

Philharmonic Society concerts, had made Thomas German Reed a famous man.

Shirley Brooks spotted Sambourne at an evening party given by the German Reeds on 19 June 1869. A regular guest from the *Punch* staff was Francis (Frank) Cowley Burnand. Burnand was eight and a half years older than Sambourne and their careers were, for better or worse, to be entwined until 1906. Introduced by Alfred Reed while Sambourne was working at Penn's, they soon became close friends. Burnand recalled that Sambourne was "barely twenty" at the time of their meeting,[43] which would place it at the beginning of 1864. Their backgrounds were very different. The son of a Swiss father working in London as a stockbroker, Burnand lost his mother following his birth in 1836 and his only sister not long afterwards. The hard-working father had little time for the boy, who spent his life at boarding school or with relatives.

Educated at Eton and then, from 1854, at Trinity College, Cambridge, Burnand had always been interested in drama and was a founding member of the university's Amateur Dramatic Club (the ADC). As a child he was frequently taken to the theatre or the opera and his first farce, *Guy Fawkes Day*, was performed while he was still at Eton. Burnand considered careers as actor, lawyer and churchman. The last option was closed first by his conversion to Roman Catholicism and then by his decision to abandon plans for admission to the Catholic priesthood. He qualified as a barrister, but never practised, becoming instead a successful author of fiction and drama, particularly known for his burlesques of popular plays and for his satirical comedies. Burnand wrote over a hundred plays and his *Cox and Box*, with music by Arthur Sullivan, was performed by the *Punch* staff and their friends in 1866 in aid of Charles Bennett's family. His satire on the Aesthetes, *The Colonel* of 1881, was popular both in London and on tour.

It was through the novelist George Meredith that Burnand met Frederick 'Pater' Evans, joint owner of *Punch*. Meredith was also responsible for the publication of short stories by Burnand in the magazine *Once A Week*. Mark Lemon had seen his work there and rapidly recruited the author for his own staff. Burnand's earliest success as a writer for *Punch* came with 'Mokeanna, or the White Witness', a skit on sensational journalism and fiction, which began publication on 21 February 1863. In the same year he was promoted to the *Punch* table. By the time Sambourne met him, Burnand was an established member of the *Punch* staff and was also well known in the theatre.

Burnand recalled their early friendship in two tributes published in *The Daily Telegraph* after Sambourne's death. He often met Sambourne with Thomas ('Pa') German Reed at the Royal Gallery of Illustration, the small theatre in Regent Street where the German Reeds' entertainments took place before being moved to St George's Hall, Langham Place, in 1874. Both theatres had been the setting for Lemon's Falstaff evenings and Burnand's plays were regularly performed under the Reeds' management. Thomas Anstey Guthrie, a future colleague of Burnand and Sambourne, described the Gallery with its "narrow and rather stuffy" auditorium and "the plays, which were not called plays but 'illustrations', so that the strictest could see them without offence".[44]

German Reed lived at Clapham and Burnand and Sambourne would accompany him on rides to Wimbledon. Twenty-three years later Sambourne recalled patronizing the Swan Inn at Leatherhead (D. 14.4.96). On one occasion Reed invited the two young men to join him on the yacht which he owned with a friend, explaining that the boat was small, but insisting that she was comfortable. Burnand and Sambourne duly joined him at Gravesend at midday on a Saturday. Warned of the lack of space, they had brought little luggage, but they were still shocked by what they saw. The 'crew' was made up of a boy and of an old sailor with a wooden leg, a hook for a hand and poor eyesight. The boy, who was not paid, made the journey for the food and the tips. There was little to eat and no berths. Separately, Burnand and Sambourne decided to go ashore at the next stop, Herne Bay.

Burnand, who had married Cecilia Rance in 1860, lived at Hale Lodge, Edgware, where the genial Sambourne became a popular visitor with their seven children:

> He was delightful among children, and ours adored him; the smaller they
> were – and we had them all sizes – the more he loved them, and the more
> they loved him. He possessed a fund of knowledge about all sorts of things
> to amuse children. The wonderful tricks he showed them with paper and
> string would not only have puzzled a conjurer, but, on his having learnt
> to practise them, would have set him up for life.[45]

The Burnands' three year old daughter, taking a fancy to Sambourne's hair, "brushed right up on end, as if he had been suddenly frightened and his hair had not yet recovered from the shock", told him, "How lovely your hair do grow!"[46] Many years later, writing to express her sympathy to the artist's widow after

Sambourne's death, Rosie (now Mrs Maguire) remembered his "great kindness …
as a small person I thought there was *no one* like 'Mr Sammy', he used to be so
kindhearted to us at Hale Lodge".[47] Burnand eventually fathered a very large family.
Cecilia died in 1870 and, four years later, he married Rosina Jones, who gave birth
to two sons and four daughters. These children from the second marriage were to
be the close friends of Sambourne's offspring.

Burnand's recollections of Sambourne build up a picture of a cheerful,
pleasure-seeking young man who loved a party. Burnand owned a photograph of
his old friend dressed in an Austrian Hussar's costume for a fancy dress ball at the
Brighton Pavilion. Sambourne, Burnand says, was an "enthusiastic dancer", and,
when his sword began to get entangled round his legs, he hung it up with his
'shako' in the hall. On his return, he found that someone had taken the sword but
left the hat.[48] It reappeared a few days later, after an advertisement requesting its
return had appeared.

In course of time, Sambourne was to illustrate a number of Burnand's books.
The first such collaboration, dating from 1872, was *The New History of Sandford and
Merton*. This, like much of Burnand's work, was a parody of an existing text, *The
History of Sandford and Merton*, a popular book for children, published in the 1780s
by Thomas Day. In the original, the rich and nasty Tommy Merton is regularly
shown up by the poor and virtuous Harry Sandford, the son of a farmer. Their
tutor, Mr Barlow, draws out the moral of the tale. In Burnand's version Tommy is
virtuous, in contrast to the unspeakable Harry, and Mr Barlow is a social-climbing
hypocrite. For this book, related to Burnand's work in *Punch* and published by the
magazine's owners, the firm of Bradbury, Agnew & Co., Sambourne supplied
seventy-six illustrations of varying sizes. The drawings are suitably lively and comic.
He introduces a crocodile with a dentist on his back. When the dentist offers him
false teeth, the crocodile eats him. The interpolated tales, which make up much of
the text, are written in a variety of different modes, recalling Aesop, the *Arabian
Nights* and classical myth. Sambourne alters his style to suit the narrative, but
always suggests an element of mockery and caricature.

Burnand's preface to *The New History of Sandford and Merton* brings out clearly
the friendly relationship between author and illustrator. Dedicated to two of his
sons, Charles and Harry, it refers to "Mr Sambourne who has profusely illustrated
the book" and includes him in the dedication's good wishes.[49]

Our Autumn Holiday on French Rivers

Shirley Brooks was in the habit of warning Sambourne against excessive activity, treating him as "a wayward son". Though Burnard acknowledged that "perpetual motion was, with him [Sambourne], almost a craze",[50] in retrospect he felt that Brooks had exaggerated the danger when he advised "Let not even Sambo lead you astray". Sambourne pursued many of the popular sports of the period. Dressed in a yellow coat with a green collar and cuffs, he was 'out' with a wide spread of 'hunts', among them the Queen's Staghounds, the Brighton Harriers, the Old Berkeley Hunt and Lord Granville's Harriers, who hunted from Walmer Castle in East Kent. He enjoyed sailing and riding his horse, whose gift for jumping well and treading warily was reflected in the choice of his name, Blondin, that of a famous contemporary tight-rope walker. For the dashing young man of the Victorian period, a horse was the equivalent of a fast car. Near the end of his life, Sambourne told M.H. Spielmann, "I have seen something of most sports. Have hunted – yachting cruises – fishing – cycling, golf and [shooting]".[51] Most of these were to come later, but Sambourne was already rowing by the early 1870s.

In August 1873 he set out on a rowing expedition down the Seine and the Loire valleys with Charles C. Welman, Herbert Weld Blundell (who became a

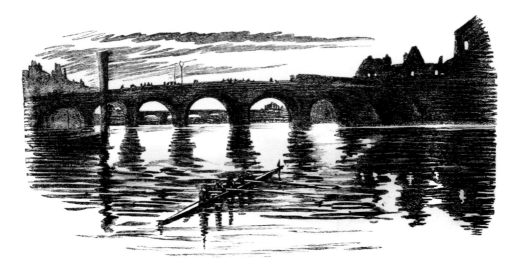

Arrival at Angers.

Fig. 12 'Arrival at Angers', illustration to J.L. Molloy, *Our Autumn Holiday on French Rivers*, 1874

distinguished archaeologist) and James Lynam Molloy. All three were trained lawyers and Molloy had worked as secretary to the Attorney-General Sir John Holker. An Irishman six years older than Sambourne, Molloy later achieved fame as a writer of popular songs, including 'Love's Old Sweet Song' and 'Bantry Bay'. Like Sambourne, Molloy was a regular guest of the German Reeds. He had collaborated with Burnand, setting his lyrics to music for performance at German Reed 'Entertainments'.[52]

Molloy's account of the rowing expedition, *Our Autumn Holiday on French Rivers*, published in 1874, gives occasional revealing glimpses of Sambourne, identified only by his position in the boat, Bow. Molloy raised Sambourne's social position, telling his readers that Bow had been at Eton. According to Molloy, he was originally recruited from his studio in Uxbridge, and hesitated to join the party because of his poor French. This statement is corroborated by Shirley Brooks, who thought that "the Thames might have been a good enough river for him, but he [Sambourne] said he wanted to *improve his French* – I imagine he will *hear* some that may not improve *him* if he runs up against a bargeful of Seine cads, as he is certain to do."[53]

The expedition proved more strenuous than the participants had expected. They took their own small boat, the *Marie*, with them, carrying it occasionally when the rivers proved not to be navigable. Starting in Le Havre, they went through Rouen to Paris, continuing south to Orleans and Tours before turning west to Angers and Nantes. From Nantes they started to row north to the Channel, but abandoned the journey at Redon. Sambourne needed to return in order to finish his contributions for *Punch*. He had, however, left some work behind him, including an 'Essence of Parliament' heading for 16 August which Shirley Brooks thought "very clever and the artist has shown himself in his own initial".[54] In a tiny self-portrait Sambourne appears skulling along the long stroke of his own signature.

In the course of their seven-hundred-mile journey, on 19 August, the crew of the *Marie* were wrecked in the Seine close to the Abbey of Saint-Georges de Boscherville, near Rouen in Normandy. They lost much of their luggage and Sambourne found himself swimming for his life against a strong current. He later described the experience to Shirley Brooks:

Sambourne came to grief, and tho' we can laugh now it might have been bad work. The boat swamped where the Seine is very wide, and they had

to save themselves by swimming; he thought it was 'all up' at one time, for he could not reach shore but got to a friendly boat.[55]

A memorial was later placed inside the abbey by "An Irishman and Three Englishmen", thanking the Virgin for their escape. A little later, the crew survived a second near-catastrophe, this time on the Loire, when three of the party (by then swelled to five) were nearly sucked into dangerous sandbanks which had already claimed many lives.

Molloy's account of the journey is vigorous and well written. He describes the countryside and the nights spent in villages and towns along the route, with a strong sense of place. Robert Louis Stevenson's biographer Graham Balfour believed that *Our Autumn Holiday* was an inspiration behind Stevenson's *An Inland Voyage* of 1878, and Jerome K. Jerome's *Three Men in a Boat* of 1889 is another possible literary descendant. The vividness of Molloy's writing is excellently matched by Sambourne's illustrations (figs. 12, 13). Bow is said to be endlessly sketching the scenes through which the boat passes and the pretty young girls whom the crew meet in the evenings. Scattered through the book are fifty-six illustrations, ranging from full-page designs to small sketches of figures, places and objects. Some original drawings, thickly worked in charcoal, still hang at 18 Stafford Terrace. These drawings, with their distinctive dark areas and clearly defined outlines, differ in style from Sambourne's later work. Regrettably perhaps, they represent a path not taken.

Sambourne emerges from *Our Autumn Holidays* as a typical young blood. His enthusiasm for his vocation as an artist is underlined in Molloy's account. He is the owner of the dog, Gyp, who provides much of the humour. Bow is also decidedly susceptible to female charm. Sambourne's attraction to the 'fair sex' was to be lifelong. At a Thames boating outing off Teddington in 1878 a particularly attractive girl caught his eye, a moment he remembered many years later. When, from the 1880s, he kept a diary, he often commented on the pretty women he saw in the streets, on the bus or in the theatre. Towards the end of his life he began to pursue schoolgirls, taking their photographs with a concealed camera. At the end of Molloy's story "Bow and Three found they would not have sufficient time to complete the distance, and were anxious to get back to England".[56] Work called, or perhaps the girl of the moment.

St. Florent.

Fig. 13 'St Florent', from J.L. Molloy, *Our Autumn Holiday on French Rivers*, 1874

NOTES

1 Sambourne Archive, Kensington Library, ST/1/2/2/1.

2 Entry for Linley Sambourne in R.C. Lehmann, revised Shirley Nicholson, *Oxford Dictionary of National Biography*, Oxford (Oxford University Press), 2004.

3 Letter to M.H. Spielmann, 25 August 1907, *Punch* archives.

4 The designer of the cover for 'The Sketch: A Chat with Mr Linley Sambourne', *Illustrated London News*, 28 January 1893, p. 121.

5 Kim Tolley, 'Music Teachers in the North Carolina Education Market, 1800–1840: How Mrs Sambourne earned a comfortable living for herself and her children', *Social Science History*, XXXII, 1, Spring 2008, p. 94.

6 See 'Thomas Sambourne: A Building Speculator in Late Eighteenth Century Sheffield', *Transactions Hunter Arch. Society*, X, 3, 1975, pp. 161–66.

7 Tolley, p. 94.

8 Ditto, p. 95.

9 Ditto, p. 96.

10 Ditto, pp. 75–106.

11 George Du Maurier, *Peter Ibbetson*, London (Osgood, McIlvaine), 1892, vol. 1, p. 112.

12 Letter of 20 November 1851, Kensington Library, ST/1/2/4.

13 *The Daily Mail*, 6 August 1910.

14 Letter of 17 February 1903, Kensington Library, ST/1/4/824.

15 Letter of 21 October 1899, Kensington Library, ST/1/4/709.

16 See note 4.

17 *The Daily Telegraph*, 4 August 1910.

18 Letter of 22 February 1857, Kensington Library, ST/1/2/6.

19 Letter of 7 February 1857, Kensington Library, ST/1/2/5.

20 See note 18.

21 *The Liverpool Post*, 14 August 1910.

22 *The Evening Standard*, 3 August 1910.

23 See note 21.

24 Ditto.

25 *Sala's Journal*, 10 June 1893, p. 538.

26 See note 4.

27 Ditto.

28 Letter from B. Morris, *The Times*, 8 August 1910.

29 See note 3.

30 Ditto.

31 See note 4.

32 Joseph Hatton, 'The True Story of *Punch*', *London Society*, XXX, July 1876, p. 58.

33 M.H. Spielmann, 'Our Graphic Humorists: Linley Sambourne', *Magazine of Art*, 1893, p. 330.

34 Ditto, p. 329.

35 Alison Smith, 'A "Valuable Adjunct": The Role of Photography in the Work of Linley Sambourne', *British Art Journal*, III, no 1, Autumn 2000, p. 13.

36 Laurie Anne Brewer gave an excellent paper on this subject, 'Mistress of Creation: Women's Fashions and the Victorian Animal Products Industry through the Eyes of Linley Sambourne', at the CHODA conference, *Dress and The Natural World*, held at the Courtauld Institute in London on 28 June 2008.

37 Alex Potts, 'Natural Order and the Call of the Wild: The Politics of Animal Painting', *Oxford Art Journal*, XIII, 1990, p. 20.

38 Sarah Burns, "Party Animals: Thomas Nast, William Holbrook Beard, and the Bears of Wall Street', *American Art Journal*, XXX, 1999, pp. 9–35.

39 Linley Sambourne, 'Political Cartoons', *Magazine of Art*, 1892, p. 23.

40 Shirley Brooks, Diary entry for 18 December 1869, London Library.

41 Shirley Brooks, Diary entry for 13 September 1871, London Library.

42 Arthur à Beckett, *The à Becketts of "Punch"*, London (Constable), 1903, pp. 196–97.

43 F.C. Burnand, 'Mr Punch's Table: Another Vacant Seat', *Daily Telegraph*, 6 August 1910.

44 F. Anstey, *A Long Retrospect*, Oxford (Oxford University Press), 1936, p. 40.

45 See note 43.

46 Ditto.

47 Letter of 3 August 1910, Kensington Library, ST/2/3/274.

48 See note 43.

49 F.C. Burnand, *New History of Sandford and Merton*, London (Bradbury, Agnew & Co.), 1872, p. vi.

50 F.C. Burnand, 'Mr Punch's Table: Another Vacant Seat', second article, *The Daily Telegraph*, 8 August 1910.

51 See note 3.

52 For J.L. Molloy, see Desmond Moore, *Love's Old Sweet Song*, Tullamore, 1997. I am grateful to Sean Hackett for bringing this book to my attention, and for other information about Molloy.

53 G.S. Layard, *Life, Letters and Diaries of Shirley Brooks of 'Punch'*, New York (Henry Holt & Co.), 1907, p. 559.

54 Ditto.

55 Ditto.

56 J.L. Molloy, *Our Autumn Holiday on French Rivers*, London (Bradbury, Agnew & Co.), 1879, p. 280.

Chapter 2

Marriage, 18 Stafford Terrace and the Art World

With a regular job and rising prosperity, Sambourne was in a position to contemplate marriage. His first meeting with his future wife, Marion Herapath (fig. 15), took place in 1872 at the home of his cousin Frances (Fanny) Barker. Fanny was the elder daughter of Sambourne's aunt and uncle, Sarah and Arthur Linley, and the wife of Charles Barker, a railway secretary who rose to the position of railway director. Barker and Sambourne enjoyed each other's company and the two men made riding expeditions together. Marion's father Spencer Herapath was also involved in the railway business, operating on the London Stock Exchange with large investments in South American companies. It was probably through this connection that Fanny came to know Marion and her old school-friend Toula (Tilda) Frick.

Christened Mary Anne after her mother, Marion Herapath had renamed herself early in life, no doubt feeling that her new name had a more elegant, up-to-date ring. Within the family circle, however, she was usually known as Polly, and this was how Sambourne addressed her, although he sometimes dubbed her Minnie and she is always 'M' in his diaries.

Marion was of a higher social class than her future husband. Her parents had two substantial houses, 18 Upper Phillimore Gardens in Kensington, and Westwood Lodge, a Victorian Gothic mansion near Ramsgate. Marion's paternal grandfather, John Herapath, had designed locomotives and written a well-regarded book on mathematical physics. Her father was a Fellow of the Royal

Fig. 14 The drawing room at 18 Stafford Terrace, looking south, 1923

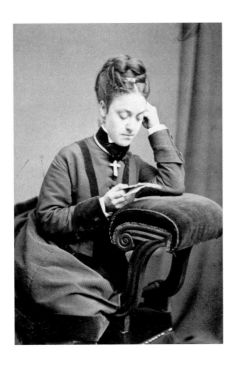

Fig. 15 Marion Herapath, aged 18

Society. Marion, the second surviving child of his marriage to Mary Ann Walker, was the eldest daughter in a very close-knit family of eight children.

Marion's gifts lay in languages and music. Born in 1851, she had spent two years at school in Brussels, returning to London at the age of eighteen in 1869. Photographs show her with fashionably coiled hair, with an added 'hair piece', like that in a number of Sambourne's early *Punch* drawings. He was much attracted by this lively and intelligent girl and began to visit the Herapath home. Marion's eldest brother, Spencer, was a good friend, and Sambourne probably knew him before meeting Marion. Given his financial position, however, Sambourne was not the match her parents would have hoped for.

Only when his aunt Jane died on 16 March 1874, and an inheritance from the Barr Estate gave him an additional £650 a year, money raised on the rental of leasehold buildings near Hyde Park Corner and in Canning Town, was he able to offer marriage. The money had been left to Jane for her lifetime by her aunt, Sarah Linley, with the instruction that it should then be passed on to Linley Sambourne. In compliance with the law, this inheritance had come under the control of her husband James Barr. In his will he had stated that Jane should inherit his own property for her lifetime, and that, on her death, it would pass to members of the Barr family. In Jane's later years a series of complicated legal manoeuvres resulted in a compromise between the Sambourne and Barr families over the division of James Barr's estate.

With this income behind him, Sambourne began to correspond with Marion. Two letters, respectfully addressed to "Miss Herapath", date from 29 April and 15 May. Like all Sambourne's early letters to Marion, they are edged in black, a sign

of mourning for his aunt. Both involve arrangements to provide her with seats for the theatre, one of the 'perks' of his work for *Punch*. In one he mildly teases her for her regular attendance at the annual Royal Academy exhibition, where she thoroughly studied each work. Sambourne speculates that she must know every picture by heart and asks her whether there were still as many green dresses, perhaps a reference to the visitors rather than to the paintings.

Writing from the Garrick Club (of which he had become a member in 1874, put up by Shirley Brooks and seconded by Frank Burnand) on 21 May, Sambourne made Marion a proposal of marriage, writing to her father at the same time. The letter of proposal, and those which followed, give a remarkable insight into the progress of a mid-Victorian courtship. By modern standards the suitor's approach is formal, but the anxiety and emotion are evident.

> I hardly know how to begin or express myself, but I want to ask you a very great question – that is – if you will be my wife? … If you will marry me I will love & care for you & do all I can to make you a good husband. I don't know what to hope or think, sometimes I have thought you might care a little for me – may I hope so? I am not & never shall be a rich man but I have enough to live quietly & you know pretty well what my position is. I am sure I could make you happy if you care for me.[1]

Marion was startled and surprised. She was now twenty-two. One of her younger sisters had married two years before, but this was apparently her first offer. Sambourne waited at the Garrick for a reply but none came. Then Spencer Herapath contacted him and the two men met. There was no response from Marion until the following day, Friday 22 May: "I cannot tell you how yr letter took me by surprise, I had no idea that you cared in the least for me. I can't quite believe it even now."[2]

Marion told her suitor that she was glad that he had written to her father and that the two men had talked together. If he were free, her mother would be pleased to see him on Sunday 24 May. Mrs Herapath had been as surprised as her daughter by the proposal. Evidently Sambourne was unable to come on the proposed date, so a meeting was arranged for the following Tuesday, at 1.30, before lunch. Marion's mother addressed Sambourne by letter, telling him in confidence that her daughter would want to see him before Wednesday 27, when he was due to dine

with the family. A letter from Marion to Sambourne suggests that he was accepted on Tuesday 26 May. Her other letters at this time are concerned with neutral subjects like theatre tickets and arrangements for him to dine at Upper Phillimore Gardens. Such was the formality of the age that, until her father gave his consent, her letters are still addressed to Mr Sambourne. Marion continued to visit the Royal Academy and to go to the theatre and to concerts. These last, she believed, would bore her fiancé and so she did not expect him to join her. She particularly asked that, when he came on a Sunday, he should not follow her into church after the beginning of the service, as this would upset her. In the same letter she expressed a hope that "you are not going to say anything very dreadful tomorrow as I am getting rather nervous".[3]

Sambourne, the only child of a widowed mother, no doubt found an added attraction in the warmth of the Herapath family. On their side, the Herapaths may have been anxious that the young artist was marrying their daughter for her prospects, but, whatever their doubts, they treated him with kindness and consideration throughout this delicate period. One daughter, Annie, had made a disastrous marriage which ended in separation and disgrace, and the Herapaths may have been thankful that Sambourne, although less wealthy than they might have hoped, was reliable. Their concerns eventually centred on the need for Marion to know her own mind, and not to be hurried into marriage.

Once Marion had accepted the proposal, visits to Uxbridge to meet Mrs Sambourne were arranged. By 10 June on his side and 17 June on hers, letters refer to "My sweet darling pet" and to "My darling Linley" or "Dearest Linley" or "Lyn".[4] Sambourne was soon planning to break up his household at Pen Close in Uxbridge, and to let his accommodation in order to make a little more money. He often rode up to London on Blondin, staying with Frank Burnand in Great Marlborough Street and dreaming of finding lodgings in Kensington so that he could see Marion more easily. His mother made more than one visit to Yorkshire during this period, and her son, after seeing her off, would run straight round to Kensington. Frances's ill health, Sambourne reported, was a result of being "so much alone", an ominous foreshadowing of the difficulties which were to develop between mother and daughter-in-law.[5] Another problem was Gyp, the hero of the French rivers episode, whom Sambourne could not bring to London and for whom arrangements had to be made.

This state of upheaval increasingly disturbed Sambourne's equilibrium: "My life is one long blank when I am away from you", he told Marion.[6] As he wrote, linen and silver were being packed up around him. On her side, Marion worried that he was making himself ill by sitting up too late at night to finish drawings. To add to his anxieties, the Herapaths were planning to go down to Westwood, making it more difficult for him to see Marion. Nor were Marion's letters entirely consoling. Responding to his frequent missives, she asked him if he had anything to say other than the "old story which takes so long to explain & yet so little when told".[7] She disliked his characteristic signature – a series of strokes – and asked him to sign his name properly.

Sambourne evidently wished that his bride and her family would name the day. October was suggested, but Spencer Herapath's poor health threw this idea into jeopardy. On 19 June, however, an October wedding was agreed. Marion was now worrying about her lover's sexual advances. On his own in Uxbridge, during a season of exceptional heat, he made his feelings clear in a letter of 10 June, written immediately after his return from seeing her.

> It already seems an age since I had you in my arms. Oh! Marion dear I am sick with love for you. You *cannot* tell what it is for me to go away from you. How I long for the time when we can be happy together as long as life lasts.[8]

Marion's response is evident from an undated letter written after one of his visits. She tells him that she was blushing right through dinner and planned to invite a third party to be with them the next day in order to prevent "a tete a tete with you as I do not wish to look as if I had been cooking …. Don't come tomorrow unless you have made up yr mind to behave yourself".[9] This may relate to a note in which Marion writes that her fiancé's letter to her father had arrived, and that he had let her off "easily", but that her younger brother and sister, Edgar and Jessie (aged twenty-one and sixteen), were "far more vexed".[10]

Sambourne was still in Uxbridge on 25 June: "I have worked hard all day and shall keep on an hour or two longer. I've had a wretchedly lonely dinner all by myself and very badly cooked too. I shall shift up to London on Saturday if all be well so that I can begin work in town on Monday if possible."[11] He spent some time at Westwood during the Herapaths' summer holiday and in the weeks before the

wedding, staying in 'The Cottage' with Marion's brother, Spencer. Once a week he returned to London to attend the *Punch* dinner and deliver his cartoons to the offices. He also needed to leave enough work to cover his absence from the paper during his honeymoon tour, and was under pressure from William Bradbury to complete the title page for a book.

Sambourne, ever the artist and designer, took an active interest in the preparations for the bridesmaids' salmon-coloured dresses, suggesting hats *à la* Rubens instead of the more usual bonnets, and sending Marion a sketch of a woman in a picture-frame hat, like that worn in Rubens's famous *Chapeau de Paille*, a painting which had entered the National Gallery three years before. In a flash of humour, he advised her not to change the colours in case the salmon were disappointed.

Ten days before the wedding, unhappy at leaving her family, Marion made it clear that she was having doubts about the marriage. Sambourne wrote assuring his bride of his own concern, but telling her that his love was only deepened by her affectionate nature. He begged Marion to tell him of any anxieties, and, as he had throughout the courtship, expressed a hope that she "would try to love me a *little*".[12]

The difficulties were overcome, and the marriage took place at 11.30 on 20 October 1874, at St Peter the Apostle, Broadstairs, with the reception in a marquee at Westwood. According to the newspaper, the day was bright and sunny, although, years later, Sambourne recalled it as having been misty. Marion was followed by six bridesmaids – two of her younger sisters, two friends, a cousin of her own and a cousin of the bridegroom, Alice Linley, a daughter of his godmother Sarah. Sambourne was attended by five groomsmen – the bride's four brothers and a cousin. Of these attendants, only Alice Linley was neither friend nor relative of the bride. Sambourne's wishes had been followed to the letter, and the bridesmaids' outfits were described in the press as made of "salmon colour batiste, trimmed with ruby coloured ribbon and Rubens hats".[13] The name of the best man is given as Mr W.F. Thornton. Leslie and Charlie Thornton are both mentioned in later letters from Marion Sambourne, and they may have been family friends or cousins. There were a few relatives and friends of Sambourne's present – Sarah and Arthur Linley and the painter Adolphus (Dolly) Storey, with *Punch* represented by John Tenniel and Frank Burnand and his new wife. Others from London were "at the last moment prevented from attending".[14] Frances Sambourne seems to have been absent. With the paths covered in flowers and the band of the seventy-

seventh Regiment playing, this was what the local newspaper described as a "grand and fashionable marriage".[15] It was clear that Sambourne had married well. Signing the parish register, he gave his profession (like many at the time) as "gentleman".

Sambourne's marriage, following on his invitation to the *Punch* table, was a decisive step in his life, and it was one which gave him much needed stability. Marion later said that, if her husband did not spend at least an hour and a half with her every day, he would feel bereft. What we know of his bachelor life gives the impression of a gregarious young man of enormous energy and ambition, enjoying exercise and sport but also anxious to prove himself as an artist. Never conventionally handsome, his attraction lay in his warmth. Children, like the Burnand family, adored him because he made time for them and gave them a sense that they mattered. He happily played his part as 'one of the boys', but was something of a flirt, entranced by good-looking women.

Marion and he shared a liking for literature, and she often read aloud to him as he worked. He did not, however, approve of her expressing strong views about literary matters in public. Both were enthusiastic theatre-goers, but the couple's interests were not identical. Marion loved music, but it held little interest for her husband. This was characteristic of a period when music was widely regarded as a feminine art and when Englishmen were not encouraged to pursue musical tastes. Both Sambournes, however, enjoyed great art and she was his regular companion at Royal Academy Private Views. Marion was undoubtedly proud of her husband, of his work and of their home.

After the wedding, the newly married pair drove to Dover and then crossed to the Continent. Rome, Florence and Venice were on their itinerary. Sambourne took his work with him, and two drawings, both for the 1875 *Punch* 'Almanack', are dated from Rome and Venice. There is a paucity of evidence about the Italian journey. The couple went to Pompeii, which delighted them, but Linley was worried by Marion's wish to climb Vesuvius, and apparently dissuaded her. It would be good to know how Sambourne reacted to the statues and paintings of Italy. He was, among other things, seeing the originals of those famous works with which he had wrestled as a South Kensington art student, the *Laocoön* and the *Apollo* Belvedere. The photographs of the Sistine Chapel and the Vatican statues at 18 Stafford Terrace apparently date from this journey to Rome. Marion was unwell there, and, deciding that the city did not suit them, they made a rapid departure. In Venice they stayed at

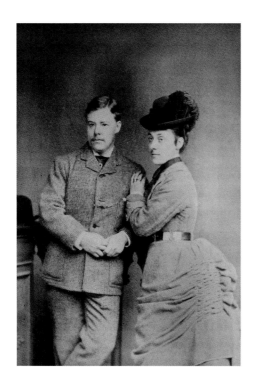

Fig. 16 Linley and Marion Sambourne on their honeymoon in Rome, 1874

the Hôtel d'Europe and Marion recalled how she made her husband sketch San Giorgio Maggiore at sunrise. The couple had their photograph taken in Rome and again in Venice (fig. 16). As Marion's biographer Shirley Nicholson writes: "Linley looks rather stolid … Marion … is wearing a saucy hat and a simple elegant dress which shows off her trim figure. Photographs taken later in life are less flattering, but in this one she appears a lively pretty girl with more sparkle than her husband".[16]

On their way home the Sambournes passed through Monaco ("quite a change after many churches and pictures"),[17] Nice and Paris, where they stayed at the Hôtel Meurice. Marion shopped for dresses and they saw *La Demi Monde* at the Théâtre Français. Sambourne told his brother-in-law that the play was the talk of Paris, but that he hoped that it would "not be too bad for Pollie to explain to me". "[Have] we not spent some money", he complained, expressing weariness with sightseeing and travelling and a wish to be at home and at work once more.[18]

The couple returned to London in early November. At first they stayed with Marion's parents and Sambourne wondered whether to hire a studio, fearing that his equipment would be "in the way at Phillimore Gdns".[19] Life inevitably changed after marriage. The aspiring illustrator on the fringes of society was drawn into two new worlds, that of the prosperous Herapath family and its links with the City, and that of the younger married artists who were settled in London. This latter group is not so easy to define, but it certainly existed, and from it came many of the close friends of the newly wed Sambournes. Above all, Sambourne's life changed when he moved into 18 Stafford Terrace, Kensington, which was to be his home until his death, thirty-five years later (fig. 17).

Kensington, once the site of the London gravel-pits, was developing into a prosperous district. Thomas Anstey Guthrie, a later colleague on *Punch,* wrote of the High Street in the 1860s, before it became a fashionable shopping place: "I can remember small bakers' shops with big placards showing the prices of bread, and I think there were low ginshops or public-houses But towards Kensington Gardens the houses had red-tiled roofs and bow-fronted shop windows, with a pleasant air of belonging to a country market town."[20] The Phillimore Estate, where both the Sambournes and Herapaths lived, played an important part in changing the character of the area. The development of the Estate, on the southern edge of Campden Hill, began in the late eighteenth century with Phillimore Place, home of the painter David Wilkie from 1812 to 1824. In 1855 Charles Phillimore released land on the estate to a builder named Joseph Gordon Davis. Davis, in his turn, appointed builders for different areas.

Stafford Terrace, the last part of the building project, was begun in 1868, by Walter Nash. The majority of the terrace was in place by 1871 but the work was not completed until 1874, the year before the Sambournes moved in. The house is classical in style, five floors high, including a basement with the kitchen, wine cellar and coal-hole under the street. Simon Jervis defines the inhabitants of the estate in the 1860s as "professional men or the equivalent, and Stafford Terrace, as listed in the 1871 census, before No. 18 had been finished, followed the same pattern". Among the Sambournes' neighbours were "retired officers, senior civil servants, a barrister, a Knight's widow living with her daughter, and several tradesmen The only profession lacking in 1871 but common elsewhere on the Phillimore Estate was artist. The arrival of Sambourne at No. 18 ... thus reflected statistical probability".[21]

Fig. 17 18 Stafford Terrace before the house was painted white

18 Stafford Terrace

The Sambournes moved into Stafford Terrace in 1875. The house was almost new, but they were not the first inhabitants. The previous occupier, Mrs Elizabeth Bentley, had died in 1873. The Herapaths contributed half of the £2000 asked for the eighty-nine-year lease and their daughter also received £100 per annum as a settlement on her marriage.

Sambourne set about re-decorating his new home. As an artist with advanced tastes, he naturally chose to decorate in the Aesthetic style, just becoming fashionable. Not for him the old-fashioned wall coverings and furniture associated with the Great Exhibition of 1851. £70 was spent on William Morris wallpapers, dados and friezes were introduced and the woodwork was painted blue-green. (The expensive embossed red and gold paper, resembling old leather, was hung in the first-floor drawing room later, but only as a surround for the pictures.)

The morning room, at the back of the house on the ground floor, was extended and the distinctive glass bay was built out from the dining-room window at the front, initially for a display of ferns. The general work, carried out by Walter Nash, cost £240. In September 1874, before they moved in, Marion wrote to her husband: "How hateful of little Nash not to come to reasonable terms detestable little man".[22]

From the start, the dominant style of the new house was Early Aesthetic. There are numerous blue-and-white Chinese import vases, beloved of the painters Dante Gabriel Rossetti and James Whistler, both of whom helped to popularize the craze. Much of the Sambournes' blue-and-white collection stands on shelves high up on the walls, a decorative motif characteristic of the Aesthetic style. Sunflowers – popular with the Aesthetes – and flowers in blue-and-white vases appear in the stained-glass windows that Sambourne later designed for the drawing room. Similar vases and more sunflowers were painted onto the interior doors. Sambourne was proud of the window at the southern end of the drawing room, close to his working desk: "My own design ... there is the rising sun, and the birds on the wing, something to make London more cheerful."[23]

Much of the furniture is characteristic of an Aesthetic interior. Charles Handley Read explained: "We are in the period of Art Furniture, launched in 1871

Figs. 18, 19 The drawing room at 18 Stafford Terrace, looking north (top) and the dining room (bottom). Photographs by Argent Archer, 1923

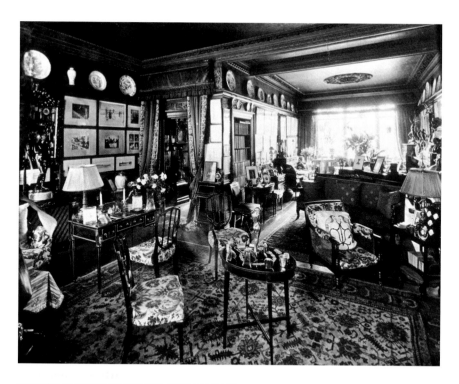

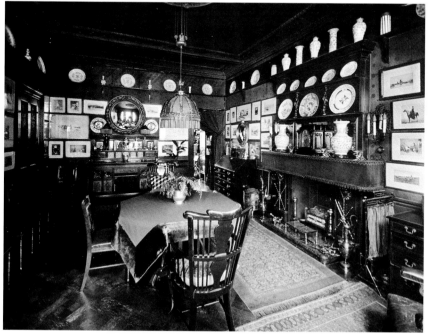

by Collinson and Locke ... with light pieces of turned wood, ebonized black, touched with gold ... the kind of furniture you see, precisely, in the over-mantle of the morning room That is an example of pure 70s or 80s 'art furniture'."[24] The painted sideboard in the dining room is in the manner of Sir Charles Eastlake's *Hints on Household Taste* of 1868 or of B.J. Talbert's *Gothic Forms Applied to Furniture, Metalwork and Decoration for Domestic Purposes* of 1867. Charlotte Gere and Lesley Hoskins note that Sambourne "appears to have been familiar with *Hints* when furnishing his London house ... but the large amount of French furniture in the house was unusual, and the delicate Sheraton pieces in the morning-room were well ahead of taste at that date".[25] The French-style furniture, with some late eighteenth-century pieces and some good copies made in Victorian London, is in the drawing room. Sambourne told an interviewer in 1889 that it was "genuine every bit of it".[26] We do not know the date of Sambourne's first visit to Paris, but it is possible that he helped with the John Penn display at the Paris exhibition of 1867 and acquired his taste for French furniture then. His absence from *Punch* during the summer months of that year would support this supposition. Sambourne was an *habitué* of sales and antique shops and continued buying new pieces and ceramics until the end of his life. The decoration of the morning room, however, is believed to have been largely the work of Marion, so that the pictures hanging there and the Sheraton furniture, with the later pieces in the Sheraton style, may reflect her taste as much as his.

A decade or so later Sambourne decorated the bedroom fireplace with casts of *Morning* and *Evening* from Michelangelo's Medici Chapel in San Lorenzo, Florence. True to his artistic calling, he hung up around the house photographs of Old Master paintings, bought in Italy. The subjects include frescoes by Raphael and Michelangelo from the Vatican Stanze and the Sistine Chapel and, on the walls of the hall and staircases, photographs of famous classical statues. Most of these are to be found in the Vatican Gallery in Rome – the *Apollo* Belvedere, the *Ariadne*, the *Dying Gladiator*, the *Discobolus* among them – but the famous bust of *Clytie* comes from the British Museum. Some years later, in 1886 and 1887, Sambourne bought casts of further statues for the house, a *Venus de Milo*, copies of the Vatican *Minerva* and of the Farnese *Bull*, a once-famous group sculpture from Naples. In the drawing room is a reduced cast of a more recent work, John Bell's statue *Eagleflare*, an American Indian holding up his bow and aiming at an eagle. As "a celebrated example of anatomical sculpture",[27] this copy of a piece made famous at the 1851

exhibition was a well-chosen purchase for an animal draughtsman. Sambourne bought it for £3. 5 shillings in Victoria Road in 1895. This, like the introduction of casts from Michaelangelo in the main bedroom, is an example of the way in which the decoration of 18 Stafford Terrace developed over the years.

The art world

Living close to her parents, Marion was a daily visitor in Phillimore Gardens, while her husband worked at home or visited his clubs, the Garrick and the Beefsteak. His work for *Punch* continued to be his first priority. Unhappily for him, Shirley Brooks, always a loyal supporter, had died in February 1874, not long before Sambourne's engagement and marriage. Brooks left very little for his wife and family, and the novelist Anthony Trollope, with the painters John Millais and William Powell Frith and with Sambourne's *Punch* colleague, Tom Taylor, found themselves faced with the task of raising a fund for them.

Taylor, Brooks's successor as editor of *Punch*, was a man of many gifts, a lawyer, journalist, playwright, biographer and Professor of English at London University. Even so, he is generally dismissed as a less inspired editor than either of his predecessors. Sambourne's work for the paper, however, shows little change under Taylor's management, and it seems that Taylor left him to work much as he had under Brooks, contributing 'Essence of Parliament' drawings, cartoons about fashion and style, and the 'fine art' cartoons which inspired some of his best work. M.H. Spielmann, a Sambourne supporter, believed that "under the *régime* of masterly inactivity – the happy policy of *laissez-faire* — of Tom Taylor, the talent had burst forth into luxuriance, not to say exuberance".[28]

In 1880, at the end of Taylor's editorship, Sambourne began upon a new series, the 'Fancy Portraits', one of his most successful innovations for *Punch.* Centrally positioned in the upper half of the page, each of these small drawings featured the caricature of a celebrity and, beneath it, a telling quotation or humorous poem. The absurd guise, the head often out of scale with the body, was part of the joke, but, on each occasion, the humour was sharpened by an awareness that the guise was, after all, better chosen than it might seem.

The early examples included a number of statesmen. The first victim, on 2 October 1880, was a Liberal politician, Lord Hartington, as an oil-lamp. Gladstone, presented as a Scottish dancer, came next. The series, usually appearing weekly,

drew in novelists, poets, dramatists, musicians and artists, together with scientists, lawyers, military men, sportsmen, entrepreneurs and politicians. Occasionally Sambourne was drawing people whom he knew personally, like the sculptor Joseph Edgar Boehm, the naturalist Richard Owen, the scientist Norman Lockyer or the stockbroker and philanthropist Sir Moses Montefiore. The 'Fancy Portraits' often coincided with some event in the subject's life. Royal Academicians were greeted on their election; the Empress Elizabeth of Austria was drawn while hunting in Britain; Frederic Leighton on his retirement as Colonel of the Artists' Rifles; Liszt, Sarah Bernhardt and Adelaide Ristori while performing in London; and Eiffel when he had just opened his tower. The best-known example shows Oscar Wilde, at the height of his Aesthetic fame, as a sun-flower (fig. 20).

A few of the 'Fancy Portraits' were critical of their subjects. The Duke of Bedford was accused of spending his money on refitting his yacht when the fruit and vegetable market at Covent Garden was sinking into dirt and mud. Sambourne drew the Duke as he should have been, in elegant eighteenth-century dress, walk-ing along a neat flower bordered path, with the Floral Hall like a Greek temple behind him (P. 7.5.81; fig. 21). Wilkie Collins, wrapped in a sheet and holding a candle, is surrounded by his successful novels, "doing Ink-And-Penance for having written the [less successful] Black Robe" (P. 14.1.82). These delicate and witty cartoons brought out the best in Sambourne, who employed small letters to underline subtle allusions. In the Wilkie Collins drawing a dog, labelled *Fosco* after the villain of *The Woman in White*, has a brightly shining 'moonstone' just above his nose.

During 1878 Sambourne provided the illustrations for 'Stapmore' by 'Weeder', Burnand's parody of the popular novelist Ouida (Louise de la Ramée). The artist followed it up on 20 August 1881 with 'Fancy Portrait, No. 45', showing Ouida out-raging the pieties of the age (fig. 22). Smoking and showing her ankles, she wears a sleeveless dress with her hair hanging loose. Her casually held cigarette not only confirmed that she was rebelliously unfeminine, but also recalled the name of the heroine of her best-known novel, *Under Two Flags*, published in 1867. The caption, from *Hamlet*, reads 'O fie! 'tis an unweeded garden'. In all, there were one hundred and eighty 'Fancy Portraits', all carefully numbered, in a series which came to an end on 12 July 1884. There were occasional unnumbered examples in later years, in-cluding drawings of Rudyard Kipling and Ranjit Singh, the cricketer.

PUNCH'S FANCY PORTRAITS.—No. 30.

DUKE OF BEDFORD, K.G.

Fig. 20 'Fancy Portrait' no. 37: *Oscar Wilde*, *Punch*, 25 June 1881

Fig. 21 'Fancy Portrait' no. 30: *The Duke of Bedford*, *Punch*, 7 May 1881

Sambourne's financial anxieties must have increased when Marion became pregnant. Their first child, Maud Frances, was born in the year after their marriage, on 5 August 1875, at Marion's parents' home in Upper Phillimore Gardens. Sambourne celebrated his fatherhood at the next *Punch* dinner, returning home the worse for wear.

Book illustrations

Only four weeks later, on 2 September, the happy father left London for a month's journey to Scotland with Arthur à Beckett. Marion, the newborn baby, a nurse and the dog Gyp remained behind with the Herapaths at Westwood. This Scottish trip was supposedly a working expedition rather than a holiday. À Beckett was writing a travel book, commissioned by William Bradbury, and Sambourne was his

PUNCH'S FANCY PORTRAITS.—No. 45.

OUIDA.

" O fie! 'tis an unweeded garden."—*Hamlet*, Act I., Scene 2.

Fig. 22 'Fancy Portrait' no. 45: *Ouida, Punch*, 20 August 1881

illustrator. Arthur à Beckett had already edited two journals (neither of which had survived), and, at the time of their departure, he had recently achieved his ambition to follow his father Gilbert, one of the first writers for the paper, onto the staff of *Punch*. His brother, also Gilbert, became a *Punch* writer in 1879.

Writer and artist left in the early morning aboard the steamship *Seven Seas*. By evening they had reached the coast of Yorkshire. The sea became rough and Sambourne occupied his time in drawing the unhappy passengers. One sketch, of a girl leaning over the side, is wittily entitled *The Old Story*. After a night on board, they eventually landed in Granton and then travelled to Edinburgh.

The first evening was fine, but on the following morning it was raining hard, a foretaste of the journey to come. Not to be deterred, Sambourne declared that he would work while the sun shone, and take cover when it rained. À Beckett gives a verbal sketch of his companion "carrying his bag of sketches and pencil cases and a chair of peculiar construction",[30] with à Beckett himself bringing along the coats and umbrella. Sambourne's folding chair is described as looking like "a small flight of steps" when not in use and, when in use, like a "seat for someone who has just been in a battle".[31] À Beckett, speaking from experience, noted that you had to understand the chair's construction if you were not to capsize. They placed themselves on Calton Hill, which looked down over Edinburgh and was a popular place for landscape artists. À Beckett spent three hours helping to put the chair up and down, stowing it under bushes when rain fell and taking it out again when the weather improved. The artist soon drew the attention of a professional tour guide and a group of local urchins.

Like many artists of the picturesque mode, Sambourne frequently introduces people into his scenes of Scottish landscape. In the drawing as it finally appeared, *The One O'Clock Gun*, à Beckett appears as a small figure seen from behind (fig. 23). When the desired image was captured, Sambourne would 'fix' his drawings, preparing the 'chalk' (in fact made of charcoal) image with size, an important provision when travelling in inclement weather.

Making a tour of the sights of Edinburgh, the two men had a chance meeting with an old friend of à Beckett, the actor Charley Collette. They were pleasantly surprised to find that their bill at the "comfortable" Royal Hotel was "not a heavy one" and that they had been misinformed about Scottish prices, "which we had heard before starting were sure to be high and mighty".[32] Sambourne and à Beckett

Fig. 23 *Edinburgh, The One O'clock Gun*, September 1875,
for Arthur à Beckett, *Our Holiday in the Scottish Highlands*, 1876

then left Edinburgh and began their journey north. A train journey took them to Stirling. "The arrival at Stirling comes back to me", à Beckett writes in his autobiography, "the old fashioned hotels with 'slappers' – slippers provided for any guest who wanted to take off his boots."[33]

Next day Sambourne drew Stirling Castle on its hilltop. Looking back after twenty-eight years, à Beckett remembered the scene: "I see my friend hard at work with his drawing for our book. As I was not wanted for 'a figure in the foreground', I took a stroll now and again, coming back to him to see how he was getting on."[34] Sambourne also sketched a tumbledown house in a less fashionable district of the town, once again attracting an audience of children.

After seeing the battlefield of Bannockburn, the two men went on to Perth, where, according to à Beckett, who may be exaggerating for comic effect, they were mistaken for prisoners on their way to the Assizes. North of Perth the countryside reminded them both of the landscapes of John Everett Millais. Millais had surprised everyone by exhibiting *Chill October* (Lord Lloyd Webber collection), the first of his large landscapes of the Tay Valley in Scotland, at the Royal Academy of 1870. Between 1873 and 1877 he began to paint around Birnam, famous from the

scene in Shakespeare's *Macbeth* in which the witches tell the usurping king that he will survive until Birnam Wood comes to Dunsinane. In the Academy exhibition of 1875 Millais had shown a fine Birnam landscape, *Over the Hills and Far Away* (private collection), a visionary prospect looking from Birnam towards Dunkeld. Sambourne would certainly have seen it.

The pair were broadly following the old eighteenth-century picturesque journey from Edinburgh to the Highlands, although modernized transport meant that they moved much faster and spent less time at each of their stopping points. At Dunkeld, a staging post for travellers, the press of tourists was such that they were lucky to find rooms. His work disrupted by high winds and racing clouds, Sambourne had great difficulty in drawing the scenes of their journey, but persistence triumphed and one result was an illustration of *Inverness from the River.*

From Inverness Sambourne and à Beckett went on by coach to Gairloch on the west coast. Sambourne, à Beckett recalled, "never lost a chance" to draw,[35] and, once settled in the hotel, he took his chair onto the rocks and began a drawing of the island of Skye, seen across the water. Unfortunately it was a Sunday, and this was a strictly Sabbatarian area. Sambourne:

> nearly incensed the entire fisher-man population to lynch us. My poor
> friend was suffering from faceache, but still stuck to his easel in spite of
> a murmur of indignation. He got rid of me by insisting that I would im-
> prove the composition by standing in the foreground. I was regarded as
> a heathen because, according to my drawing, I was unable to go to church
> (kirk), and the population thought I was as bad as the other man. For-
> tunately, before we had furnished the subject for a paragraph under the
> heading of 'Popular Murder of Two Writers for *Punch*', the faceache drove
> Sambourne within and I followed him.[36]

The illustration appears in the book as *Gairloch – Sunset* with a back view of à Beckett in the foreground.

Sambourne's "faceache", which kept him awake all night, resulted from an infected tooth, only relieved when the abscess burst. He also had a stye on his eyelid and à Beckett, too, endured a spell of illness. Given the cold wind and continuous rain, Sambourne was glad that he had decided to take his heavy Ulster coat. Marion Sambourne suspected that her husband sometimes drank far too

much in the evenings: "It strikes me you were slightly gay when you wrote your last letter, perhaps drinking Baby's health, but I forgive you, as champagne is decidedly exhilarating."[37]

From Gairloch the steamer took them over to Skye. After the bad weather of their earlier travels, they were now blessed with three fine days. One highlight was climbing the Quiraing, a strange group of rocks in the north of the island. They took a guide, but à Beckett nearly had a serious fall, the thought of which was still haunting him days later.

Returning to Inverness on the mainland they travelled through the Highlands to Fort William and Glencoe. The wild valley of Glencoe, scene of the massacre of the Macdonalds by the Campbells, had been judged, from the eighteenth century, to be a perfect example of the sublime landscape. Next came the Inner Hebrides, with Staffa Island and Fingal's Cave, a picturesque icon of the early nineteenth century, celebrated by Mendelssohn. À Beckett and Sambourne found it unpleasantly crowded. After visiting Iona they returned through the Island of Mull to Loch Lomond. The Trossachs seemed "pigmies" by comparison with the Highlands.[38] The 'season' was virtually over, and they were alone in the Trossachs Hotel by Lake Katrine, a popular location for artists, including Horatio McCulloch, whose magnificent landscape had been painted a decade before (1866, Perth Art Gallery). They took the train to Euston Station from Glasgow (which they liked although it rained again). À Beckett commented (rather patronizingly):

> Until we passed the Border, on our way home, we found nothing in Scotland that was not kindly and good-tempered. The people appeared pleased to see us wherever we might go, and my friend's pencil and my own pen seemed a constant source of admiration to the simple-minded denizens of North Britain.[39]

In these characteristic final remarks, à Beckett declared: "What a pleasant trip we have had", to which Sambourne's responded: "How jolly it has been".[40] In his letters home, however, Sambourne complained that he had wearied of à Beckett's company.

At one point in à Beckett's published narrative he remarks that their frequent changes of plan resulted in problems with their mail. Letters from Marion Sambourne to her husband do, however, survive. Not surprisingly, they often betray some irritation. Marion declared that she was glad that her husband was enjoying

Scotland, and wished that she too could be "surprised" by its beauty.[41] She begged him to take her away when he returned or in the following year, should he be given a commission: "It wd be so jolly, especially if you are a good boy & behave".[42] On one occasion Marion refers to a promise which he had made to her "before little baby came" and admonishes him not to "flirt too much".[43] "Don't fancy you will be able to do what you like with yr little wife because she has a will of her own too – wait & see."[44] "Don't you dare be a moment later than Saty. [25th] or won't I bully you!"[45] More affectionately, she told him that "our interests are one, I see & feel that more now we are separated".[46] In his replies, her husband told her how much he missed her and longed to see her again.

The travellers may have been delayed. Sambourne missed Maud's christening, which took place at St Peter's Thanet on 21 September, three days before her father's return. His absence from Maud's baptism probably aroused less comment than it would today, but it is hard to see why the ceremony could not have been re-arranged for a week later. On his return Sambourne went straight to Stafford Terrace, where the cook, who had been paid only until 18 September (a further in-dication that he was late), was waiting. He then hurried down to his wife and child, in time for Marion's twenty-fourth birthday on 29 September.

Punch work also awaited him. Sambourne had been away during the parlia-mentary recess, so that there had been no call on him to draw initial letters for the 'Essence of Parliament' column. A group of sketches for a series called 'The House and the Home', mocking (somewhat hypocritically) the pretentions of Aesthetic interior design, and said to be by "Leonardo della Robbia de Tudor Westpond Tomkyns", must have been completed before he went away. There are no Scottish cartoons and, unlike à Beckett, Sambourne was not sending work back from his travels. (He was not yet committed to a cartoon a week, so journeys out of London were not a problem.) On Wednesday 29 he was back at the *Punch* table, where the staff toasted à Beckett. The new member of staff was triumphant: "As I said in re-turning thanks: *It was the proudest moment of my* life! Hurrah!!!!"[47] À Beckett set to work to produce the Scottish book. The title page is undated, but *Our Holiday in the Scottish Highlands* is generally assigned to 1876. The green cover bears two names, those of the author and the illustrator, an indication that credit was equally divided. À Beckett's writing is informative and cheerful, humorous, but not comic. In comparison with John Leech's cartoons of Mr Briggs's adventures in the

Highlands, published in *Punch* in 1861 and later issued as a set of engravings, this is a discursive travelogue rather than a satire. As was the case with Molloy's *Our Autumn Holidays on French Rivers*, Sambourne is not only the illustrator, he is a character in the story that à Beckett tells. The drawings are among his finest, but many of them are not perfectly matched to the letterpress. The illustrations for the earlier *French Rivers* volume often show oarsmen and pretty girls, balancing the more lyrical studies of rivers and bridges. In the Scottish volume there are a few small sketches of tourists and local people, usually seen alone, but the full-page plates are landscapes. The small figures (mainly drawn from à Beckett) are scarcely characterized and, with the large skies over seas and broad lakes, the overall effect of the *Scottish Highlands* drawings is one of melancholy and autumnal beauty, not an exact parallel with the masculine bonhomie of the text. As Thomas Hardy noted in 1878, the palette of British landscape painters was becoming increasingly sombre. Scenes of the Scottish autumn, like those by John Millais, were replacing the light Mediterranean idylls of earlier years, and Sambourne's illustrations fall within the broad outlines of that movement in taste.

The book was widely reviewed, with many critics praising the drawings. "This table-book unfolds some of the most truthful effects in black-and-white ever obtained by lithography … the artist is … capable of treating light and shade with as much skill as genuine feeling," was one verdict.[48] The *Whitehall Review*, describing him as "one of the most talented of the *Punch* draughtsmen", praised Sambourne's *Punch* work with its "singularly clever studies for costumes" and his "wonderfully natural and faithful … graceful, forcible and realistic" Highland drawings.[49] A less enthusiastic writer, however, thought that à Beckett had not given proper attention to the scenery and that his text was "silly and vulgar". Nor did Sambourne escape from the strictures of this critic, who found his landscape drawings "uninteresting and unintelligible".[50] In fact, they are among his most original early works.

In the following years, 1876–77, Sambourne worked on his third contribution to the picturesque/topographical tradition. This was a set of drawings illustrating the Venice stanzas from Canto Four of Byron's *Childe Harold's Pilgrimage*. The continuing popularity of *Childe Harold*, originally published between 1812 and 1818, is evident from Victorian guidebooks, whether issued by John Murray or Baedeker. The memory of Byron, who had lived in Venice between 1816 and 1819, was

Fig. 24 *Small loch near Achnasheen*, September 1875,
for Arthur à Beckett, *Our Holiday in the Scottish Highlands*, 1876

particularly treasured by British tourists. No traveller to the city omitted to stand upon the Bridge of Sighs with "a palace and a prison on each hand".

Numerous British artists had painted in Venice, among them Richard Parkes Bonington, E.W. Cooke and, above all, J.M.W. Turner, and three years after Sambourne's visit James Whistler would begin work on the twelve Venice etchings commissioned by the Fine Art Society. Sambourne does not show obvious influences from his predecessors, nor, it seems, was he thinking of John Ruskin, since he does not draw precise architectural details. He bought a group of photographs of Venice, either in 1876 or while on his honeymoon, and, although he made the drawings on the spot, these may have been have been useful to him.

Sambourne's thirty Byron drawings, of which some still hang at 18 Stafford Terrace, were destined for a magnificent publication issued by Bradbury, Agnew. The sumptuous purple binding is decorated with gold designs, the Lion of St Mark among them. The famous sights of Venice are illustrated, many of them having no specific relation to *Childe Harold*, although there are prints of the Bridge of Sighs and of Byron's own *palazzo* on the Grand Canal. The Rialto, the Doge's Palace, San Giorgio, St Mark's

Moonlight on the Grand Canal.—S. Maria della Salute.

Fig. 25 *Moonlight on the Grand Canal, Santa Maria della Salute*,
illustration to Canto IV of Byron's *Childe Harold*, 1878

are all included, but the overall effect of the drawings is more personal than this would suggest. A number focus on long skylines, with the towers and domes of the Venetian churches placed against them (fig. 25). William Bradbury asked Sambourne to write a personal preface, with his impressions of Venice, telling him not to "be afraid of it; only write it naturally – and we shall have a good Preface".[51] Sambourne did as he was told, but the Preface struck Bradbury as "too candid" and it never appeared.[52]

Sambourne returned to Venice in the early spring of 1876, taking Marion with him. He was working on his book, but two cartoons also date from this second visit. One, published on 29 April, shows Mr Punch in a gondola with his dog, Toby, and a woman companion. They are seen from the church of San Giorgio with the church of San Vitale on the left and the Redentore on the Guidecca in the centre. The caption reads: 'What did Mr Punch do in the Easter Recess? Volunteer Review! Not a bit of it! He just popped over, and had a few days of delightful *Dolce Far Niente* at Venice'. The artist was able to re-use the design. A drawing of the same scene, minus Toby, appears in the Byron volume. In a second cartoon (P. 13.5.76), Mr Punch,

complete with Italian army uniform, stands outside Florian's Café in St Mark's Square. This is more obviously a *Punch* drawing than the gondola scene. Punch is presented as a comic figure with thin legs and an overlarge body, sporting a wink. The caption reads: 'In his Easter Trip to Venice, Mr Punch tries on an Italian uniform, and oh! Wouldn't he like to wear it for twelve months!' The signature, *Sambourne, Venice,* is uncharacteristic, shown upside down and without its usual flourish. Sambourne found a later opportunity to introduce a Venetian scene to *Punch*. In December 1879 he drew a full-page cartoon on the subject of the battle between the British and the Italians over the proposal to renovate the front of St Mark's. Sambourne shows the President of the Royal Academy, Frederic Leighton, and the Prime Minister, Benjamin Disraeli, sustaining a blast of water from the Italian press, while the champion of 'Anti-Scrape', William Morris, is blown into a canal (P.13.12.79).

Coming as they did after the French Rivers and Scottish scenes, the Byron drawings were Sambourne's last important attempt at topographical work and a unique venture into the illustration of a volume of serious poetry. He was suffi-ciently proud of them to invite guests to an exhibition of his drawings of Venice and Verona at 18 Stafford Terrace on 24–25 July 1876. Some newspaper and journal critics disliked the volume, and, though others were enthusiastic, sales only went "pretty well".[53] Bradbury, Agnew did not repeat the experiment, and, from now on-wards, Sambourne's book illustrations were largely comic and satirical, often com-missioned for children's books. The comparative failure of the Byron volume was an element in a slow process of narrowing aspirations.

A delightful exception is to be found in his three drawings for Smith Elder's edition of W.M. Thackeray's lectures on *English Humourists*, published in 1879. Sambourne's subjects are three eighteenth-century writers, Matthew Prior, John Gay and Alexander Pope (fig. 26). Prior is drinking heavily in an inn, while the bar-maid checks up his reckoning on a board. Gay is in a summer garden with a bust of Aesop behind him and a classical flute and mask of comedy on the ground, roses encircling the design. Pope, in his Twickenham villa with his dog at his feet, is sur-rounded by portraits. A bust of Homer and a wreath of flowers form a decorative motif. Sambourne could have paid no finer tribute to the eighteenth century.

By the late 1870s, however, Sambourne had almost abandoned his wider ambitions as an illustrator and was predominantly a political cartoonist. The inexorable demands of a weekly magazine established the basis for his working

life, and it was only with difficulty that he accomplished his later masterpiece, the drawings for *The Water Babies*.

The evidence for this change of direction comes from the drawings themselves. Years later, Sambourne told a journalist that illustration paid less well than magazine covers, commissions for invitations or advertisements. The real truth seems to have been that book illustrations represented a concentrated effort over a sustained period, and that, as his social life flourished, Sambourne was unwilling to make this commitment for the limited return. There are no signs that he regretted the change, but Sambourne was not a man to wear his heart upon his sleeve. Marion was plagued by financial worries and by her husband's extravagance, and Linley, for all his exuberance and bonhomie, knew that he had to keep drawing in order to cover expenses.

It is regrettable that Sambourne missed a chance of working with Charles Dodgson (Lewis Carroll). Dodgson approached George Du Maurier in 1873, asking him to illustrate a book of poems, *Phantasmagoria*, but Du Maurier's health would not allow him to accept the commission. Six months later, in June 1874, Sambourne was asked to provide five illustrations for one of the poems, 'The Lang Coortin'. Dodgson's letters to Sambourne give the artist a remarkably free hand, always allowing that the writer had "a *veto*, in case the result should be hopelessly at variance with his meaning. I will jot down any ideas that occur to me as being desirable to introduce, and you can use the suggestions, or not, as you choose."[54]

Sambourne and Dodgson met in April 1875, but, in December of that year, Dodgson sent a New Year card showing two figures. One, who appears to be Shakespeare, clutches a volume of *Phantasmagoria*, while a small rotund figure sits on two volumes. The quotation from *Twelfth Night* sent with the sketch could be applied to many of Sambourne's authors and publishers down the years: "He never told his love, But sat, like patience on a monument, Smiling at grief". Dodgson was among the first of a line of disappointed people, waiting for Sambourne to complete a project. Two and a half years later he received one drawing. Dodgson thought it "an astonishing exhibition of skill and patience", but no more arrived and the project came to nothing.[55]

From the 1870s and early 1880s Sambourne's work for *Punch* often reveals his enduring interest in the fine arts. Photographs of different works of art are a striking feature of 18 Stafford Terrace, and the inventory taken in 1877 makes it

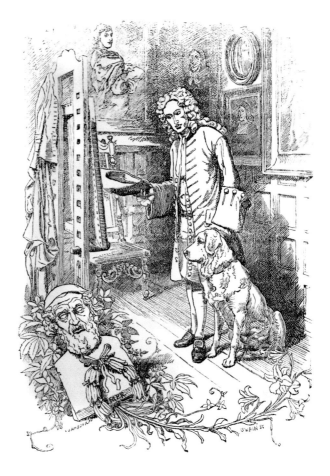

Fig. 26 Drawing of Alexander
Pope from W.M. Thackeray,
English Humourists, 1879

clear that there were many in the house by that date. Those in the dining room
reproduce popular paintings of the day, very often French, which Sambourne
had seen at the annual Paris Salon. Today, these fading reproductions seem oddly
homogeneous. Many, like the battle scenes, are historical in subject. Generally,
however, they are high-spirited evocations of a vanished and idealized world,
drawing upon the conventions of Dutch genre painting. There are paintings be-
longing to the so-called Cardinal School, humorous demonstrations of the
human foibles of churchmen. A few of the artists are well known – Jean-Leon
Gérôme, for example, whose *Phryne before her Judges* (1861, Kunsthalle, Hamburg)
Sambourne adapted for a cartoon, *Unveiling the Budget* of 22 April 1903. There are
photographs from the work of the Spanish artist Mariano Fortuny, with knights
in armour or oriental warriors, and scenes of army life by Ernest Meissonier.

Art-world friendships

In the artistic world of London, cartoonists and illustrators mingled freely with painters and sculptors. Sambourne's surviving correspondence of the 1870s is evidence of his friendships with a number of painters, among them Lawrence Alma Tadema (the artist of life in ancient Rome), Luke Fildes (a social realist and portraitist) and, from the older generation, William Powell Frith, famous for his modern-life subjects like *Derby Day* (1858, Tate Gallery) and *The Railway Station* (1862, Royal Holloway College). Frith wrote Sambourne a particularly warm letter of appreciation for the gift of a drawing in 1878: "If there is any fortunate individual who gets more enjoyment of your work than I do he is to be envied".[56] These artists invited the Sambournes to their houses, and, in turn, visited them in Stafford Terrace. Frederic Leighton lived in Kensington, but Sambourne had a professional rather than a personal relationship with this giant of the art establishment. John Millais he knew far better, and a photograph of his self-portrait hangs by the drawing-room fireplace. There is, however, no record that either Millais or Leighton ever dined at 18 Stafford Terrace.

Among the Sambournes' closest friends were the group of artists known as the St John's Wood Clique. During the early Victorian period this north London suburb had the somewhat ambiguous reputation of being a haunt of kept women. In 1854 William Holman Hunt, the Pre-Raphaelite painter, exhibited his *The Awakening Conscience* (Tate Britain) in which such a woman suddenly sees the folly of her ways. To satisfy his need for accuracy, he had painted the scene in a St John's Wood house. The members of the Clique began to move to the area a little later, from the early 1860s. They were a loosely associated group of young artists, specializing in historical scenes and genre paintings of amusing or touching episodes in modern life. Henry Stacy Marks, a leading Clique artist and an occasional contributor to *Punch,* was, in his later career, from the 1870s, well known for painting animals, sometimes in comic guise, sometimes seriously. Fifteen years older than Sambourne, he had some influence on the younger draughtsman's own anthropomorphic cartoons and Sambourne occasionally parodied him.

Other members of the Clique were Philip Hermogenes Calderon, J.E. Hodgson, George Adolphus (Dolly) Storey and William Yeames. All were more or less contemporaries of Sambourne, who not only admired their work but often joined in their high-spirited and convivial expeditions and entertainments. In July 1880,

for example, Storey told Sambourne the details of a forthcoming outing to Ightham Mote in Kent, a romantic fourteenth-century house with later additions. The party were to leave Charing Cross station at 11.25 and to dine at the Crown Hotel at 6.00.

The Clique were among the artists immortalized by the painter and photographer William Wilkie Wynfield in a series of calotype portraits. His subjects posed in costumes based on Old-Master paintings. A letter of June 1878 from the painter George Boughton acknowledged Sambourne's return of a Frans Hals costume. Boughton used historical dress for his work, but Wynfield posed his sitters in a similar style. Born in England, a decade before Sambourne, Boughton had been taken to America as a baby, but had returned to Europe, trained in Paris, and then settled in London in 1863. A talented landscapist, he painted historical subjects, but without attempting precise archaeological accuracy in the manner of the Clique. Boughton lived on Campden Hill, very close to the Sambournes, in a studio house built in 1876 to designs by the fashionable Aesthetic and Queen Anne-style architect Richard Norman Shaw. A painting by Boughton hangs in the drawing room at 18 Stafford Terrace.

Boughton and Sambourne were two of a group dubbed 'the regulars' who travelled to Paris every year to see the Salon. The third member was a near contemporary of Sambourne, Luke Fildes. The two had both been students in Chester in the late 1850s, Fildes at the Mechanical Institute, but there is no record of their meeting then. Fildes exhibited his best-known work, *Applicants for Admission to a Casual Ward* (Royal Holloway College), at the Royal Academy in 1874, the year of Sambourne's marriage and move to Kensington. Sambourne hung a photograph in his dining room. A masterpiece of social commentary, the painting shows a group of the poor and indigent queuing in the freezing cold to seek shelter and medical aid. In 1876 Fildes began building a house in Melbury Road near to the homes of Frederic Leighton and G.F. Watts. A legacy enabled him to commission a large and imposing residence, designed by Richard Norman Shaw and far more impressive than 18 Stafford Terrace. Like Sambourne, Fildes had married in 1874 and the neighbouring families became close friends, Fildes eventually standing godfather to the Sambournes' son, Roy. A painting by Fildes of a young girl, a gift made in 1884, still hangs on the wall of the morning room of Linley Sambourne House.

Another artist who lived in a Norman Shaw house in Melbury Road was Marcus Stone, son of the painter Frank Stone. The younger Stone specialized in

romantic genre scenes, set in the eighteenth and early nineteenth centuries. He is best known today as the illustrator of Dickens's *Our Mutual Friend*. Stone and his wife Laura were good friends of the Sambournes through the later 1870s and the 1880s and Marion frequently records visiting their house. After May 1888, however, the visits came to an abrupt end. There is a cryptic exchange of letters between Sambourne and Laura Stone about a missed dinner arrangement, and a problem of some kind evidently arose from this. Sambourne's diary entry for 17 July 1888 has two later notes added to it. One reads: "Mrs Marcus Stone took offence from this date & has not called for a year. July 5 1889." A second addition follows: "Nor for ten years. Sunday June 6 1897." The Sambournes still saw the couple occasionally, when Marcus Stone's paintings were on show before the Royal Academy exhibition or at public events. Stone signed the register at Maud Sambourne's wedding in 1898 and later diary entries suggest that relations were, to some extent, restored from that date.

Adaptations of artists' works

Sambourne also established friendships among his fellow illustrators. His letters of praise to those whom he admired, including Randolph Caldecott and Walter Crane, were warmly appreciated. Most of his artist friends, with the exception of Crane and Caldecott, were either full or associate members of the Royal Academy. Sambourne would frequently solicit photographs of their Academy works for his growing collection. Some hang on his walls, mingled with the French Salon pieces. He was always at the Private View of the Royal Academy, and at the show Sundays, when artists displayed their Academy works in their studios before submitting them. Many were flattered by the attention and the publicity, but Lady Butler wrote in 1874 to tell him that no photograph of her *The Roll Call*, the great success of the year, was available. John Millais, conversely, was delighted with the "[wood] cut" from his *Effie Deans* of 1877, "neat & perfect", like all Sambourne's work.[57] Millais had exhibited the painting at the King Street Gallery in aid of the Artists' General Benevolent Institution. There is no record that Sambourne asked the painter for a photograph, nor was the "cut" used for a *Punch* cartoon. Sambourne, who was a supporter of the charity, may perhaps have made his print for them.

Stacy Marks is known to have approved of Sambourne's adaptation of his painting *Science is Measurement* (Royal Academy of Arts), which drew on Marks's

own experience of measuring the bird skeletons at the Royal College of Surgeons. It was shown at the Royal Academy exhibition of 1879 and was accepted as Marks's diploma work, to mark his election as a full Academician. Sambourne's cartoon shows Disraeli, as Prime Minister, contemplating the problem areas of Afghanistan, South Africa and Ireland, represented as the skeleton bird, with Mr Punch as a scientist (P. 16.8.79). Sambourne used a second work by Marks, this time an advertisement for Pears Soap, on 10 June 1882. In *Lather-Day Saints*, the Liberal Prime Minister, William Gladstone, and the Radical, John Bright, replacing the two monks of the original drawing, are washing their hands of, or 'lathering', the guilt of the Irish leader Charles Stuart Parnell, who had just been released early from prison.

Among the paintings for which Sambourne sought a reproduction was *An Anxious Moment* (Royal Holloway College) by Briton Rivière. Rivière, like Sambourne himself, was known as an animal artist and was an *habitué* of the London Zoo. He had been elected an Associate of the Royal Academy in 1878, the same year that he exhibited *An Anxious Moment*. The painting shows a flock of geese facing the threat of a tall black hat, dropped into their path. Sambourne's cartoon, of 27 July 1878, celebrates the award of the Grande Medaille of the Exposition Universelle in Paris to John Millais and Hubert von Herkomer (fig. 27). The Royal Academicians, their faces recognizable, appear as Rivière's group of geese, all hissing at Herkomer (the black hat), while Millais flies away behind them. The painting had attracted a great deal of interest and comment in the Academy exhibition. In her catalogue of the Holloway Collection, Jeannie Chapel notes that "most of the reviews saw the painting as genuinely funny".[58] Sambourne's cartoon was very popular with the artistic community. He distributed copies, perhaps off-prints from *Punch*, to his friends and Rivière was among those who wrote to thank him. At the same time, Rivière asked for the return of a photograph of *Sympathy*, his painting of a young girl sitting on the stairs with her dog (1877, Royal Holloway College). In order to protect his copyright, Rivière explained, he wanted Sambourne either to send back the photo or to destroy it. Sambourne clearly appealed against this, and a letter from Rivière tells him that he can keep the photograph. Both the photograph and the cartoon were framed and are now on the walls at 18 Stafford Terrace.

Sambourne appreciated the satirical possibilities which a flock of geese offered him. In a cartoon of the previous year, drawn for an 'Essence of Parliament' column on 16 June 1877, the source painting was by a German artist, Ludwig Knaus.

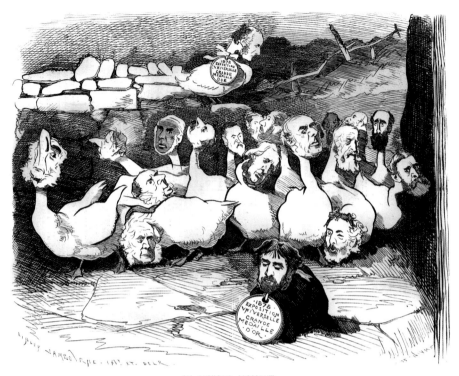

AN ANXIOUS MOMENT.
(*With Punch's Apologies to Mr. Briton Rivière, A.R.A.*)
"Exposition Universelle," 1878. J. E. Millais, R.A., and H. Herkomer honoured with the Grande Medaille in the English School.

Fig. 27 *An Anxious Moment, Punch,* 27 July 1878

In Tausend Angsten ('A Thousand Terrors', untraced) of 1872 shows a young girl holding a piece of bread being menaced by a flock of geese. This was another work of which Sambourne bought a photograph. Knaus was well known for this motif. In a painting of the same year, *Das Vesperbrot* ('The Snack', Cologne), a young girl feeds vegetables to an importunate group of birds. For his cartoon, Sambourne showed the radical politician John Bright in the role of the girl, holding a slice of bread labelled 'Vote'. He uses the group of geese to represent those unmarried women who were hoping to be enfranchised. Waddling along in their bonnets, they are treated as figures of fun. The one man with them, a bearded figure, is labelled as Jacob Bright, John Bright's brother. Jacob Bright and his wife were prominent supporters of the women's rights movement, whereas John Bright had changed his mind on the issue, and spoke strongly against the proposed changes in the debate of 1876. The premise of the original Knaus painting is therefore

reversed. The young girl becomes a middle-aged man, and, unlike the frightened female of the original, he has the upper hand. Sambourne must have enjoyed reversing the gender of his comic geese, female in his Knaus cartoon and male in his Rivière parody. There is an acknowledgement of the source on both drawings: '"Geese" after L. Knaus (Slightly Altered)' on the earlier example, and, on the second, 'With Punch's Apologies to Mr Briton Rivière, A.R.A.'.

Sambourne's adaptations of artists' work were always a form of compliment. Their paintings, the cartoons imply, were well enough known for readers of *Punch* to recognize them. Like his two drawings of geese, Sambourne's choice also reflected his own preferences, often for animal subjects. Those Sambourne cartoons of the 1870s and early 1880s which draw upon works of art are an indication of his close interest in painting and sculpture. They are one element in a strategy to introduce the art world into *Punch*. The first examples were submitted during the editorship of Shirley Brooks, who evidently sanctioned the experiment, and Taylor was happy for the series to continue. At this stage in his career Sambourne was not parodying Old Master works, but paintings and sculptures of his own day or of the comparatively recent past.

A painting from the 1860s provided the subject for a cartoon of 3 January 1880. This was Thomas Faed's *Worn Out* (1868, formerly Forbes Magazine Collection). In the original an exhausted carpenter has fallen asleep beside his sick child. The cartoon marks the turn of the year, with the workman, transformed into a ruined umbrella, representing 1879 (fig. 28). Typical of Sambourne are the two snails, crawling up the window and the wall, and the barometer, pointing to high pressure (a wish for better weather in the new year). Sambourne's use of the Faed painting, a 'tear-jerker' on a serious issue, for a fairly trivial cartoon may suggest, unusually, some mockery of the original. Shown at the Academy when Sambourne was a young aspirant on *Punch*, the work had clearly caught his eye. Well known from prints, it would also have been familiar to his public.

Sambourne much admired Frederic Leighton's *The Athlete struggling with the Python* (Royal Academy of Arts), of which he made frequent use in his cartoons. The original bronze version of the statue was shown at the Royal Academy of 1877. Sambourne wrote to Leighton soon afterwards, but was too late to purchase a reduced bronze replica. Many people were surprised and impressed that Leighton had branched out into sculpture, and Sambourne could be sure that the work

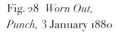

Fig. 28 *Worn Out,*
Punch, 3 January 1880

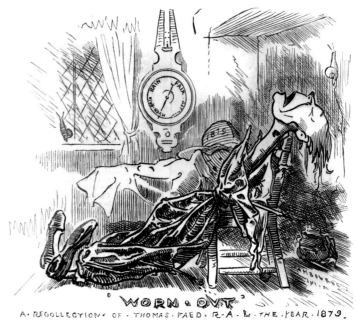

would be recognized when he incorporated it into a cartoon a few weeks after the *Athlete* first appeared, on 26 May 1877 (fig. 29). The caption read: 'Mr Leighton's group admits of so many applications. This is *Punch's* (With his compliments to the sculptor)'. The athlete, identified by his fez, is Turkey, posed naked against a background of fallen classical stones, while the helmeted and multi-fanged snake is Germany. 'Which will win?' was the caption.

Sambourne used the Leighton sculpture for two further cartoons, both of 1882. For a small drawing in the 'Almanack', *The Crinoletta Disfigurans: An old parasite in a new form*, he attired the *Venus de Milo* in a bustle, with, beside her, the names of two earlier cartoonists who had condemned the fashionable disfigurement of women's bodies, 'Leech, Punch's Almanack, 1861' and 'Hogarth'. To the right of Venus, on a plinth labelled 'Aesthete struggling with fashion, after Leighton', a woman in a tight dress wrestles with whalebone coiled around her in the form of Leighton's snake.

The third cartoon, of 23 September 1882, is entitled *Swell struggling with the cig'rette poisoner*. Sambourne, himself a heavy smoker of cigars, shows a man in evening dress, caught in the coils of a skeleton snake while lighting his cigarette

' WHICH WILL WIN ? "

Mr. Leighton's Group admits of so many applications. This is *Punch's*. (With his Compliments to the Sculptor.)

Fig. 29 *"Which will win?"*, Sambourne's version of Frederic Leighton's
An Athlete struggling with a Python, Punch, 26 May 1877

from its mouth. This cartoon is aimed specifically at cigarettes, at a time when they were thought vulgar in comparison with cigars.

Contemporary sculpture also provided the subject for a cartoon showing France as a woman hushing an angry child. '"Tiens Toi Donc Tranquille", with apologies to M. Dalou', reads the caption (P. 1.2.79). The occasion was the Republican opposition to the Conservative French President, Patrice MacMahon,

who was forced to resign a year early. The sculptor Aimé-Jules Dalou had come to London as a refugee in 1871 and had begun to teach modelling at the South Kensington Art School. "Dalou's subject matter in England was dominated by the theme of peasant women seated with their babies", writes Susan Beattie,[59] and Sambourne must have seen these at the Royal Academy. The calm maternal affection of Dalou's work is replaced in his cartoon by a worried mother with a raging, scarlet-faced baby, who wears a Phrygian cap and waves a banner labelled 'rouge'.

It may have been Sambourne's continuing fascination with the Napoleonic period which encouraged him to draw upon an earlier work, William Salter's famous painting of the Duke of Wellington at the annual Waterloo Banquet (1836, Apsley House). Appearing in *Punch* on 7 May 1881, it showed the Royal Academicians at their own annual banquet (fig. 30). The President of the Royal Academy, Frederic Leighton, takes the place of Wellington with John Millais beside him and G.F. Watts behind. In the foreground is a group of inebriated artists who are asleep, smoking or scrambling for a bottle. In the background are the dim shapes of the paintings in the exhibition for that year, with Leighton's *Idyll* (private collection) prominent among them. Sambourne's 'Waterloo' cartoon was one of a long series in which he featured the Royal Academy exhibitions. These traditionally open in the first week of May, and the Private View and the later Soirée were important milestones in the calendar of Victorian high society, the Private View marking the opening of the fashionable London season.

In the first of these cartoons, published on 11 May 1872, Frederic Leighton and John Millais, as workmen, toil underground to remove piles of shillings, the entrance fee paid by crowds of visitors to the Academy (fig. 31). Over the years the Academy was the subject of many highly elaborate and ingenious full-page drawings by Sambourne – a commentary on the fame of the institution and its members. He assumed a knowledge of art among *Punch*'s readers, although there are often small capitalized words and names to guide the observer. Such was the prestige of the Academy that the faces and productions of its members seemed appropriate material for what was intended to be a comic magazine.

Sambourne did not follow up his 1872 contribution in the following May, although a complex drawing about the Academy appeared rather more than a year later, on 2 August 1873. An art barometer (with the newly built Burlington House

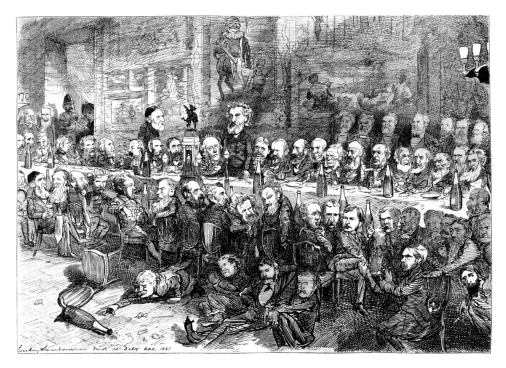

ROYAL ACADEMY BANQUET AT BURLINGTON HOUSE.
(After a well-known picture.)

Fig. 30 *Royal Academy Banquet at Burlington House, Punch,* 7 May 1881

at the top) is seen to be falling. For no known reason except that he had several at home, barometers are a frequent feature of Sambourne's cartoons. In this example the dominant artists Frederic Leighton, John Millais and Philip Hermogenes Calderon are seen climbing up to the summit. Millais carries a camera, a reflection of his increasing preoccupation with portraiture. Leighton wears a house painter's hat and apron while carrying a decorator's paintbrush, a reference to his mural commission for the South Kensington Museum, now the Victoria and Albert Museum, for *The Arts of Industry as applied to War* and to *Peace*. In the corner of the cartoon, a bonfire of 'pot boiler' canvasses is taking place. Meanwhile, the President of the Royal Academy, Sir Francis Grant, is seen at the centre, flanked by a cheque and a ticket for the Academy dinner, his glass raised for a toast.

At the Academy: A Picture Puzzle appeared on 22 May 1875, with the Academicians as clothes pegs on a washing line, their works (clearly numbered from the exhibition catalogue) hanging out to dry below them. In 1877 the opening of the

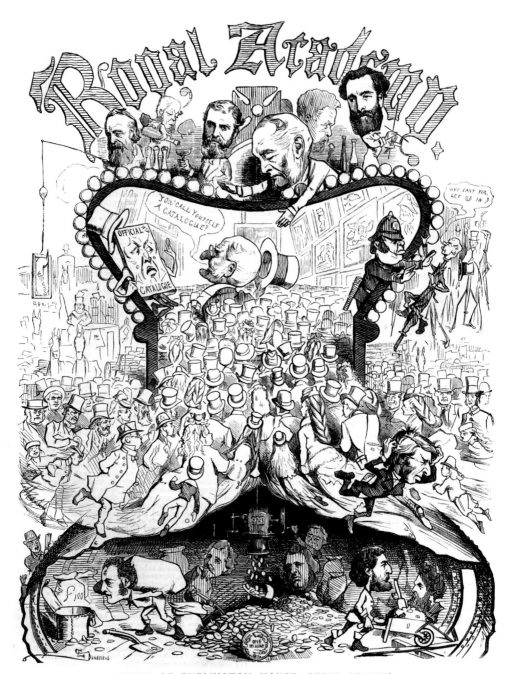

VISION OF BURLINGTON HOUSE. SIXTH OF MAY.

Fig. 31 *Vision of Burlington House, Sixth of May, Punch,* 11 May 1872

rival exhibition at the Grosvenor Gallery gave Sambourne a further opportunity for artistic satire. On 12 May he published a full-page cartoon showing the Royal Academy as a peacock (peacocks symbolized vanity, but were also adopted as icons by the Aesthetes) with small likenesses of the members in the 'eyes' of the feathers, and Grant at its head. The Grosvenor Gallery's skeletal peacock has only two artists in its tail, the heads of Edward Burne Jones and James Tissot, whose work was prominent at the Grosvenor in 1877.

In the battle which developed between the Academy and the new galleries, like the Grosvenor, Sambourne's sympathies lay with his friends in the Academy, rather than with the outsiders. His cartoon on the Ruskin versus Whistler trial makes both contestants look equally silly (P. 7.12.78; fig. 32). They are presented as birds, with the judge handing Whistler his farthing's damages for Ruskin's libellous attack on his painting *Nocturne in Black and Gold: The Falling Rocket* (1875; Detroit Institute of Arts). The costs incurred by both sides are shown as two snakes. Whistler was notoriously litigious, and Sambourne was sensible enough to write to him (after the cartoon was in the press but before publication), insisting that he meant no personal offence to a fellow artist at a difficult time. He received a particularly gracious reply: "I know I shall be only charmed, as I always am, by your work, and if I am myself its subject, I shall only be flattered in addition." Whistler went on to describe Sambourne as "the most subtle" of the *Punch* staff.[60] Like Sambourne, it would appear, Whistler knew what he was doing. He spent some time drafting his letter, and later published it in *The Gentle Art of Making Enemies.*

Tom Taylor, the editor of *Punch,* also acted as an art critic for *The Times.* He had appeared for Ruskin at the trial and Whistler recognized that Sambourne would have to act under instructions from his editor: "Whatever delicacy and refinement Tom Taylor may still have left in his pocket (from which, in court, he drew his ammunition) I doubt not he will urge you to use, that it may not be wasted".[61] *Punch,* however, was not an overt supporter of Ruskin, and, two years after the trial, Sambourne showed him as Narcissus in a 'Fancy Portrait', gazing desolately into a pool, with an altar to Ruskin's idol, J.M.W. Turner, in the background. Words on a much smaller altar, recalling Sambourne's former career, read 'Engineer Mechanic. Watt – Steam Engine' (P. 18.12.80). Ruskin did not include Sambourne in his tribute to black and white draughtsmen in *The Art of*

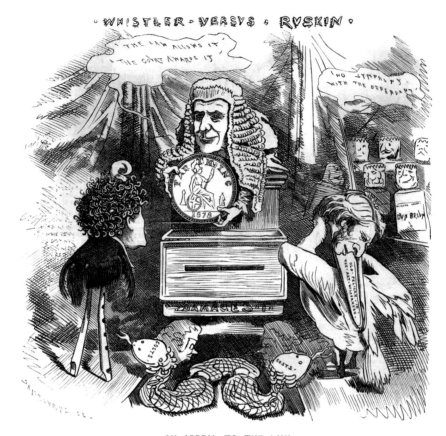

AN APPEAL TO THE LAW.

NAUGHTY CRITIC, TO USE BAD LANGUAGE ! SILLY PAINTER, TO GO TO LAW ABOUT IT !

England of 1883–84 and M.H. Spielmann believed that this was because Ruskin did not admire Sambourne's "hardness of line".[62]

In 1881 Sambourne joked about two Aesthetic favourites, the painter Edward Burne Jones and the poet Algernon Swinburne, showing them in a 'Fancy Portrait' as potted hyacinths, the implication being that they were hopelessly effete (P. 15.1.81; fig. 33). To make the point clearer, in an oblique attack on Burne Jones and the Pre- Raphaelite school, Sir John Gilbert, the ageing history painter, was praised in another 'Fancy Portrait' for representing sturdy masculine knights, not "limp lanky forms of sickly hue" (P. 28.1.82).

Francis Grant died in 1878 and Sambourne reacted favourably to the appointment of his successor as President of the Royal Academy, Frederic

PUNCH'S FANCY PORTRAITS.—No. **14.**

LEFT
Fig. 32 *An Appeal to the Law,*
Punch, 7 December 1878

RIGHT
Fig. 33 'Fancy Portrait' no. 14:
Flowers of "Culture"; or, A
Swinburne-Jones Cutting, Punch,
15 January 1881

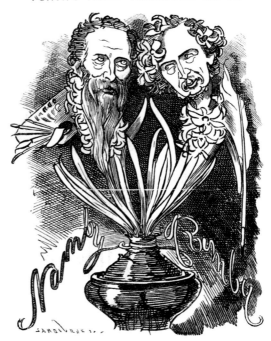

FLOWERS OF "CULTURE"; OR, A SWINBURNE-JONES
CUTTING.

Leighton. Down the years he continued drawing the Academicians under the leadership of their President. They are seen in the rigging of a boat, with their paintings on the sails; as the Argonauts rowing their trireme; as birds coming into shore, with Leighton as a gull above them; gathered round a maypole with Leighton at the summit; or simply in fancy dress.[63]

Sambourne had set up a tradition, which he continued to follow for many years. He had also involved himself in a great deal of hard slog in the representation of so many likenesses. His diaries show that he often took four days over these cartoons instead of the usual one or two. He was helped by photographs and *cartes de visite* and, when he included tiny versions of the year's paintings, by numerous visits to the Academy exhibition. At a later point in his career he was nearly arrested for sketching, while it was on the walls of the Academy, Edward Burne Jones's painting of a mermaid drawing a victim down to the sea-bed, *The Depths of the Sea* (1886; private collection) in preparation for a cartoon on the problems of

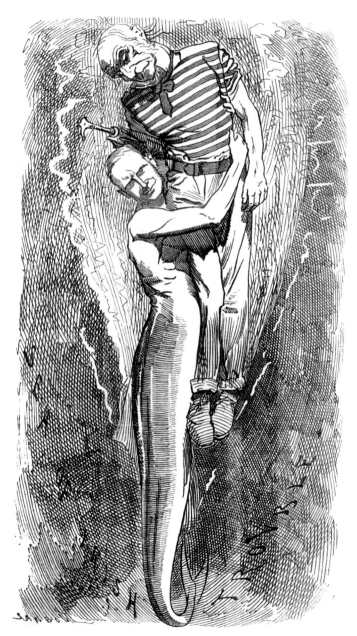

'**And** in the deepest Depths a deeper still ;" or, Morley the Mermaid and the Grand Old Man in the Irish Sea of Troubles. (*An Ulster-Marine Study after Burne-Jones, A.R.A.*)

Fig. 34 *And in the deepest Depths a deeper still; or, Morley the Mermaid and the Grand Old Man in the Irish Sea of Troubles, Punch,* 15 May 1886

Gladstone's Irish policy (fig. 34). By this time, Burne Jones had become a friend:

> I went to the Academy to get a thumb nail sketch of it & was immediately
> stopped not to say arrested by an officious detective & marched off below
> & my drawing confiscated. It was not without its humorous side as Burne
> Jones & most of the R.A.s & A.R.A.s were & are personal friends of mine.[64]

Sambourne felt, with some justification, that the situation was a little absurd, since the Academy did not own the copyright in the painting, and were, in any case, publishing reproductions of the exhibited works in their catalogue and allowing the illustrated papers to do the same. The cartoon duly appeared and the story became a favourite with Sambourne. This was also one of his last 'art' cartoons, a fitting coda to an association from which the cartoonist could draw both pride and personal satisfaction.

These were hard-working but enjoyable years for Sambourne. With visits to friends and family, outings with the *Punch* staff and others, he was already finding it hard to squeeze everything into his schedule. His problems were, however, to increase considerably in 1880, with the death of Tom Taylor and the accession of Frank Burnand to the *Punch* editorship.

NOTES

1 Birr Castle Archives, Birr Scientific and Heritage Foundation, Courtesy of the Earl of Rosse.

2 Ditto.

3 Birr Castle Archives, no date, probably May–early June 1874.

4 Birr Castle Archives.

5 Birr Castle Archives, 20 June 1874.

6 Birr Castle Archives, 10 June 1874.

7 Birr Castle Archives, no date, probably mid June 1874.

8 See note 6.

9 Birr Castle Archives, no date.

10 Birr Castle Archives, 24 June 1874.

11 Birr Castle Archives.

12 Birr Castle Archives, 10 [October] 1874.

13 *Kent Coast Times*, 22 October 1874.

14 Ditto.

15 Ditto.

16 Shirley Nicholson, *A Victorian Household*, London (Barrie & Jenkins), 1998, p. 20.

17 Undated letter, Kensington Library, ST/1/2/1358.

18 Ditto, letter of 30 November 1874, ST/1/2/1357.

19 See note 17.

20 F. Anstey, *A Long Retrospect*, Oxford (Oxford University Press), 1936, p. 30.

21 Simon Jervis, 'How an Artist's House May Survive', *Country Life*, 25 January 1979, pp. 210–11.

22 Birr Castle Archives, 17 September 1874.

23 'How I do my *Punch* pictures: An Interview with Mr Linley Sambourne', *Pall Mall Gazette*, 8 November 1889, p. 1.

24 Charles Handley Read, transcript of a lecture given at 18 Stafford Terrace before October 1971.

25 Charlotte Gere and Lesley Hoskins, *The House Beautiful*, Aldershot (Lund Humphries), 2000, p. 78.

26 See note 23.

27 See note 24.

28 M.H. Spielmann, 'Our Graphic Humorists: Linley Sambourne', *Magazine of Art*, 1893, p. 331.

29 Ditto.

30 Arthur à Beckett, *Our Holiday in the Scottish Highlands*, London (Bradbury, Agnew & Co.), 1876, p. 21.

31 Ditto, p. 22.

32 *The à Becketts of 'Punch'*, London (Constable), 1903, pp. 189–90.

33 Ditto, p. 190.

34 Ditto, p. 189.

35 Ditto, p. 197.

36 Ditto.

37 Birr Castle Archives, 21 September 1875.

38 *Our Holiday in the Scottish Highlands,* p. 139.

39 Ditto, p. 13.

40 See note 38.

41 Birr Castle Archives, 9 September 1875.

42 Ditto, 10 September 1875.

43 Ditto, 7 September 1875.

44 Ditto, 21 September 1875.

45 Ditto, undated letter.

46 Ditto, 15 September 1875.

47 *The à Becketts of "Punch",* p. 187.

48 Kensington Library, volume of newspaper cuttings, ST/7/1/1.

49 Ditto, ST/7/1/3.

50 Ditto, ST/7/1/2.

51 Ditto, letter of 29 September 1877, ST/1/3/1/8.

52 Ditto, letter of 29 October 1877, ST/1/3/1/11.

53 Ditto, letter of 29 December 1877, ST/1/3/1/15.

54 Morton N. Cohen and Edward Wakeling, *Lewis Carroll and his Illustrators,* Basingstoke (Macmillan), 2003, p. 333.

55 Ditto, p. 335.

56 Kensington Library, Linley Sambourne Archive, ST/1/4/11/45.

57 Ditto, ST/1/4/3/1.

58 Jeannie Chapel, *Victorian Taste: The Complete Catalogue of the Paintings at the Royal Holloway College,* London (Zwemmer), 1982, p. 128.

59 Susan Beattie, *The New Sculpture,* London and New Haven (Yale University Press), 1983, p. 14.

60 James Whistler, *The Gentle Art of Making Enemies,* ed. Sheridan Ford, New York (Stokes), 1890, p. 59.

61 Ditto.

62 See note 28.

63 *Punch,* 8 July 1876; 9 May 1885; 12 July 1879; 12 May 1883.

64 Kensington Library, Sambourne archive, letter to A.M. Levi of 30 September 1902, ST/7/1/190.

Fig. 35 Sir Frank Lockwood, fantasy sketch of Sambourne
riding in Rotten Row with the Archbishop of Canterbury

Chapter 3

A London Life

The Sambourne family was completed on 19 August 1878 with the birth, at their home, of a son, Mawdley Herapath. The Mawdleys were believed to have been a grander branch of the Sambourne family, and the choice of name was a sign of Linley's aspirations. It did not stick, however, and the boy was always known as Roy. His arrival was a joy to his parents, but it also meant more expense for them.

As was typical of a middle-class household at this time, the children and their nurse were usually to be found in the nursery. Marion would visit her parents at their country home, Westwood, sometimes for extended periods, and, as they grew older, Maud and Roy often accompanied her. On other occasions, the children would remain in Kensington and their father, who had to be in town for part of the week, reported on their progress in regular letters. In June 1886 Sambourne told his wife that he regretted having to stay in London but believed that one of them should be there to keep an eye on the staff. Returning unannounced on one occasion, he had found the servants out for the evening and the house unguarded.

There can be no doubt that Sambourne enjoyed fatherhood and felt great affection for his children, "the chicks". He reported their illnesses with anxiety, their recovery with palpable relief. This was a father who liked having his children at the dining table or taking them on expeditions, often to the Zoo or museums. At Christmas 1886 he arranged a magic-lantern show for all to watch. Maud sometimes visited local households, sharing a governess with a friend, but, from 1884, Miss Penn was employed to teach both children at home.

Sambourne's diary

Sambourne began to write a daily diary in 1882, following in the footsteps of his wife, who had done the same the year before. For the rest of his life he kept this record in handsome volumes, with space for two days on each page. Over the years the entries became more extended. The diaries give brief accounts of Sambourne's doings, sometimes with crisp comments on people and occasions. A dinner, for example, is "bad" or "good", just occasionally "atrocious". Re-reading his words over the years, he would add red ink annotations at the foot of the pages. Some draw attention to the importance of a day in the past, others note how events affected later history. Sambourne's colleagues paid tribute to his exceptional memory, and the diaries must have helped him to check facts. The reader will find sparse comment on current events. Politics may have been a large part of Sambourne's livelihood, but they seldom figure in his diary. Only major upheavals like the fall of a government, the death of Queen Victoria, or the liberation of Mafeking are mentioned.

This was a professional artist who was also a 'man about town' or 'club man'. The diaries record domestic life, journeys, entertainments, reading, and

they provide a terse account of a draughtsman's work. A feminist reader might recoil from the divided world exposed here, showing so clearly the masculine/ feminine split within Victorian society, but Sambourne was certainly not exceptional among the men of his day. Like many Victorians, he was much concerned with his health, and, in true British fashion, he takes daily note of the state of the weather, commenting on the climate in most diary entries.

Fig. 36 Sambourne with his daughter Maud, *c.* 1876

There is no room (and apparently little desire) for descriptions of the author's feelings or state of mind. These are not confessional or reflective journals, although, for a Freudian, the accounts of his dreams may have a certain interest. Often briefly recorded as "strange" or "curious", they are occasionally described in more detail. In his sleeping world, for example, Sambourne took the glamorous actress Ellaline Terriss into dinner, shortly before seeing her play *Cinderella* (D. 7.1.94). A "nightmare" found him staying as a house-guest of Alfred de Rothschild in Paris (D. 23.4. 96), and another was a "strange dream of taking a country house. Seat changed into an organ, mixed up with too great an outlay for income" (D. 9.3.99). These examples, amongst others, seem to reveal anxieties about his financial position. Some took him back to his early life: "Strange dream of Mrs Penn at The Cedars" (D. 8.3.99), while others were simply bizarre: "Strange dream of Lord Randolph Churchill & stuffed wolf put into his compartment & frightening him" (D. 3.12.94).

On a spiritual front, a reader of the diaries will learn that, although his wife and family attended regularly, Sambourne never went to church on a Sunday, except when staying with a clergyman. He might, however, call into a church for prayer at times of great stress and would, of course, attend weddings and funerals. Sambourne's evening reading sometimes included books by Darwin or studies of the relation of religion and science, but we can gain no further insight into his position on the Victorian religious debate. He was presumably a freethinker, but the subject is not discussed within the pages of his diary. Nor does the topic emerge in his cartoons. This was one contentious issue which *Punch* – perhaps fearful of giving offence, perhaps influenced by the Roman Catholicism of both its editor, Frank Burnand, and his deputy, Arthur à Beckett – generally avoided.

Nor is much to be learned, unless we read between the lines, about Sambourne's relations with his wife. There are moments when it is clear that though M, as he usually calls her, is unwell, or in a state of anxiety about her children or her family, her husband nevertheless sets out for a ride, or for a visit to the club, theatre or music hall. Marion's preoccupation with her health could become tedious and Shirley Nicholson speculates that this may sometimes have driven her husband out of the house:

One wonders how much she complained aloud, or if only her diary knew how ill she felt. Her husband seems to have been sympathetic, 'To Crystal Palace, had Bath chair and quite enjoyed day, dear Lin helped wheel me about, did not feel a bit tired'. But there must surely have been times when Linley felt impatient – perhaps his enthusiasm for early morning rides in the park was an excuse to escape from Marion's seediness.[1]

On one occasion, at Christmas 1886, Frances Sambourne suggested that this "seed-iness" might be a source of annoyance. Marion angrily recorded the remark in her diary: "Mrs S said my health very trying for Linley, feel extremely annoyed".[2] Such comments, too near the truth for comfort, earned Frances Marion's epithet, "*La belle-mère très désagreable*".[3] That Marion felt no liking for her mother-in-law is evident from her diaries.

For all her health problems, Marion was very active in the house. It was she who oversaw the children's education and managed the governess together with the domestic staff. Sambourne was responsible for the horses, the grooms and the dogs as well as the interior decoration, the hanging of paintings and the acquisition of furniture. Aware that her husband was 'loving', Marion is not often critical of him in her diary, but his preoccupation with buying furniture was an increasing source of irritation: "Every corner in the house now fitted with corner cupboards …. Two new arm chairs, it never rains but it pours with Lin, epidemic of chairs now!"[4] "Lin putting up pictures on stairs all morning." Marion was even more irritated by her husband's other obsession, "endless endless endless photography!"[5]

On very rare occasions the normally affectionate wife expressed more power-ful feelings, if only to her diary. One such entry was made in December 1888, when she was deeply distressed by her brother Spencer Herapath's bankruptcy: "Feel awfully done up. Often think it a pity Lin ever married – only cares about his home as a sort of warehouse for surplus furniture – our lives drifting apart."[6] There is a draft will leaving everything to her two children folded into the same diary.

Only when she was seriously ill, in the last decade of Sambourne's life, does his diary give expression to deep feeling for Marion. When they were apart, how-ever, he frequently wrote genuinely affectionate letters, if usually concerned with financial, family or household matters. On occasions, he admonished her quite sharply:

You must *not* ask people to dinner and then go away. We shall make serious enemies if you do. The Grossmiths were within an ace of coming on Sunday, only Mrs G being ill prevented it. Write at once to Mrs Grossmith and say how sorry you are that she is ill and that they could not come. The rest you must get out of as best you can.[7]

This must have been an unusual event. Marion was naturally gregarious, enjoying the couple's social life and forming warm friendships with many of their neighbours.

Leslie Geddes Brown has suggested that Sambourne deliberately used Marion as a model for the plain women in his cartoons: "His hypochondriac wife tended to be kept for the uglier characters, perhaps in revenge for her attitude to his photography".[8] This is a little too calculating. Sambourne photographed everyone for his cartoons, particularly at times of great pressure, and he certainly used his own image for countless undignified subjects.

Sambourne occasionally expresses his worries about the energetic Roy's bad behaviour, but, when the boy went to Albion House School in Margate at the age of ten, his father fell into a state of depression normally associated with a mother. He rode past the building, hoping to catch a glimpse of his son, and when Roy climbed onto the school wall he gave him an encouraging kiss. In May 1889 Roy wrote from school telling his parents that he was being beaten by the staff and bullied by the other boys. He begged them to take him away. Sambourne, trying to discover whether Roy was exaggerating, consulted a fellow artist, Walter Crane, whose son was in the same dormitory. In his reply, Crane explained that he had heard no complaints and that his son seemed to be happy. He believed that the headmaster, Mr Schimmelmann, was a man who cared for his pupils' welfare. As a result, Sambourne sent a reassuring letter to Marion in June 1889, pointing out that their anxieties about the school might not be justified.

Sambourne, however, was less directly involved with the children's education than their mother, whose diaries tell us more about the problems caused by their son's lack of application. As he grew older, 'Dear Roy', as he is almost invariably named in the earlier diaries, became a regular companion on his father's outings to the theatre, exhibitions or places of historic interest. On occasion they went into a church together, but only because of Roy's liking for architecture. It seems the male members of the family were natural companions for one another once outside the house.

Fig. 37 Roy Sambourne as a child Fig. 38 Maud Sambourne as a child

The quiet and retiring Maud gave less trouble than Roy. Occasionally, she *was* naughty, a fact which her father records without anger. She did not go to school, although there were a number of excellent establishments in the vicinity, including Kensington High School, founded by the Girls' Public Day School Trust. Her various teachers, like her second governess, Miss Florence Gill, who lived with the family from 1889, are sometimes mentioned in passing, but their intimate place in the family circle could not be gauged from their employer's diary. Maud inherited her father's gift for drawing, but he says surprisingly little about this until, as a teenager, she began to contribute to magazines on her own account.

Sambourne's mother was a member of the artist's household for several months of every year. His affectionate feelings for her have, once again, to be inferred from his characteristically uninformative diary entries. "Dined quietly at home with Maud & Mother", he says, which perhaps recalls a cosy meal with two people to whom he was devoted (D. 29.1.89). We hear of Frances Sambourne reading aloud while Linley worked on his cartoons. On one occasion he records a

present of a silk kerchief from his mother and her comings and goings are briefly noted in his diary.

When not in Kensington, Frances stayed with relatives in Worksop, Sheffield, St Neots in Huntingdonshire and Cheshunt in Hertfordshire. Her letters to her son frequently express anxiety both that she may be distracting him from his work and that his social life is too exhausting. She was worried about the scale of his expenses, regretting, for example, his purchase of a second horse. Frances writes of her own financial position, and that of her relatives, in some detail, sometimes adding up her income and expenditure on the back of letters received. It is clear that she was nervous while bills were unpaid and haunted by a fear of penury. Her son often sent her a little money, sometimes the proceeds of her own railway shares. On one occasion he also offered to send some whisky.

Like her husband, Marion notes Frances Sambourne's arrivals and departures in her diary, but with dread and relief respectively. Frances was often depressed and worried about her health, which is a frequent topic in her letters. She suffered from severe arthritis and seems to have spread an atmosphere of gloom through the household. The children loved her, however, and their grandmother would stay at home with them when their parents went out for the evening. That Sambourne himself floated above the tension between his wife and his mother (of which he must surely have been aware) is strongly implied by his diaries. Marion makes it clear that she tried hard to control her irritation and dislike. Just possibly, she succeeded in convincing a husband who would not have wished to recognize the truth of her emotions.

Marion's own mother and father, when not in Kent, were still living round the corner in Upper Phillimore Gardens, where she could visit them frequently. Marion's family remained an important feature of life at 18 Stafford Terrace, and the extended Herapath clan were frequent hosts to the Sambournes. The brothers and sisters all married, and most of them produced children. Marion's younger brother, Conrad, after overcoming considerable opposition, married Effie, the daughter of the successful sculptor Sir Edgar Boehm, in 1885. The Boehms were good friends of the Sambournes and the relationship probably aided Conrad's suit. Of other Herapaths, the Sambournes saw most of Marion's sister Ada, otherwise known as Tabby or Tabs. Her well-to-do husband, Hamilton Fletcher, whom she married in 1883, was the son of one of the founders of the White Star shipping company. The

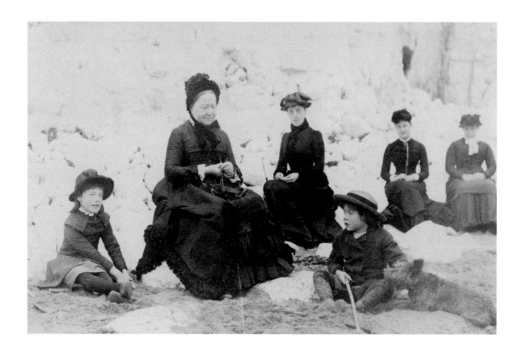

Fig. 39 The Sambourne family on the beach, 1884 (Frances Sambourne is
in the centre, Marion behind her, Maud to the left and Roy to the right)

Fletchers rented a number of large houses in the Southern counties during the
1880s and 1890s and the Sambournes often stayed with them at the Anchorage,
near Christchurch in Hampshire, or in the magnificent Pyt House in Wiltshire.
Another sister, Jessie, known as Midge, married Hamilton Langley, who had in-
herited an estate in Argentina. Like the Fletchers, the Langleys entertained the
Sambournes in substantial country houses.

　　As in all large families, there must have been some alliances or particularly
close friendships, and perhaps some coolness, but Sambourne's diary gives little
indication of such things. His friendship with Marion's brother continued, and
Spencer was a welcome visitor at 18 Stafford Terrace. Marion, however, found
Spencer's wife, Ada Oakes, difficult. In September 1886, writing to Marion from
Spencer's rented lodge at Linton in Scotland, Sambourne explained that, although
he missed her, he did not want the children to come into contact with their aunt.
Spencer was declared bankrupt two years later and Marion's diary records:
"Disgrace – Lin awfully upset about it".[9] Sambourne mentions Spencer's

bankruptcy in his diary, but only when she had died in 1897 does he refer to the second daughter, Annie Herapath, who married William Furrell, "went to the bad" and was disowned by her family.

Fortunately perhaps, Marion's father did not live to see Spencer's disaster. His death in 1884 signalled the beginning of a slowly developing change in the Sambournes' way of life. His widow found it impossible to keep up her London home and settled in a flat in Albert Hall Mansions. A tenant was sought for Westwood, but none appeared. It slowly became apparent that Mrs Herapath's finances were not flourishing, and it was discovered that one of the executors of her husband's estate was embezzling her funds. This, together with the increasing weakness of the South American railway shares on which the family's prosperity was based, meant that Westwood had to be sold. Her father's death brought Marion no extra wealth, a matter of some bitterness to her. Her income had been fixed at £100 a year at the time of her marriage and, while her brothers and sisters (often better off than she) each gained an extra £50 a year, Marion, having had a thousand pounds advanced for her house, was excluded.

Meeting the deadline

Most people's lives settle into patterns as they grow older, and Linley Sambourne's was no exception. The timetable of his week, however, was more rigid than most. The dominant pattern was built around the publication of *Punch*, which, until late in his life, was always on Saturday. The process began with the *Punch* dinner on Wednesday evenings, ten days before the journal came out. Some contributors, like George Du Maurier, resident in Hampstead, were very irregular participants at the table, but Sambourne was invariably there. From the mid 1880s he formed the habit of taking a Turkish bath on the way, in the well-known establishment at 92 Jermyn Street. He sometimes walked from Kensington or, alternatively, he walked on from the West End to Bouverie Street. His diary notes those whom he met at the Turkish bath, including Leighton, the lawyer Charles Russell (a riding companion of Sambourne's), and an unnamed stained-glass artist who remembered him from the art classes in Langham Place. Another Turkish bath subsequently opened in Northumberland Avenue and Sambourne joined the Bath Club in Dover Street in 1895, giving him three establishments to choose from.

On the way home from the *Punch* dinner Sambourne would share a cab with another member of the staff. From January 1887 it was usually the writer Thomas Anstey Guthrie, who lived nearby at 6 Phillimore Gardens. Famous from a young age as the author of *Vice Versa* (1882) – the story of a domineering father who finds himself in his son's place at boarding school – Guthrie, who wrote under the name F. Anstey, was a talented member of the *Punch* team, known for his parodies and fantasy novels. He attempted to write serious fiction, and had some success with a farce, *The Man from Blankleys*, but never matched his early achievement. After Guthrie moved away in 1889, Sambourne would travel into the West End with John Tenniel, then part from him at the Isthmian Club in Piccadilly, and take a cab or bus home.

Sambourne's own cartoon subject was not always decided at the dinner, and Thursdays were dominated by an anxious wait for the arrival of instructions. His diaries record his irritation when no letter came from Burnand or from Edwin Milliken, whose letterpress Sambourne was often asked to illustrate. Milliken, best known for his ''Arry' poems, which mocked a "low-bred fellow (who 'drops his *hs*') of lively temper and manners",[10] "suggested most of the cartoons and wrote verses to face them".[11] Eventually, at some point on Thursday, or, in the worst case, on Friday morning, the letter came and Sambourne could settle to his work.

Photography

When under such pressure of time, Sambourne had difficulty in drawing the human figure and catching a likeness. The solution, which he found in the 1880s, was photography. Until then taking photographs had been largely the pursuit of professionals or of near-professional amateurs. Now it became a more popular pastime. The price of equipment was falling, cameras were lighter in weight and, with the widespread use of the gelatin dry-plate, the processes were less arduous. Sambourne was already making use of photographs in his work, some taken for him by others, some, like the popular *cartes de visite* of politicians, from commercial outlets. Now he could complete the work for the cartoon using his own resources.

In the spring of 1882 the Sambournes visited the Surrey home of an artist friend, well known for his nautical scenes, James Clarke Hook. Juliet McMaster has shown how this coincided with the publication of one of Sambourne's Royal

Academy cartoons, and how Hook purchased and then annotated the original drawing with the names of the artists represented.[12] Hook's sons, Bryan and Allan, were becoming expert photographers, specializing in artists' portraits. Photographs were taken of the whole party and copies sent on to 18 Stafford Terrace. This was a revelation to Sambourne, who must have been fascinated by the processes involved and by the idea of a possible transformation of his own working practices.

Even so, it was not until a year later, on 19 August 1883, that Sambourne wrote in his diary: "Took my first photograph." At around the same time he bought a camera. His earliest photographs were commercially printed, and then, in 1885, the landscape painter Tristram Ellis taught Sambourne how to make his own prints. Ellis, who made many expeditions to the Middle East and Asia Minor, had taken up photography to record his travels.

Photography had great advantages for a man working to a deadline and in his own home. In 1886 Sambourne took out a license with the Platinotype Company, allowing him to use paper coated with platinum. Later he began to use platino-bromide paper, which meant that he no longer needed direct sunlight for his work. After 1894 he employed the cyanotype or blueprint method, which did not require a totally dark room and could be developed rapidly. Over the years, Sambourne bought a number of cameras, some on traditional stands, others hand-held. For his negatives he at first used glass plates and then celluloid flat films, marketed from the 1890s.

The photographer would recruit his children, his relatives or the domestic staff to take up particular poses, sometimes wearing costumes borrowed from artist friends or from an agency, and would then use the prints as guides for his drawing. He always tried to get exactly the right clothes and accessories, on occasion borrowing the Lord Mayor's robes, or a clergyman's cape to stand in for Alfred Tennyson's famous black cloak. He was proud that he had photographed, and worn, hats once owned by Napoleon and Wellington: "I have done what probably no other man on earth has done, I have worn the hats of the two greatest soldiers on earth".[13] When "investigating a point before I begin to draw", he told an interviewer, he would spend hours "in order that some incidental fact may be accurate".[14] When none of his usual models would do, and he needed a policeman, a brewer's drayman, or a working man throwing a brick during a riot, the artist would send out for the original. If no one else was available, Sambourne often

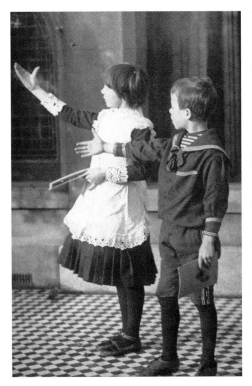 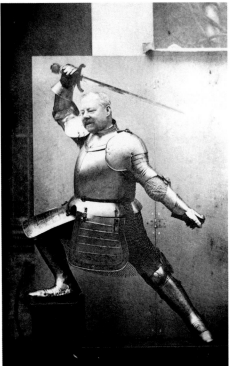

Fig. 40 Maud and Roy posing for their father, 1885 Fig. 41 Sambourne posing in armour

posed himself in different guises, and many of these comic self-portraits are now preserved among his prints.

The tight *Punch* timetable meant that the negatives had to be developed rapidly, and Sambourne began to use the bathroom as a darkroom, equipping it with a shelf. He first "skemed" his subject, then took photographs of the poses. These were promptly developed, printed and dried. Some of his prints were still developed commercially, but not those intended for immediate *Punch* use. Others could afford to wait until he set up a special printing session, like that on 23 March 1887: "Developed a lot of plates. Found out the reason of fogging – light at back." With the years Sambourne changed his cameras, his chemicals and his paper, but the principle remained the same for the rest of his career. At a later date, Sambourne described his chosen method to a journalist. If possible, he said, he would have preferred to use a live model:

… but it is impossible. Much of my work is of necessity, very rapid. Often I cannot get the model I require at a moment's notice, and where there is not this difficulty there is the other – that by artificial light I cannot see to draw from a model. I use the camera instead, for I do not agree with those artists who condemn the aid of photography altogether. Where, I should like to know, am I more likely to get the next best thing to a live model than in an exact reproduction of individuals of every type I may require?[15]

By the time that Sambourne made this statement, photography had come to interest him at least as much as drawing. Not all of his photographs represent people. Among the twelve thousand or so prints that Sambourne accumulated are examples showing fish, animals, antique objects, weapons and armour, ships and the sea, buildings and landscapes as well as objects of all kinds. These formed an archive to which he could refer for the details of his drawings, and his filing and annotation of his photographs was a regular and important activity.

One source of material was to be found in the Zoological Gardens in Regent's Park. It might be expected that Sambourne, like his friend Henry Stacy Marks, would make frequent visits to the Zoo in order to draw and photograph the animals and birds there. In fact, there are few references to the Zoological Gardens in his diaries for the later 1880s and 1890s, when he was evidently relying upon existing photographs. More surprisingly, Sambourne made fewer expeditions to the Natural History Museum after it had moved to South Kensington from Bloomsbury in the early 1880s. He read widely on zoological matters and drew Sir Richard Owen, the keeper of the Natural History collections, both for a 'Fancy Portrait' and for an illustration to *The Water Babies*, but there is no evidence that he made great use of the museum once the whole collection was assembled there in 1883.

Armed with his photographic reference material, from which he sometimes traced the outlines, Sambourne worked through Friday, usually finishing late in the evening. Marion or his mother would read aloud as he sat at the garden end of the first floor, drawing at an easel made to his own design. Unlike his painter friends, he had no studio until after Maud's marriage in 1898. A mirror helped him to "reverse pictures just as I want to draw them" and the lighting was arranged to assist him in his work: "This gas burner, made for me by Sugg, is my idea; there's

a 100-candle power there, and so I work independent of night or fog".[16] After fin-
ishing the outlines of his cartoon, he would shade his work, establishing the light
and dark areas. He avoided cross-hatching (conveying thickness through crossing
parallel lines) where possible, preferring to give the illusion of solidity or of dis-
tance by varying the thickness of single lines. A boy would wait for the drawing and
speed away as soon as it was completed. Sambourne's granddaughter, Lady Rosse,
could remember this Friday night ritual more than sixty years later. The cartoon
once dispatched, the artist could eat a late dinner with a bottle of wine or cham-
pagne, its provenance often carefully noted in his diary. He would then fall asleep,
sometimes still sitting in his chair.

Sambourne, like other cartoonists, was understandably irritated by the
common notion that his job must be 'fun'. Writing to Sir Isidore Spielmann in
March 1900, he explained that he had to decline an invitation (and also probably
miss some committee meetings for an International Exhibition Jury) because he
must attend the *Punch* dinner:

> ... if I do *not* attend I do *not get* my subject sometimes until late on Friday
> causing me serious delay & consequent hurry after. Few people are aware
> of the extreme trouble & pressure for *time* that my drawings – such as
> they are – entail ... the cartoon ... *must* go in by 8. oo on Friday evenings
> & I do not get the subjects settled till mid day Thursday.[17]

On Saturdays, a sense of relief must have been palpable. Occasionally, a second
(and smaller) drawing had been asked for and was completed in the morning
and, from time to time, Sambourne would ride to Bouverie Street to collect his
month's pay.

Horses

On most days Sambourne would take an early ride in nearby Rotten Row, the
fashionable bridle path which runs along the southern edge of Hyde Park. His
Punch colleague, Harry Furniss, explained that this was a central feature of upper-
class life:

> That mile and a half sprinkled with all sorts and conditions of equestrians
> from the 'Liver Brigade' in the early part of the day, to the cream of society,

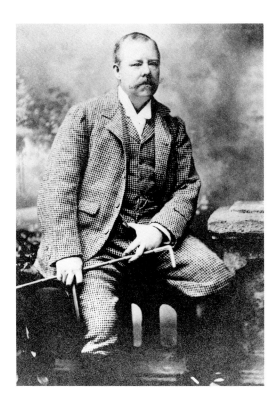

Fig. 42 Sambourne in riding clothes, 1895

and the principal leaders of the professions, politics, and fashion that
thronged it for the rest of the morning. Every one who was anybody
regarded it as a social meeting-place.[18]

In the Row Sambourne would meet friends, some on horseback or in their car-
riages, others walking. A fanciful sketch by the lawyer Frank Lockwood shows
Sambourne, in his straw hat, bow-tie and loud checked jacket, riding in the Row
with the Archbishop of Canterbury, Edward White Benson (see fig. 35, p. 92). *One
of the Liver Brigade*, a witty caricature by the engraver and illustrator John Hipkins,
shows Sambourne from behind, perched high on the saddle, with his coat flying
wildly and his crop raised in the air.

According to Furniss, for all "the infinite pains with which he would im-
press on us his desire to be regarded as a riding man", Sambourne did not have
a good "seat in the saddle. I believe he assumed being the country gentleman
riding to cover, but personally I have never seen a riding man lean over his
horse's neck as he invariably did."[19] Sambourne normally wore country tweeds,

another aspect of his cultivation of an image and style. A journalist, visiting him in 1886, reported:

> Mr Sambourne's own face is characteristic; his sunken eyes have a keenly humorous expression, with much penetration. In costume he prefers a cross-country, Newmarket, or sporting air, and persistently eschews any approach to artistic fashion. He does not wear a red or yellow necktie; still less does he affect surroundings of bilious olive or tawny yellow. He is even less artistic-looking than Mr Frith or Mr Horsley: he looks like a man who farms his own estate, and is specially interested in the breeding of horses.[20]

Over the years, the Sambournes owned a number of horses, their doings regularly recorded in their diaries. At first a single horse, Punch, was kept specifically for Linley's morning rides. After 1884 the family also owned a carriage and so needed a second horse. Punch was demoted to carriage duty and, for a short time, Pippin carried her owner on his expeditions. Pippin, proving unreliable, was replaced by Folkestone, and he and Dolly, bought in 1886 and always known as 'the Mare', were the family horses for many years, with Folkestone as carriage horse. When the Sambournes moved to Ramsgate for months at a time, the horses and the groom went with them and Linley would keep up his daily ride along the coast. He liked to attend the horse auctions at Tattersalls, and he occasionally visited Crabbet Park in Sussex, where the writer and traveller Wilfred Scawen Blunt kept a stud farm.

The horses were housed in stables in Phillimore Place, with a groom and family living on the upper floor. The various grooms – Cave, Waters, Crane, Jolly, Otley and Upton – came and went like the horses. They have achieved some permanent fame as regular models for their employer's photographs. Marion sometimes complained about their driving and their careers often ended in dismissal for drunkenness. Employing a groom must have involved the family in considerable expense, but buying and selling horses was a part of a gentleman's life in the nineteenth century. The Sambournes probably spent more than they could afford in keeping up appearances in this way.

Dinner parties

Frequent guests at formal evening parties in Kensington or further into town, the Sambournes made use of their carriage when dining out. Sambourne's diary usually records which of the female guests he took into dinner. He would often sit between two women and it was on the basis of their conversation that he would decide whether to rate the evening slow or enjoyable. He always hoped that whisky – rather than port, which he never mentions – would be served to the gentlemen after dinner. These dinners were lengthy occasions, with the Sambournes regularly returning home after midnight.

A memorable dinner took place at the Burnands' house at 64 Russell Square on 28 February 1878. The Sambournes had been invited to meet a special guest, and they wrongly assumed that this was to be the man of the moment, Henry Morton Stanley, recently returned from his adventures in Africa. In excited anticipation, Marion Sambourne donned her African jewellery, a present from her brother and of "rare and remarkable beauty".[21] The Sambournes were among the last to arrive and Burnand, already aware of their mistake, persuaded a journalist on *The Standard*, Alfred Watson, to play the role of Stanley, drawing his other guests (who included W.S. Gilbert) into the charade.

On his arrival and introduction to 'Stanley', Sambourne decided that his recent likeness of the African explorer, while not quite accurate, had been a reasonable attempt. The evening was a difficult one for Watson. Sambourne asked him many questions and, when asked to elaborate on one of Stanley's tales, Watson was reduced to saying that it was not a suitable story to tell before ladies. Marion "acknowledged the introduction" with "admiration, not to say reverence", which "did not tend to make matters any easier".[22] Burnand had planned to own up after dinner, but a suitable moment never presented itself. Having managed to sustain the bluff, Watson made his escape, pretending that he had to attend a soirée at the Royal Geographical Society. When Burnand enlightened the Sambournes they were initially unable to believe him, so complete had been the deception. "'My dear Frank', he [Sambourne] replied, shaking his head with the most knowing air in the world, 'you can't humbug *me*. No! No! It won't do. *I know Stanley when I see him.*'" Relations between Burnand and the Sambournes were strained for a time, "but Mr and Mrs Sambourne being the kindest people, took a lenient view of the case, and when on an early occasion we were invited to dine at their house, the only

revenge they took was to put on their card that this 'was *not* to meet Mr Stanley'".[23] In later years Burnand always insisted that his old friend never showed resentment at being duped in such a public fashion.

The Sambournes gave their own dinners, returning hospitality and entertaining new friends. A number of menus have survived, typical of late Victorian dinners, amazing later generations with the number of courses consumed. From 1891, an extended table-top could be placed over the octagonal dinner table, enabling the Sambournes to invite up to twelve guests. The table-top was used for the *Punch* jubilee cartoon in that year, and may have been purchased for the purpose.

As time passed, the group of friends in the Kensington area widened. A particular favourite with the whole family was Sylvinia Rose Innes, who came from a legal family with South African connections, and became an intimate, often dining with the Sambournes *en famille*. Marion had known her in the past, and when her husband met "little Miss Innes" in 1886, finding her "as pretty as ever", Sylvinia expressed a wish to reacquaint herself with her old friend.[24] Sambourne, in an astute observation on Kensington social distinctions, suspected that Miss Innes detected some hesitation on Marion's part now that the Herapath house in Upper Phillimore Gardens had been given up. Her husband insisted, and Sylvinia Rose Innes's name is among those most often cited in his diaries.

Another local friend was the solar physicist Norman Lockyer, who held a post at the Royal College of Science in South Kensington, eventually rising to become director, with his own observatory. Sambourne met Lockyer through fellow artists, and over the years he continued to see him at dinner parties and on cruises. Lockyer, a widower, had a seaside home at Westgate-on-Sea and, while the Herapaths were still at Westwood, Sambourne and he often saw each other in Kent. Both men played tennis at the nearby home of the painter William Quiller Orchardson. Lockyer was a regular dinner guest in Stafford Terrace and he reciprocated with dinners at the Reform Club, where, on different occasions, Sambourne's fellow guests included the scientist Thomas Huxley, the Astronomer Royal William Christie, the painter Lawrence Alma Tadema and the musicologist Sir George Grove. Sambourne drew a 'Fancy Portrait' of Lockyer, standing on the clouds and posed against a smiling sun (P. 22.12.83; fig. 43). He carries a box of tools labelled 'Science' and sports a pair of wings marked 'Nature', the name of the science magazine that he edited. Sambourne's subtitle, *Illuminating the Sun*,

PUNCH'S FANCY PORTRAITS.—No. 167.

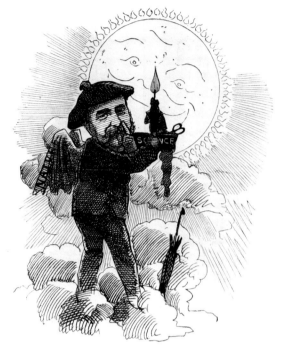

NORMAN LOCKYER, F.R.S.,
ILLUMINATING THE SUN.

Fig. 43 ' Fancy Portrait' no. 167: *Norman Lockyer, Punch,* 22 December 1885

refers to Lockyer's research into the solar atmosphere. His discovery of the element helium was eventually rewarded with a knighthood.

A number of the Sambournes' friends were artists, but others were wealthy professionals, like the Messels, the Joshuas, the Sebag Montefiores and the Ionides – a Greek shipping family, settled in London. Many of their friends were Jewish, among them Sir Moses Montefiore, who put together a remarkable collection of Jewish documents and artefacts, and Isidore Spielmann (knighted in 1905), who organized an Anglo-Jewish historical exhibition and became President of the Jewish Historical Society of England.

Marion's family background had a part to play in the Sambournes' popularity, as did Sambourne's growing reputation as a cartoonist, but his good humour and cheerfulness must have been a factor. The qualities which made him an ideal companion for a shooting holiday in Scotland or for a nautical expedition must have brightened many a dinner table.

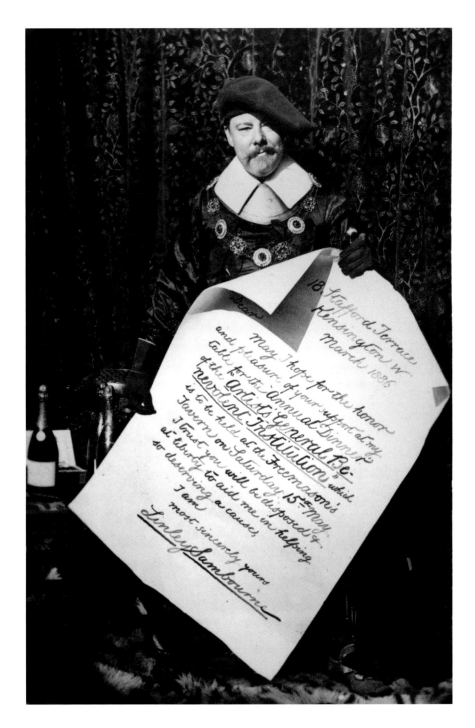

Fig. 44 Sambourne inviting a friend to the Artists' General
Benevolent Institution Annual Dinner, 1886

Some evenings took Sambourne to all-male dinners at a private house or club. These parties generated more noise and jollity than the formally organized mixed dinners. Marion Sambourne, trapped upstairs, writes of the sounds of merriment when they took place in her own home. Charitable dinners, like those for the Artists' Benevolent Institution, were another feature of Sambourne's social life. Two amusing photographs show him in different military costumes, bearing a large piece of paper inviting the recipient to help a deserving cause and sit on his table at the Freemasons' Tavern on 15 May 1886 (fig. 44). At his side are tempting bottles of champagne.

Sambourne often lunched or dined at one of his clubs, the Garrick and, until 1894, the Beefsteak. He would usually have eaten at the Club Table, with other members who happened to be there at the time. Like many artists, he joined the Arts Club, but not for long. When he left in 1885 he explained to a friend, who was seeking election, that he had resigned because he made so little use of the facilities. Friends entertained him at other establishments – Brooks, the Athenaeum or the Travellers among them.

The Garrick was Sambourne's usual haunt, and many of his letters bear that address. Set up in King Street in 1831 for "the promotion of all the interests of the Drama",[25] the Garrick moved to its imposing Venetian-style building in Garrick Street in 1864. Sambourne would lunch, dine or simply drop in. The London men's club was a familiar haunt of the well-born and professionals. Entry was by election, and those who were regarded as unsuitable (on grounds of personality, lifestyle, class or race) either failed to gain sufficient votes or were blackballed (a veto was put on their election by other members). Sambourne was not a member of one of the very grandest clubs until 1896, when he was elected to the Athenaeum, an establishment with a very long waiting list.

If Sambourne kept fit through his daytime sporting activities, he made up for it on many indulgent evenings out. Two or three times a week he would drink more than was good for him, sometimes regretting it when he felt "liverish", "bilious" or "seedy" the next day.

THE LATE PANIC.

" CASTE."

Fig. 45 Initial letter 'C', with actors, John Hare, George Honey and Squire Bancroft, from Thomas W. Robertson's play, *Caste*, *Punch*, 29 July 1867

The theatre

Dinner parties were not the only form of entertainment. The Sambournes were avid theatre-goers. When in London they were usually at a play at least once a week, if not more, often attending matinees. This was a time when there were theatres in all parts of the city, but, although sometimes to be found at the Court Theatre (later the Royal Court) in Sloane Square, Sambourne was essentially a West End man. Accompanied by Marion, he was a regular at a wide range of venues, usually sitting in seats and boxes provided for him as a member of the *Punch* staff. As with the railway 'passes' that came with the family's shares, Sambourne did not expect to pay for theatre seats. He was very irritated when he found it "difficult" to get into the Opera House to see Emma Albani in Wagner's *Flying Dutchman*: "Wanted me to pay" (D.1.7.93). His correspondence with the American theatre manager and dramatist Augustin Daly, who, with his leading

actress Ada Rehan, brought a company to London in the late 1880s, is a characteristic example. Daly opened his own, eponymous theatre in Cranbourne Street, Leicester Square, in 1893. Sometimes Sambourne wrote to ask for seats for himself and the family, sometimes his letters acknowledge the gift of a box or a seat in the stalls. He provided drawings for programmes in return. Among the plays seen at Daly's was Sheridan's *School for Scandal*, starring Ada Rehan as Lady Teazle.

As his children grew up Sambourne regularly took them to pantomimes at Drury Lane and Covent Garden and to children's plays like *Alice in Wonderland*. This last expedition was on a night of traditional London fog. Maud and Marion were sent home by train and Sambourne and Roy walked: "At end of Piccadilly got into worst fog I was ever in which gave me a cold after. Dear Roy a brick. Felt our way home" (D. 31.12.88). These early visits to the theatre must have set the pattern for Roy's later passion for the stage, and for actresses in particular.

The theatre enjoyed a golden period throughout the second half of the nineteenth century, with playhouses in many towns. Sambourne was an *aficionado*, but he was by no means exceptional in his regular theatre going. A fellow Garrick member, Squire Bancroft (later Sir Squire), had set up the pioneering Prince of Wales's Theatre in Tottenham Court Road with his wife, Marie Wilton, in the 1860s. Bancroft recalled Sambourne as "an amusing little creature, always very horsey in get up".[26] The Bancrofts replaced the working-class pit with the stalls as we know them today and drew on the domestic and social dramas of Thomas William Robertson rather than the spectacular melodramas of an earlier period. Sambourne saw Robertson's best-known play, *Caste,* an analysis of the effect of social prejudice on human relationships, in the opening production at the Prince of Wales's in 1867. Among his earliest initial letters for *Punch* was a letter C, featuring three leading members of the company with the word *Caste* underneath them. One of the three was John Hare, in the rôle of the lower-class comic character Sam Gerridge (P. 29.7.67; fig. 45).

Sambourne attended a number of later revivals of *Caste.* One, in 1883, was at the Haymarket Theatre, where the Bancrofts had taken over the management, and where the Sambournes were *habitués*. He declared that another revival, at the Garrick Theatre in 1894, was markedly inferior to the 1867 production. Seeing the play for the last time in 1902, Sambourne clearly enjoyed it once more, and Marion, who was with him, was moved to tears.

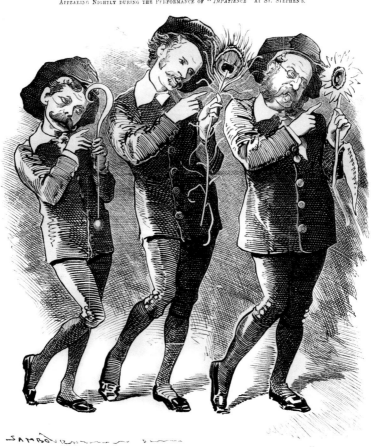

THE TROUBLESOME TRIO

Appearing Nightly during the Performance of "*Impatience*" at St. Stephen's.

Sambourne could claim that his theatre-going fed into his work, and he missed few of the great hits of the period. He saw most of the comic operas of W.S. Gilbert and Arthur Sullivan, performed at the Savoy Theatre, some of them several times over, starting with the Aesthetic satire *Patience* in 1882. On 11 November that year he alluded to *Patience* in a cartoon satirizing three break-away Conservative politicians, Lord Randolph Churchill, Sir Drummond Wolff and Ashmead Bartlett. Dressed in knickerbockers and velvet jackets, they clutch the Aesthetic icons of the peacock feather and the sunflower (fig. 46).

This was typical of the way in which Sambourne reflected his interest in drama in *Punch*. Several playwrights and actors appeared in his 'Fancy Portrait' series, including the prolific dramatist Henry James Byron, with his record-breaking play *Our Boys* (P. 3.12.81), the Italian actors Tommaso Salvini and Adelaide Ristori

LEFT
Fig. 46 *The Troublesome Trio*, from the left
Lord Randolph Churchill, Sir Drummond
Wolff and Ashmead Bartlett, *Punch*, 11
November 1882

RIGHT
Fig. 47 'Fancy Portrait' no. 75: *Henry Irving*,
showing the actor as Romeo with Ellen Terry
as Juliet, *Punch*, 18 March 1882

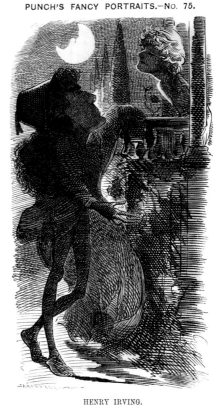

HENRY IRVING.
" Romeo ! Romeo ! Wherefore art *thou* Romeo !"
Shakspeare.
[*.* But had the Divine Williams witnessed the performance, he might
have been able to satisfy his own query.]

(P. 15. 3. 84; 8.7.82), Sarah Bernhardt (P. 15. 4. 82) and, a personal friend from his visits
to Broadway, the American actress Mary Anderson, on 29 December 1883, in the
year of her first appearance at the Lyceum.

As a member of the Garrick Club, Sambourne was frequently in the company
of actors and dramatists. John Hare, whose performance in *Caste* Sambourne had
admired, was one fellow member. Hare, who became the manager of the Garrick
Theatre, was among Sambourne's riding companions. At the club Sambourne
would chat with the great actor of the day Henry Irving, and with Irving's friend
John Laurence Toole, another famous actor manager, known for his comic and
burlesque roles. Irving acquired the management of the Lyceum Theatre in
Wellington Street (near the Strand) in 1878 and his company retained its premier
position for many years. With the architectural and historical sets by Hawes Craven

and William Telbin and their huge casts, these Lyceum productions were legendary.

Irving invited Sambourne to the champagne parties on the stage which followed his opening nights. He was there on 8 March 1882 after the opening of *Romeo and Juliet*. The next week's 'Fancy Portrait' featured Irving as Romeo, with a flattering caption declaring that Shakespeare would have known the answer to the question 'Wherefore art thou Romeo?' had he seen Irving (P.18.3.82; fig. 47). The first performance of Irving's famous *Hamlet*, on 2 May 1885, was a "great night" for Sambourne and he saw Irving in W.G. Wills's *Faust* on at least six occasions, from the first night on 19 December 1885. Four days after that event, Sambourne was working on Irving's head as Mephistopheles for a cartoon *The latest Faust or Wills's Smoking Mixture* (P. 2.1.86). On one of these visits Sambourne and Roy went behind the scenes after the performance: "Roy v. excited, Irving most kind to him, not home till 3."[27]

Marion often accompanied her husband to the first night parties, including that for *Macbeth*, with Ellen Terry as Lady Macbeth, in December 1888. Marion wrote: "Great crowd, supper ready. Met many friends."[28] Neither Irving nor Ellen Terry were ever dinner guests at the Sambournes' home. To invite Ellen Terry, who had two children from her relationship with E.W. Godwin, to 18 Stafford Terrace may have been a step too far, although Sambourne was a fellow guest with her at a friend's Garrick lunch-party. The actress Madge Kendal, Tom Robertson's sister, was a friend of the family, so Marion cannot have had an intrinsic objection to the profession. Sambourne did invite Irving to dinner on at least one occasion, but this is likely to have been a party held at the Garrick. Irving was unable to come, nor was he when he received an invitation to Maud Sambourne's wedding.

The Sambournes' closest actor friend was Arthur Blunt (Arthur Cecil), whom Sambourne had met through the German Reeds. Blunt, who starred in some of the comic roles of Arthur Pinero's plays, was a regular dinner-guest at Stafford Terrace, where he would sing for the assembled party. On one occasion Marion notes that "Mr Blunt sang, Lin snored aloud".[29] Blunt was a notable eccentric, "a combination of absent-mindedness and irritability".[30] Anstey Guthrie, who often met him at 18 Stafford Terrace, recalled that "in private life no actor could have had less of the theatre in his appearance than Arthur Cecil, whose delicately precise speech and bearing rather suggested a pleasant type of college don".[31] To Harry Furniss, Blunt was a "quaint fellow" with "an insatiable appetite".[32] When

he died, aged only fifty-two, in 1896, both Sambournes were much distressed, and, after he began cycling, Linley occasionally took in Blunt's grave at Mortlake cemetery as a point of pilgrimage.

The Sambournes had a penchant for the society dramas and comedies of the period, including such once popular pieces as W.S. Gilbert's *Engaged* and A.W. Pinero's *Sweet Lavender*. Sambourne saw another play of the same kind, Victorien Sardou's *Dora*, usually performed in London in a version by Clement Scott entitled *Diplomacy*, several times. The Sambournes were in the audience for a number of plays by Henry Arthur Jones, a dramatist known for his social commentary. Among them were his first major success, *The Silver King*, in 1883 and *Mrs Dane's Defence* in 1901. Sambourne thought *Mrs Dane* "an unsatisfactory play, admirably played" (D. 12.3.01). *The Sign of the Cross*, the much-praised religious drama by the actor manager Wilson Barrett, which opened at the Princess's Theatre in 1896, seemed to him well staged but otherwise "long" and "dreary" (D. 11.1.96). More to his taste was George Alexander's successful production of *The Prisoner of Zenda* at the St James's Theatre. Sambourne saw it at least three times, on the second occasion following it up by reading Anthony Hope's original novel.

Sambourne did not leave his passion for accuracy behind when he went to the theatre. In November 1899 he saw Dion ('Dot') Boucicault the younger in *A Royal Family* at the Royal Court and commented on the "good costumes & delightful play" (D. 31.10.99). He noted, however, that the actor playing the part of the Turkish ambassador was wearing the wrong sword and offered to lend his own. Boucicault gratefully accepted.

Many of the plays which the Sambournes saw are long forgotten, among them those of their friend, the *Punch* editor Frank Burnand. A few names still in the current repertory stand out. They saw *Charley's Aunt* by Brandon Thomas at the Globe in 1893, and A.W. Pinero's *Dandy Dick* at least twice, in 1887 and again in 1900. Sambourne thought well of Pinero's famous play about a woman with a past, *The Second Mrs Tanqueray*: "Wonderful play. Mrs Patrick Campbell very good" (D. 2.6.93). *Trelawny of the 'Wells'*, Pinero's affectionate comedy about the advent of T.W. Robertson in the 1860s, was one of the last plays which Sambourne saw, in 1910.

He was present at performances of Oscar Wilde's plays and praised the acting of George Alexander, the actor manager associated with the productions at the St James's Theatre. The Sambournes met Wilde socially. On one occasion Wilde

accidentally spilt his claret down Marion's dress, and, on another, he "devoted his attention to Maud & was most kind".[33] Wilde and Pinero both contributed to the genre of the 'fallen woman' play, of which Alexandre Dumas's *La Dame aux Camélias* was a forerunner. Sambourne saw Sarah Bernhardt in the leading role in July 1892. He thought her "very good" but was equally captivated by a "pretty woman in stalls" (D. 18.7.92).

Broadly speaking, Sambourne did not attend the most avant-garde performances of his day. He was there for the early productions of J.M. Barrie's plays – like the 'fallen woman' drama *The Wedding Guest*, which he found "unpleasant" (D. 27.9.00) – but not for the more radical works of George Bernard Shaw. This makes it all the more surprising that he was present at one of the most shocking theatrical events of the later nineteenth century, the Independent Theatre Society's private production of Henrik Ibsen's play *Ghosts*, in March 1891. Banned from public theatres for its daring, if indirect, reference to venereal disease, *Ghosts* aroused passionate reactions both for and against. Not in Sambourne, unfortunately. Not only did he give no comment on the performance, but he was unable to remember the name of the dramatist, and describes it in his diary as "'*Ghosts*' by ..." (D. 19.3.91). Nor does he mention any other play by Ibsen. The famous and highly contentious first night, given privately by the Independent Theatre company at the Royalty Theatre on 13 March, was a 'one off'. Sambourne records seeing the play on 19 March, after supper at the New Lyric Club with a fellow Garrick member, Dr G.W. Orwin. The small theatre at the New Lyric Club provided a setting for a number of private productions of plays banned by the Lord Chamberlain. Bernard Shaw's drama about prostitution, *Mrs Warren's Profession*, was seen there nearly a year later, in January 1902. Before the *Ghosts* performance Sambourne was introduced to a member of the D'Oyly Carte company, the singer and actress Rosina Brandram, and he took the opportunity to read through a sketch by Rutland Barrington and Jessie Bond. Like Brandram, Barrington and Bond performed in Gilbert and Sullivan operas, although, later that year, they separated from the D'Oyly Carte for a time and set up their own touring company.

Sambourne's interest in the theatre stretched to lectures given by actors and dramatists, including Herbert Beerbohm Tree, who spoke at the Royal Institution on 26 May 1893, "the 1st actor that ever lectured there" (D. 26.5.93). Earlier in the same year Sambourne had seen Tree in Stuart Ogilvie's adaptation of Charles

Kingsley's novel about a priestess in ancient Rome, *Hypatia*. A fragment of Tree's performance was captured on film. "Dull", was Sambourne's verdict on the stage play, but, as it was suitable for the whole family, he took his son to see it and the two talked with the actor, still "in costume", afterwards (D. 26.1.93).

On a lighter note, Sambourne would often end an evening at the Empire Music Hall in Leicester Square, then at the height of its success under the management of John Hollingshead. From time to time, he met one of his models, Kate Manning, there. She was probably performing in some way, but other women used the area to importune passing men. The Empire's famous balcony promenade was seen by some reformers as an affront to the city's morals and the theatre was closed down for a time in 1894. Sambourne drew a cartoon on the subject, *Mrs Prowlina Pry. –'I hope I don't intrude!'* (P. 27.10.94; fig. 48), which shows a hideous, black-clad woman with lorgnette and binoculars making her way into the theatre, where a huge commissionaire puts out his hand to try to block her. A poster to her left declares: *Empire Theatre: 3000 Employes [sic] will be thrown out of work if this theatre is closed by the L.C.C.* and the accompanying poem declares

> They are denser
> Than *Punch* imagines, our new Bumble-Band,
> If Mistress Pry's decision they abide by;
> But *should* they fail us, *Punch* throughout the land
> Will wake the people prudes and prigs are tried by!

On quiet evenings at home, when he was neither dining out nor at the theatre, Sambourne would read after dinner, or listen to Marion or his mother reading aloud. Books were regularly supplied from Mudie's Circulating Library. His range was wide, largely made up of non-fiction, often biographies, science or travel writing. Napoleon remained a popular subject. There are some references to the major novelists of the period, like George Eliot and Thomas Hardy. Dickens's *Our Mutual Friend* was once selected for Marion's reading and *A Tale of Two Cities* for his mother's. A discussion of the work of Rudyard Kipling, then famous as the author of *Plain Tales from the Hills*, led to several months of Sambourne reading stories from *Black and White*. He met Kipling in person at the Royal Academy dinner in 1891 and drew a 'Fancy Portrait' of him three years later (P. 16.6.94). As a contributor to the *Strand Magazine*, Sambourne would have received complimentary copies of

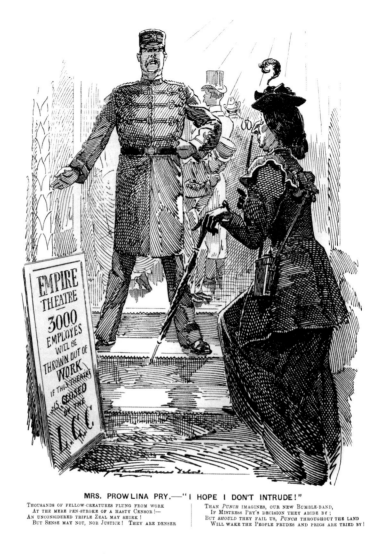

MRS. PROWLINA PRY.——"I HOPE I DON'T INTRUDE!"

THOUSANDS OF FELLOW-CREATURES FLUNG FROM WORK
AT THE MERE PEN-STROKE OF A HASTY CENSOR!—
AN UNCONSIDERED TRIFLE ZEAL MAY SHIRK!
BUT SENSE MAY NOT, NOR JUSTICE! THEY ARE DENSER

THAN *PUNCH* IMAGINES, OUR NEW BUMBLE-BAND,
IF MISTRESS PRY'S DECISION THEY ABIDE BY;
BUT *SHOULD* THEY FAIL US, *PUNCH* THROUGHOUT THE LAND
WILL WAKE THE PEOPLE PRUDES AND PRIGS ARE TRIED BY!

Fig. 48 *Mrs. Prowlina Pry. —"I hope I don't intrude!"*, Punch, 27 October 1894

the publication, and he reports reading popular short stories by Rider Haggard and Arthur Conan Doyle, both of whom he knew personally. Marion and Linley Sambourne discovered the novels of Emile Zola and Linley read *Germinal* and *Nana* in the 1880s. Zola was considered indecent in some quarters, and Marion was not enthusiastic. Reading would often send Sambourne to sleep in his chair, and with these evening naps sometimes came dreams or nightmares. He not infrequently records waking and finding himself alone there after midnight. Marion would bang on the floor and he would totter upstairs to bed.

Exercise

Sambourne often worked on Sundays but it was also a day for strenuous exercise, usually a riding expedition west of London over Wimbledon and Putney Commons or through Richmond Park. Sometimes with a companion, like Anstey Guthrie, he would refresh himself at an inn, a favourite being the Greyhound at Hampton Court, or at the homes of friends. He rarely went north but, in 1889, there were several expeditions to see balloon ascents from Muswell Hill. This was intended to provide the background for a cartoon, *The Modern Pursuit of Pleasure*, which shows a rough and over-excited mob watching a balloonist ascending in front of Alexandra Palace (P. 22.6.89). After witnessing one such ascent, Sambourne returned through Highgate and down what is now Highgate West Hill. Finding himself uncertain of his route through Kentish Town, he was relieved when he managed to make his way home to Kensington.

There was no cartoon involved when Sambourne rode back to North London in October 1890 in order to study the scene of a crime. The bodies of Phoebe Hogg and her baby daughter had been found separately in the Swiss Cottage and Maida Vale areas, and the case attracted considerable interest. On the morning after the murder Sambourne made his way to view the site, and he even came up from Ramsgate to attend the last day of the trial, when the mistress of the victim's husband, Mary Eleanor Wheeler, was condemned to death. Feeling against Wheeler ran high, particularly because of the death of the baby, and her notoriety was only increased when it was realised that her father, too, had been hanged as a murderer. In his diary Sambourne described her apparent lack of feeling when the judgement was given against her. Sambourne was not in the habit of attending trials but this case caught his imagination – perhaps something to do with the fact that Wheeler was an attractive woman.

From time to time, there were more extended riding expeditions. One, in July 1882, was recalled by Frank Burnand:

> Any number of delightful rides have we enjoyed together, one of the many and one of the best and longest having been a couple of days in Epping Forest, when Linley Sambourne, Tenniel and myself put up our horses at the Forest Inn, Chingford, dined happily, slept well, rose early, and rode all day, arriving in London about eight in the evening. A most delightful 'outing'.[34]

Fig. 49 Sambourne riding with John Tenniel, *c.* 1890

Sambourne's diary explains that they lunched at the Wake Hotel in the forest and then set out at 2.30 for the long ride home, passing through Enfield and Southgate. "Tenniel done up. Very tired", is his comment on their return (D. 1.8.82).

In 1890 an unofficial group of riders formed themselves into the Two Pins Club, commemorating two famous horsemen associated with the roads north of London, John Gilpin and Dick Turpin. The original members were two lawyers, Frank Lockwood and Charles Russell, the actor John Hare, and five of the *Punch* staff, Burnand, Tenniel, Sambourne, Furniss and Rudolph Lehmann.

Lockwood, who had started out on the stage, was, like Sambourne, a member of the Garrick Club. A talented draughtsman, he was frequently seen sketching while seated in court and was an occasional contributor to *Punch*. In a distinguished career, he was elected MP for York, appointed Solicitor General and knighted. Lockwood is best known today as one of the lawyers involved in the prosecution of Oscar Wilde in 1895. He died comparatively young, in 1897.

Charles Russell, born in Ireland and later a Kensington resident, was Attorney General under Gladstone and one of the great lawyers of the age, known as a ferocious opponent. Ennobled as Lord Russell of Killowen in 1894, Russell, like Lockwood, had connections with the arts. He was the lawyer for the defence in the famous case of Belt versus Lawes, when Belt sued the journalist Charles Lawes for saying that the artist did not carve his own sculptures. This was one case which Russell lost, but he achieved a considerable reduction of the damages on appeal.

The standing of Lockwood and Russell meant that the Two Pins Club visited some leading figures from the establishment, including Lord Rosebery. Sambourne's contribution was more limited; he was supposed to "provide at his own expense the notepaper and envelopes required for the business of the Club, and shall invent and draw a design, which design, also at his own expense, he shall cause to be stamped or otherwise engraved on the said notepaper and envelopes".[35] Needless to say, the allotted task was never carried out.

Several of the group were in the habit of riding down Rotten Row during the week, and their Sunday itinerary would be settled then. These Sundays were pleasant occasions, with receptions in members' country houses. As the membership grew and began to include non-riders, however, the original purpose was lost, and the club survived for only three years. According to Furniss, it came to an end with the elevation of Charles Russell to Lord Chief Justice in 1894. It was during one of these Sunday rides, on 29 May 1892, that Lockwood is said to have played a trick on Sambourne, who had been boasting about his "boyish pranks" in the Weybridge area. Sambourne may have been joking, rather than fantasizing, when he recalled smoking his first cigarette there and chatted about Sir Henry Tomkins and the "Rector's pretty daughter". Lockwood, "observing lettering on the side of a house, 'General Stores', casually asked our excited reminiscent if he 'knew a General Stores about these parts?'" The reply was: "'General Stores! Of course I do, but he was only a Captain when I lived here!'"[36] Sambourne recorded the ride and the origin of the story in his diary, with a reference to Lockwood's "chaff" (D. 29.5.92). Down the years, he apparently enjoyed this joke against himself as much as any one.

Riding was one form of exercise; walking, often in and out of central London, was another. Sambourne also took up some of the newer sports which became popular during the late nineteenth century. From 1884 he records playing lawn

tennis with well-to-do Kensington neighbours like the publisher Andrew Tuer, of Field & Tuer, later the Leadenhall Press. Tuer, who was a noted art collector, commissioned Sambourne to make a drawing of his tennis court with the Kensington scene spread out behind it. A journalist calling at 18 Stafford Terrace noticed it: "A magnificent sketch of Kensington Church and a large tennis lawn in front, 'done for a friend', especially caught my attention and delighted me with its wonderfully beautiful and exactly accurate perspective".[37] Before his bankruptcy, Marion's brother Spencer had his own tennis court, as did the silk mercer Arthur Lewis, husband of the former actress Kate Terry; the painter William Orchardson's court at Westgate-on-Sea has already been mentioned. Later, Sambourne would play with Sir Alfred Hickman in Kensington Palace Gardens. Surprisingly, he frequently records games of lawn tennis in December, January and February.

Ice skating, more appropriate to the winter season, was popular throughout the Victorian period, and Sambourne enjoyed the sport in Roy's company at rinks in Hyde Park, Barn Elms and Ramsgate. Games of billiards are frequently noted in his diary, particularly those with his brother-in-law, Edgar Herapath. He played golf when in Scotland. These sports all provided him with useful ideas for *Punch* cartoons. Sambourne was highly competitive, keeping a record of the score, even when it was no more than a game of backgammon or billiards played with his son.

Every late summer, like a good clubman, Sambourne enjoyed the all-male shooting parties which were such a feature of upper-class life. They enabled him to extend his social network. To begin with his host was usually his brother-in-law, Spencer Herapath. In 1882 he was fishing and shooting with Herapath at Linton, Sutherland, as a second stage in a Scottish expedition with a double purpose. Sambourne's first port of call, after arriving from London by sea, was Kepplestone, the Aberdeen home of Alexander Macdonald, a wealthy trader in granite. Sambourne had known Macdonald since 1877 and had been visiting him in Scotland since 1880. When Macdonald was in London Sambourne dined with him and Macdonald, in his turn, was a dinner guest at 18 Stafford Terrace.

Unable to walk for the last twenty years of his life, Macdonald nevertheless kept his hand firmly on the business and, in his spare time, actively collected the work of contemporary painters. Sambourne's *Punch* colleague, Henry Lucy, remembered Macdonald being pushed round the Royal Academy exhibition in a bath chair and he regularly attended the annual Academy dinner. In 1881

Macdonald happened to see Gladstone looking at John Millais's portrait of his great political rival, Disraeli (National Portrait Gallery). Macdonald described the scene to Sambourne and commissioned him to make a drawing (fig. 50). Disraeli had died soon after posing for the painting, which was respectfully placed in a free-standing position in the Academy's Gallery Three, the frame draped with black crape. It can be seen in the background of W.P. Frith's *Private View at the Royal Academy* (1881; Pope Family Trust). Sambourne's drawing shows Gladstone looking sternly at his enemy's portrait, an echo perhaps of a popular nineteenth-century painting, Paul Delaroche's *Cromwell gazing at the Body of Charles I* (1831; Nimes, Musée des Beaux Arts).

Among Macdonald's closest friends was the painter George Reid, a native of Aberdeen who returned each summer from the south. In 1880, Reid presented Macdonald with a portrait of another summer visitor, John Millais, bearing the legend, *From R and JEM to AM 21ˢᵗ Oct. 1880*. This was the beginning of Macdonald's collection of artists' portraits. The majority of the ninety-one portraits (of eighty-nine artists) were carried out within the space of four years. Reid painted Sambourne's colleague Charles Keene, a frequent guest at Kepplestone, in 1881 and the following year Millais contributed a portrait of another member of the *Punch* staff, George Du Maurier. Most of the portraits are ovals, 12 x 10 inches in size.

Macdonald dined with the Sambournes on 2 May 1882 and must have persuaded his host to sit to Reid when he came to Aberdeen. There were two sittings, on 9 and 11 September, and the portrait presented to Macdonald bears the message, *To A.M. from R. and Linley Sambourne Sept 11ᵗʰ 1882* (fig. 51). The painting stresses the directness of Sambourne's character as he looks quizzically out at the viewer. Henry Lucy recalls that Macdonald paid £15–25 pounds for the portraits, telling the painters and their sitters that he was forming a collection to rival the group of artists' self-portraits in the Uffizi Gallery, Florence. They are in the Aberdeen Art Gallery today, together with Sambourne's drawing of Gladstone. Hearing of his friend's death two years later, in December 1884, Sambourne wrote in his diary: "Poor Macdonald died aged 47" (D. 27.12.84).

From 1883 onwards Sambourne's Scottish shooting expeditions were hosted by the wealthy brewer Vernon James Watney, who rented Tressady Lodge in Sutherland. Sambourne's accounts of his morning rides in London often note that he met Watney, a fellow member of the Garrick Club. By the 1890s Watney owned

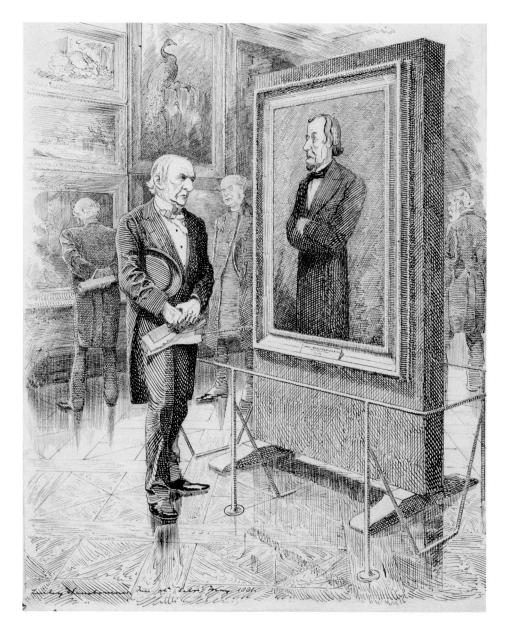

Fig. 50 Gladstone looking at the portrait of Disraeli, 1881
Aberdeen Art Gallery and Museums Collections

Fig. 51 Sir George Reid, *Linley Sambourne*, 1882, Aberdeen Art Gallery and Museums Collections

a house in Hampshire and another in Berkeley Square. Sixteen years younger than Sambourne, he was still a bachelor when the cartoonist first stayed at Tressady.

The routine was invariably the same. Sambourne would arrive by overnight train in the last days of August, often travelling with the great and the good heading for Highland lodges. Watney met his guests at Helmsdale station and took them on to Tressady, a large Victorian stone house about one and a half miles outside the village of Rogart on the River Fleet. Built on high ground with thick woods between the house and the road and the sea, Tressady was leased from the Duke of Sutherland. Watney built onto it and the house was eventually bought by a later generation of the family. Their stag-head trophies still hang inside the door, one

shot by Watney's son Oliver. Behind the house the garden drops away steeply and, on the side away from the sea, there is an Italian-style garden with tall fir trees.

The days at Tressady were spent shooting. A friend who knew Sambourne from later parties, Katherine Galbraith, recalled that he was always full of energy, ready to go out onto the moors as soon as he arrived. Grouse was the main attraction, but there were occasional forays after deer, rabbits, duck and snipe. The sportsmen would walk out with ghillies, shooting the birds 'put up' for them by the beaters. Sambourne comments on his success or failure with the gun, recording the number of birds and other animals killed: "Shot indifferently", he notes in his diary on 1 September 1888. In the evenings, and on the quiet days, there were games and expeditions to nearby attractions like Dunrobin Castle, seat of the Duke of Sutherland.

Sambourne would have to devote some of his time to preparing his *Punch* assignment, which would occasionally feature his surroundings and occupations. He would photograph the scenery, the dead game and his fellow guests and then, relaxing after the rigours of the day, he would enjoy a cheerful dinner, commenting in his diary on the quality of the food and the wine. Until the early 1890s these were all male parties, and, when his wife wrote implying that he was drinking too much at the merry dinners, Sambourne replied telling her that there were three clergymen among the guests at Tressady and that, in that year at least, meals were very sober occasions.

The Abbey/Parsons group

One set of Sambourne's friends were professional men, public-school and university educated, and often honoured with knighthoods or peerages. In the early 1880s he made the acquaintance of an entirely different circle, gathered around the illustrator Edwin Austin Abbey. Born in Philadelphia in 1852, Abbey was eight years younger than Sambourne. Known to be exceptionally convivial, Abbey had first crossed the Atlantic in 1878, to work on drawings for an edition of the work of the seventeenth-century poet Robert Herrick. By the time that Sambourne met him in 1883, the American artist had decided to settle in England. The introduction may have come through one of Abbey's Kensington friends. These included the Scottish marine painter Colin Hunter, who lived at 14 Melbury Road, and Abbey's fellow-countryman George Boughton, one of the regulars on Sambourne's annual jaunts

to Paris. The names of these three men frequently appear in Sambourne's diaries through the mid and later 1880s, together with that of Abbey's close friend, the illustrator and landscapist Alfred Parsons. In his biography of Abbey, E.V. Lucas records that Sambourne first dined with him in the winter of 1883, and there were many such occasions in the following years. On 23 January 1886, for example, Sambourne notes a very late return home after an evening with Abbey, Parsons and the American painter John Singer Sargent at the Arts Club in Hanover Square. On the following day Sargent and Abbey came to dinner. "Good evening", Sambourne commented.

The Abbey/Parsons group did much to widen Sambourne's network of artists, actors and writers. On 3 April 1884 Parsons invited him to a dinner for the American actor Lawrence Barrett, where Sambourne's fellow guests included Henry James, John Singer Sargent, George Du Maurier, W.Q. Orchardson and W.S. Gilbert. Then, on 7 June 1886, Sambourne met the writers Edmund Gosse and H. Rider Haggard, with James Whistler, at a dinner given by Abbey at the Continental restaurant in Waterloo Place off the Strand. At an Abbey/Parsons dinner on 18 February 1887 Sambourne made the acquaintance of the American author of short stories, Bret Harte, who was to become a friend of the family and particularly close to Marion. Another guest was the scholar and collector of fairy stories Andrew Lang, who later commissioned a number of illustrations from Sambourne. These were evidently cheerful occasions. Late hours are generally recorded when he was with the Abbey circle and Sambourne returned home from this party at four in the morning.

Abbey and Parsons now joined the annual visits to the Paris Salon, and Sambourne, Fildes and Boughton travelled there with them in 1884. This was another occasion for late-night enjoyment. The party dined, lunched and supped at a variety of restaurants, the Palais Royal, the Lion d'Or, Le Doyen, the Café Américain, the Café de l'Opéra, the Café Ambassadeurs (where they sat near the Prince of Wales) and the Café Foyer. They were sometimes joined by friends, including Sargent and Maurice Bonvoisin, the caricaturist who worked under the name 'Mars', and who became friendly with Sambourne – Bonvoisin was in some senses his French opposite number. In the 1890s Bonvoisin would occasionally visit the Sambournes in London, something which Linley, who now found him a terrible bore, anticipated with the deepest gloom.

Abbey was close to the whole Sambourne family. In January 1884 he took eight children, including Maud and Roy, to the pantomime. It was perhaps after this occasion that Roy startled everyone by declaring that "a pantomime was better than the circus but Church was better than all".[38]

In 1885 the American illustrator Francis (Frank) Millet, another close friend of Abbey, leased Farnham House in the village of Broadway, Worcestershire. From then on Broadway became an extension of Kensington. Other artists followed, Parsons and the illustrator Frederick Barnard among them. Once the site of several country inns, this was now a quiet, historic village on the edge of the Cotswolds. It was in the garden at Farnham House that John Singer Sargent painted his famous scene of Barnard's daughters lighting Chinese lanterns, *Carnation, Lily, Lily, Rose* (Tate Britain), shown at the Royal Academy of Arts in 1887. In early 1886 Abbey and Millet took a seven-year lease on Russell House, in which Sargent joined them. Stanley Olson describes Broadway as "an illustrator's library, with so many useful models of antiquity, with Stratford-upon-Avon so handy for Shakespeare reference".[39]

When the American actress Mary Anderson, who later became a Broadway resident, played Rosalind in *As You Like It* at Stratford-upon-Avon, the whole group travelled over to see her. No doubt encouraged by Abbey, Sambourne had already featured a drawing of Mary Anderson in one of his 'Fancy Portraits', on 29 December 1883, where he defended 'the American Evening Star' from those reviewers who had criticized her performance in the double role of Queen Hermione and her daughter Perdita in *The Winter's Tale* (fig. 52). For Sambourne, Mary Anderson, with her costumes designed by Abbey, was "the lovely statue" who comes to life in the last act of the play. This was a performance he saw several times over the years. He was at the Lyceum to see her twice in 1887 and, on 7 December, he arrived just in time for the fourth act, in which she appeared as Perdita.

Sambourne joined a group of artists, including Abbey and Sargent, for a river party to Henley in early July 1886, and his first visit to Russell House came in December of the following year. Broadway may have been an artists' colony, but Sambourne had come to hunt as well as to draw. Having felt unwell overnight, he took a dose of "Yankee cholera mixture" and joined the hunting party, though keeping at a safe distance from the action (D. 17.12.87). In the afternoon a model, Miss Brown, posed, presumably for his camera. The other two days of Sambourne's

PUNCH'S FANCY PORTRAITS.—No. 168.

Fig. 52 'Fancy Portrait' no. 168: *The American Evening Star*, Mary Anderson, *Punch*, 29 December 1883

THE AMERICAN EVENING STAR.

MISS ANDERSON, BY JOVE! JAUN-
-DICED CRITICS MAY FROWN *AT* YOU,
BUT YOU'RE THE LOVELY STATUE,
MISS ANDERSON, BY JOVE!

visit to Broadway were taken up with dinners and drives, and with a visit to Stanway House, home of Lord Elcho. Lady Elcho, one of the group of high-born lovers of the arts known as 'the Souls', was often at Broadway.

Sambourne's association with the Abbey/Parsons circle continued to flourish. They formed a dining club called the Nucleus, and another called the Kinsmen, for which Abbey and Sambourne designed a menu card in 1887. Two very different

figures – one tall and thin, the other short and fat – stand on either side, making it impossible to decide which artist was responsible for which. Sambourne was popular with this Anglo-American coterie. John Singer Sargent's biographer, Evan Charteris, records that Sargent, who had been taking riding lessons, would join Sambourne on his Sunday rides:

> … a cavalcade including Mr Jacomb Hood [the painter], Linley Sambourne, Shakespeare, the singer, and Sir George Henschel [the singer and conductor] would issue from the streets of London … and clatter through Putney for a gallop in Richmond Park.[40]

For Sambourne himself, the change from the more familiar round of *Punch* colleagues, Royal Academicians and Herapath relatives was stimulating. The Abbey/Parsons group (most of whom had formally trained in art schools) organized a sketching club, but it does not appear that Sambourne attended it. This was, however, the period when he created some of his best designs, including the illustrations for Lord Brabourne, Hans Christian Andersen and Charles Kingsley and a series of fine drawings for the *Punch* 'Almanack'. Sambourne was an illustrator of a very different kind from Abbey and Parsons. They created atmospheric pictures, with light and shade subtly employed to give an effect of realism, Abbey occasionally supplying the figures to Parsons's landscapes. They attempted to evoke a bygone age by exact replication of period furniture, costume and accessories. In comparison, Sambourne was a linear artist who presented an image which immediately declared itself as a construct, not an attempt at realism. It is likely, however, that Abbey put work in Sambourne's way (as he did for Parsons), and Sambourne's connection with *Harper's New Monthly Magazine* may well have come through such an introduction.

Abbey shared a London studio with Parsons, at 54 Bedford Gardens, Campden Hill. Sambourne became a regular visitor. He was able to photograph models there, a task less easy to do at home, especially after he began photographing from the nude in 1887. He notes that his first nude print, taken on 24 February of Miss Wilkinson, was made for Abbey.

Photographs from models may have been intended to aid Abbey with his current project, a series of illustrations to Shakespeare's comedies commissioned by *Harper's*. As an illustrator, however, Abbey worked from models in historical

Fig. 53 Kate Manning posing at 54 Bedford Gardens, 1888

costume and it was only in his later years that he began to make nude studies of his own. Though by this point the friendship between the two men had cooled, it may have been on Sambourne's recommendation that Abbey first made use of such prints.

Martin Postle has identified the other models who came to Bedford Gardens as Kate Manning (fig. 53), Louisa Price and Harriet (Hetty) and Lily Pettigrew. Kate Manning was sixteen and the Pettigrews, well known and successful models, were sixteen and eighteen respectively when they began to work for Sambourne. Postle notes that, although the photographs "appear to be intentionally erotic" (on one occasion the girls were posed naked as though they were wrestling with each other), the prints "were used by Sambourne in relation to his professional work".[4] Postle also reports that Sambourne usually contacted his models at the last moment in order to make the arrangements for these photographic sessions. This was presumably a result of the late arrival of the cartoon subject. There are

lists of addresses at the front of Sambourne's diaries, a means of communicating with the models promptly when they were needed. Though many of the nude photographs related to Sambourne's cartoons and commissioned drawings, those of the Pettigrew sisters did not. It seems probable that Sambourne took pleasure in his relationship with these women of a lower class and even became addicted to taking erotic photographs of nude girls. He would have argued, however, that the most respected of academic painters, including Frederic Leighton, began their work with drawings from nude models, though their paintings would show the figures clothed.

The convenient arrangement with Abbey came to an end in 1891. Life for the American artist had begun to change in the late 1880s. Having previously worked as an illustrator and water-colourist, he now started to paint in oils, embarking on the first of his decorative mural schemes at the Amsterdam Hotel in New York. It was a switch which several illustrators made, Fred Walker among them, but there is no indication that Sambourne himself ever considered becoming a painter.

In April 1890 Abbey married Mary Mead and, in 1891, he moved away from the artists' community in Broadway to Fairford in Gloucestershire. Abbey's gregariousness probably conflicted with a need for "uninterrupted peace and isolation while working".[42] His major paintings, like *Richard, Duke of Gloucester, and the Lady Anne* (Yale University Art Gallery) and the *Holy Grail* murals for the Boston Public Library, were all carried out after his marriage. For his friends, however, Abbey's move was a serious loss. In September 1890, soon after Abbey's marriage, Sambourne, who had been photographing one of the Pettigrews (clothed) in the Bedford Gardens studio, noted that "Abbey hardly spoke, in fact rude" (D. 21.9.90). Possibly the new Mrs Abbey had discovered the use that Sambourne was making of the studio. Stanley Olson succinctly expresses the change in Abbey's personality: Mary Mead supplied Abbey "with ambition, helped to cool his friends' affection, and gave him no children".[43] Abbey, Parsons and Sambourne remained friends, although they saw much less of one other. Closing a letter to Parsons, written in December 1891, with a suggestion that they meet before the first night of Irving's *Henry VIII*, Sambourne laments: "All our pleasant evenings seem to have slipped into the past & are a memory only."[44]

Despite Sambourne's inclination for "pleasant evenings" and leisure, he was always caught in a struggle between his natural instinct and the need to earn money, flouting the stereotype of the unworldly artist in his attention to financial matters. There are references in his diaries to dividend payments, to negotiations over his salary and to payments for drawings. Dining with W.H. Bradbury on 21 April 1884, for example, he arranged a settlement of £100 a month from *Punch*. Sambourne had made some investments of his own to complement his wife's shares in South American railways, but they had to be paid for by making drawings. On one occasion he told Marion: "They are standing out for £2300 for the shares but I shan't give that altho' I am most anxious to get the shares because I shall then hold £650 a year & if I can only put these by it will be quite a little fortune at the end of the time."[45] Things were never easy, however: "My purse [is] short", Sambourne wrote to J.C. Horsley in November 1888, and money worries continued to dog him throughout his working life.[46]

NOTES

1 Shirley Nicholson, *A Victorian Household*, London (Barrie & Jenkins), 1998, pp. 37–38.

2 Ditto, p. 47.

3 Ditto.

4 Ditto, p. 128.

5 Ditto, p. 129.

6 Ditto, p. 98.

7 Ditto, p. 55.

8 Leslie Geddes Brown, 'Linley Sambourne's Candid Camera', *Sunday Telegraph Magazine*, 16 April 1994, p. 35.

9 Nicholson, p. 96.

10 *Shorter Oxford English Dictionary*, 1955.

11 R.G.G. Price, *A History of Punch*, London (Collins), 1957, p. 120.

12 Juliet McMaster, '"That Mighty Art of Black-and-White": Linley Sambourne, *Punch* and the Royal Academy', *British Art Journal*, IX, no. 2, Autumn 2008, p. 72.

13 'How I Do My *Punch* Pictures', *Pall Mall Gazette*, 8 November 1889, p. 1.

14 *Yorkshire Post*, 4 August 1910.

15 *Westminster Gazette*, 3 August 1910.

16 See note 13.

17 British Library, letter of 22 March 1900, MSEngMisc. d. 88, f. 547.

18 Harry Furniss, *The Two Pins Club*, London (John Murray), 1925, p. 1.

19 Ditto, pp. 106–08.

20 'Celebrities at Home: Mr Linley Sambourne at Kensington', *The World*, 24 March 1886, p. 6.

21 F.C. Burnand, *Reminiscences Personal and General*, London (Methuen), 1904, vol. II, p. 289.

22 Ditto, p. 295.

23 Ditto, p. 307.

24 Letter to Marion Sambourne of 20 June 1886, formerly collection of Anne, Countess of Rosse.

25 Richard Hough, *The Ace of Clubs*, London (André Deutsch), 1986, p. 15.

26 Squire Bancroft, *Empty Chairs*, London (John Murray), 1925, pp. 92–03.

27 Nicholson, p. 126.

28 Ditto, p. 103.

29 Ditto, p. 62.

30 Harry Furniss, *The Confessions of a Caricaturist*, London (T. Fisher Unwin), 1901, vol. I, p. 287.

31 F. Anstey, *A Long Retrospect*, Oxford (Oxford University Press), 1936, p. 226.

32 See note 30.

33 Nicholson, p. 142.

34 Burnand, vol. II, p. 43.

35 Furniss, vol. I, p. 278.

36 Ditto, vol. I, p. 276.

37 See note 13, p. 2.

38 Letter of 9 January 1884, to Marion Sambourne, formerly collection of Anne, Countess of Rosse.

39 Stanley Olson, 'Sargent at Broadway', in *Sargent at Broadway: The Impressionist Years*, London (John Murray), 1986, p. 16.

40 Evan Charteris, *John Sargent*, New York (Scribners), 1927, pp. 118–19.

41 Exh. cat., *Public Artist: Private Passions: The World of Edward Linley Sambourne*, Royal Borough of Kensington and Chelsea and *The British Art Journal*, 2001, p. 21.

42 E.V. Lucas, *Edwin Austin Abbey*, New Haven (Yale University Art Gallery), 1973, p. 5.

43 Stanley Olson, *John Singer Sargent: His Portrait*, London (Macmillan), 1986, p. 119.

44 Letter of 27 December 1891, formerly collection of Mrs Pilgrim.

45 Kensington Library, letter to Marion Sambourne, 8 March, no year (probably 1884), ST/1/2/187.

46 Bodleian Library, letter of 16 November 1888, MS Engc2225.

with many a flirt and flutter
In there stepped a stately raven.

Chapter 4

Sambourne at Work:
The Artist at Bay

The nature of Sambourne's occupation made it difficult for him to maintain concentration over a long period. Unlike his lawyer or business friends, he worked from home, and could make his drawings whenever he liked, as long as he fulfilled deadlines. Easily distracted and with an inbuilt impulse to delay starting work, Sambourne often found himself running out of time. "Wish Lin would get more forward with work", his wife wrote in her diary, although at times she feared that he was overworking.[1]

The weekly *Punch* pattern imposed its own discipline, but *Punch* was not Sambourne's only employer and his work as an illustrator for books and magazines had to be carried out between Saturday and Wednesday afternoon. It is often hard to tell from the diaries whether Sambourne was fulfilling commercial or private orders for drawings. Many purchasers wanted specific *Punch* cartoons, for which Sambourne normally charged twenty or twenty-five guineas. Some were ordered by the individuals who appeared in the drawings or by their relatives. Other buyers were attracted by the subjects or by the quality of the drawings themselves. Sambourne was prepared to make copies for fifteen guineas, telling one correspondent that the original had been drawn in a great hurry and that the duplicate would actually be a better piece of work. Copyright was not included, and had to be purchased for an extra ten pounds.

Some irritable letters were sent to Henry C. Burdett, whom Sambourne believed to be a friend of Burnand, and who paid only ten guineas. Telling Burdett that he was not used to bargaining, Sambourne asked the purchaser to keep quiet

Fig. 54 *The Raven*, frontispiece for *Poems and Essays of Edgar Allan Poe*, 1881

about the price, since this was half his regular fee. If the drawing had been sold through an agent, he told him, an extra 25% commission would have been levied. Burdett, clearly nettled, wrote to protest, provoking an apology from Sambourne, who sent off the drawing as requested.

International Fisheries Exhibition Diploma

An outstanding example of these extra commissions was the diploma given to successful exhibitors at the International Fisheries Exhibition held in London in 1883 (fig. 55). This was the first of the giant trade exhibitions which were a feature of London life at this period. Sambourne was approached by Sir Philip Cunliffe Owen, the Director of the South Kensington Museum, but does not give details of the contract between them in his diary. Between May and October the artist was a regular visitor at the exhibition, taking numerous photographs with the help of John Sheridan, the keeper of the aquarium. The family sometimes accompanied him, and, on occasion, he dined at the popular exhibition restaurant.

The original drawing for the diploma, on which Sambourne worked between April 1883 and January 1884, now hangs at 18 Stafford Terrace and is considered to be his masterpiece. This was a commission which he took very seriously, working long hours over many months. When Marion complained that friends would be offended if he cried off a social event because of the Diploma, he told her: "Its [*sic*] so trivial compared with the work."[2]

After winning the commission, Sambourne had explained to his wife that he must draw from a nude model. He needed to justify himself to Marion, who must have known that her husband had a roving eye: "What I said about model for such a subject is an absolute necessity. I'll see what I can do & get her photod but shall have to finish from the life. I have two lively nymphs one salt water the other fresh."[3] Sambourne believed that a model called Kate Beverley would fill the bill, but letters of enquiry to artist friends failed to locate her. On John Millais's advice, he asked the painter and art teacher John Ballantyne for his advice in finding a girl with "a good tall figure with long limbs. Anything Dumpy or fat is the reverse of what I require".[4] A model called Alice Smith appeared in Stafford Terrace announcing that she had come to sit (D. 3.5.83). She was disappointed not to be employed on the spot. Two days later commercial photographs were taken of her, but away from Sambourne's home.

The design of the certificate radiates around an empty space where the name of the winner would be written, with a bust of Queen Victoria at the summit. It interweaves a mass of objects connected with fishing, both at sea and on land. Fish-eating and sea-going birds, a polar bear, seals and other sea creatures are all represented. At the top of the design a group of nymphs recline under banners reading *Aqua Viva* and *Aqua Marina*. The freshwater lake, in the right-hand corner of the drawing, was almost certainly drawn from photographs of Frensham Pond in Sussex, which the Sambournes visited with James Clarke Hook and his family in 1882. A river fisherman, for whom John Millais, in deerstalker hat, was the model, stands by a lake, while a boat, with three men fishing, can be seen across the water. Millais was a passionate fisherman and Sambourne had sketched him when staying with the painter and his family at Birnam, near Perth, in 1880. Behind him is a shaded figure drawn from another of Sambourne's friends, Norman Lockyer.[5]

A formal title is printed below the design, but there are none of the tiny letters and labels which are such a feature of Sambourne's *Punch* work at this period. The effect, however, resembles a giant version of an elaborate 'Almanack' drawing, with stylish nymphs, foliage, birds and other animals. Seeing the completed diploma in January 1884, Millais expressed himself "delighted", but suggested various changes, including some to his own profile. Sambourne carried out the alterations two days later and the diploma was delivered two days after that, at 3.30 pm on 7 January 1884. He was paid £280 early in 1884.

This was decidedly late for an exhibition which closed in October 1883. The press had announced that, as a result of the high numbers involved, the copies of the diploma, engraved in France and printed by Joseph Swain, would not be ready in time. This must have been the official story, and the winners evidently had to wait for their certificates. Seeing the first proof on 16 May, Sambourne himself was "dreadfully disappointed". Next day, however, he was cheered by a better version. There was a plan for a colour printing, which would have been carried out by the German-born artist Hubert von Herkomer, but this seems to have come to nothing. One reporter complained that the lettering for the winner's name in the centre of the design was in a quite different style to Sambourne's work, but the general response was very favourable. Thirty-five people, including John Tenniel, George Frederic Watts, Edwin Abbey, Alfred Parsons, Luke Fildes and Randolph Caldecott, came to 18 Stafford Terrace to see the original drawing, and Sambourne's artist

Fig. 55 *The Diploma for the International Fisheries Exhibition*, 1883–84, Linley Sambourne House

friends wrote to congratulate him on the achievement. Tenniel, who praised the drawing to Sambourne's face, complained elsewhere that the diploma gave him eye-strain, but this was a churlish comment on a richly abundant and flowing design, which combines Sambourne's love of animal drawing with his decorative talent. *The Times* was nearer the mark with its account of "a bit of quaint symbolical art of really high merit, and standing alone in its class in our time".[6]

Invitations, advertisements and covers

There were other unusual and prestigious commissions. An enlightened Lord Mayor, Sir James Whitehead, anxious to break away from the customary "highly-coloured card of poor design", asked Sambourne to draw the invitation card for his inaugural banquet in 1888 (fig. 57).[7] Whitehead, who bought both the pen-and-ink drawing and the copyright from the artist, was so proud of the result that he printed a eulogy: "The invitation card … depends for its effect, not upon colour or decoration, but upon the intrinsic merits of the design, and the artistic subordination of a wealth of detail to the general idea of the whole."[8]

With his usual passion for accuracy Sambourne borrowed the Lord Mayor's robes in order to photograph them. His complex and detailed design shows the first Lord Mayor, Henry FitzAlwyn or Fitzailwin, seated opposite Sir James, with the two men set against the Tower of London in the background. Beside them are objects of their time, weapons for FitzAlwyn and, beside Whitehead, the "inventions of a peaceful age … the penny postage stamp, the railway, the telegraph, the electric light, and an exquisite piece of pottery, as representing art". Scenes from the history of the City of London surround them. The card, "with its dainty draughtsmanship, cleverness of arrangement, and general effect, took the City Fathers' fancy immensely",[9] and Whitehead believed that "this unique and exquisite example of Mr Sambourne's draughtsmanship – [was] probably the best that ever emanated from his fertile brain and facile pen".[10] The commission was not without problems, however. There were arguments over the payment, an issue which Sambourne had to take to the Lord Mayor himself. He rightly considered the fee of £84 inadequate and asked for an interview which proved "unsatisfactory" (D. 19.1.89). The matter must have been sorted out for, in retrospect, Sambourne looked on this as one of his "most congenial commissions",[11] and he was sufficiently pleased with the drawing to exhibit it at the Royal Academy in 1889.

Fig. 56 Advertisement for Philip Morris cigarettes, 1889

Augustus Harris, the actor and dramatist, also commissioned a design for an invitation, for the Baddeley Night party at Drury Lane Theatre in January 1887. Robert Baddeley, an eighteenth-century actor, formerly a cook, provided in his will for cake, wine and punch to be distributed in the Green Room every Twelfth Night. This became an annual ritual, a banquet and a ball taking the place of what had been a simple frolic for actors.

Winchester Clowes, the printer and publisher, commissioned graphic work from Sambourne. They became friends, and the artist was an occasional guest at Clowes's house in Hitchin. Other names are scattered through the diaries, some, like his tennis host, Andrew Tuer, asking for specific subjects, others apparently commissioning Christmas cards or book illustrations. Commissions for advertisements included those for Rose's lime juice, Mazawatte tea, the Lancashire Railway and for Philip Morris cigarettes (fig. 56). When the letter from Philip Morris arrived in the autumn of 1889, Sambourne, working at uncharacteristic speed, "dashed off a

ildhall,

1888.

HEAD, Lord Mayor.

LDERMAN } Sheriffs.

CHAIRMAN.

W. H. & L. COLLINGRIDGE, CITY PRESS, LONDON. E.C.

Fig. 57 Invitation to the Lord Mayor's Banquet, 1888

'thumbnail' upon the back of their letter. Two days afterwards I go out and see the whole of London placarded with my young lady perched upon a cork smoking a cigarette".[12] The advertisement, for cork-tipped cigarettes, is particularly dashing, with a young woman in a rakish Granada hat, her black-stockinged legs extended to a considerable (and decidedly indecorous) length below her skirt. Her Spanish costume reflects both the current vogue for flamenco and the popularity of Bizet's opera *Carmen*, first performed in 1875. Carmen's work in a cigarette factory associated her with the tobacco trade, and the caption, 'A Luxury to the Lips', tells its own story.

Sambourne designed the covers for a number of magazines and journals, including *The Pall Mall Gazette, The Sphere, The Sketch* and *The Naval and Military Gazette.* He provided drawings for *The Pictorial World, The Illustrated London News* and *The Piccadilly Magazine.* For a new magazine, *Black and White*, he drew a full-page 'Medley', playing on the theme of black and white, with two women in the contrasting colours at the centre and a myriad of pairs around them; a white cat and a raven, a medieval knight and a bride in white, a polar bear and a black bear, a negro and a white baby. Lily stems and blackberry branches frame the tightly packed design (fig. 58).

One of Sambourne's more surprising cuts was *Beer Blocks the Way*, drawn for *The British Workman*, a magazine intended for the industrial classes and selling at a penny a copy. A sturdy drayman holds a rope as he lets down a beer barrel into the cellar of a public house. Held up behind him are a group of philanthropists, with William Gladstone prominent among them. Their good works cannot proceed while the lure of beer inhibits them. Sambourne turned to his friend Vernon Watney for help with the drawing and was lent the services of a Watney's employee for a set of photographs taken in the summer of 1886. Ironically, perhaps, one of the magazine's crusades was for the establishment of alcohol-free public houses for working men, and this drawing, which also sold as a print, was a part of that campaign.

There are few details of these commissions in Sambourne's diaries. Some would take him only two or three days, while work on others stretched over weeks. We can gain some idea of what he usually charged from a correspondence with George Faulkner & Sons, who wrote proposing that he should work for them. The artist replied (on two separate occasions) saying that he did not entirely understand what was needed, nor was he sure of the size of the projected drawings. "I can only mention roughly that I should think it would be about 50 guineas."[13]

"BLACK AND WHITE—A MEDLEY."

DESIGNED BY LINLEY SAMBOURNE

Fig. 58 Medley for *Black and White* magazine, 1891

A clear picture of how Sambourne set about a particular project comes from an interview published by *The Illustrated London News* in 1893. A reporter came to discuss the cover for a new magazine, *The Sketch*. Sambourne explained that he had set out with the intention of drawing a figure in the act of sketching, and showed the reporter a range of experimental designs, including one in the style of the currently fashionable French eighteenth-century painter Antoine Watteau, and a second with a *Venus de Milo*, "as she was supposed to be, writing names on shield".[14] The chosen drawing featured a woman seated on a globe with St Paul's Cathedral behind her and a mask of Drama at her feet.

In 1885, seven years after Sambourne had included a snail labelled *Black and White* in his annual Academy cartoon, the Royal Academy opened a Black and White Room, permitting illustrators to exhibit at the Summer Exhibition. The sale of Academy drawings represented a step towards recognition. Nervous about the Academicians' response, Sambourne told John Millais in 1886 that he hesitated to send in the Fisheries diploma lest it should be turned down. Encouraged by Millais's response, he went ahead. The drawing was accepted, and he continued to submit, usually his designs for the 'Almanack', or cartoons and book illustrations of which he was particularly proud. He also exhibited drawings at the Paris Exposition Universelle in 1889; the Fisheries Diploma, a book illustration and some *Punch* work. Walter Crane, Charles Keene and Kate Greenaway were among his fellow British exhibitors. Sambourne was awarded a bronze medal and the certificate still hangs at 18 Stafford Terrace.

Book illustrations

The artist had occasional work as an illustrator of books. He submitted designs for a number of comic works, some published by Bradbury, Agnew & Co., proprietors of *Punch* from 1872. Edward Jenkins's *Ben Changes the Motto* of 1880 was a satire inspired by Benjamin Disraeli's foreign policy and his appearance at the Congress of Berlin. There are scenes in a number of inns, two of them, the Crescent Hotel and the Black Eagle Tavern, representing Turkey and Prussia respectively. Sambourne, who had already made a mark with his caricatures of Disraeli in *Punch*, had no difficulty in drawing the statesman as a chameleon, a harlequin or a waiter, all in outrageous settings. *Society Novelettes* of 1883 was a collaboration with Frank Burnand and others, demanding a grotesque style, with characters shown as heads

perched on birds' feet. For *The Green above the Red* of 1889, by C.L. Graves, Sambourne caricatured Gladstone and his Irish policy, a familiar subject in *Punch*.

Sambourne worked with Arthur à Beckett once more on *The Modern Arabian Nights*, published by Bradbury, Agnew in four paperback parts in 1885. The four stories broadly parody the original *Arabian Nights*. À Beckett chose 'Ali Babar', 'The Fair Circassian', 'Haroun Al Raschid' and 'Aladdin', turning them into satires on bankers, lawyers, politicians and men of business. Each has a coloured frontispiece or a colour plate, and there are numerous black-and-white illustrations, both small and large, together with a host of inventive initial letters. Many of these commissions for comic novels or parodies required Sambourne to make humorous drawings, combining human and animal or bird features. Today, when the satire has lost its point, the humour seems a little contrived and archaic and the drawings lack the elegance and flowing style of his best work.

Fortunately, Sambourne occasionally illustrated works of more lasting quality. He provided the frontispiece for Andrew Lang's edition of the *Poems of Edgar Allan Poe*, published by Kegan Paul in 1881. A bird, the fateful raven, comes through an archway, and stands upon a book with crumpled pages (see fig. 54, p. 138). The illustrator perfectly captures the Gothic quality of the lines quoted from Poe:

> With many a flirt and flutter
> In there stepped a stately raven.

Very unusually, Sambourne annotated his copy of this Poe volume: "The original drawing of the frontispiece was done at my father-in-law's house 'Westwood Lodge', St Peter's, Isle of Thanet, Kent in October 1881". A second note states that the copy was given to him by Kegan Paul, suggesting that illustrators did not always receive complimentary copies of their own work.

In 1880 Alexander Macmillan commissioned Sambourne's finest book, an edition of Charles Kingsley's *The Water Babies*, first published in 1863. With his talent for the grotesque and his skill in drawing animals, the cartoonist was the obvious choice for the project. The commission was for forty drawings, including initials, inset plates and full pages, at a proposed fee of £250–300. "The drawings wd. be done on paper & reproduced. The sole rights &c for reproduction being with you but the original drawings with me," wrote Sambourne.[15]

Sambourne began work eighteen months later, in January 1882. From 1884 he

began to take his own photographs in order to help with the designs. A number were of Roy and Maud, the models for Tom and Ellie, the two children in the novel. He continued to use these throughout the long project, rather than drawing once more from the originals who were, in any case, growing up.

Some designs reveal Sambourne's gift for the grotesque and threatening, responding to the undercurrents of Kingsley's text. In the drawing of the hoodie-crows, the birds whom Kingsley compares to "American citizens of the new school",[16] the crows are at their annual caucus, with one speaker on a sheep's skull boasting about pecking out lambs' eyes or swallowing young grouse. They kill a virtuous female crow but then gorge themselves on a poisonous dead dog. As a result one hundred and twenty-three of them drop dead. Another alarming illustration shows Tom finding the bullying chimneysweep, Mr Grimes, enduring an appropriate punishment, trapped in a chimney with only his head appearing at the top. At the gate of Grimes's prison stands a blunderbuss with human characteristics, leaning on a stick with hands and feet, the muzzle like an elongated face with a single eye.

For the more idealized figures, Sambourne employed photographs of models. He was most at home with those episodes in Kingsley's book describing animals,

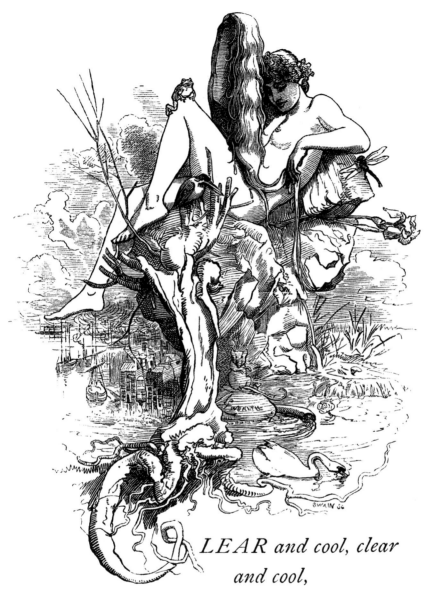

LEAR and cool, clear
and cool,
By laughing shallow, and dreaming pool ;
Cool and clear, cool and clear,
By shining shingle, and foaming wear ;

LEFT Fig. 59 *Tom and the Lobster* from *The Water Babies* by Charles Kingsley, 1885

ABOVE Fig. 60 *Clear and Cool* from *The Water Babies* by Charles Kingsley, 1885

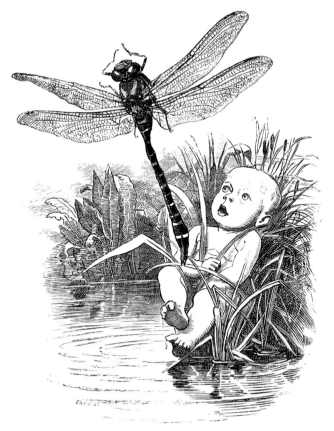

Fig. 61 *Tom and the Dragonfly* from *The Water Babies* by Charles Kingsley, 1885

fish and birds (figs. 59, 61, 62). An aquarium was installed at 18 Stafford Terrace in 1884 in order to help him with his work. A dead fish and an otter were secured, and other animals were studied and sketched at the Zoo or the Natural History Museum (still in Bloomsbury in the early 1880s). A number of *Water Babies* drawings recall the Fisheries Certificate, particularly the design illustrating the poem 'Clear and Cool' (fig. 60). A willow tree, a water spirit, aquatic creatures and boats in a harbour can all be paralleled in the diploma, and the same photographs must have been used. The different parts of the drawing are carefully and exactly drawn, but the scale of the illustration is deliberately distorted – the tree, for example, is half the size of the main figure.

Work on the Kingsley illustrations came in fits and starts. The original commission for forty drawings must have been revised. By March 1883 Sambourne had done over fifty and reckoned to do twenty more. Apologizing for the delay and asking Macmillan for an advance, he explained: "I wish I could work quicker. This I will say that there will not be a careless drawing or one that I need to be ashamed

of."[17] The Fisheries diploma then intervened, and, by August of the following year, Sambourne had completed only seventy illustrations and was contemplating a further fourteen, "mostly small".[18] He was now planning the layout of the whole volume, and deciding where the illustrations should be placed in the text. Throughout the final negotiations he insisted that the plates should be next to the passage they illustrated, not on a separate page. On the whole he had his way. The larger plates are surrounded by a framing line, and Sambourne wanted to vary this according to the size and shape of the plate, but this battle he lost. Each page is framed by a standard line. The book was intended for the traditional Christmas market but the chance was missed in 1884 and *The Water Babies* eventually came out just in time for Christmas 1885. Sambourne showed it to his *Punch* colleagues on 16 December. At 12s 6d it was expensive, but, as a quality volume, it sold well.

The story of the publication of *The Water Babies* provides one example of Sambourne's proverbial dilatoriness. The project took nearly five years from start

Fig. 62 *Tom and the Otter* from *The Water Babies* by Charles Kingsley, 1885

to finish, and Sambourne's letters to Macmillan take the form of excuses for non-completion. He worked on the illustrations sporadically, but the results are impressive. When Sambourne dined with Hubert von Herkomer in Bushey in April 1885, Herkomer's pupil Mary Godsal noted his remarks on the *Water Babies* designs, "which he said he was doing with great care and delight – of the way he did his own work on the blocks and the use of photos".[19]

Before finishing the *Water Babies* series, Sambourne had begun work on another commission, this time from Longmans Green, for *Friends and Foes from Fairy Land* by Edward Knatchbull-Hugessen, 1st Baron Brabourne, a politician and writer of children's books. For this volume Sambourne provided nineteen drawings, some full-page and some smaller, together with a frontispiece and a title vignette (figs. 63, 64). Brabourne's book is made up of three stories, all dealing with supernatural beings, often of a malicious and vengeful kind. 'The Cat Man', the story of a man who is turned into a cat, gave the illustrator welcome opportunities to draw both animals and a young girl, taken from his daughter Maud. 'The Witches of Headcorn'

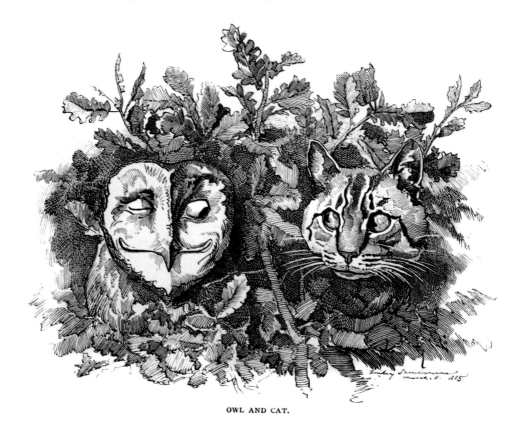

OWL AND CAT.

tells of the malevolence of Kentish witches, one of whom kidnaps the daughter of a farmer, John Cheeseman. Sambourne used his own likeness for Cheeseman, guying his squat form and round face. The original drawing for the initial letter J, showing a hedgehog (metamorphosed from the witch's son) curled within the curve of the letter, is still at 18 Stafford Terrace and is much admired. In the story the hedgehog character is by no means as delightful as he appears in the drawing and meets with a particularly unpleasant end. For the short final story, 'Rigmarole or the Search for a Soul', Sambourne drew a full-page study of a hawk pouncing upon a pigeon, which is actually a metamorphosed elf, another example of animal violence.

Sambourne was able to use details from existing work for the *Friends and Foes* drawings. The frontispiece of the benevolent Fern Fairy, a draped woman with an owl, is similar to some 'Almanack' drawings. In the heading for the final story, the small child/elf Rigmarole, standing in front of a toadstool, is close to Tom in *The Water Babies*. Most pleasing of all these Brabourne illustrations is the title-page vignette, where a boy sits with his head in his hands (fig. 64). This is Roy perched on a log with his foot stretched out in front of him. Longman was more fortunate than Macmillan in terms of delivery. Sambourne read the book and sent in some early drawings in February 1885. The rest of the designs occupied him until mid August, although most had been completed by the end of June, taking him between one and three days each. *Friends and Foes* was published in 1886 with a fine blue-and-gold engraved binding.

LEFT
Fig. 63 *Owl and Cat* from *Friends and Foes from Fairy Land* by Lord Brabourne, 1886

RIGHT
Fig. 64 Title-page illustration from *Friends and Foes from Fairy Land*, Roy Sambourne as Rigmarole

RIGMAROLE IN DESPAIR.

Fig. 65 Roy Sambourne posing for 'Soldiers! Soldiers!'

Macmillan's attempt to commission Sambourne to illustrate five of the stories of Hans Christian Andersen ran into the sand. Work began in October 1885 while the artist was finishing *The Water Babies*. Excited by the project, he pressed ahead through the early months of 1886 and a contract for fifty drawings was signed in November. This time the publisher prudently inserted a penalty clause stating that, if the drawings were not completed in three years, the agreement would be cancelled and Sambourne would have to repay the £100 advance. The work was put on one side and not until May 1887 did Sambourne note that he was drawing "Mouse and Mole" for "Thumbelisa" (D. 24.5.87; see figs. 67, 68). A bad cold in March 1888 resulted in another finished drawing, and others were carried out from time to time, but, as more and more social and sporting events are recorded in Sambourne's diary, momentum was lost. Sambourne occasionally met Macmillan socially, and letters were exchanged with the publisher's nephew, Frederick Macmillan, about his progress. Sambourne promised more drawings in 1892 and 1894, and a few were actually completed. "Everything comes to him who waits – even to a publisher," Macmillan told him, "[I] shall be very glad if you can see your way to stick at them now, so that we have the book ready for next Autumn."[20] This was in 1894. Three years later, Macmillan was still trying to publish in the autumn, "but must have the rest of drawings by middle of June".[21]

There is matter for regret here, as Sambourne's creative talents, often best expressed in independent projects, fell victim to his lifestyle. In 1889 he was

" Soldiers ! Soldiers ! "

Fig. 66 'Soldiers! Soldiers!' from 'The Dauntless Soldier', in *Three Tales by Hans Andersen*, 1910

approached by Harry Quilter, the art critic and editor of the *Universal Review*, asking him to illustrate a poem by George Meredith, 'Jump to Glory Jane', which tells of a deeply religious rustic widow who literally and metaphorically 'leaps' to God, encouraging others to join her and disconcerting the Church as she does so. Meredith, who admired Sambourne's work in *Punch*, approved Quilter's choice, if with the proviso that the drawings should not be "burlesque outlines".[22] In a note on the poem, Quilter recalled that Sambourne had been either on holiday or too busy, and had turned the commission down. It was offered to a younger *Punch* artist, Bernard Partridge, who took fright at the subject, and the young Laurence Housman eventually took up the commission.

Sambourne's last set of illustrations, fifty-six drawings for Frank Burnand's *The Real Adventures of Robinson Crusoe*, published by Bradbury, Agnew in 1893, were wrung from him through years of cajolements and threats from William Bradbury. In February 1892 Bradbury expostulated that "the latest 'talent' of our mutual friend F.C.B. should be buried in the lap of inertia … lying neglected but rolled up in the tympanum of the printing press …. Do my dear Sammy make an effort and finish what has to be done & what you intend to do to it".[23] Burnand's Robinson Crusoe is a small-scale villain who constructs a fraudulent narrative about his time on the island. Sambourne's illustrations, like his other work for Burnand, are essentially caricatures, not inventive creations like his Kingsley or Brabourne drawings.

Figs. 67–68 'A great ugly toad hopped in at the window' and 'She came to the door of a field-mouse's home', two illustrations from 'Thumbelisa', in *Three Tales by Hans Andersen*, 1910

Punch drawings

Bradbury, as Sambourne's employer, was in a good position to insist upon having his drawings. Others, like the Macmillans, found that commissions were delayed or left incomplete. Tasks with a clear-cut deadline, like the illustrations for the annual *Punch* 'Pocketbook' calendar or for the 'Almanack' fared better. They required concentrated effort and Sambourne was capable of this, often working for twelve hours at a stretch. However, as he frequently procrastinated, he would usually find himself finishing in a hurry.

Sambourne's work on the 'Almanack' became more demanding as the years went by. The annual publication was seen as an opportunity for the *Punch* cartoonists to display their skill in a special number. Each October an 'Almanack' dinner took place to initiate the project, at the Bedford Hotel until 1885 and later at Bouverie Street. Each 'Almanack' contained a calendar for the following year. Sambourne was always responsible for the front page, where the calendar appeared. His contributions (unlike those of the other artists) usually played on the theme of time or the changing seasons. For 1885 he contributed a page with fantastic designs for the signs of the zodiac and in 1886 the title page featured the magazine staff as 'Zodiac Knightes of King Punch's Rounde Table'. "Sambourne, a *bon viveur*, pokes gentle fun at himself as Aquarius, seated glumly before a glass of water."[24]

In the later 1880s Sambourne's 'Almanack' work was extended to take up several full or half pages. On occasion, he would break the calendar up into quarters and decorate them accordingly. He drew classical-style friezes with politicians and public events in 1884, knights in armour in 1886, fairy tales in 1888 and classical mythology in 1889. These contributions for the last two years of the decade were exceptional for their ingenuity in combining human figures and animals within roundels or oblongs surrounded by flower or tree shapes. In their own way, these drawings, like other Sambourne contributions to *Punch* in these years, look forward to the swirling shapes of the Art Nouveau style. Many of them feature a lithe young woman, her luxurious pose drawn from one of Sambourne's photographic sessions.

That the 'Almanack' drawings, among Sambourne's finest work, were ever completed owes much to the energy of the *Punch* editor from 1880, Frank Burnand. Sambourne's diary records what he calls "worry letters" from Burnand and, in

OUR GUIDE TO THE GROSVENOR GALLERY.
(First Visit.)

LEFT
Fig. 69 Vignette of F.C. Burnand,
Punch, 22 June 1878

RIGHT
Fig. 70 *Embarras de Richesses, Punch*,
25 August 1894

those which survive, the editor frequently berates the illustrator for his failure to deliver drawings or cartoons on time. The relationship between Sambourne and Burnand was an extraordinary one. They were old friends, neighbours when the Sambournes took lodgings in Ramsgate, their children and their wives constantly together. Even so, Burnand was by far the most difficult of the five editors with whom Sambourne had to deal. At this stage, in the early 1880s, Burnand was a strong and active manager, encouraging when he needed to be, but determined to maintain the success of the magazine. To the dilatory Sambourne Burnand seemed irritating and dictatorial. From Burnand's point of view, Sambourne was a "cus of an obstinate chap",[25] "more like a spoilt child than a man of business If all our artists & contributors upset my plans as you have done the issue of a number would be impossible."[26] When Sambourne had changed the subject of a *Punch* cartoon on his own initiative, Burnand wrote: "Let this be understood in future – if you do *not* receive from me on a Friday a letter by 11 a.m. you will always do the subject previously settled. If no subject has been previously settled you will not proceed with one until you have heard from me."[27]

Sambourne's main contributions to *Punch* were now found in a second cartoon, or 'cartoon junior' as Burnand liked to call it. In 1881 Burnand had invited a

86 PUNCH, OR THE LONDON CHARIVARI. [August 25, 1894.

EMBARRAS DE RICHESSES.

The Old Lady of Threadneedle Street. "Go away! Go away with your nasty Money! I can't do with any more of it!"

journalist of great flair, Henry Lucy, to take over the 'Essence of Parliament' column, formally the work of Shirley Brooks and Tom Taylor. Lucy, who had close ties with politicians, wanted his illustrator to work from life, something which Sambourne felt unable to do. As a result, his place on the column was taken over by the dynamic Harry Furniss. The full-page cartoons which Sambourne now contributed were often on political or public subjects, but they were not so closely related to personalities or events in the House of Commons.

There is little evidence that Sambourne was seriously interested in party politics. On the whole he drew what he was told. Usually, however, he would be left to work out the details of a design on a designated topic. Just occasionally, as with a cartoon, *Embarras de Richesses,* where the Bank of England, 'The Old Lady of Threadneedle Street', rejects bags of money being offered by speculators,

Sambourne notes that he suggested the subject himself (P. 25.8.94; fig. 70). As it happened, this cartoon, a response to the large amount of money in the City at the time, was criticized because it wrongly implied that the Bank paid interest on deposits.

One distinctive feature of Sambourne's cartoons is his use of words, printed in capital letters, to drive home the point by suggesting relevant allusions. These rarely take the form of speech bubbles from the mouths of his animals or human beings. More often, the words are placed in a fanciful position, as the titles of books or as headings on objects scattered around the cartoon. In using this device, Sambourne was following in the footsteps of his *Punch* predecessor Charles Bennett, who had introduced key words into his initial letters. Like much Victorian art, Sambourne's cartoons have to be 'read' and the mass of information disentangled. These are not small 'paintings' in black and white, like the social cartoons of George Du Maurier, but the work of a fertile imagination, spilling out in all directions. Not everybody admired his style. In his book on *The Aesthetic Movement in England*, published in 1882, Walter Hamilton declared that Sambourne was an eccentric: "Linley Sambourne's style is peculiar, and only fitted to delineate the odd fancies of his own brain; quaint and original they are, but not *Society* pictures."[28]

Sambourne was sometimes able to venture into cartoons on more general subjects, often drawing attention to extremes of fashion. His admiration for Albrecht Dürer is well attested but his own technique is essentially different. His elegance, and his fascination with the female form and costume, owe something to the work of a nineteenth-century draughtsman whom he greatly admired, John Leech. On one occasion, Sambourne contrasted a tiny sketch of a Leech cartoon showing girls in crinolines with a comparable design of his own with young women in the tight dresses and bustles of the 1870s (P. 1.1.76).

Sambourne's work as a cartoonist reflects the general interest in the creation of museums and cultural institutions in South Kensington, Albertopolis as it was sometimes called. A cartoon of 6 August 1887 shows Science as a spectacled young woman with an electric light on her head, appealing to John Bull to be allowed to have a museum of her own: "Am I not worthy of as much consideration as Music and Geology?" she asks. Music must refer to the Royal College of Music, founded in 1882. In March of that year Sambourne noted in his diary that he had spent two days working "on Prince & Band" (D. 2.3.82). The occasion was a meeting to discuss

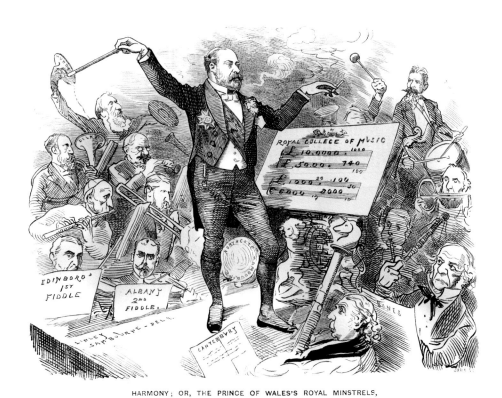

HARMONY; OR, THE PRINCE OF WALES'S ROYAL MINSTRELS,
WHO *WILL*, WE HOPE, PERFORM OUT OF ST. JAMES'S PALACE HALL.

Fig. 71 *Harmony; or, The Prince of Wales's Royal Minstrels, Punch,* 11 March 1882

the foundation of the College, sponsored by the Prince of Wales, later Edward VII, who appears in the cartoon (of 11 March; fig. 71) as an orchestral conductor. The College's supporters, many of them politicians, are represented as musicians under his leadership. Among them are two of his brothers, the Dukes of Edinburgh and Albany, as violinists, Gladstone with a clarinet, the Conservative statesman Sir Stafford Northcote playing the tambourine, the Archbishop of Canterbury, E.W. Benson with the bassoon and Cardinal Manning, the first Roman Catholic Archbishop of Westminster, with a flute.

Given his interest in animals and in anthropomorphism, it is not surprising that, as in his early fashion drawings, Darwin's theory of evolution lurks in the background of many of Sambourne's more fantastical designs. There is, once again, a sense that human beings are regressing into their animal origins. The dramatic variations in scale between different figures in Sambourne's drawings, like his pre-occupation with insects and crustaceans, reflect the Victorian fascination with

microscopes as a means of analysing the details of the natural world. His style may also owe something to the tradition of fairy painting which developed in England from the eighteenth century. The fairy painters employed striking variations of scale to convey the relative sizes of fairies, plants, animals and human beings. For Sambourne such variations often designate the relation of persons of major importance to those of minor relevance, a significant distinction in his political work. William Feaver has accurately judged the effect of these stylistic qualities on Sambourne's work as "cartoon junior" and on his place within the magazine: "The emphatic line and surreal comedy of his early *Punch* cartoons were in dramatic contrast to the more academic touch of Tenniel's editorial 'cuts'."[29]

Work for *Punch* or for other employers had to be fitted round a plethora of activities. Sambourne often came back from the country, or from a short holiday in Folkestone or Brighton, in order to attend the Wednesday dinner. He always hoped to get a subject at the 'Table'. What usually happened, however, was that Tenniel's subject was decided, and Sambourne's left hanging. That Sambourne had grounds for irritation is clear from the number of occasions when he had to wait until late on Thursday to receive his instructions. On the other hand, in the early 1890s, he frequently sent in the cartoon on Saturday morning, drawing a remonstrance from Burnand: "You do not seem after all these years to be aware that you delay all the printers over the entire making up of the number It is not a question of an occasional exception, but it is now regularly every week.'[30]

As the second cartoonist, Sambourne was called upon to represent the leading politicians. Gladstone was already a familiar subject, and the Grand Old Man's well-known features can have given him little trouble. Sambourne pictured Gladstone in numerous poses, as a swan, the summit of Snowdon, a knife-grinder, or as a rural musician, wooing the agricultural vote (represented by a pretty country girl) in a parody of Christopher Marlowe's poem, 'The Passionate Shepherd to his Love' (P. 28.3.91; 8.10.92; 31.1.91 and 19.12.91).

Among the younger politicians, *Punch* frequently held Joseph Chamberlain up to ridicule. The Birmingham-based Chamberlain was known for his involvement in the reform and extension of local government. In his opposition to Irish Home Rule, he left the Liberal party in 1886 and took the Unionists into the Conservative camp. Later in his career Chamberlain abandoned the supporters of free trade and became committed to tariffs that would uphold imperial preference.

Sambourne drew Chamberlain as 'Plumber Joe' in one cartoon, walking along a snowy street past water pipes labelled with the current issues, the Irish question and the House of Lords. "If these 'ere pipes 'ud only bust, there'd be a charnce of a job for me!" is the plumber's reaction (P. 23.2.95). In a nod to his colleague's famous illustration to Lewis Carroll's *Alice through the Looking Glass*, Sambourne once showed Chamberlain as the Red Queen, sitting next to a crowned Alice, who represents 'The Thunderer' or *The Times*, with Sir William Harcourt, who served as the Liberal Chancellor of the Exchequer, playing the White Queen on the other side (P. 18.7.91; fig. 72). In the accompanying prose column, the two politicians, in a parody of Carroll's ninth chapter, argue about Home Rule and Chamberlain's support for local government, vying for the support of the newspaper. Sambourne presents Chamberlain's distinctive profile for the bad-tempered Red Queen. Appearing far younger than he was, Chamberlain was clean-shaven at a time when

THE RED QUEEN AND THE WHITE; OR, ALICE IN THUNDERLAND.

Fig. 72 *The Red Queen and the White; or, Alice in Thunderland, Punch*, 18 July 1891.
Sir William Harcourt on the left, Joseph Chamberlain on the right

politicians were generally bearded. The novelist George Meredith, objecting to Chamberlain as a man swept away by the idea of the moment, characterized him as a man with "a lean, long head and adventurous nose".[31] Sambourne, like many cartoonists, liked to make a feature of politicians' noses, Chamberlain's distinctively pointed, Gladstone's hooked and squared. Harcourt, by contrast, appearing as the anxious White Queen, is characterized by a huge double chin.

The widespread popularity of *Punch* provoked some politicians to invite the staff to their homes and receptions. On the other side of the fence, some cartoonists, Harry Furniss being a prime example, were to be seen at Westminster, studying faces and mannerisms, picking up gossip and, in some cases, forming friendships with the men they were satirizing.

Lord Rosebery

This was never Sambourne's way, and it could be argued that the need to draw likenesses of political figures was increasingly forced upon him by his job, rather than by natural curiosity. This makes his acquaintance with Archibald Primrose, Lord Rosebery, of particular interest. From 1889 to 1890 Rosebery achieved considerable success as the Chairman of the newly established London County Council and then, from 1892 to 1894, as a well-respected Foreign Secretary. His premiership, however, lasted less than two years, from 1894 to 1895, and was a time of discord within the Liberal party. Rosebery's isolation in the House of Lords, rather than the Commons, made it harder for him to exert control over the diverse and warring elements in his party, and his battle with the Chancellor of the Exchequer, William Harcourt, was all the more bitter because Harcourt was party leader in the Commons.

Sambourne's first image of Rosebery was a 'Fancy Portrait', *Our 'Rosebery Plate'*, of 4 June 1881, drawn when Rosebery was serving under Gladstone as Undersecretary for Scottish affairs. The 'Fancy Portrait' illustrates, not Rosebery's political life, but his fame as a racehorse owner. In the week of the Derby, a slim and elegant Rosebery is shown with a statue of a racehorse behind him, and a notebook in his hand. Beside him is a rose tree, a motif continued in his buttonhole, and on the ground is a palette labelled 'ART' next to a primrose, a reference to Rosebery's family name. His wife, the former Hannah Rothschild, acquired the drawing in January 1882, apparently as a gift. Sambourne evidently gained the impression that

she disliked it. Hearing of this, Lady Rosebery assured him that she much admired it, and invited Sambourne to a reception at the Roseberys' Berkeley Square home, to meet her husband in person. She continued to purchase drawings from the artist, and, in the last year of her life, asked him if she could buy "the one in which Gladstone appears as Napoleon at the head of an army and on horseback".[32] This was *A Big Battle Picture!* of 2 November 1889, with Gladstone in military uniform holding a telescope. Sambourne became a 'regular' at Hannah Rosebery's London receptions and, at the time of her death in 1890, an event which devastated her husband, Rosebery wrote to acknowledge Sambourne's letter of sympathy.

The majority of Sambourne's Rosebery cartoons were drawn during his time as Tenniel's deputy, the 'cartoon junior'. A number were published during the 1880s, including one featuring Rosebery and the German Chancellor, Bismarck, in the same drawing (P. 6.6.85). On 5 July 1893 Sambourne was given the London

ROSEBERY TO THE RESCUE!

Unjust Steward. "Foiled! But no mattah! a time will come!!"

Fig. 73 *Rosebery to the Rescue!*, Punch, 15 July 1893

County Council as a subject, and drew an eighteenth-century scene with Rosebery defending a young girl, London, from a highwayman or robber. Rosebery holds a sheet with a list of the city's problems and needs, including slums, fog, sanitation, water, libraries and open spaces (P. 15.7.93; fig. 73). When Rosebery's party was elected to power in March 1894, Sambourne began to plan a cartoon playing on the name Primrose. In the event, he contributed a small print, drawing on a 'Lyrical Ballad' by William Wordsworth, 'Labby or the Parliamentary Peter Bell' (P. 17.3.94). The cartoon shows Henry Labouchere, in Radical mode, with Rosebery framed in a primrose plant behind him. The quotation reads:

> A primrose by a river's brim
> A yellow primrose was to him,
> And it was nothing more.

Labouchere and Rosebery, once friends, were now at daggers drawn. One reason for this was that, two years before, Labouchere had failed to secure appointment as ambassador to the United States. He offered to support Rosebery if the latter would recommend him for the post. Rosebery refused, even when Labouchere's wife begged him to change his mind. It is clear that Queen Victoria, who had blocked Labouchere's entry into the cabinet because of his 'immoral' private life, would not have allowed him to go to Washington. Labouchere never forgave Rosebery and proposed a successful amendment to the first Royal Address of Rosebery's administration so that, unusually, a new address had to be submitted to the House of Commons. This personal battle supplied the background to Sambourne's cartoon.

Sambourne was constantly drawing Rosebery throughout the second half of 1894. The Prime Minister appeared in a variety of roles, all faintly ridiculous. He was Paris with the Apple of Discord, trying to choose a Poet Laureate to succeed Tennyson; Bob Acres, the bucolic squire in Sheridan's *The Rivals*, and, in classical dress, he listened to Gladstone as Homer (P. 8.12.94; 10.11. 94; 17.11.94; fig. 74). It was this last cartoon that drew a warm letter of appreciation. A difficult man, plagued with depression and insomnia, Rosebery had, for once, enjoyed a joke:

> It may amuse you to hear that when dead-baked on Thursday morning, my eye lit on your delightful picture of Gladsonius & his weary listener, and that I at once burst into a Homeric (or should I say Horatian?) laugh that lasted

A POLITICAL CONFERENCE.

"GLADSTONIUS PARVAM REM HORATIANAM COMPOSITIONIS SUÆ AD ROSEBERIUM RECITANS."

Fig. 74 *A Political Conference*, Gladstone (left) and Rosebery, *Punch*, 17 November 1894

some minutes. For which rare and delightful sensation and its recuperative effects accept the hearty thanks of

 Sincerely,

 Rosebery

There were several witnesses present at this convulsion![33]

Sambourne photographed both his groom, Otley, and himself for the figure of Rosebery, but he also had a number of opportunities to meet the Prime Minister. Rosebery spoke at the Royal Academy dinner after his election, and he was guest of honour at a dinner given by Sambourne's riding friend Sir Edward Lawson at Tadworth Court, Banstead, in June. Sambourne, who was staying in the house, noted that Rosebery came and went "with distant bow" (D. 9.6.94). On the following day, Sunday 10 June 1894, the party walked over the racecourse, where

Rosebery's horse, Ladas, had won the Derby a week before, and then lunched at the Durdans, Rosebery's eighteenth-century Surrey house near Epsom. This was Sambourne's second visit; he had lunched there with the Two Pins Club in 1892 and had seen Ladas "as a yearling" (D. 29.5.92). On the first occasion Sambourne, who shared a love of horses with Rosebery, had noted "many Stubbs & Herrings' sporting pictures". An earlier guest at the Durdans, Henry James, had also admired the paintings, but his taste was for Watteau and Gainsborough.

Rosebery, like Sambourne, was fascinated by Napoleon and he had accumulated a large collection of Napoleonic memorabilia. On his 1892 visit Sambourne had been pleased to see a cast of Napoleon's head and now he delighted in the former emperor's shutters, brought back from St Helena. In retirement, Rosebery published a book on Napoleon's last six years. There is no record of Sambourne having read this work, but Marion read aloud to him from Rosebery's life of William Pitt in 1892.

The Prime Minister's career as a racehorse owner, winning the Derby on no less than three occasions, was a subject for Sambourne's pen. An amusing example shows Rosebery as a non-conformist, forswearing the racecourse for fear of losing low-Church support, a step which he never took (P. 16.6.94). On his visit in 1892, Sambourne must have mentioned that he hoped to breed from his own mare. As a result she was sent to the stables at the Durdans to be covered.

The Liberal government fell in June 1895 but Rosebery remained leader of the party until the following year, and Sambourne continued to draw him, often locked in rivalry with Harcourt. Appropriately enough, at Sambourne's own suggestion, one cartoon shows Rosebery as Napoleon on St Helena, brooding on Harcourt (P. 3.8.95). On this occasion Otley, in a hired uniform, posed as Napoleon. Elsewhere Rosebery appears in many guises, including those of street musician with an accordion, bull-fighter, fat boy, and, returning to the eighteenth century, the benevolent Dr Primrose in Oliver Goldsmith's *Vicar of Wakefield* (P. 6.1.97; 20.6.96; 31.10.96; 17.10.96). Resigning as leader of the party, Rosebery thankfully put party politics behind him, but he remained a popular figure who allowed himself to be drawn into discussions about a return to office. These fluctuations are marked in *Punch*. A fine Sambourne cartoon shows the politician on the edge of a swimming pool, trying to decide whether or not to jump in (P. 24.7.01). In a private letter, H.H. Asquith took up the theme, possibly recalling

the cartoon: "He was afraid to plunge and yet not resolute enough to hold to his determination to keep aloof."[34]

Oddly, Sambourne now found Rosebery's head difficult to draw. He notes, on more than one occasion, that he had to scrub out his work and start again. It is true that these images sometimes border on the grotesque, as though the face of the older Rosebery presented Sambourne with a particularly acute problem with likeness.

Georges Boulanger and William II

One overseas politician whom Sambourne enjoyed presenting in different guises was the Frenchman Georges Boulanger, now largely forgotten except by historians of later nineteenth-century France. Boulanger, a successful general, advocated a stronger and more authoritarian government, a return, some felt, to Napoleonic days. *Punch*, as a liberal (and English) paper, steadily attacked Boulanger, and Harry Furniss described him as "the chief of French *poseurs*".[35] Boulanger was a tall, handsome figure, but Sambourne regularly photographed himself for the part. Over a period of two years he showed Boulanger in various roles, fighting a duel against a political opponent; as an armoured flying fish, returning in triumph to Paris, where he had made significant political gains (P.13.8.87; 13.4.89). He lurks in the background of *La France's Lament*, illustrating a poem on France's need for a strong leader and the false attractions of the straining, strutting and crowing Boulanger: 'a cock is not an eagle' (P. 2.3.89). In *Up Again!* Boulanger manages to stay afloat in the sea, while French Republicanism, represented as Marianne in a Phrygian cap, confesses her anxieties about the future (P.1.9.88; fig. 75). A poem, presumably by Milliken, accompanied this drawing, and included the lines:

> Is he a sort of Brummagen Buonaparte?
> A squeezable and clayey mask of Caesar?
> Who pulls the rope of this pest popinjay?

For all Sambourne's protestations about the seriousness of his work, he must have had some fun in drawing such a colourful figure as Boulanger, with his spurs, army boots, medals, swords and swagger. However, even here there were problems with Burnand. In December 1889 Sambourne was asked to draw the French general once more, but, a day later, Burnand sent a note changing his mind. Sambourne did not see that the note had fallen into the letter box and so

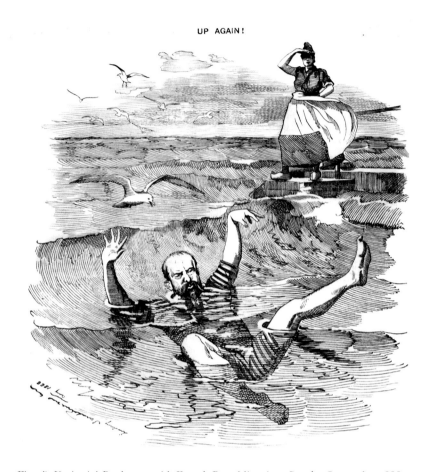

UP AGAIN!

Fig. 75 *Up Again!*, Boulanger with French Republicanism, *Punch*, 1 September 1888

continued working. Eventually, however, the instructions were found and he switched to a far less congenial subject. Burnand must have decided that Boulanger, after a failed *coup d'état* and a lost election, was no longer news.

Boulanger's reactions to *Punch*, if he saw it, have to be guessed. It is known, however, that Sambourne's work caused considerable annoyance in Germany. On 5 March 1892, *Punch* published a cartoon entitled 'The Modern Alexander's Feast; or, the Power of Sound'. The subject was the young German Emperor, William II, who was said to have shouted his speech at a banquet in honour of the province of Brandenburg. A mocking verse by Milliken described how the "Shouting Emperor" appeared like a "New Alexander" and how he "Rose from his chair" to

defend his part in the struggle between the crown and the Reichstag, or parliament, in the debate over the German Army bill:

> With Jovian air,
> And, hanging up his thunderbolts with care,
> What time his eagle gave a gruesome glare,
> The nectar gulped again and yet again:
> Then stooping his horned helmet firm to jam on,
> Voted himself the New God – Jupiter – (G)Ammon!

Milliken and Sambourne worked together on this assignment, with Milliken calling at 18 Stafford Terrace every day for discussions. Sambourne followed Milliken's verse closely, showing William II as a ridiculous Jove, standing on the clouds, grasping a bundle of thunderbolts labelled 'Speech' in one hand and a drinking cup in the other.

The dramatic result passed into *Punch* history. "For nearly forty years," said one authority, "*Punch* has been regularly taken in at the Prussian royal palaces in Berlin and Potsdam. The Emperor William has just issued a private order that *Punch* is to be struck off the list of journals which are supplied to him."[36] Ten days after the publication of the cartoon Sambourne told Burnand what had happened, and they decided on a riposte. This was *Wilful Wilhelm*, a skit on Heinrich Hoffmann's *Struwelpeter*, which appeared on 26 March (fig. 76). Sambourne photographed a young boy for the Emperor and then showed him tearing up *Punch*. The offending cartoon lies on the ground, torn in two and with a black cross marked on it. In the background is Tenniel's most famous cartoon, *Dropping the Pilot*, which shows the aged Bismarck after William had sacked him. Among the books thrown onto the floor are volumes entitled 'Anti Socialism', 'Alliance Bismarck' and 'Bismarck's Policy'. The struggle for power between William II and Bismarck and the fate of the great German statesman were the subject of a number of Sambourne cartoons, and the Chancellor's departure from power was an event close to the heart of *Punch* and of the nation. This was not the end of the story. Although William II's dictatorial ways were the subject of further *Punch* cartoons, by Sambourne and others, it was reported that "he again received his *Punch* regularly, but, to save appearances, it arrived from London every week in an official-looking envelope, which was opened by the Kaiser's own hands, and by him duly stowed away in his library".[37]

WILFUL WILHELM.

An Imperial German Nursery Rhyme. (*From the very latest Edition of "Struwwelpeter."*)

Wilful Wilhelm. "TAKE THE NASTY *PUNCH* AWAY!
I WON'T HAVE ANY *PUNCH* TO-DAY!"

YOUNG WILHELM was a wilful lad,
And lots of "cheek" young WILHELM had.

He deemed the world should hail with joy
A smart and self-sufficient boy,

And do as it by *him* was told;
He *was* so wise, he *was* so bold.

SNEAKING SEDITION.

MR. PUNCH GIVING THEM ROPE ENOUGH.

LEFT
Fig. 76 *Wilful Wilhelm, Punch,*
26 March 1892

RIGHT
Fig. 77 *Sneaking Sedition,*
Henry Hyndman on the left,
John Burns in the centre and
Henry Champion on the right
Punch, 20 February 1886

Complaints

Contentious cartoons could cause trouble, for the contributor as well as the paper. *Sneaking Sedition*, of 20 February 1886, shows Mr Punch hanging three puppets (fig. 77). That these figures represented three leading socialists, Henry Hyndman, John Burns and Henry Champion, who were then "before the law on a political charge",[38] accused of seditious conspiracy, gave particular offence in some quarters. Sambourne received letters both of complaint and of praise. He noted in his diary: "This cut created great animosity on acct of its being too strong …. Little thought such a bother would be made about it" (D. 12 and 17.2.86). A case was taken out against *Punch*, and William Bradbury wrote jokingly to tell Sambourne that he might expect to find himself in Holloway prison. Burns later took a more light-hearted view of the cartoon: "On one occasion … *Punch* suspended me, pictorially of course, from a gallows tree. This I, of course, regarded as Mr. Punch's humorous desire to see me in an elevated position."[39] There was

a "Great Socialist meeting in Hyde Park" on the following Sunday, and Sambourne was "nervous about house" (D. 21.2.86).

Punch regularly received letters complaining about cartoons, and, on one occasion, Sambourne was actually threatened with violence. On 3 August 1889 a cartoon, *Twopence Coloured*, appeared in *Punch* (fig. 78). The cartoon referred to a recent law case in which G.E. Sims (whom Sambourne always calls Simons), a journalist on *The Sun*, failed to gain an injunction. Sims sought to compel a magistrate, Mr Bridge, to issue a summons for assault against the Duke of Cambridge, the commander-in-chief of the army. The cartoon showed Bridge with the two judges who decided the case, all hovering in the air like angels. The Duke is on the right and Sims (spelt Simms on this occasion) appears on the left as an animal with big ears and thin legs, wearing a top hat. Sims claimed, with some justification, that, although he was said to be represented as a deer, the animal drawn by Sambourne had neither tail nor antlers, and was, in actual fact, a donkey. He wrote to Sambourne on 8 August, telling him: "I intend to thrash you the first time I meet you."[40] On the advice of a leading solicitor, George Lewis, Sambourne took out a summons against Sims. The case came up before Alderman Andrew Lusk at the Mansion House. Sims was charged with "using threats towards Mr Edward Linley Sambourne, whereby he went in fear of bodily injury". Sambourne claimed that he was alarmed at the prospect of a street brawl. The cartoon, he insisted, was good-natured and not intended to be unkind to either Sims or the Duke. It simply referred to a public event. Sims, who pleaded guilty, said that he had written the letter "under circumstances of great provocation".[41] He claimed that the teasing to which the cartoon had exposed him had been intolerable and that he had fallen out with an old friend as a result. He regretted sending the letter and would have never have behaved violently. Sims was bound over to keep the peace for six months, on his own recognizance of £100, and ordered to pay costs. Sambourne wrote in his diary that the case was "good fun" and that it lasted less than an hour (D. 21.8.89).

As his editor, Burnand was always trying to reform Sambourne. In January 1884 he suggested that the artist should keep a daily news notebook to help in the generation of ideas for cartoons. Sambourne, he thought, should send in a mixed cartoon, grouping the events of the past week. Sambourne did, for a time, contribute drawings bringing together small vignettes of the month's (rather than the

Fig. 78 *"Twopence Coloured"*,
Punch, 3 August 1889

"TWOPENCE COLOURED!"

"HA! HA! ONCE MORE THE RANGER IS FREE!"

[The Judges dismissed Mr. Simms' appeal for a *mandamus* to compel the Magistrate to issue a summons against H.R.H. the Duke of Cambridge.]

week's) news, grouped about a glamorous model representing the season of the year. At the same time, Burnand told his friend that he planned to reduce the number of 'Fancy Portraits', to avoid boring the public. A third request was for Sambourne to write "sharp notes" for his drawings, part of a move to return to the close relation of text and illustration, which Burnand felt had "fallen into disuse" in the magazine.[42] Sambourne's negative reaction to Burnand's advice can be gauged from a Burnand letter, written a few months later:

> I mention this as you are perpetually labouring under some damned stupid impression that I want to reduce your work whereas my aim & object is to get your *best* work before the public & not allow you to fritter your power away in niggling and worthless subjects. I have always pointed to you as the coming Cartoonist with a style specially your own.[43]

This came four days after a letter asking Sambourne to sign himself simply 'E.L.S.', which Burnand thought more dignified than 'Linley Sambourne inv.' or 'delt.' or a dated signature. Sambourne, who modelled himself on the Old Master draughtsmen, did not obey the instruction.

On occasion Burnand descended to pathos: "I seldom call for much; but when I have asked you to illustrate certain poems (just to keep 'em by me for use) you have not done so, but grumble – as if it were a personal wrong – at not being asked to do something totally different."[44] Burnand complained that Sambourne was the only member of his staff who did not give him "stock in hand for a couple of weeks ahead".[45] As Richard Price explains in his history of *Punch*, Burnand often had personal reasons for this need to have a stock of completed work: "He would make up the illustrations for the pages a month ahead and then go off on holiday."[46]

Burnand was so nervous that he might not get his drawings in time that he once sent Sambourne a programme to follow, which the latter duly pasted into his diary for 1889. Dated 13 October, the letter underlines the final date for 'Almanack' drawings, 10 November, "which is 5 weeks from now. Ample time. Nov 10 last day of sending in".

In 1886 W.H. Bradbury, a man with a notoriously short temper, who had succeeded his father, the genial William Bradbury, as joint managing director of *Punch*, was driven to demand the outstanding 'Almanack' drawings:

> Well! my lad! you're lucky! you are a *proper one* to be sure! – you take your ride, you do a little work, then you lunch & then a little society & then dinner & wind up in the mad vortex of Fortune's Wheel of Fashion – but you don't *work* – my lad! Or else the best Almanack as ever emanated from Mr Punch's Little Men would almost be ready for publication now. Instead of which its waiting for Sammy![47]

Ramsgate

The 'Almanack' work was generally done in the autumn, although, in 1884, Sambourne began work on his drawings in January and was well advanced with them by the time of the Almanack dinner. This annual spell of hard work encouraged the Sambournes to make an autumn visit to Ramsgate on the Kent coast. There were less distractions in an out-of-season resort, and Sambourne would

work for days on each drawing. He told a reporter that the problem of fog in London was his chief reason for going to Ramsgate, where there was more light during the winter.

Ramsgate had become a popular resort in the early nineteenth century, when terraces and crescents of houses were built, facing out over the sea. William Powell Frith's famous painting *Ramsgate Sands* (Royal Collection) illustrated life at the seaside in the mid century, with the Royal Hotel (1884–85) prominent on shore. Marion Sambourne knew Ramsgate well, near as it was to her family home at Westwood Lodge, and she was happy with the change of location.

In 1883 there had been talk of renting a house in Surrey – at Clandon from Lord Onslow – but, the following autumn, the Sambournes returned to familiar ground and rented Park House at Dumpton, near Westwood. Then, a year later, they found a house in the town of Ramsgate itself. From 1888 they took up their annual abode at various addresses in Prospect Terrace on the West Cliff. This was no holiday letting in the modern style. Prospect Terrace was the Sambournes' alternative to the grand houses rented by wealthier members of the Herapath family. The Sambournes came for three months, and they brought many of their household effects and some of the staff with them. Photographs for Sambourne's work were taken to Ramsgate, and, on one occasion, he forgot them and had to return to London to pick them up. He would usually travel up to London on the train for the *Punch* dinner on Wednesday, stay two nights in town, send off the drawing on Friday night and return to Ramsgate on Saturday. On his free evening in town he would dine at a club and visit the Empire Music Hall in Leicester Square.

By the 1880s Ramsgate was no longer a smart watering-place, but a comfortable middle-class enclave. Frank Burnand had settled in Royal Crescent some years before and may have encouraged his *Punch* colleague to join him in the town. That it had once had a slightly Bohemian aspect is suggested by a reviewer of Wilkie Collins's play, *Rank and Riches*, who refers to the "freedom" of the town's "manners".[48] Collins, like the Sambournes and the Burnands, lived in Ramsgate for part of the year. He is not mentioned in Sambourne's diaries, however, and it would appear that the writer's irregular lifestyle (he lived with two women, neither of whom was his wife, and spent summers in the town with one mistress and their children, pretending to be Mr and Mrs Dawson and family) placed him beyond

the pale of Ramsgate society, even that of broad-minded artists. F.R. Leyland, the shipping magnate and patron of James Whistler, was to be seen about the town (he lived in nearby Broadstairs) with his own mistress (whom he married after his wife's death). Far more respectable were Jane Pugin, the third wife and widow of the architect A.W.N. Pugin, who had died at his home in Ramsgate in 1852; Henry Weigall, the portraitist, with his wife, Lady Rose, a daughter of the Earl of Westmorland; and Moses Montefiore and his family.

From Ramsgate Sambourne was able to vary his rides, travelling round the Isle of Thanet, sometimes visiting friends on the way. There were long sea walks, along the cliffs, and through the surrounding countryside. Roy was often his father's companion, accompanying him on his walks and rides and on skating expeditions. Father and son would also play billiards together. The Albion Club, from which Sambourne's letters are often addressed, provided a substitute for the Garrick, and a chance to get out of the house. Only once, in 1891, did the Sambournes let their London home during their absence in Ramsgate. The tenants damaged a chair and it was decided that £80.00 did not cover the effort of preparing and re-ordering the house, so the experiment was not repeated. The Sambournes continued their autumns in Ramsgate until 1893, leaving their Kensington house largely unoccupied for months on end.

NOTES

1 Shirley Nicholson, *A Victorian Household*, London (Barrie & Jenkins), 1988, p. 15.

2 Letter to Marion Sambourne, no date, formerly collection of Anne, Countess of Rosse.

3 Kensington Library, letter of 16 April 1883, ST/1/2/134.

4 Letter of 8 May 1883, R.G. Watkins, Catalogue 45, no 66.

5 I am very grateful to Shirley Nicholson for her identification of Frensham Pond and of Norman Lockyer.

6 *The Times*, 15 December 1885.

7 *City Press*, 6 August 1910, and separate page printed by the *City Press*.

8 Ditto.

9 *Pall Mall Gazette*, 4 August 1910.

10 *City Press*, 13 August 1910

11 See note 9.

12 'How I do my *Punch* pictures', *Pall Mall Gazette*, 8 November 1889, p. 1.

13 Letter of 3 October 1886, Ian Hotchkins, cat. no. 76, summer 1994, no. 249.

14 'The Designer of the Cover for *The Sketch*: A Chat with Mr Linley Sambourne', *Illustrated London News*, 28 January 1893, p. 1.

15 Leonee Ormond, 'Linley Sambourne: The Water Babies and Tales of Hans Andersen', *British Art Journal*, II, no 3, Spring/Summer 2001, p. 49.

16 Charles Kingsley, *The Water Babies*, London (Macmillan), 1885, p. 290.

17 See note 15, p. 50.

18 Ditto.

19 Unpublished diary of Mary Godsal. I am grateful to Grant Longman for sending a copy of this entry to the Sambourne archive.

20 Letter of 15 March 1894, formerly collection of Anne, Countess Rosse.

21 Letter of 17 February 1897, ditto.

22 C.L. Cline, ed., *The Letters of George Meredith*, Oxford (Clarendon Press), 1970, vol. II, p. 977.

23 Kensington Library, letter of 6 January 1892, ST/1/3/1/54.

24 Roger Simpson, 'King Arthur at the *Punch* Round Table, 1859–1914', *Arthuriana*, IX, no. 4, 1999, p. 112.

25 Letter of 13 May 1883, formerly collection of Anne, Countess of Rosse.

26 Letters of March 16 (no year given) and 31 March 1882, ditto.

27 Letter of 31 March 1882, ditto.

28 Walter Hamilton, *The Aesthetic Movement in England*, London (Reeves & Turner), 1882, p. 76.

29 William Feaver, *Masters of Caricature*, London (Weidenfeld & Nicholson), 1981, p. 108.

30 Reena Suleman, 'The Developing Artist: The Work of Edward Linley Sambourne', *Living Pictures*, I, no. 1, 2001, p. 34.

31 *The Letters of George Meredith*, vol. III, 1549.

32 Kensington Library, letter of 31 March 1840, ST/1/4/285.

33 Ditto, letter of 17 November 1894, ST/1/4/498.

34 Leo McKinstry, *Rosebery: Statesman in Turmoil*, London (John Murray), 2005, p. 425.

35 Harry Furniss, *Confessions of a Caricaturist*, London (T. Fisher Unwin), 1901, vol. II, p. 251.

36 M.H. Spielmann, *The History of Punch*, London (Cassell), 1895, p. 192.

37 Ditto, pp. 193–94.

38 Ditto, p. 235.

39 Ditto.

40 *Daily News*, 22 August 1889.

41 Ditto.

42 Letter of 3 January 1884, formerly collection of Anne, Countess of Rosse.

43 Leonee Ormond, 'Linley Sambourne', *Nineteenth Century*, IV, no. 4, Winter 1978, p. 84.

44 Ditto.

45 Letter of 13 May 1883, formerly collection of Anne, Countess of Rosse.

46 R.G.G. Price, *A History of Punch*, London (Collins), 1957, p. 156.

47 See note 43.

48 Alison Clarke, 'The Other Twin: A Study of the Plays of Wilkie Collins', PhD thesis, University of London, 2003, p. 201.

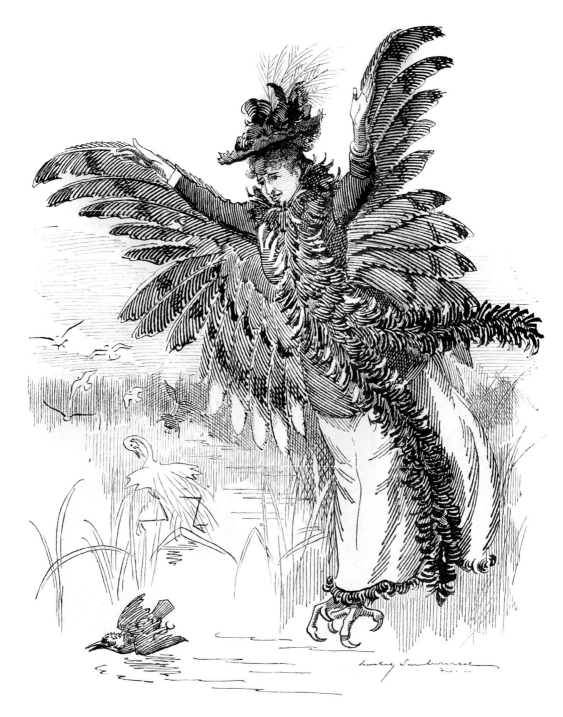

A BIRD OF PREY.

Fig. 79 *A Bird of Prey*, *Punch*, 14 May 1892

Chapter 5

The Pursuit of Pleasure

*P*unch provided Sambourne with his regular income and, unlike the artists, *Punch* took no holidays. As a result, Sambourne had to plan ahead, taking his materials with him on all absences from home, whether visits to Marion's sisters, shooting holidays in Scotland, or occasional longer-haul journeys, like that to Russia in 1890. Every few years he would treat himself to an expedition to Paris. Sometimes with his wife and her brother Spencer, sometimes with the 'regulars', the group of artist friends, he would enjoy the annual Paris Salon, and the city's galleries, restaurants and nightly entertainment in the musical theatres. One successful late Sambourne cartoon was a response to the floating of a scheme for a Channel tunnel that would bring Paris closer to London (P. 2.1.07; fig. 80).

Paris

Sambourne had good reason to look forward to the development of a tunnel. The shares which he bought in railway companies provided the family with free travel, although there was sometimes a crisis when a 'pass' had not arrived or had been forgotten. Taking advantage of this privilege, Sambourne regularly spent Sundays in Calais. He would leave home at a reasonable hour, catch the boat train from Victoria Station and connect with the ferry at Dover. He frequently met friends on the journey, or at lunch in Calais. Home again by eight o'clock or so, he would think nothing of going on to an evening function, or of entertaining friends at Stafford Terrace. In the early months of 1897 he recorded that he had travelled to Calais on ten consecutive Sundays. There were twenty-two trips in 1897 and twenty-one in 1898 and 1899.

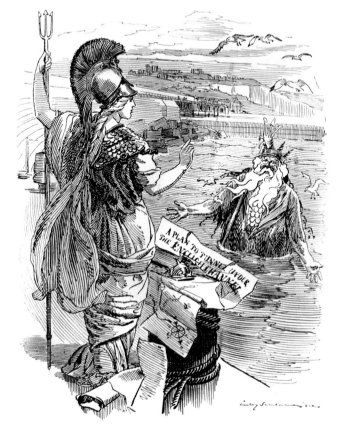

PUNCH, OR THE LONDON CHARIVARI.—January 2, 1907.

HANDS BENEATH THE SEA.

Father Neptune. "LOOK HERE, MADAM. I'VE BEEN YOUR PROTECTOR ALL THESE YEARS, AND NOW I HEAR YOU THINK OF UNDERMINING MY POWER."
Britannia. "WELL, THE FACT IS I WANT TO SEE MORE OF MY FRIENDS OVER THERE, AND I NEVER LOOK MY BEST WHEN I'VE BEEN SEA-SICK."

LEFT
Fig. 80 *Hands beneath the Sea, Punch,* 2 January 1907

RIGHT
Fig. 81 Harry Furniss, *The Punch Staff on their Way to Paris, Punch,* Special Number, June 1889 (Furniss, bottom right; Sambourne, in cap on right; Burnand, lighting cigar, left; Du Maurier, in white suit and glasses, left)

In 1889 *Punch* published a special number to celebrate the opening of the Eiffel Tower, and the staff travelled there for the occasion. It was also, although the British tended to ignore the fact, the centenary of the onset of the French Revolution. The Eiffel Tower was the centrepiece of the Exposition Universelle, a huge international exhibition with art galleries grouped around the tower. Sambourne had prudently completed his drawings for the special issue of June 29 1889 before leaving home. One cartoon, entitled *'Great Attraction' – Birds of all Nations Flying to La Tour Eiffel*, shows different species, comically representing a

EN ROUTE. MR. PUNCH AT LUNCH.

variety of countries, circling around the lighted tower. The second is a 'Fancy Portrait' of Gustave Eiffel shown as his own tower surmounted by a face and top hat.

The *Punch* party lunched on the train to Calais, a scene captured by Harry Furniss, who sketched a smoky compartment with a waiter bringing in bottles of champagne (fig. 81). "Splendid lunch," was Sambourne's verdict (D. 16.6.89). The staff were divided between two Paris hotels, the Grand and the Continental. Sambourne shared a room at the Continental with Furniss, which he described as "awfully hot. Slipped between bed & wall" (D. 16.6.89).

Over the next three days the group set out to enjoy themselves. They went up the Eiffel Tower on both the first and second mornings, but Sambourne could not get above the second stage because of the crowds. He lunched there on 17 June. During his stay Sambourne made visits to the fine-arts section of the exhibition assembled in galleries around the tower. *Punch* patriotically noted that the show included works by Millais, Leighton, Watts and Fildes "and gentlemen nearly equally illustrious".[1] In the Eastern section, "Egypt, Algiers etc.", Sambourne twice witnessed dancing. He found the Tunisian dance "indecent" (D.17-18.6.89). In a poem

in *Punch*, ''Arry in Parry', Milliken also recalled the North African young women without much enthusiasm:

> The East must be 'ot and no herror! but podgy young minxes arf drest,
> A-wobbling their 'ips to wild music seems nuts to the swells of the West.
> Whether Tunis or Egypt perdoosed 'em their ways wos not pooty or nice,
> And for beauty a ice-gal from Peckham would lick 'em two times out of twice.[2]

In between the expeditions there was the usual round of restaurants, cafés and theatres. Many of the restaurants were well known to Sambourne from earlier visits: "Same table as '84. Lovely girl & 3 men. D.M. [Du Maurier] delighted" (D. 17.6.89). Furniss and Du Maurier illustrated these scenes for *Punch*. In Du Maurier's drawing two Englishmen (from Clapham), dining at the Ambassadeurs, let their dinner get cold while gazing at the girl on stage.

This journey to Paris marked the last year of the 1880s in convivial fashion. Sambourne spent much of his time feeling hot, feverish and sick. He caught cold as they left the Cirque Molier in the early hours of one morning and was unable to eat his lunch on the second day, feeling "very ill & seedy" (D. 18.6.89).

Country pursuits

That too much good living sapped the quality of Sambourne's work has already been suggested. The great illustration projects of the 1880s were behind him. With his family growing up, and expenses inexorably rising, the struggle to make ends meet became worrying. At the same time life became more hectic, and the pursuit of pleasure more intense. In the 1890s it also became more expensive, enjoyed in the higher reaches of society. The Sambournes began to enjoy weekend house parties, sometimes with wealthy friends, sometimes with Marion's relatives, the Langleys and the Fletchers.

The 'nineties have been dubbed 'naughty', a decade given over to pleasure and sometimes to decadence. True to form, Sambourne's diaries chronicle a large measure of fun. By the end of the 1880s, the diaries of husband and wife showed just how far they had risen socially since the beginning of the decade. The 1890s were to carry them further into the world of the rich and famous.

Every late summer found Sambourne shooting in Scotland, often at Tressady with the Watneys, but also as the guest of numerous other hosts. Those who

entertained the Sambournes rented magnificent houses from their aristocratic owners for the shooting season. In 1894 and 1896 the family was invited to Ayton Castle in Berwickshire, a baronial mansion in red sandstone, owned by the Mitchell Innes family but let to Kensington friends, the ship-owner Charles Galbraith and his wife Katherine. Sambourne amused himself by playing tennis, cycling with Roy, and with partridge shooting and rounds of golf. In 1897, with Maud at a house party in Skibo Castle, Dornoch, Sutherland, he was dismayed to be told not to smoke on the stairs. From Skibo, rebuilt by Andrew Carnegie a few years later as a grand Scottish baronial mansion, and today a celebrity hotel, he went on to a shooting party, hosted by Mr and Mrs Vickers, at Achnashellach. An "extraordinarily pretty parlour maid" was noted twice in the diary (D. 3.9.97 and 4.9.97). Next came Wester Aberchalder, where Sambourne stayed with the Wallace family. His final port of call was Terregles, Dumfries, rejoining Marion as a guest of the Galbraiths. Here he was restricted to shooting rabbits with Roy. In all, Sambourne was away from London for three weeks, sending back cartoons to *Punch* as usual.

There were winter expeditions to East Anglia or Hampshire, for duck and pheasant shoots, with all the diversions of pleasant company, local expeditions and evening card games. Marion's sisters, Jessie (Midge) Langley and Ada (Tabby) Fletcher, and their wealthy husbands invited the Sambournes to their country houses – sometimes for shooting, sometimes to see the naval review from the comfort of a private yacht, or sometimes simply to enjoy life in the country or near the sea. The Fletchers leased a number of properties including Pyt House, an imposing early nineteenth-century house near Tisbury, Wiltshire. They owned The Anchorage, on the coast near Christchurch in Hampshire. The Hamilton Langleys were often in Argentina, but, at the beginning of the twentieth century, they settled at Stoke Edith Park, a late seventeenth-century house in Herefordshire, where Sambourne could join his brother-in-law's shooting parties and Marion enjoy visiting her sister.

More than a hundred years later, there appears to be a certain conflict between Sambourne's annual expeditions to shoot grouse and game birds in Scotland and his membership of the Society for the Protection of Birds. The Society had been founded in 1889 and Sambourne joined in 1892. Below his signature he drew a large egg. This, he explained, represented the embryo society, and from it he hoped a bird might be hatched which "should extend her protecting pinions over all her tribe".[3]

Sambourne saw no contradiction between membership of the society and his sporting activities. Nor was he alone in this. Naturalists like Sir Lionel Rothschild, who set up a zoological collection, later bequeathed to the British Museum, and John Guille Millais, son of the painter, were also keen sportsmen.

There were, as Sambourne would have been quick to point out, two different kinds of bird. Those shot in Scotland in the autumn and in East Anglia in the winter were game birds – grouse, pheasants and partridges, reared to provide targets for sportsmen. There were huge numbers of them and (at that time) no suggestion that they were scarce or needed protecting. For the great Scottish estates, shooting was a way of life, providing employment for many living on the land, and entertainment for the owner's friends. After the 'glorious twelfth' of August, when the shooting season began, sportsmen would send the birds they had killed to the tables of their families and friends. London restaurants and clubs proudly put game on the menu.

Fishing was another sport integral to Highland life. The owners of rivers would often let the 'beats' or stretches of water. John Millais was among those who rented Scottish estates for the fishing. Sambourne, as a fisherman, was killing the creatures he drew with such careful observation and delight in his illustrations and cartoons. The photograph of his first salmon, which provided the basis for an illustration in *The Water Babies*, is still hanging in his house today.

However strange it may seem, Sambourne was genuinely committed to his role as a protector of birds, a species which had a particular fascination for him. Several of his early cartoon drawings of women show them in costumes made of feathers or in dresses designed to resemble particular birds. Later, he would borrow books to help him perfect the details of the appearance and habits of different species. *Punch* also promoted the bird protection movement, publishing a number of cartoons supporting the campaign against the use of feathers, wings, or of whole birds, as fashion accessories. In doing so the magazine was joining forces with the writer William Henry Hudson and the painter George Frederic Watts, both of whom protested passionately against cruelty to birds, pointing out the effect upon their young, left to starve after the parents' death. Watts's *A Dedication 'To all who love the beautiful and mourn over the senseless and cruel destruction of bird life and beauty'* of 1898 is a painting of a woman, her head bowed in sorrow over the remains of birds laid out on an altar. It now hangs in the Watts Gallery at Compton,

Surrey, near his dramatic early painting *The Wounded Heron* of 1837, which became an icon for the bird preservation movement.

Sambourne's direct contribution to the movement began on 12 March 1881 with a small cartoon called *Rare Birds*. An owl, some giant sea birds, a pelican and a group of small birds are shown with the caption: 'Ornithological "Hop" given to celebrate the coming into operation of the wild birds' protection act. Chaffinchs "Not in it"'. In 1883 came two cartoons paying tribute to the Princess of Wales, later Queen Alexandra, who had refused to attend 'The Tournament of Doves', a pigeon-shooting competition. One cartoon, *Two Queens of Beauty – Aphrodite – Alexandra*, appeared on 3 February 1883 and the other, *Triumph of Sir Pigeon! Last Scene of the Tournament of Doves in the presence of H.R.H. the Princess of Wales*, on 17 March. Four years later, Sambourne's cartoon of 17 September 1887, *A Plea for the Birds. (To the Ladies of England)*, showed "a feather-hatted woman pinning a sea-gull to the ground with one cruel foot".[4] With this cartoon came a poem, probably by Milliken, imploring women to halt the trade in feathers. Two more cartoons, *A Bird of Prey* and *The 'Extinction' of Species; or The Fashion-Plate Lady without Mercy and the Egrets* were published in *Punch* on 14 May 1892 and 6 September 1899 (see fig. 79, p. 186). Both reflect concern over the importation of birds' wings since changes to the law had made it more difficult to use home-grown birds for the purpose. Slides were made from these cartoons and used by lecturers promoting the work of the Royal Society. It was hoped that Sambourne would contribute a drawing for use on the society's Christmas card, but "unfortunately extra work and other causes hindered the project".[5]

As we have seen, Sambourne often had little control over his choice of subject-matter as a cartoonist. But it would appear that, where bird preservation was concerned, he was not simply a member of the *Punch* team, but an active supporter of the aims of the Society, telling its leaders that he was "ready to assist you in any way I can by my work".[6]

The broad outlines of Sambourne's life remained the same through the 1890s, but one major break in routine came in 1894, when the annual exodus to Ramsgate was given up. Shorter holidays to hotels in south-coast towns like Brighton and Folkestone now provided a break from the winter fogs in London. Boulogne and Paris were alternative destinations and, in 1896, the Sambournes were with the Hamilton Langleys at the Grand Hotel at Biarritz in south-west France, a resort made fashionable by Napoleon III and the Empress Eugénie.

The Baltic cruise

The most extended and adventurous of the Sambournes' expeditions occurred at the opening of the decade, in 1890. On 31 May Sambourne noted in his diary, "Mrs Watney's invite for yacht came". Blanche Watney, born Blanche Burrill, was Vernon Watney's mother, the widow of James Watney, chairman of the brewing company and later Member of Parliament for East Surrey. A yacht had been chartered to take Mrs Watney and her friends on a Baltic cruise. Vernon married Lady Gwendolyn Margaret Wallop, daughter of the Earl of Portsmouth, early the following year and his courtship may have been a motive for contriving a lengthy absence for his mother.

Sambourne settled the issue of his absence from the *Punch* table on a ride into North London with Frank Burnand. "All right," was Sambourne's laconic account of Burnand's response to his request (D. 3.6.90). Elsewhere he noted that Burnand asked him to "send me notes of your voyage to Sweden and Norway, and the land of *Hamlet*. You'll see lots of funny things, and you'll take a humorous view of what isn't funny; send me your humorous views" (P. 9.8.90).

Mrs Watney twice delayed the departure, but the expedition finally got going on Monday 23 June. Sambourne had spent the previous weekend on a riding expedition with his Two Pins Club friends. He was up at 5.15 on Monday morning packing his cases and frantically paying bills and writing cheques. Leaving Kensington at 8.35 the Sambournes arrived at Waterloo at 9.00, and just managed to catch the train for Portsmouth.

The yacht, the *Palatine*, was waiting for them. Marion was delighted: "450 tons all newly painted lovely fittings. Shall never forget how beautiful she looked as we came round her." Marion's cabin had a "bath let in floor, large hanging closet & endless drawers. Luxuriant hangings of pale blue & buff satin damask".[7] Sambourne, who had his own cabin, sometimes used Marion's bath, but he more often "tubbed on deck: deck'd out in my best towels" (P. 9.8.90).

The couple's companions were John Dashwood Goldie, a former Cambridge oarsman, after whom the second Cambridge boat is still named, Miss Clarke (a good pianist), Dr Barker (who may have been attending on Mrs Watney) and a friend known only as 'the Admiral'. Goldie was a keen fisherman and Sambourne sometimes joined him in fishing expeditions when the yacht was in port. On the first evening afloat they all dined together with Mrs Watney, "after lovely

phosphorescent waves & new moon" (D. 23.6.90). Their route took them along the coasts of England and Scotland. Sambourne sketched and photographed scenes on board, on the shore or at sea, noted the birds and insects which flew onto the deck, and read widely. The sea was occasionally rough, and various members of the party succumbed to sea-sickness, but not Sambourne. In a diary note which presages later difficulties, he notes: "Mrs W still unwell & upset about weather" (D. 30.6.90).

Finally, on Wednesday 2 July, the *Palatine* set off across the North Sea. The gales had moderated but the sea was still strong, and Sambourne was soon the only able-bodied passenger. A cartoon which appeared in *Punch* on July 19 shows Mr Punch and a charming girl in a boater catching the first glimpse of Norway. Sambourne seems to have been asleep when the first glimpse was sighted at 6.00 am on 3 July. Burnand, with some justification, thought the cartoon "more pretty than humorous" when it arrived in Bouverie Street, but he published it nevertheless (P. 9.8.90).

From Bergen, the *Palatine* began to make the popular exploration of the Norwegian west-coast fiords. Travellers making the same journey included the Dowager Empress Eugénie of France on board the *Victoria* and groups of less re-fined tourists, whom Sambourne scornfully dubbed "English Arrys" (D. 3.7.90). Both crossed the path of the *Palatine's* passengers from time to time. Many tourists travelled to Norway for the fishing, while others were there to enjoy the midnight sun. In his crowded diary entries, Sambourne notes the beauty of the scenery and the activities of the local people. In Trondheim his eye was caught by the strange Gothic sculpture of the cathedral, and he visited the menagerie and the waxworks.

Trondheim was the *Palatine's* northernmost point, after which she returned to Bergen via Kristiansund, where the party set out in two carriages to look at the waterfalls and inland scenery. Sambourne frequently records bad weather and wind during their time in Norway, writing in *Punch* of "torrents of rain. Anyone can draw water – but draw rain!" (P. 16.8.90).

Once back in Bergen, Sambourne found the inevitable 'worry letter' from Burnand. They had made an arrangement that Sambourne would send back work from the *Palatine's* stopping points. His *First Glimpse of Norway* cartoon appeared in the magazine on 19 July, but there had been two weeks before that without a Sambourne cartoon. The gap was filled by Harry Furniss, whose contributions increased during Sambourne's absence.

Sambourne's diary records work on drawings for *Punch* while the boat was at sea. Early in the voyage he drew a *British Squaw* cartoon and posted it home, but Burnand decided not to publish it. On 18 July Goldie and Marion were called upon to pose for a photograph, but this cartoon, whatever it was to be, never appeared. Far more time and energy were spent on Sambourne's pencil landscape sketches or on his (sometimes fruitless) photography. He complains that the leg of the camera stand broke and had to be mended and that water had damaged the plates.

Once they entered the Baltic, the cities of Copenhagen, Stockholm and St Petersburg were their chief ports of call. Between Lervik and Copenhagen, Sambourne, under pressure from Burnand, worked on a cartoon of Mr Punch driving a piebald horse amidst mountain scenery, with Toby behind him. This was the centrepiece of a four-part series called 'From Our Yotting Yorick, P. A.', with letterpress by Sambourne, purporting to be 'Jetsam', or later 'Flotsam', writing on board the *Placid* during a Baltic cruise. In this first episode, published on 9 August, the *Hamlet* theme is continued with two small sketches recording Sambourne's disappointment as he ran on deck to see the very top of the castle at Elsinore: "More like a Thames pumping station than castle" (D. 20.7.90). 'From our Yotting Yorick' is an extraordinary illustration of the relationship between Burnand and Sambourne. The four pieces, and the first two in particular, are continuous dialogues between Sambourne and his friend and editor, jokes at Burnand's expense as the writer mocks the repeated demands for more humour. It is to Burnand's credit that he published them!

After more rough weather the party were relieved to reach Denmark safely. In Copenhagen, where they moored on July 20, they enjoyed the Tivoli Gardens and a tour of the Kronenburg Palace. The museum dedicated to the work of the sculptor Bertel Thorwaldsen disappointed Sambourne: "Egyptian building with atrocious frescoes." He preferred the zoo. A letter from Burnand was awaiting him at the post office and caused Sambourne "much upset" (D. 21.7.90). He had posted a cartoon earlier in the day, however. *The Church-Going Bell: Sunday Morning, Coast of Norway*, a drawing made on 6 July, showing Norwegians in traditional costumes rowing to Church across the Sogna Fiord, was published on 2 August (fig. 82). For this cartoon Sambourne was able to combine one of his drawings of a mountainous landscape with a more detailed study of a rowing boat and its occupants.

Responding to Burnand's demand to "send something funny", Sambourne declared that this drawing was "very humorous … a pretty peasant woman in a boat – '*belle,*' you see …. The idea of people going to Church in a boat!"(P. 9.8.90).

The rough sea on the voyage to Stockholm made even Sambourne feel "most uncomfortable" and he feared that his camera might be damaged (D. 22.7.90). On their arrival, the usual round of sightseeing followed. Sambourne, with a bad headache, was not in the best humour. "Nothing much [was] worth seeing" and lunch at the Cosmopolitan was "dear & bad" (the high prices in Sweden continued to be a cause for anxiety) (D. 24.7.90). Marion found the royal apartments "distinguished only for bad taste, carpets hangings etc atrocious".[8] There were problems over tips, and, to make matters worse, Goldie, Sambourne's regular companion on the boat and on shore, was leaving the party.

"THE CHURCH-GOING BELL."
SUNDAY MORNING, COAST OF NORWAY.
(*By Our Yachting Artist.*)

Fig. 82 *The Church-going Bell: Sunday Morning, Coast of Norway, Punch,* 2 August 1890

After this bad start, Stockholm improved, although the pictures in the Nationalmuseum were rated "poor" (D. 26.7.90). As was his practice in other cities, Sambourne visited shops selling photographs, adding to his collection of prints of local scenes and costumes, together with some Swedish nudes. Two months later, his memories of Stockholm appeared in *Punch* in the last of his 'Yotting Yorick' pieces. He describes it as a "stunning place", with "very handsome" girls, "tall, with long legs. Men good-looking also". But food dominates his short article, illustrated with a tiny sketch of a man, who may be Sambourne himself, looking at a smörgås-bord: 'A side-table with caviare Lax, cut reindeer tongue, sausages, brown bread, prawns, kippered herrings, radishes, sardines, crawfish, cheeses. Should spell it "Lax and Snax"' (P. 20.9.90). One highlight of the time in Stockholm was an evening at the Hasselbacken restaurant, "where you dine in delightful little green arbours, and lots of Swedish girls about. Capital dinners, A 1 wine, and first-rate music with full band". The entertainment closed with a firework display (P. 20.9.90).

If Sambourne had brightened up, Mrs Watney was less than happy. She was "upset" with a dinner on the *Palatine* and then "very seedy & upset" at lunch the next day (D. 26–27.7.90). As they left Stockholm for Russia, Sambourne simply noted: "Mrs W oh! Lunch. Most unpleasant about food etc. etc. Wretched dinner Mrs W. Rows all round" (D. 29.7.90). The Admiral and Miss Clarke were "in consultation" with Mrs Watney, who was "very upset & still in cabin" (D. 30.7.90).

On 31 July they passed by the naval base of Cronstadt on the Neva, and the golden dome of the Cathedral of St Isaac in St Petersburg soon came into sight. St Petersburg was popular with late nineteenth-century tourists from western Europe and America. At first sight the city proved another disappointment: "1st impression of Russia. Droskys. Dirty. Pushed M off pavement" (D. 31.7.90). To Marion herself the Russians looked "quite different to any people I have yet seen. Slav or Tartars, morose stern-looking big and broad".[9] An old woman looked sus-piciously at an English sovereign, usually accepted anywhere. Sambourne's diary frequently refers to the "nuisance" of "passports & kopeckking attendants" at the museums and to drivers dissatisfied with payments or gratuities (D. 4.8.90). Putting a small sketch of a Drozhky driver into *Punch*, Sambourne asked: "Not unlike old toy Noah's-Ark man, eh?" (P. 16.8.90). Beggars and drunkards were a hazard in the city streets and he noted in *Punch* that the Russians were not "ill-

favoured but ill-flavoured, that is, in a crowd" (P. 16. 8.90). As late as November 8 1890 he was still expressing his dislike both of Drozhky drivers and 'Arries in a cartoon of *'Arry in St Petersburgh.* "Arry, clad in tweed plus fours and deer-stalker hat, stands with his hand outstretched trying to make a large and out-raged droski driver understand that he could have gone the same distance in a London hansom cab for less money'.

The British Vice Consul in St Petersburg, James Whishaw, a ship-broker and steamship agent, became a good friend. Sambourne played tennis at his home and a visit was arranged to the family country house in Mourino, set in picturesque country twelve miles north-west of the city. Seeing "wooden houses" and "dirty people" on the journey, Sambourne wanted to capture the effect for himself and seized the opportunity to photograph the buildings and local inhabitants (D. 10.8.90). He regularly refers in diary entries to Whishaw's taking cartridges from him and, when the party left St Petersburg, Sambourne sold him the rest of his supply for £3. 10. 0. Writing his memoirs more than forty years later, Whishaw mis-takenly believed that the visiting cartoonist had been George Du Maurier. A keen hunter of bears, he recalled "purchasing from him a cartridge magazine for two hundred cartridges. I was very keen to get this as such a thing could not be ob-tained in St Petersburg".[10] This was a time of repression in Russia, following the assassination of the reforming Czar, Alexander II, in 1881, and ammunition must have been hard to come by. Sambourne may have intended to shoot duck in the Baltic, but there is no record that he ever did so.

The party's guide to St Petersburg turned out, to Sambourne's evident sur-prise, to be "such a black man" (D.1.8.90). Under his surveillance the Sambournes and Miss Clarke saw St Isaac's and the Guards' Cathedral, where the blood-stained sword and uniform of the assassinated Emperor were a 'must' for all tourists. The black man was dismissed after two days, as a punishment for turning up late for an expedition. He clearly found alternative employment without delay as they saw him "all over the place" (D. 4.8.90).

Sambourne was delighted by the military museum in the Sts Peter and Paul fortress but unenthusiastic about the paintings and sculptures in the School of Art and in the Academy of Arts. He saw the zoo – "Poor animals. Fine lions" (D. 5.8.90) – and the Natural History Museum, set up by Peter the Great and still open to the public today, with its "skeleton of mammoth & hair like tobacco leaves,

not wool. Stuffed specimens & new anatomical museum. Specimens of abortions in bottles" (D. 9.8.90). The Winter Palace with its jewelled chapel and pictorial relics of the Napoleonic wars exhausted him, but he never tired of St Isaac's, with its music and constant human panorama: "Saw little bandy legged child & also man & child in arms kissing icons. Little children nibble their candles" (D. 9.8.90). The Hermitage Museum, with its "wonderful pictures", entranced both Sambournes. A Van Dyck self-portrait struck Linley as "like Oscar Wylde [*sic*]". The only disappointments in the Hermitage were the "poor statues" by the early nineteenth-century sculptor Antonio Canova (D. 4.8.90). The work of Canova has much in common with that of Thorwaldsen, and Sambourne clearly disliked their style of neo-classical sculpture.

The party had met a number American travellers on their journey and in St Petersburg they found more "Yankees", including one gentleman with two daughters: "Pretty one would run up ladder to see dome. Steps up to Cathedral 209+55+256 = 520 steps" (D. 6.8.90). Far less appealing were the party with the American Consul and his wife: "Such bounders. 'Real cute'" (D. 5.8.90).

Mrs Watney did not leave her cabin until they had been in St Petersburg for five days. Sambourne seems to have raised the question of departure with her, for, by the end of the evening, she "would not say goodnight" (D. 5.8.90). Both Dr Barker and Miss Clarke also threatened to leave and the atmosphere became fraught. Marion wearied of Miss Clarke's company and she became, like so many spinsters in the Victorian period, a problem figure.

Matters were evidently patched up, and the party accompanied Mrs Watney on a number of expeditions, including one to Catherine the Great's country palace at Peterhof. Mrs Watney expected her guests to be punctual and when the Sambournes and Miss Clarke emerged from a long tour of the Winter Palace it was to find her waiting for them: "Fat in the fire", wrote Sambourne (D. 9.8.90).

Sambourne's diary gives a glimpse of tourism in pre-revolutionary Russia. Among the visiting travellers in the city was what he describes as a "large party of Cook tourists" (D. 1.8.90). Visitors on a private yacht were a cut above such groups and were able to establish contact with a number of locals. Sambourne met expatriate residents, including Whishaw and Dobson, the *Times* correspondent. At the Consulate he was introduced to Alfred H. Brown of 10 Pall Mall, a naval architect who was doing business in Russia. Sambourne narrowly missed attending the naval review, the

invitation arriving too late. Through his expatriate connections he was introduced to at least one member of the Russian aristocracy, Prince Belakovskiy.

Sambourne barely mentions the political situation in Russia at the time of his visit. Russia was involved in negotiating various treaties with European powers, and was seen as an increasing threat to British interests in India. Sambourne's concern was with internal affairs. He refers briefly, on 12 August, to seeing a "mutilated" *Punch*. This must have been the number for 9 August with Tenniel's cartoon *Nile to the Neva*, a commentary on Alexander III's harsh treatment of the Jews in Russia. Sambourne later told M.H. Spielmann that any cartoon or article dealing with a Russian subject was liable to be censored: "The page was either torn out or erased in the blackest manner by the Bear's paw. I have seen some of Mr Tenniel's cartoons so maltreated, and have myself been frequently honoured in the same way."[11]

Once Sambourne had left Russia he began to refer explicitly to the censorship. In *Punch* he describes the tall Russian soldiers: "If I'm caught making fun of these soldiers, I shouldn't have a word to say for myself!" He tells a (presumably apocryphal) story of having been found inside the chief prison of St Petersburg, the fortress of Sts Peter and Paul, and fearing that he was being mistaken for a Jew. "The Skipper says that he's heard that the persecution of the Jews has just begun again. Cruel shame, but I daren't say this aloud, in case anyone should understand just that amount of English" (D. 16.8.90).

A small sketch shows a short and rotund Sambourne with two huge moustachioed Russian soldiers, one looking at a number of *Punch*. Sambourne reports that he was shown out of the fortress and made his way back to the yacht, thankful not to have ended up in the Siberian mines: "There, that's all over now, and *jamais* will I go and put myself within the clutches of the Russian Bear again". "Neva no more!", is Sambourne's punning farewell to St Petersburg (P. 30 and 16.8.90).

As with the Drozhky drivers, Sambourne did not forget the Jewish issue when he returned to London. His friend Isidore Spielmann was a member of the Russo-Jewish Committee and editor of *Darkest Russia*, a journal which began publication in 1890. The focal issue for the committee was the treatment of Jews under the restrictive 'Temporary Rules' imposed in 1882. In 1892 Spielmann refused to Chair the British Committee for the Russian Fine Art Exhibition because, as a Jew, he would have had to ask special permission to travel to Russia.

Russian subjects continued to appear in cartoons of the early 1900s, including *The Russian Wolf and the Hebrew Lamb*, published on 20 December 1890, of which Sambourne was obviously the author. A bullying Russian in traditional costume (not the Western dress of St Petersburg) is trying to hide an elderly Jewish man from the anxious figure of Dame Europa (see fig. 83). The cartoon, like so many of Sambourne's, is based upon a "well-known Picture", William Mulready's *The Wolf and the Lamb* (1820; Royal Collection), in which a bully tries to hide his victim from the boy's mother. Without doubt this was one of those cartoons which Sambourne told Spielmann had been censored on the Czar's orders. It would appear that he did not choose the subject himself, however. At the *Punch* dinner on 10 December, three cartoons were decided upon, and the following morning Sambourne wrote to ask a fellow cartoonist, E.T. Reed, for the loan of a book with a copy of the painting. He worked for two days and sent it off on Friday 12.

The departure from Russia, originally fixed for 11 August, was delayed for two days because of Mrs Watney's ill health. On 12 August the captain of the *Lady Torfrida*, a British-owned boat chartered by the Russian Admiral in Chief, drove her into the harbour wall. The whole *Palatine* party went out to look at the considerable damage, before going into town to say goodbye to their friends. (The boat must have come off better than the wall, as Sambourne saw her again in the summer of 1893.) The *Palatine* finally left St Petersburg on 13 August, passed down the Neva and sailed out into the Gulf of Finland.

Sambourne, still suffering from an upset stomach, which had plagued him during the last days in Russia, photographed military emplacements and naval vessels down the river. Then, at four in the afternoon, he descended into his wife's cabin and "got to work again after a fortnight's delay. Put in sailors & Lapps of luxury. Break off for tea on deck. Worked till dinner time" (D. 13.8.90). This was the third part of 'Our Yotting Yorrick', recording an imaginary visit to Lapland. Two fur-clad Lapps read *Punch* and two grotesque Lapp children offer drinks to the sailors. In small sketches Mr Punch rides off on a reindeer, or salutes the midnight sun from North Cape. Burnand appears in a small drawing as a gargoyle (or 'gargle'), with the caption, 'Norse Type from rude carving Viking period not extinct XIXth Centy'. "You're always bothering me for something droll, and now you've got it" (P. 30.8.90).

The last days of the Sambournes' voyage on the *Palatine* took them back to Copenhagen. Sambourne collected his letters from the post office, but found

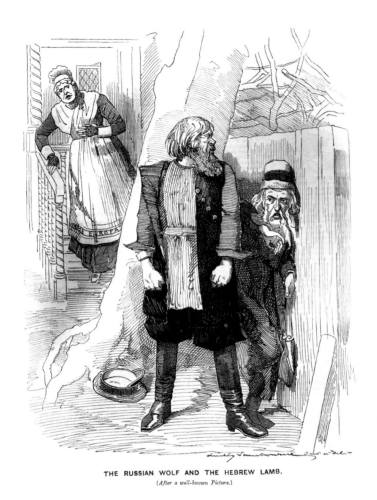

THE RUSSIAN WOLF AND THE HEBREW LAMB.
(After a well-known Picture.)

Fig. 83 *The Russian Wolf and the Hebrew Lamb, Punch,* 20 December 1890

nothing of importance. For all his anxiety to retrieve letters, he usually tore them up as soon as he had looked at them. Next, Sambourne told Mrs Watney that he and his wife planned to leave the boat and return to England. "Did not like it. Dressed. Dinner. Dull evening. Mrs W had boxes locked up" (D. 19.8.90). In the morning Linley and Marion packed their bags: "Mrs W up. Exceedingly disagreeable to M & self about packing. Thought I had lost £1. o. o. Unpacked & found it ….Words with Mrs W about Russian caps …. Mrs W a nuisance. Hung about." Finally they escaped: "Goodbye to Mrs Watney. Hurray!" (D. 20.8.90).

The Sambournes had missed the birthdays of both their children. Sending her brother an illustrated letter on 19 July, Maud expressed her irritation that her

parents would not be there in time for her fifteenth birthday on 5 August, telling him how dull it was without them. The Sambournes had probably planned to be in England for 19 August, Roy's twelfth birthday, and their disappointment may have been a factor in the decision to leave the boat, although, departing when they did, they could never have been home in time for the day itself.

Sambourne's diary reveals how tired he had become of Mrs Watney's petulance. In *Punch*, which she must have read, he complains of the absence of drink between meals, apparently the rule on the *Palatine*. He was anxious about his work and yet another 'worry letter' from Burnand was awaiting him at home. Marion, on her side, was not pleased to have to pack in a hurry, leaving the comfort of the *Palatine* for uncomfortable trains and ferries. "Slow tedious journey" and "horrid steamer", was her verdict, although she was "delighted to see dear chicks" when they reached home on 22 August.[12]

Despite all the personal difficulties and rough weather, the Russian journey was an important event for Sambourne. It introduced him to a very different world, and aroused his social conscience. Though he never expected to return to Russia, the experience had deepened his perspective, a foretaste of the more profound cartoons of his last years.

NOTES

1 'A Full and Complete Guide to the Exhibition', *Punch*, 29 June 1889, p. 317.

2 *Punch*, ditto, p. 320.

3 'Mr Linley Sambourne and the Birds', *Notes and News, Royal Society for Protection of Birds*, IV, no. 3, September 1910, p. 1.

4 Kedrun S. Laurie, '"If I had Wings": Country Writers and the Claims of Conservation', Ph.D. thesis, University of London, 2003, p. 87. I am grateful to Dr Laurie for her help with material on Sambourne and the bird conservation movement.

5 See note 3.

6 Ditto.

7 Shirley Nicholson, *A Victorian Household*, London (Barrie & Jenkins), 1998, p. 108.

8 Ditto, p. 109.

9 Ditto.

10 *Memoirs of James Whishaw*, ed. Maxwell S. Leigh, London (Methuen), 1935, p. 145.

11 M.H. Spielmann, *The History of Punch*, London (Cassell), 1895, p. 194.

12 Nicholson, pp. 110–11.

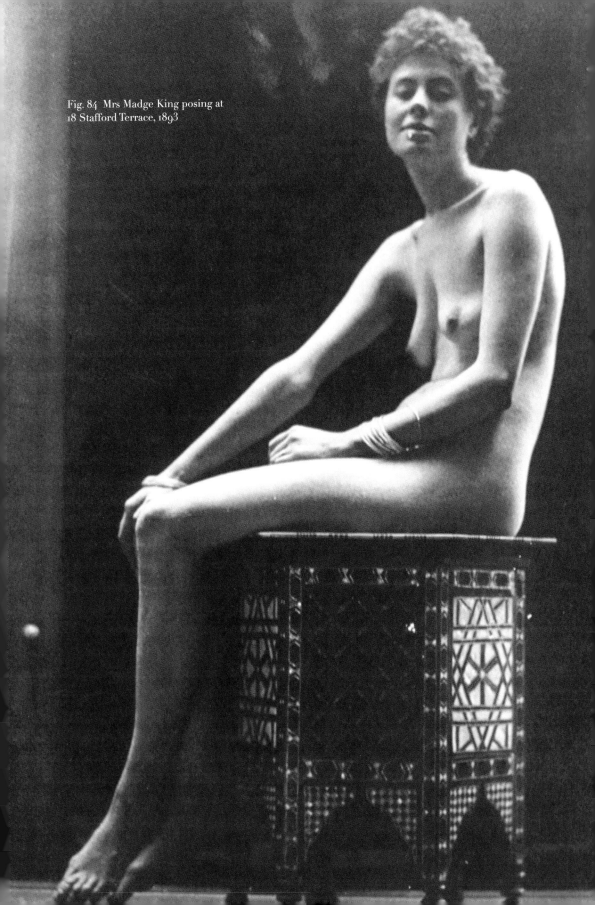

Fig. 84 Mrs Madge King posing at
18 Stafford Terrace, 1893

Chapter 6

The 1890s

An important change in life at 18 Stafford Terrace came in 1892, when Sambourne buried his mother in Highgate Cemetery beside his father and his paternal grandmother. Frances Sambourne had continued her peripatetic existence, staying for weeks or months with relatives in Sheffield, with Mary Worth in Bristol or with Sarah Linley in Ealing. She was taken ill at Bristol in June 1890, and her son hurried down to see her. On this occasion Frances recovered and returned as usual to Stafford Terrace, much to Marion's irritation. Sambourne notes a worrying incident in December 1891, when Frances Sambourne "put dog out & spoke at Mademoiselle [Maud's governess]. Unpleasant" (D. 20.12.91).

In the spring of 1892 it was decided that Frances should move into rooms with Mrs Cox in nearby Edwardes Square. This worked for a time, and allowed her to visit Stafford Terrace for the day and to receive visits. Her son made arrangements to pay for her coal fire, insisting that she kept warm and that she must not worry about the expense. However, he often remarks in his diary that Frances was depressed or crying. In response, he expressed concern for his ageing mother, but did little. He even forgot her eightieth birthday in 1891, so preoccupied was he with his work and his social life. He only remembered the date when sitting quietly on the train, travelling down to a seaside holiday in Christchurch. That his mother had spent the day by herself is apparent from his letter of apology.

In September 1892 Frances decided that she must leave Edwardes Square, and Marion was once more facing a search for pleasant rooms and a sympathetic landlady. In October, without having moved rooms, Frances set out on a visit to her sister Sarah in Ealing. During her stay, on 5 November 1892, Frances Sambourne died suddenly and quietly. Sambourne was much distressed. "Dear Lin terribly cut up",

Marion wrote in her diary.[1] Looking through Frances's effects made him even more unhappy. Frances had died in possession of £25 in notes and £2 in cash. He searched unsuccessfully among his own papers for "one single letter of my poor mother's since 1889" (D. 7.11.92). Finding her last letter to Roy was some comfort.

Two days after the funeral, Sambourne attended the first night of Irving's *King Lear*. In his gloomy mood it might have struck a note with him. His diary records: "Oh dreary play" (D. 10.11.92). At a shooting party with Hamilton Fletcher in the following week there were "many thoughts of my poor mother & regrets had no photo of her at the last" (D. 12.11.92). His distress must have increased when a letter of sympathy from his sister-in-law, Ada Herapath, arrived, expressing thankfulness that Frances had not died in Edwardes Square.

Money matters

Mary Ann Herapath died two and a half years later, after a long period of ill health. Mother and daughter had seen each other very frequently, and Sambourne periodically notes that he and his wife dined in Albert Hall Mansions. Marion, devastated by her mother's death, found herself at a financial disadvantage once more, as, unlike her brothers and sisters, she was unable to access the capital from her parents' estate. Given Sambourne's financial circumstances in 1874, Mr Herapath may have wished to protect Marion's inheritance and so laid down in her marriage settlement that she must access her income through appointed trustees. However, now that her father's estate (in trust for her mother's lifetime) was divided among his children, Marion's income was increased and her money worries somewhat relieved. That she took her finances seriously and managed her own affairs as far as she could is clear from Marion's diaries, with their careful lists of her investments on the back pages.

Through the 1890s Sambourne continued to buy furniture and introduce changes into the house. Far more relaxed about money than his wife, he was slow to pay his bills. Sugg, whose lamp Sambourne proudly showed off to a journalist, was kept waiting for payment and Theo Puzey, who worked for the Stafford Terrace builder Walter Nash, recalled that:

> Linley Sambourne never once settled up his account. It was rendered
> quarterly and he would never query any item, probably never looked at [it]

again after opening – and when sometimes in Autumn when work was at its highest and wages had to be found each week I could always write and ask for a 'cheque on account' – Back would come a characteristic reply always in the two coloured inks – 'Dear Nash. I do not make profits from others [sic] labours but work with my own brain and create, but here is a cheque for £30 on account.' Always for £30 because that was his payment from 'Punch' for his cartoon.[2]

Not all creditors were as long-suffering as Walter Nash. In July 1896 Sambourne wrote, with considerable irritation, to a solicitor, complaining that a summons had been taken out against him for an unpaid bill: "I hardly know exactly what the small balance is & in no way can there be any occasion for either Messrs Yates Haywood or yourselves to rush into serving a summons & for such an amount. I wrote on the first opportunity I had …. I hardly think you have acted with even common courtesy to any one as well known as I am."[3] This threatened summons was not a unique event. Sambourne does not even allude to it in his diary, suggesting that the matter was of no great importance to him.

Sambourne had begun to use cheques to pay his bills, and would receive a bankbook with a statement from Mr Lemon of the London and County Bank at the eastern end of Kensington High Street. He bought and sold shares, recording the transactions in his diary. Railway shares remained a favourite purchase, bringing with them the advantage of free travel. However, these acquisitions were not always to his advantage: "Terrible news of L.C.& D. Rly" came in July 1897 when the company paid only one and a quarter per cent to their shareholders (D. 22.7.97). After hearing these tidings, on a Thursday, Sambourne was so upset that he could not work. He only completed the cartoon at 2.15 pm on Saturday, an exceptionally late hour.

After some hesitation, he sold his investments in Apollinaris mineral water. Like George Du Maurier, he had worked for the firm, designing advertisements and labels, and he may have been paid in shares. When money was particularly short, Sambourne would return to the Hans Andersen drawings for Macmillan. After a brief flurry of activity, however, he gave up the project once again. At these difficult times he would express relief when Burnand asked for a second drawing, thus increasing his *Punch* income for the month.

Roy and Maud

Roy's school fees were a major outlay. Roy left Albion House, his preparatory school in Margate, in 1891, destined for Eton. His parents had hoped that he would win a scholarship, but, although he could do well in class if he exerted himself, Roy was more interested in sports than lessons, and the full fees had to be found. Once at Eton, Roy was a constant anxiety. He did not apply himself to his studies and his reports were usually poor. In October 1893 his housemaster, Mr Ainger, informed the Sambournes that Roy had been briefly arrested by the police for throwing stones and, a little later, he was nearly suspended from school for smoking. Sambourne's diary sometimes mentions Roy's rude behaviour in the houses of his parents' friends. There were compensations. The Sambournes enjoyed the glamorous aspects of Eton life, always attending the Fourth of June celebrations, usually on the river launches.

After leaving school in 1897, Roy spent some time at a crammer's, Mr Scooles, before taking the entrance exam for Oxford. He failed to gain entry to Christ Church or Magdalen, but eventually, after extended negotiations, he was admitted to University College in January 1898. Sambourne loved visiting Roy in Oxford, and Marion was charmed by the town and by the sight of her son in cap and gown. As in his schooldays, Roy was a far from model student. His tutor, Harold Davies, explained that Roy had come to Oxford hoping for no more than a fourth-class degree, but insisted that he would do better, "provided he does not relapse into a spasmodic way of working".[4] Davies recommended a teacher who could encourage pupils to work harder. Davies's efforts were, however, un-availing. His parents hoped that he would become a lawyer, but, when Roy left Oxford in 1900, it was, to their dismay, without a degree. He had not neglected all opportunities, however. Roy made many friends, some of them wealthy enough to cover his expenses.

Maud, in contrast to Roy, gave very little trouble as she entered upon adult life. She would sometimes draw with her father, and found outlets for her work as an illustrator. With her mother as chaperone, she organized contracts with pub-lishers. Maud's style is characterized by elegance and charm. Fascinated by the Linleys of Bath, she liked to draw young women in eighteenth-century costume. Sambourne proudly showed off her work at the *Punch* table and she contributed some drawings to her father's magazine.

Fig. 85 Maud Sambourne, 1895

Unfortunately for Sambourne, Maud 'came out' into society and needed expensive new clothes at the very time when Roy's school fees had to be paid. At first she was invited out in company with her parents, but her charm and beauty soon won her friends like Sylvinia Rose Innes, with whom she dined and made expeditions to the theatre. Maud led an active social life, attending balls and visiting family friends, including the Vernon Watneys and Sir Alexander and Lady Henderson of Buscot Park.

Maud was admired by many, among them P.J. Blair, a young man from Edinburgh, whom she had met while staying with the Galbraiths at Ayton Castle. There were a number of suitors, but Blair and Leonard Messel, the son of friends of the Herapath family, were the most persistent. Blair proposed to her in 1895 when she was twenty. He was rejected and firmly told that Maud was not thinking of marrying him or anyone else. A year and a half later, in May 1897, Leonard Messel, a stockbroker like his father, following the etiquette of the day, approached Sambourne with a formal proposal for her hand. Maud, a good friend of his sisters, told her father that she did not wish to accept, but she kept

her options open. A letter from Sambourne to Lennie explains that Maud's parents had no personal objection to him but that he could not allow his daughter to marry into a family where "there would not be even more than the ordinary cordial reception". The young man had evidently offended Sambourne's *amour propre* in some way, provoking an uncharacteristically pompous explanation: "This is warranted by her qualifications to say nothing of my own position in Society and the World".[5]

Over the next months, Lennie continued to approach Maud's parents, both by letter and in person. Marion evidently liked the serious-minded young man, although Sambourne, who was less enthusiastic, sometimes thought that Lennie talked too much. Marion wrote in her diary: "Poor boy feel v. sorry for him, but it cannot be thought of for many reasons".[6] Maud was not too young to marry, but Marion may have felt that the Messels were too wealthy, out of the Sambournes' league. Given the Sambournes' many Jewish friends, the Messels' German-Jewish origins were unlikely to have worried them and Lennie's father had, in any case, changed his faith upon marriage. For a time the Sambournes declined to see Lennie, protecting Maud from the intense pressure. Eventually, however, encouraged by Marion, Sambourne agreed to sanction an unofficial understanding between the two young people, although he insisted that no formal engagement was to be entered into until the autumn of 1897.

Sambourne was deeply embarrassed by his meeting with Lennie's father: "Disagreeable interview with Mr Ludwig Messel about Mite [Maud] & Lenny. Lasted 20 minutes. A sort of settlement" (D. 13.7.97). From Messel's point of view, the lack of a satisfactory dowry was an issue, and the Sambournes continued to fear that, given their financial circumstances, Maud would not be welcome within the Messel family. Lennie, however, reassured them on this point. Maud hesitated through the summer before accepting the proposal. When the engagement was announced in October, Blair, the rejected suitor, followed her into church and insisted upon having it out.

The wedding was arranged for 28 April 1898 at St Mary Abbot's Church, Kensington. While she and her mother shopped for her trousseau, Sambourne bought silver and jewellery for his daughter. On the day itself, there was a panic when the dress was late in arriving, but all was well and Sambourne drove to church with Maud, noting that she was "behaving well & looking charming"

(D. 28.4.98). The ceremony was at three o'clock and, with the reception at the Royal Palace Hotel, the whole occasion was over by five o'clock, a brief event compared to those of today. There was a long guest list and Sambourne reports borrowing £3000 in July 1897. This whole sum is unlikely, however, to have been needed for the wedding expenses. While the newly married couple set out on their honeymoon by the Italian lakes, the Sambourne family went into the West End on a bus to see J.M. Barrie's *The Little Minister* at the Haymarket Theatre.

On their return from honeymoon, the Messels moved into 37 Gloucester Terrace in Bayswater, north of the park. Many visits were exchanged between the two households and the Sambournes' first grandchild was born at 18 Stafford Terrace on 31 August 1899. During a tense morning of waiting, Sambourne took Lennie for a walk, and was then delighted to find Marion nursing the newborn baby on their return. The boy was christened Linley Francis in October, a compliment which delighted his grandfather. A few weeks later the Sambournes reached their silver wedding anniversary, making this a year of family celebrations.

Health

Health was a constant preoccupation for Sambourne, as for so many Victorian diarists. There were heavy colds, attacks of influenza and liver and stomach problems. His left nostril periodically became inflamed. He was aware that he ought not to put on too many pounds, and often recorded his weight before and after taking his Turkish bath, once expressing horror that it had crept above thirteen stone. In the mid 1890s, however, his diary refers to a problem with haemorrhoids (piles) and "P. very painful" becomes a frequent entry. After years of discomfort he submitted to an operation, carried out at home on 4 March 1899 by Dr Pepper from Wimpole Street, with the help of the family's general practitioner, Dr Orton. Home operations were a feature of the period: Roy had been operated upon at 18 Stafford Terrace for the removal of his tonsils. Marion tried to conceal from her husband the fact that a nurse had been installed the night before his operation, wisely, it seems, for Sambourne was greatly annoyed when he found out. (Later, he took a considerable liking to Nurse Varnham.) "Like an execution," was his comment on the preparations (D. 4.3.99), and he was unconscious with chloroform for one and a quarter hours.

The operation was successful, and, after several painful days (though no more severe than what had gone before), Sambourne was allowed up. He remained at home for three weeks, contributing nothing to *Punch* during that time and not attending the dinner until 12 April. When he did return, after an absence of six weeks, his colleagues drank his health, but he was still "intensely disgusted & annoyed" by their lack of attention. The cause of complaint seems to have been the long discussion of Tenniel's cartoon subject, while Sambourne's was left undecided. "Getting tired & weary of playing 2nd fiddle all these years and wish I could get out of it," had been his reaction on another such provoking occasion (D. 5.1.98).

Sambourne's physical discomfort had been exacerbated when he rode a bicycle. Roy took up the sport in the 1890s, and his father decided to follow him. Although he always claimed that he had tried cycling in Paris in the 1860s, his first recorded ride with a modern machine was an experiment with a tricycle in 1893. He evidently found it hard to master and knocked down a little girl on the Fulham Road. The child was not badly hurt, but he had to give his name and address to a policeman and a tip to a labourer, who promised to take her home. A second cyclist offered his details should a witness be needed. On the following day, the girl's father appeared in Stafford Terrace and was given half a crown, which seems, fortunately, to have settled the matter.

By July 1895 Sambourne had acquired his own bicycle and, after six weeks of lessons, he threw himself into the sport with all his customary energy. The 'safety bicycle' with pneumatic tyres had first become available a decade earlier. At the time Sambourne cursed the spreading craze as cyclists disrupted his equestrian rides, either blocking the path or brushing past and frightening his horse. Now he was to be seen in the mornings, bicycling through the streets of Kensington rather than riding in the Row, as his horse riding was steadily, although not entirely, eclipsed. His cyclometer recorded that, by January 1896, he had covered a thousand miles in six months, and by April 1899 the figure was five thousand miles. The routes were often much the same as those he had taken on horseback, Hampton Court and Richmond, for example, with lunch at an inn and conversations with fellow bicyclists. Roy was sometimes his companion, but never Marion, who tried to learn the skill but could not master it.

Not long after the purchase of his own machine, Sambourne introduced a bicycle as a motif for the heading to Volume 109 of *Punch*, showing Mr Punch and three

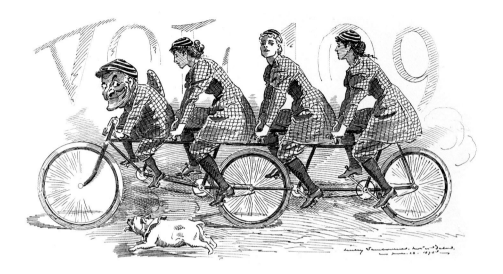

Fig. 86 Heading for *Punch*, vol. 109, 1895

young women on a three-wheeled cycle (fig. 86). For this he photographed Miss Cornwallis, both nude and clothed, for three hours, seating her on what seems to be a draped stool and noting in his diary that she was a "plain woman" (D. 15. 6. 95).

Once the cycle had been acquired, Islington and Lloyd Square became places of pilgrimage and Sambourne began to write down his memories of familiar scenes in the area. The square itself seemed shabbier than it had in his childhood, but the bell which his aunt Ann used to ring was still there beside the New River. One ride took him through Holloway and up the hill to Highgate, where he made notes on the position of the family grave, anxious not to forget its location.

The bicycle was for use in daylight. On his way home from London at night, Sambourne often used the horse-drawn buses which ran from Piccadilly and Hyde Park Corner. We catch a glimpse of these bus journeys in a letter which was published in *The Times* on New Year's Eve, 1896. A correspondent had complained that, catching a "pirate" bus from Hyde Park Corner on Christmas evening, he had been charged sixpence instead of the usual penny. He drew particular attention to two young servant girls who were much upset by the additional expense. Sambourne responded with an account of a similar journey on the same evening for which he

had been charged twopence. He was told that the two regular companies had closed down at six o'clock, and that extra wages had to be paid to staff working late on a holiday: "I should have thought (it being Christmas Day) that most people would have appreciated the convenience of being helped on their way even at a trifling extra cost," he wrote, noting that none of the bus companies had a legal monopoly and that the 'pirate' buses, which he often used at this time, were usually faster and more relaxed.

Photography

Sambourne's passion for photography continued to develop. With the ending of his arrangement to take photographs at Edwin Abbey's studio, he was forced to look elsewhere. Marion's dislike of photography and of the household disruption it caused has been noted by a number of writers: "Her ... diaries are littered with irritable notes: 'Lin at those everlasting photos' ... 'More of those hateful photos' ... 'Lin busy with photos, in & out, curtains taken down for it'."[7] Sambourne's diary reveals a few occasions when models came to Stafford Terrace. There were two dates in 1892 when his wife was at home. Then, on 8 March and 16 March 1893, in the absence of Marion, who was in Ramsgate, Sambourne posed his nude models on the Moorish table which still stands in the morning room. This was hardly a satisfactory arrangement, given the ubiquitous presence of household staff in a Victorian middle-class home. A month later he found a solution by joining the Camera Club in Charing Cross Road, where he could reserve a room for his work. The first woman whom he photographed there was Kate Derben (who had come to Stafford Terrace). It was through her that he met Mrs Madge King, a favourite model (see fig. 84, p. 204). Others, their names and addresses listed in the front of his diary, were Annie Green and Ada Fletcher. Martin Postle has shown that there was a network of artists' models in London, and that they would pass on the names of friends to their employers. They moved frequently and, "far from being random fallen women, compelled to model as an alternative to prostitution or penury, had by now begun to form an organized professional network, marketing their collective services by word of mouth and via established contacts".[8]

There has, inevitably, been much speculation about the nature of Sambourne's relations with his models. To Mary Ann Roberts his terse comments on "their flaws and attributes" in his diaries – "good figure", "long, slim legs", "ugly and stupid",

Fig. 87 Maud Easton posing, 1891

"good hands", "much deteriorated", and so on – mean that "many of the nude photographs amount practically to images of misogyny".⁹ Martin Postle rightly responds by noting that Sambourne's diary entries are generally little more than notes or lists. Few of the nude photographs are particularly stylish or artful. They are what they purport to be, photographs of nude women. Although some show models with their legs open or in provocative poses, they bear little relation to the titillating commercial pictures which were circulating at the time. Martin Postle has identified Maud Easton (fig. 87), who posed for Sambourne between 1891, when she was nineteen, and 1893, as the subject of the "most sexually explicit" of the photographs.¹⁰ A number of the nude studies of her, lying on a table or draped over a chair, were taken at Abbey's studio in 1891 but she is often shown at least partially dressed. Alison Smith notes that Sambourne was "particularly interested in the way classicists such as Leighton and [Albert] Moore adopted the ancient Greek convention of *draperie mouillée* both to reveal the underlying figure and to express states of agitation and relaxation".¹¹

Many of these photographs relate directly to Sambourne's work as an artist, but by no means all. If they found their way into *Punch*, it was for the stylized

'Almanack' drawings and the introductory headings rather than for the male-dominated political cartoons. That his elegant women were appreciated by *Punch's* readers is evidenced in Sarah Grand's novel, *The Heavenly Twins*, published in 1894. The incorrigible twins, Diavolo and Angelica, enjoy looking at the magazine with their tutor, Mr Ellis. As part of their unconventional education, he contrasts the "bulging vulgarities" of Charles Keene, the "classical purity of figure" of Tenniel and the "attenuated forms of women as they are" in the cartoons of George Du Maurier with "Linley Sambourne, that master of the lovely line, [who] pointed the moral by drawing women as they should be".[12]

Work at *Punch*

Punch continued to be the main source of Sambourne's income and he watched his accounts very carefully. He was paid a regular sum for his work on the paper, which basically consisted of a minimum of one cartoon a week. However, William Bradbury had decided in October 1891 that Sambourne should be paid separately, not only for the 'Almanack', but also for the extra work involved in the headings and tailpieces to the volume, the preface and the index. He had taken over this work, unpaid, on the death of Charles Keene. The first such cheque was sent at the end of March 1892. In June 1892 Sambourne was paid fifteen guineas for the heading illustration for the preface to Volume 102 and five guineas for the tailpiece. For the index the figures were ten and five guineas, with ten guineas for the heading for Volume 103. Unfortunately, when Sambourne next sent in a statement, for the same amount, in August 1892, Bradbury was unwell, and the invoice was queried. Sambourne replied saying that he had been paid for the 'Almanack' or Christmas number for many years past, and that this further account was based upon the same scale. From 1883 through the later 1880s and 1890s regular sums of £100 were paid into his bank account on the first of every month. In the year from June 1897 to June 1898 this, with extra payments for extra drawings amounting to £194. 5. 6., gave him an annual income from his *Punch* work of £1394. 5. 0. In addition he was earning money from outside commissions and from the Barr estate.

During the 1890s Sambourne was sometimes asked to draw cartoons on social issues. These gave him greater opportunities for the exercise of his talents than his political work. A fine example is *Death Insurance*, an attack on those who were offering fraudulent insurance policies to the poor. In an exceptionally dark design,

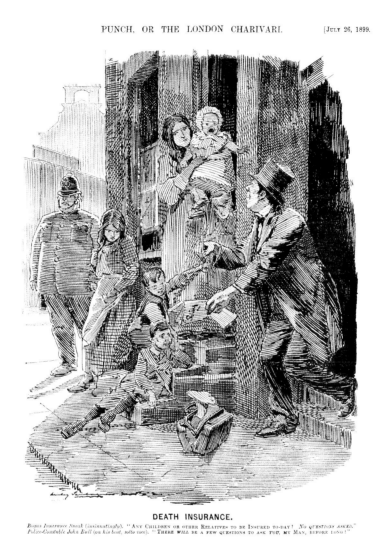

DEATH INSURANCE.

Bogus Insurance Sneak (insinuatingly). "ANY CHILDREN OR OTHER RELATIVES TO BE INSURED TO-DAY? *NO QUESTIONS ASKED.*"
Police-Constable John Bull (on his beat, sotto voce). "THERE *WILL* BE A FEW QUESTIONS TO ASK *YOU*, MY MAN, BEFORE LONG?"

Fig. 88 *Death Insurance, Punch,* 26 July 1899

a woman stands on the steps of her slum home with her four children around her. On the left a 'Bogus Insurance Sneak' tries to get her to sign up, saying 'No questions asked', while, on the right, is 'Police-Constable John Bull' (on his beat, *sotto voce*), saying, 'There *will* be a few questions to ask *you*, my man, before long!' (P. 26.7.99; fig. 88). For this cartoon Sambourne rode through the area on his bicycle, looking for a suitable dwelling to photograph. Then he posed his groom, Otley, for the insurance man. "A boy & his baby" were recruited for the children

(D. 20.7.99). An existing photograph presumably sufficed for the policeman. Sambourne occasionally called in the local constabulary in order to give greater authenticity to his cartoons. He told an interviewer in 1893: "I may want a policeman – perhaps you know how rarely a policeman is drawn accurately – well, I turn to this drawer, and in a quarter of a minute I can put my hand on dozens of photographs of a policeman."[13]

A more dramatic example of the darker side of Sambourne's work is *The Devil's Latest Walk*, where the devil appears as an anarchist, standing in front of one of Edwin Landseer's lions in Trafalgar Square and about to throw a smoking bomb. The National Gallery and St Martin in the Fields are behind him and an encircling mob raise their hands in support (P. 3.3.94; fig. 89). A trembling window cleaner, scarcely able to keep his balance, posed for the devil on the Sambournes' garden wall. Privately, Sambourne called this cartoon "The Devil as Labourer". He wrestled with the expanse of sky behind the dominant figure, making alterations and adding looming cloud.

The occasion for the cartoon was the violent death of Martial Bourdin, blown up by his own bomb in Greenwich Park on 15 February 1894. The bomb, probably destined for the Royal Observatory, had been given to Bourdin by his brother-in-law, H.B. Samuels, who may have been a double agent, working for the police to arouse public fury against the anarchist movement. Three days earlier an anarchist had thrown a bomb into a restaurant, killing one person. The Bourdin story caught the imagination of the novelist Joseph Conrad, whose *The Secret Agent* of 1906–07 draws upon what was known as the 'Greenwich Park outrage'. Bourdin's funeral, held at Finchley Cemetery on February 23, was disrupted by violence when an anarchist tried to make a speech and had to be protected from an angry crowd. Sambourne's diary reads: "Funeral of Bourdin. Mob hooted the anarchists" (D. 23.2.94).

The growing women's movement was a current issue which *Punch* felt the need to tackle. As the century drew on cartoons on the subject became frequent. Many were the work of George Du Maurier, commentaries on the incursion of outspoken women into polite society and (potentially) the professions. In a Sambourne cartoon of 21 March 1896, *Ladies not admitted*, the classical goddess of wisdom and learning, Minerva, bespectacled and complete with helmet and owl, tries to enter an Oxbridge college, only to be find her way barred by a grim-faced don. 'Very

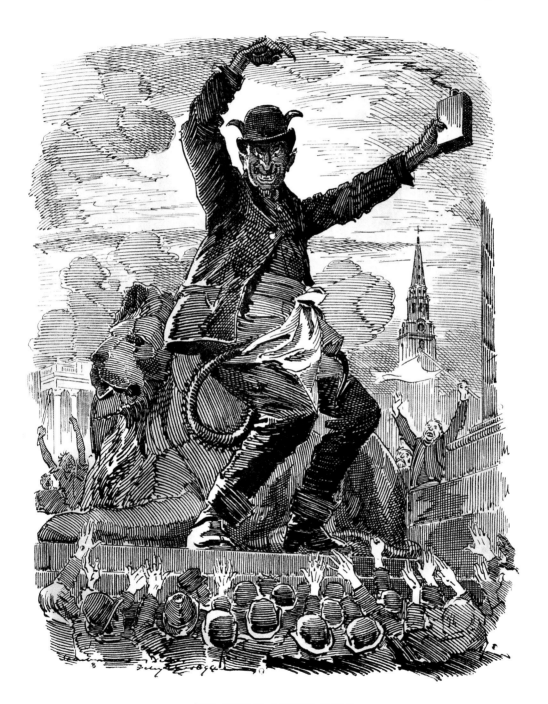

THE DEVIL'S LATEST WALK.

Fig. 89 *The Devil's Latest Walk, Punch,* 3 March 1894

sorry, Miss Minerva, but perhaps you are not aware that this is a monastic estab-
lishment.' This marked the rejection by both Oxford and Cambridge of proposals
to admit women students to the BA degree.

The political movements by which campaigners sought to achieve equality
were frequently the target for Sambourne's cartoons on the 'woman question'.
Gladstone's nervousness over the Women's Liberal Federation resulted in a draw-
ing of the Prime Minister as Georgie Porgie, running away from a threatening
group (P. 11.6.92). In another drawing two determined women cricketers, with
'WLF' on their shirts, demand their own team. Their faces show their scorn for the
cowering Gladstone, who dithers at the wicket, ineptly wielding a bat labelled
'Suffrage'. Maud Sambourne and her friend Maud Paxton were the originals of
these dominant females (P. 28.5.92).

Maud Sambourne was called into service again for two far more sympathetic
cartoons dealing with the conditions under which young women were forced to
work. Teaching and serving in shops were among the only careers open to women
in the cities and these cartoons take up the cudgels on their behalf. *Her 'Day of Rest'*
puts the case for the exhausted shop-girl, the object of a contemporary debate on
the weekly early-closing day for shops. In a drawing echoing the work of the illus-
trators of the 1860s, particularly John Millais, the girl is shown draped wearily over
a sofa. For all the relevant title, it cannot be a complete coincidence that a volume
of a famous Victorian illustrated magazine, *The Leisure Hour*, has dropped from her
hand (P. 8.4.93; fig. 90). A parallel drawing of a year later shows an exhausted young
school-teacher of the 1890s fast asleep at her desk, while a contrasting and pleas-
ant scene of 'The Village School: Old Style', complete with an elderly dame, ap-
pears in a dream above her. The accompanying text tells us that 'To-day the scene
of the village school-mistress's labour is, as often as not, one from which bright-
ness and beauty seem for ever banished, and one calculated to depress the spirits
of the most dauntless' (P. 7.4.94).

For one defence of exploited young women, Sambourne posed himself as
a 'Sweater', clutching an umbrella with a death's-head knob, and wearing a tie
decorated with another skull. The cartoon, *Business!*, takes up the issue of the
underpaid and overworked girls who made and sold matches (P. 13.12.90). The
cartoonist may have felt particular sympathy with these exhausted young
women, as, no subject having arrived by 2.30pm on this particular Friday, he

HER "DAY OF REST."
(The Song of the Shop-Girl.)

Fig. 90 *Her Day of Rest,
Punch*, 8 April 1893

was forced to send his groom to Burnand for instructions, and then to work flat out until 11.00 at night.

A late Sambourne cartoon, published on 1 January 1908, marks a decided change in the intensity of the women's campaign. A ski-jumping suffragette leaps into the air on skis labelled 'Agitation' and holding a 'Votes for Women' flag. Miss E. Huxley was the model for a series of photographs taken on Christmas Eve. Sambourne then worked through Christmas Day, dining by himself, and finished the cartoon at 3 o'clock on Boxing Day. The task completed, he took a train from Waterloo and re-joined Marion at a shooting party held by Hamilton and Ada Fletcher at Leweston Manor, an eighteenth-century house near Sherborne in Dorset. This attractive and dynamic cartoon, *Leap-Year; or, the irrepressible ski*, represented a far from hostile

PUNCH, OR THE LONDON CHARIVARI.—January 1, 1908.

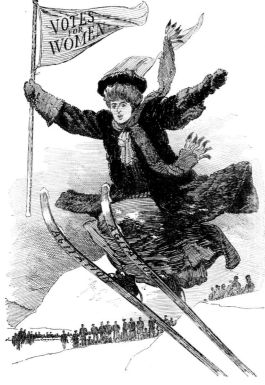

LEAP-YEAR;

OR, THE IRREPRESSIBLE SKI.

LEFT
Fig. 91 *Leap-Year; or, The Irrepressible Ski, Punch,* 1 January 1908

RIGHT
Fig. 92 *The Smells. (Edgar Allan Poe "Up to Date"), Punch,* 1 November 1890

commentary on the increasing militancy of the women's campaign (fig. 91). Later in the same year Emmeline Pankhurst was imprisoned in Holloway Jail for the first time. In the following year Sambourne had personal experience of a suffragette, when one shouted at a Foreign Office reception (presumably outside).

Sambourne, very much a Londoner, was familiar with the changes taking place in the city. In the early 1890s, when the formation of the London County Council was in the news, he was called upon to draw a number of cartoons on the state of London and its management. *The Smells: (Edgar Allan Poe "Up to Date")*, a skit on 'The Bells', is an attack on pollution, which hovers like a phantom over the streets and houses (P. 1.11.90; fig. 92). Sambourne's anthropomorphism is to the fore in *An Old Fable.* The new London County Council is shown as a frog challenging the old entrenched bull of the City of London: 'I mean to be as big as you, one day, and swallow you up. Bust if I don't!' (P. 1.2.90).

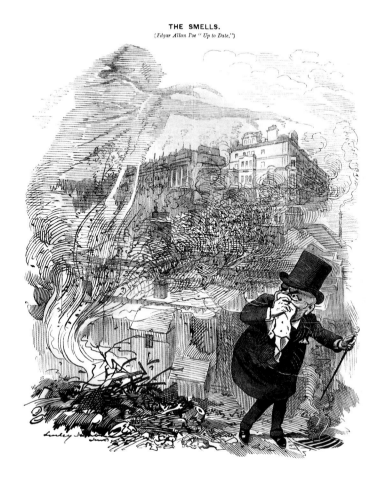

THE SMELLS.
(Edgar Allan Poe " Up to Date,")

Electricity and speed were the subjects of numerous cartoons. The end of broad-gauge railway lines, the threat of railway development in the upper Thames valley, five-day Atlantic crossings and the connection of the telegraph to Britain's lighthouses and lightships were all subjects for which the imaginative Sambourne was ideally suited (P. 4.6.92; 26.2.98; 20.8.92; 28.11.91). In one drawing a householder stands on the cartoonist's own doorstep, while an urchin electric light tries to get in. 'Ah! You're a little too dear for me – at present' is the reply, one with which Sambourne must have sympathized (P. 29.8.91; fig. 93). He was personally affected, both as horse rider and cyclist, by the developments on London's streets. A cartoon of 1895, aptly entitled *The Survival of the Fittest*, finds the artist turning back to his old style for a drawing with multiple small scenes (fig. 94. Two horses, one a shire horse and the other employed in pulling hackney carriages, look on at various signs of the times clustered around them – a big wheel, bicycles, a delivery tricycle, a

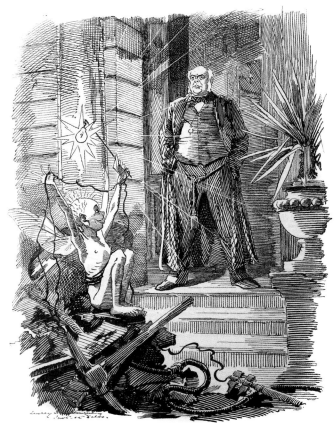

AT THE DOOR; OR, PATERFAMILIAS AND THE YOUNG SPARK.

Electric Light. "What, won't you let me in—a dear little Chap like me!"
Householder. "Ah! You're a little too dear for me—at present."

mechanical horse, a steamroller and an early motor vehicle. A factory town with smoking chimneys can be seen in the distance as one horse says, with prescience: 'I'll be shod if they won't do away with us altogether some of these days!' (P. 7.9.95).

Foreign affairs were largely Tenniel's province, and his stereotypes of Frenchmen, Germans and Russians were known the world over. Sambourne was, however, sometimes called upon for an overseas subject. Like Tenniel, although with more flair, he would signal the nationality of his figures, with France as Marianne in a Phrygian bonnet, Russia in an army helmet and Indian and Chinese figures in suitably exotic garb. The subject of one cartoon, *À bas la Vérité*, was the contentious Dreyfus affair, when the French military establishment imprisoned an innocent Jewish man on Devil's Island. Truth emerges from a well, toppling a group of generals in full uniform (P. 3.5.99).

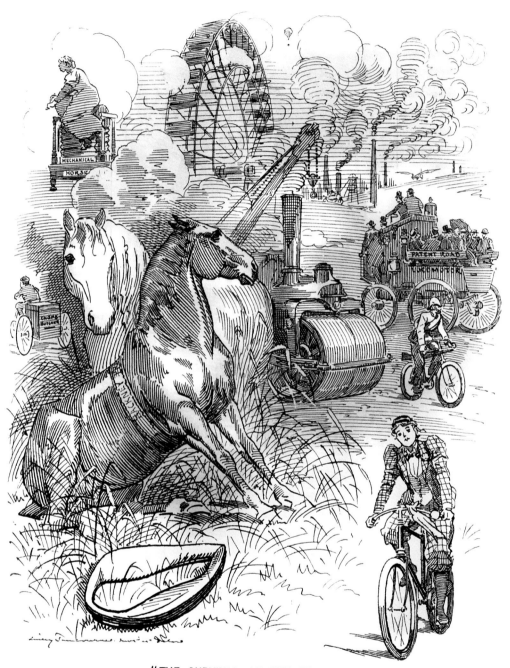

"THE SURVIVAL OF THE FITTEST."

Hackney (to Shire Horse). "LOOK HERE, FRIEND DOBBIN, I'LL BE SHOD IF THEY WON'T DO AWAY WITH US ALTOGETHER SOME OF THESE DAYS!"

Sambourne was becoming an elder statesman of the *Punch* table, a kindly influence on a new generation of artists. His penchant for mixed metaphors was a source of merriment. Bernard Partridge copied down pages of them and Anstey Guthrie published a selection in his memoirs. "There was such a silence afterwards that you could have picked up a pin in it"; "He was trembling like an aspic"; "I didn't care for her [Lady Macbeth] in the street-walking scene"; "It's like looking for an eagle in a bundle of hay", or "Of a certain painter's London studio, which he kept on but never occupied, 'There it is, like a white elephant round his neck!'"[14]

Humour was, of course, the very business of *Punch*, but there are faint indications in Sambourne's diary that he sometimes resented his position as the resident jester. When he uses the word 'chaff', in his brief accounts of the Wednesday dinners, it is nearly always intended to designate some mockery of himself. Guthrie, a good friend, gave the matter some thought in his autobiography:

> He was known to his intimates as 'Sammy', and was often the subject of always affectionate chaff. But as one of them remarked to me once, 'We treat Sammy as a sort of joke, but I'm hanged if I know why. He rides as well as most fellows, he's a first-rate shot, and a good skater, and he can hold his own at tennis or billiards!' Which was perfectly true, but Sambourne would often deliver the naïvest sayings, generally I think with full consciousness of their absurdity.[15]

Guthrie speculates that Sambourne, as a "vivacious talker", expressed "himself in the first words that occurred to him, and when they resulted in bulls or malapropisms, I believe he was as delighted as any of us, for he was by no means as simple as he liked to appear, being really both shrewd and observant".[16]

Punch's half century was celebrated in July 1891. On 18 July there was a jubilee dinner at the Ship Inn in Greenwich, a familiar stamping ground for the original contributors. At a table loaded with flowers, they ate a "Turtle & full fish dinner" (D. 18.7.91). Only Gilbert à Beckett, who died in the following October, was missing from the current staff, and Philip Agnew and Laurence Bradbury, the sons of the then proprietors, came with their fathers. There were speeches from Burnand, William Agnew and William Bradbury, John Tenniel and Arthur à Beckett. Numerous toasts were offered, and a silver cigar-box was presented to Burnand: "It was duly resolved to meet again, the same company in the same place, fifty years hence!"[17]

Sambourne's contribution to the Jubilee celebrations was the best known of his cartoons, *The Mahogany Tree* (fig. 95). The title refers to a poem written for the magazine by W.M. Thackeray, "typically ignoring the fact that the *Punch* table is an unimpressive deal".[18] Sambourne's drawing shows the staff, not at Greenwich, but at the round table in an idealized Bouverie Street, toasting a classically toga'd and laurel-wreathed Mr Punch. Behind the current staff are portraits and busts of their forebears, including the earlier editors, together with Thackeray, Douglas Jerrold, John Leech and Dicky Doyle. A painting of Charles Keene, who had died on 10 January, stands on an easel beside the table.

Sambourne photographed the members of the *Punch* team at 18 Stafford Terrace, and these images, with each raising a glass, are among his finest portrait photographs. Arthur à Beckett believed that it was "far away the best portrait" of his brother, Gilbert, "that we have in the family".[19] By the time of William Agnew's visit, the work was near completion, and Agnew expressed himself "pleased with drawing & house" (D. 27.6.91). It is an indication of the social divide between staff and proprietors that Agnew had never been to Stafford Terrace before. Having gathered his likenesses together, Sambourne worked hard from 20 June to 1 July, when he took the completed design to the weekly dinner and was "complimented on drawing". The proof was shown at the dinner a week later and duly appeared in the Jubilee number of 18 July. The original drawing, having been shown at the Royal Academy in 1892, became the property of Sir William Agnew. *The Mahogany Tree* deserves its fame, not only for the vivid likenesses of the staff, but also for the convivial atmosphere that it evokes, not an easy matter with fourteen sitters.

Not everyone liked the drawing. A sour note was introduced early on when Harry Furniss protested at the way in which he was represented. "Furniss as usual nasty about it," was Sambourne's response (D. 8.7.91). The complaints continued for weeks, and seem to have centred on the fact that Furniss was seen in profile with a rounded back to his head. Sambourne's lack of surprise was predictable since Furniss seized every possible occasion to 'chaff' him, whether about his invitation to dinner with Frederic Leighton, sending his son to Eton, or attending the naval review. Furniss also condemned Sambourne for his use of photography, claiming that he was a "slave of the camera & mere copyist" (D. 30.1.95).

Furniss was habitually jealous of Sambourne, but, in the case of the jubilee drawing, he had some justification, having conceived the idea before his fellow

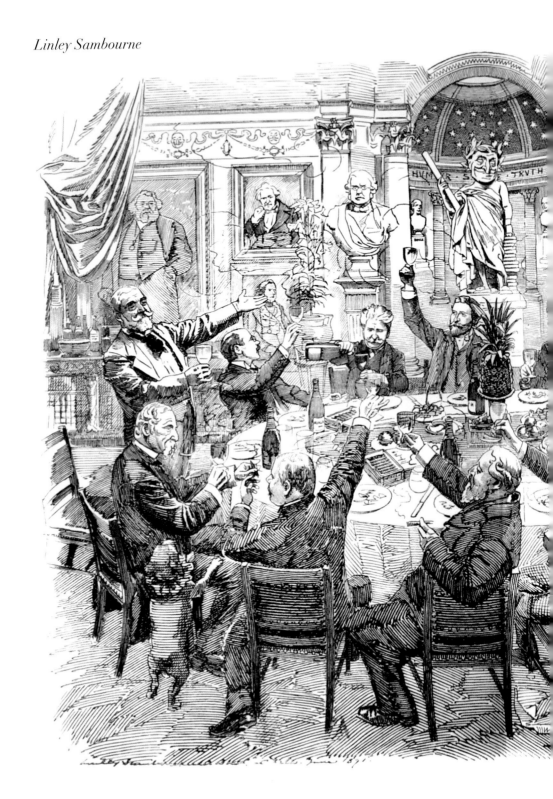

"THE MAHOGANY

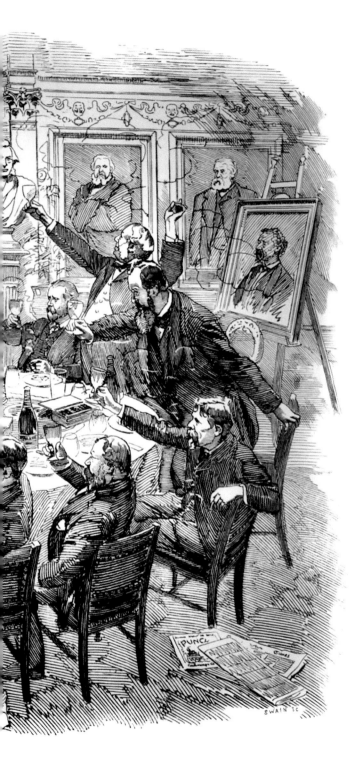

Fig. 95 *"The Mahogany Tree."*, *Punch*, 18 July 1891. Frank Burnand is standing on the left with John Tenniel on his right. Sambourne comes next, then Arthur à Beckett, Rudolph Lehmann, Harry Furniss and George Du Maurier

E."

cartoonist. Furniss had asked M.H. Spielmann to contribute letterpress to accompany his drawings for a special jubilee number, but Spielmann mentioned the idea to Sambourne, drawing down the wrath of Furniss: "What a pity, you spoke so freely to Sambourne! By so doing you placed me in rather an awkward position …. The question of having a Jubilee No of *Punch* was brought up at the '*Punch*' table last night, and Sambourne at once suggested 'doing' the table; with portraits, past and present." Furniss had felt unable to speak out against the plan, "and, as you know, it would have been of very little use my doing so, as, when once an idea is suggested to Burnand, he 'collars' it".[20]. Furniss responded by placing a drawing of the *Punch* table in *Black and White*, a magazine to which Sambourne also contributed. On 19 August Sambourne reported a "great row between à Beckett and Furniss on account of drawing …. Furniss abusive & gross bad taste". He later explained to Spielmann that à Beckett, believing the drawing to be libellous, had shown it to the *Punch* staff, provoking Furniss to lose his temper.

Furniss's bad behaviour was a feature of *Punch* dinners. A talented artist, Furniss dominated the magazine during the years that he spent there. He had sent his work to Tom Taylor without success, and joined the staff only when Burnand became editor. Furniss, nearly a decade younger, replaced Sambourne in two areas which the older artist had made his own. His satirical sketches of Royal Academy exhibits, no doubt influenced by Sambourne's own tiny renderings in the annual Academy cartoons, became famous. Furniss also took Sambourne's place when Henry Lucy demanded drawings from life for the 'Essence of Parliament' column. He was able to draw a likeness swiftly and surreptitiously and his caricatures of parliamentary figures were also legendary. Furniss is said to have invented the notion that Gladstone wore absurdly tall collars, and there are stories of his being threatened by Members of Parliament who were angry at his presentation of them. After the row at the *Punch* dinner, however, the normally fiery artist, although incensed by à Beckett's behaviour, held his hand, fearing that if he resigned from *Punch* he would lose his House of Commons Gallery pass.

Furniss gave his own version of his sparring matches with Sambourne in 1914, after his former colleague's death. Sambourne, he says, was always writing him "bogus letters and sending strangers to me on fools' errands". Knowing that Sambourne worked against the clock on Fridays, Furniss contrived a series of interruptions, including a "bogus telegram in the morning to meet some particular

noble lord at a railway station, for Sambourne to take his pick of the game he was bringing up to town".[21] He sent messages, purporting to come from Burnand, altering the subject of the weekly cartoon. He was arranging for a large box of rubbish to be sent to Stafford Terrace when he was told that Sambourne knew what was happening and begged him to stop. This was the end of the affair, Furniss reporting that Sambourne "never tried practical joking with me again".[22]

Some 'chaff' at Sambourne's expense continued, however. One joke was played on him during a visit to Paris with artist friends. Burnand and Furniss "concocted an invitation from some imaginary art society representing French art". Addressed to "the greatest English artist of the day", the society offered to pay homage to Sambourne.[23] Needless to say, they never appeared.

Furniss was not satisfied with his role on *Punch*, believing that he had been lured into a false position. He expressed his feelings forcefully and Sambourne's diary records private conversations among fellow members of the *Punch* staff, keen to talk over the situation behind Furniss's back. Sambourne, despite everything, remained friendly with Furniss and sometimes walked or rode with him even when the endless airing of grievances became deeply boring.

The end, when it arrived, was sudden. At the weekly dinner on 21 February 1894, Furniss, in aggressive mode, got in a dig at Sambourne for his success in selling drawings at a Fine Art Society exhibition the year before. He did so by pretending to have made £800 from a sale of his own drawings. "[D]on't believe it," was Sambourne's private response. Later he added a note in red ink to the diary entry: "Mr Harry Furniss dined for last time at the Punch table. Left in the middle of dinner saying he was coming back & never did no more." Furniss later claimed that he had left the paper after hearing that his remuneration was to be cut. He had decided some time before to leave the permanent staff and only take payment for drawings actually submitted, a strategy which allowed him to work elsewhere, and which, he calculated, scarcely reduced his pay from *Punch*. Possibly the proprietors had decided to cut the number of drawings which they accepted from him, but Furniss's account is not necessarily to be trusted. He set up his own parliamentary journal, *Lika Joka*, which entered into direct competition with *Punch*, but never achieved the same success. Du Maurier and Bernard Partridge contributed to *Lika Joka* but Sambourne never did. His diary records that he disliked the first number, and perceived shortcomings of the new journal were a frequent topic of

conversation with his friends. Then, on 10 April 1895, he wrote "Lika Joko is dead" in his diary, marking the moment when the magazine went out of circulation. Furniss's place as illustrator for 'The Essence of Parliament' was taken by a younger artist, Edward Tennyson Reed, appointed to the paper in 1889. Sambourne had told a common friend that Burnand was looking for a comic artist. Hearing of this, Reed, who was then in his late twenties, sent a selection of drawings to Burnand and was subsequently appointed.

Nearly two years after the abrupt departure of Furniss, Sambourne himself considered resigning from *Punch*. The cause of this dispute was a letter from Lawrence Bradbury, who had taken over from his father as joint managing director in 1893. At the end of the weekly dinner on 20 November, Burnand, having waited for Sir William Agnew to leave, told the assembled staff that he had received an "insulting letter especially about my [Sambourne's] Almanack work [on classical gods and goddesses] and D.M. [Du Maurier] Great discussion & all agree to stand by Editor's decision & by him". Sambourne summarized this as a "very unsatisfactory state of things" (D. 20.11.95). The following day, Sambourne wrote letters, including one to Anstey Guthrie in which he evidently stated an intention to resign. Guthrie replied:

> You must surely know perfectly well how greatly every member of the staff & all the public whose opinion on any question of Art & Humour is worth having admires & delights in your work & what your retirement from the Table would mean to us all – not to mention the injury it would do "Punch" – & though it is only natural that you should feel deeply hurt & indignant at those unlucky criticisms of L. By's I am sure you will come to the conclusion that they are not worth serious notice at present.[24]

Guthrie was alarmed about the future. Should Burnand resign, he told his friend, he himself would not wish to continue working under a new editor. Guthrie believed that they should both remain on board unless compelled to abandon ship. With that in mind, he burned Sambourne's letter.

A few days later, Sambourne had a long and serious talk on the matter with his wife. Then, at the next *Punch* dinner, with Lawrence Bradbury present, Burnand announced that the offending letter had been burnt and forgotten. "Hum! Time

shews," wrote Sambourne in his diary. William Agnew then replied in a "feeling & really good speech & so all ended happily for a time" (D. 27. 11. 95).

Sambourne had good reason to be annoyed by Lawrence Bradbury's criticisms. In the mid 1890s, he was at the top of his fame as an artist. The highly successful one-man show which roused Harry Furniss's envy had been held at the Fine Art Society gallery in Bond Street in June and July 1893. The Fine Art Society, which still flourishes, was set up in 1876 as a printseller, publisher and art dealer. M.H. Spielmann pointed out, in the introduction to the exhibition catalogue, that the Sambourne show would have been impossible a few years earlier as, until the end of 1888, most original drawings for *Punch* were destroyed when the blocks were cut. There are, however, a number of surviving Sambourne drawings from before this date, including some for the 'Punch Pocket Books' and for the 'Fancy Portraits'. This suggests that limited photographic reproduction was in use before 1888. On the other hand, as we have seen, Sambourne was prepared to make duplicates of his work for fifteen guineas. A number of the Royal Academician cartoons, including some based upon paintings, stretching back through the 1880s, were on sale at the Fine Art Society. Letters of thanks from his friends make it clear that Sambourne had already sent round prints from these and from other *Punch* drawings as gifts. One recipient wrote that he hoped "that you have as many impressions on China paper made as is possible without injuring the plates as they will be more valid than bank notes".[25] William Bradbury once complained that the cartoonist was taking a stack of copies of the magazine, then returning them with pages cut out, possibly another source for his gifts to friends.

Other surviving drawings from the years before 1888 include several for *The Water Babies*. Frederick Macmillan was evidently employing photographic methods at an early date. A number of these illustrations were on the walls at the Fine Art Society exhibition and some are still at 18 Stafford Terrace, either held back by the family or unsold. Given their high quality, the second alternative seems very unlikely and the same is true of the Fisheries diploma, also on display in Bond Street. A self-portrait and a marvellous 'Essence of Parliament' drawing, with Gladstone as the stag in an image derived from Landseer's *Monarch of the Glen* (c. 1851; Diagio plc), belonged to M.H. Spielmann and were marked as loans from his collection. A cartoon of *Una and a British Lion* was from "a Birmingham collection". The rest of the 242 drawings were almost entirely recent *Punch* contributions.

As the date of the exhibition grew near, Ernest Brown from the Fine Art Society became a regular caller at Stafford Terrace, persuading Sambourne to contribute more and more drawings. Finally, the decision was made to send anything which remained in the house. Sambourne helped to hang the show, attended the press view and was present at private views. He was gratified by the attendance, and, as the weeks went by, even more gratified by the sales. Unfortunately, no record of the purchasers survives, so Sambourne's patrons remain anonymous. Priced at between three and fifty guineas, they netted £1265 for him, a very large sum for the date and certainly enough to make Harry Furniss jealous.

The exhibition helped to raise Sambourne's reputation and status as an artist. Spielmann, as editor, published an article in the *Magazine of Art*, putting forward a very strong case for his friend.

> The humours of the artist, his quaintness of fancy wit and touch, are appreciated wherever art is understood, and by whomsoever [sic] looks for something more, even in a professedly humorous design, than that which is at first and immediately obvious. Mr. Sambourne, in fact, stands alone among comic draughtsmen in demanding a second examination of his work. A rapid glance rarely reveals to the beholder all that is contained and conveyed in a single drawing; and further examination never fails to awaken interest, apart from whatever inner meaning may meanwhile be discovered, in the artistic methods of the artist. This power Mr. Sambourne shares with Mr. Burne-Jones in painting, and Mr. Ricketts in serious pen-and-ink work – the power of compelling the spectator's intellectual attention, while responding to his aesthetic demands, to his love of fancy and of laughter.[26]

Artists also admired Sambourne's work. His old friend Luke Fildes wrote to congratulate him: "I needed no exhibition to know your talent: *that* for many years has been a pleasure & a cause of admiration, but, I confess to-day when I saw your beautiful work I stood before it wondering."[27] George Frederic Watts was much struck by the show and declared that Sambourne's line was "finer than that of any man alive". Walking round with a fellow artist, Lord Carlisle, he pointed out the "variety and 'vitality' in every stroke".[28] Watts told Spielmann that he "would willingly 'exchange such ability as he might possess in painting'

for the power to draw a line like Linley Sambourne – an accomplishment which he had always striven for but never attained".[29] Both Watts and Spielmann admired Sambourne's ability to draw a perfect circle, a feat attributed by Vasari to the boy Giotto. The young Vincent Van Gogh, working in London for Goupil, the art dealers, also admired Sambourne's work. Telling his brother of his treasured wood engravings, Van Gogh wrote with pride of his portfolio of work by Charles Keene and Sambourne.

Unusually for a *Punch* artist, Sambourne seems not to have aspired to be a painter, to be more than an artist in black and white. He continued to look up to Albrecht Dürer as his master, and in April 1890 he was reading about the artist. The article must have been 'The Literary Remains of Albert Dürer' by Frederick Stephens, a founding Pre-Raphaelite brother, published in the *Magazine of Art*. Three years later Sambourne drew directly upon Dürer's famous *Melancholia* (described by a critic as "the most written-about image in the history of art"), for a fine cartoon.[30] France, characterized as Marianne and wearing the Phrygian cap of the revolutionaries, plays the part of Melancholia. She sits pondering ideas of conflict and glory, represented by a huge stone marked 'Panama' and a grindstone labelled 'War'. In Sambourne's re-working, the cherub sitting on the grindstone in the original becomes a small-horned devil, the dog crouching at the woman's feet is labelled 'La Revanche' (revenge), and the globe 'Dynamite' (P. 29.4.93).

Dürer's successor in nineteenth-century Germany was Alfred Rethel and prints of Rethel's work still hang on the wall at 18 Stafford Terrace. One is a copy of Rethel's *Death as Friend*, where an old sexton dies in his chair, a skeleton Death pulling the church bell for him. This design was held up to students at the South Kensington Art School as a model of artistic excellence. The second print is the related *Death at the Masked Ball*, which Sambourne parodied in a cartoon of 18 June 1892, *Dissolution as the enemy of the London season*.

Like his fellow *Punch* cartoonists, Sambourne did not follow in the savage graphic tradition of the eighteenth century. As he grew older, however, he came to see his cartoons as part of a great tradition of caricature and political commentary. He had a liking for the work of William Hogarth and owned a handsome volume of reproductions of the artist's major works, bought for fifteen shillings on 5 April 1878. On the next day he attended a sale at Christie's and listed the prices and

purchasers of two original Hogarth paintings. Sambourne often singled out paintings and prints by Hogarth on his visits to country houses. On one occasion he saw a "Hogarth looking little girl not bad looking" in the street at Wellingborough in Northamptonshire (D. 26.5.96). Opportunities to base cartoons on designs by Hogarth were very welcome to him. In 1889 he was at work on a "small cut of Hogarthian Puck" (D. 8.6.89). This was a vignette heading a poem, 'Puck among the Pictures'. Published on 15 June 1889, it encouraged readers of *Punch* to visit an exhibition of *English Humorous Art* organized by the writer and collector Joseph Grego and then on show in Piccadilly. The poem pays tribute to the great caricaturists, and Sambourne himself appears among them, in a flattering reference to Alexander Pope's attack on "dullness":

> Then Sambourne the subtle, whose fancy to curb,
> Dulness might vainly try.

For his image of Puck Sambourne combined two Hogarth self-portraits. The clothes, palette, brush and chair come from *Hogarth painting the Comic Muse* (c. 1758; National Portrait Gallery) and the head is an exaggerated version of *Portrait of the Painter and his Pug* (1745; Tate, London). Sambourne employs his usual small capital letters to indicate the objects of satire, including royalty, humbug, fashion, statesmen, lawyers and churchmen. Alison Smith believes that Hogarth's theory of the 'line of beauty' was an inspiration to Sambourne, "a visual theory often alluded to in Sambourne's images and which he used to delineate the perimeters of human beauty as well as deviations from this ideal".[31] She refers to Sambourne's characteristic "firm undulating line" as an indication of this debt.[32]

Over the years Sambourne adapted a number of other Hogarth paintings and prints for his cartoons. In *'Ritchie's Himself Again! – (Till further notice)'* of 28 April 1888 the President of the Local Government Board, Charles Ritchie, is presented in the pose of Hogarth's *David Garrick as Richard III* (c. 1745; Walker Art Gallery, Liverpool). The occasion was the Local Government Bill, which set up county councils. Ritchie (seen as Richard III, with his name substituted for Richard's in a quotation from Shakespeare) is surrounded by ghosts in the form of parliamentary amendments.

In the early 1890s M.H. Spielmann asked Sambourne to contribute two articles on political satire to the *Magazine of Art*. They appeared in January and February

1892. The first begins with characteristic insouciance, assuring the reader that the writer understands his own failings:

> Asked by the editor of THE MAGAZINE OF ART to let him have a paper on Political Cartoons, I somewhat carelessly assented; but when frequently pressed from time to time to redeem my promise and to contemplate seriously the penning of the article, I have fought shy of it and made excuses. Like a timid man after strange hounds in an unknown country, 'the more I looked at the obstacle the less I liked it.' I cannot help feeling that although one may by force of circumstances or some vein of adaptability of his own have become a political cartoonist, perhaps he is the last who ought to intrude his ideas in writing on the subject. I can only hope the readers of THE MAGAZINE OF ART will be patient, and on that score acquit me.[33]

In this first article Sambourne tackled the eighteenth century. After completing a draft in August 1891 he happened to see Thomas Wright's *History of Caricature and the Grotesque in Art, Literature, Sculpture and Painting*, published in 1875. As a result, his article was hastily revised and Wright's book acknowledged as a source of detailed information. Like many writers on the subject, Sambourne starts with William Hogarth, before moving on to James Gillray and Thomas Rowlandson. Praising Gillray, Sambourne adds a rider of considerable relevance to his own work:

> Gillray was a very great and facile artist; had he but possessed the gift of rendering female beauty as well, his cartoons would have been irresistible; taking him all round, however, he must surely stand foremost as the first great English caricaturist, though hardly as most professional critics rank him, "the" caricaturist for all time.[34]

Sambourne turned next to George Cruikshank, a political cartoonist whom he had "frequently met … so at last I can speak of one whom I have known personally as well as by his works". Once again Sambourne's praise is mixed with regret for the absence of beautiful women: "Who has not studied those works? – full of imagination, twisted, gnarled, nightmarish at times, but alas! not a glimpse of female beauty."[35] The article ends with a discussion of the work of HB (John) and

Richard (Dicky) Doyle, father and son. "Doyle [HB] drew in an original style of his own, and although his figures were conventional and mostly attenuated and vapourish, his designs will always be interesting. The bulk of his cartoons retain the inevitable balloon."[36] The speech balloon, so often used by cartoonists down to the present day, was a pet hate of Sambourne's, glossed in a footnote as "formed by encircling words supposed to be spoken by any person on a page, with a line proceeding from the mouth of the speaker".[37]

For Dicky Doyle's "fantastically original work", Sambourne had nothing but admiration. He reminds his readers that the title page of *Punch* was Doyle's work, and that the magazine's early volumes "teem with his rich vein of fancy". Sambourne had studied the journal which the young Doyle had kept in 1840, "full of queer grotesques, and the broad humour which distinguished him from first to last".[38] Doyle's departure from *Punch*, over a crisis of conscience concerning the paper's anti-papal stance, was, in Sambourne's view, an incalculable loss.

The second article considered the work of Sambourne's own immediate predecessors and contemporaries, beginning with John Leech. From early on, Sambourne collected illustrated books and prints by Leech, many of his later purchases supplied by Benjamin Yeates of Kidderminster. Sambourne promised to pay Yeates in kind, but the promised drawings did not arrive, despite anguished appeals from the bookseller. Yeates should be added to the list of those waiting for a Sambourne drawing!

In his article Sambourne expressed admiration for Leech, the *Punch* legend whom he had never met: "No matter what professional book compilers may say about Gillray and Cruikshank, Leech was surely by far the ablest 'all round' delineator of force and character the century has produced ... life in all its forms, natural or artificial – all alike were rendered by him with a truth and fidelity, and wrapped in a humorous gracefulness, which will be a joy to untold generations to come."[39] Sambourne described some of Leech's political cartoons but with the proviso that "in many social subjects he is perhaps at his strongest and best".[40]

The article ended with a consideration of Sambourne's older contemporaries at the *Punch* table, John Tenniel, Charles Keene and George Du Maurier. Sambourne wrote of Tenniel as "strongly original", with "a style of his own in which he stands alone, and of which, although often plagiarised and imitated, he remains the master".[41] He then raised a vexed issue in describing Tenniel's method:

Endowed with the invaluable gift of 'form' to a greater degree than any
of his contemporaries, and drawing still with pencil on the hard box-
wood, all John Tenniel's lines are clear and expressive, putting the subject
before the eye with the utmost force and precision; there is never a line
too much or out of place – a rare quality in these days of sloppy work,
which however effective in its own field can never have the charm or skill
of pure line for cartoon work.[42]

Tenniel's insistence on continuing to draw directly onto the woodblock,
when younger draughtsmen favoured photographic reproduction, was the
reason for *Punch's* delay in adopting the new technology. Sambourne, with his
enthusiasm for photography, did not share Tenniel's resistance to change and,
on 21 December 1889, he wrote thankfully in his diary, "last drawing on wood".
To journalists who questioned him on what was commonly known as 'process',
Sambourne presented a positive approach. M.H. Spielmann, however, while ac-
knowledging that the new method ensured the preservation of the original
drawings, considered that Sambourne's work had lost some of its crispness as
a result of the change: "He has had to abandon his free-and-easy manner in the
use of inks of varying force, and altogether the use of the pencil. The original
delicacy of his style has been greatly modified; gradation of tone in shadow is
almost gone."[43]

In writing of Keene and Du Maurier, Sambourne had to admit that neither
was really a political cartoonist. He lists only fourteen political satires by Keene,
five of them drawn during Tenniel's absence in Venice in 1878. Du Maurier, in-
cluded in the interests of politeness, is neatly described as a consummate social
cartoonist and as the creator of types, like the aesthete Jellaby Postlethwaite, the
lion-hunter Mrs Ponsonby de Tomkyns and the *nouveau riche* Sir Gorgius Midas.
A single long sentence is reserved for Harry Furniss, whom Sambourne charac-
terizes as a draughtsman of "parliamentary summaries", rather than a cartoon-
ist.[44] While acknowledging the political content of Furniss's work, Sambourne's
definition of a cartoon was restricted to a large-set drawing, not a sketch.

Sambourne closed the article with a brief and unwilling autobiography: "Of
my own work I am loth to speak at all." He acknowledged his debt to Dürer, and
spoke directly to the reader of the heavy demands on his time and skill:

LINLEY SAMBOURNE.

(*Drawn by Himself. Engraved by J. Swain.*)

Fig. 96 *Linley Sambourne*, self-portrait drawing, 1891, from 'Political Cartoons', *Magazine of Art*, 1892

Well, I assure him, or anyone who cares for such things at all, that my 'play' is often very hard work indeed, and a good many would throw up the game if they had to keep it up week after week. To carry it out successfully you must be ready at a moment's notice to draw any conceivable thing under the sun, or in fancy far beyond it, any period, costume, or combination, ancient or modern, and deliver it over, good or bad, for public criticism in a few hours, and with a hard and fast limit of time.[45]

This was as near to a credo as Sambourne ever came in print. And he concluded with a *cri de coeur* on behalf of his profession. Cartoonists were "perforce accustomed to an unrecognised position … not officially placed even on the same level as line engravers. John Leech himself felt the cold shoulder of Academical neglect, which makes no signs of abating, and which will, in all probability at least, last the nineteenth century out".[46] Black-and-white work could now be shown at the Royal Academy, but no artist working solely in black and white had as yet been elected an Academician.

Exposition Universelle 1900

Sambourne was called upon to judge drawings, probably for a prize, at the South Kensington Art School, but, professionally, the highest honour paid to him was his appointment as a judge for Class Eight of the Fine Arts section of the Exposition Universelle in Paris in 1900. Class Eight included engravings and prints and Sambourne was involved in choosing medal winners from among the submissions. This was the only occasion on which he served on such a committee. He attended preliminary meetings of the British judges, under the chairmanship of Sir Isidore Spielmann, the brother of M.H. Spielmann and Director and Honorary Secretary of the British Fine Art Section. Unfortunately, the subcommittee meetings were usually on Fridays, and Sambourne had to apologize to Spielmann for missing a number of them when completing his weekly cartoon. Nor was this his only shortcoming. With his characteristic tardiness, he was still revising his report in May 1901. In retrospect, Sambourne was to pay tribute to Spielmann: "I owe a great deal to *him* for his invariable courtesy & kindness in the whole business of what I had to do in Paris in June 1900."[47]

Sambourne and Marion left London on 3 June 1900 and stayed at the Grand Hotel du Trocadéro for two weeks. Many friends were in the city, some on juries,

some enjoying the exhibitions, and there were lunches and dinners at a variety of restaurants and hotels, the Le Doyen restaurant being a particular favourite. Le Doyen is the subject of *The Artists' Wives* (1885; Chrysler Museum, Norfolk, Virginia), an animated and colourful painting by James Tissot, with artists and their companions celebrating the opening of the Salon at an outdoor luncheon on the restaurant's terrace. June turned out to be very hot, and the city, crowded with tourists, was often stifling. Marion frequently felt tired and unwell. She had to miss some receptions and to leave others early. The exhibition was a splendid event with hundreds of national pavilions and buildings, many dedicated to trade or cultural displays, spread out along both banks of the Seine. The central art displays took place in the Palais des Beaux Arts, still in existence today as the Grand and Petit Palais.

Sambourne was due to sit on a number of panels, and he studied the exhibition intensively before the first meeting on 6 June. Having arrived at 9.25 he then waited for an hour and a half for something to happen. When it did, the members of the different juries introduced themselves and Sambourne particularly noted the presence of old friends, Edwin Austin Abbey, Frank Millet and John Singer Sargent, among the American contingent. The British committee had objected to America's being represented by these artists, all of whom lived in England. Sambourne's fellow members of the jury for 'Gravures' were an American (the painter John White Alexander), a Dutchman and a German. They had to judge the contributions of graphic artists from different countries, and to decide who was worthy of the coveted medals. There had been a discussion in London before Sambourne left, and now he looked hurriedly at the British entries to "decide who to recommend. Short & Wylie" (D. 6.6.00). Francis (Frank) Short was best known for his mezzotint and aquatint landscapes, which were much admired by James Whistler, himself among the finest etchers ever to work in Britain. William Wyllie was a leading marine painter and an outstanding etcher.

On the following day the jury voted, awarding two gold medals to British artists. Sambourne gives three names, those of William Nicholson, David Young Cameron and Axel Herman Haig, but it appears that Nicholson's medal was awarded later, on 13 June. Sambourne's nominee, Frank Short, and Joseph Pennell, an American resident in England, also won gold medals. Pennell, a printmaker and journalist, is now best known for the biography of Whistler written with his wife. Whistler himself won the *Grand Prix* and the overall gold medal for Class Eight

went to Holland. Later, Sambourne was able to get a *Médaille d'Honneur* for an older etcher, Seymour Haden, the brother-in-law of Whistler.

D.Y. Cameron is now highly valued as a painter, a member of the group known collectively as the 'Scottish Colourists', but in the 1890s he was best known for his etchings. Haig, a Swede by birth, had moved to Britain in his early twenties. He had worked with the architect and designer William Burges, and architectural etchings and illustrations were his speciality. Haig was older than Sambourne, but the other two gold-medal winners were considerably younger, Cameron thirty-five and Nicholson twenty-eight. Nicholson had published his *Alphabet* – twenty-six wood-cuts of English figures dramatically placed against plain backgrounds – in 1898. He had been prolific in the years before the Exposition Universelle, with his prints of sporting figures and his 'London Types' and 'Twelve Portraits'. The latter group includes the well-known image of a squat Queen Victoria, her mourning black so dominant that only her face and her hands stand out from her dress. Like Sambourne's cartoons, Nicholson's drawings are imaginative rather than realistic, but quite different in style. Instead of Sambourne's delicate lines, Nicholson presents strong shapes which come close to abstraction.

Rudyard Kipling, asked to write verses to accompany the 'London Types', declined. Happy to sit to Nicholson for a now iconic portrait drawing, and well aware of the young artist's talent, Kipling described Nicholson's work as "lumps of light and shade".[48] This seems to have been a common reaction, and Sambourne twice follows the artist's name with "Oh!", a sign of his disapproval.

On June 8 the committee met to discuss the awards for French artists, and then adjourned their decision until Monday 11. The large number of French contributions was controversial, the host nation having allowed its own nationals a far higher proportion of entries than citizens of other countries. There were complaints in Britain that exhibitors from outside France were only allowed to send in one relatively small work. In the event, the committee spent all of Monday deciding on the French awards, which were judged separately from the 'Foreign' medals.

In between the meetings and the large meals, the Sambournes saw many of the pavilions and galleries, as well as visiting the Louvre, where they enjoyed the cool sculpture galleries before going upstairs to see the paintings. Auguste Rodin, disappointed that only two of his sculptures were in the main exhibition, had set up his own pavilion, with one hundred and fifty works, in the Place de l'Alma.

Sambourne was struck by the "curious impudent Balzac but many groups beautiful in form" (D.12.6.00). Marion thought that the statue looked like a "Giant Snowman" and had nothing to do with "that great man".[49]

There was a huge exhibition of contemporary art, drawn from twenty-nine countries, but Sambourne, although he particularly noted the bronzes in the German section, only reported that much was "new to see" (D. 15.6.00). He was interested in some exhibits in the national pavilions, the arms and surtout of Boabdil, the last Moorish King of Andalusia, in the Spanish section, and "Lovely Langrets in German" (D.12.6.00). These were rococo paintings by Nicolas Lancret, lent by the Kaiser from Frederick the Great's palace at Potsdam, together with some of the furniture. Marion also admired them, finding the Lancrets "most exquisite finer even than the Watteaus which are the finest specimens we have ever seen of his work".[50] This was evidence of a change in taste. Earlier in the Victorian period many critics dismissed or ignored French eighteenth-century painting as frivolous and meretricious. In the highly traditional English pavilion the Sambournes found further paintings by eighteenth-century masters, including Gainsborough, Romney, Morland and Raeburn.

There was a little time for pleasant relaxation. Sambourne went up to the second stage of the Eiffel Tower and was amused to see Marion's window at the hotel, together with his own boots. On a charabanc expedition to the Bois de Boulogne he made a speech over coffee.

The fortnight ended with a grand dinner "blazing with lights" at the Elysée Palace, hosted by the French President. Sambourne found it a "poor dinner. Sweet Champagne" (D. 16.6.00). At least there was a good cigar from a particular friend, the watercolourist, etcher and architect Ernest George, to smoke with a beer in the garden. George, who had invited the Sambournes to an evening party early in their stay, was one of the architects employed by Ludwig Messel to extend and rebuild his house at Nymans.

Sambourne apparently met John White Alexander, the American judge on his jury, for the first time in Paris. They sat together at lunch after a judging session and became firm friends. His wife gave an afternoon reception and asked Sambourne to bring Marion, but she was not well enough to "stand about".[51] For Alexander the exhibition was a triumph, as he won a gold medal for his paintings. He was planning to travel to Scotland to carry out a portrait commission and Sambourne gave him an introduction to Sir George Reid.[52]

It might be expected that Sambourne would draw a number of cartoons of the Paris exhibition, but he had been given two weeks holiday from the paper. There are, however, two references to the exhibition in his work. On 6 August *Punch* published a Sambourne cartoon entitled *Happy Thought!*, which showed the Boer leader, Paul Kruger, deciding that Holland (where he was living in exile) was "so over-run with English" that he would visit the "Paris Exhibition. They tell me there ain't any there!" However, in a later cartoon, of 14 November, Kruger is told by France that the exhibition has closed. He makes the reply: "Just my luck! So's the Transvaal".

Notes

1 Shirley Nicholson, *A Victorian Household*, London (Barrie & Jenkins), 1998, p. 131.

2 Linley Sambourne Museum, copy of a letter sent to *The Times* on 30 August 1961.

3 New York Public Library, Berg Collection, letter of 9 July 1896, to an unnamed correspondent, .

4 Kensington Library, letter of 13 October 1900, ST/4/3/3/5.

5 The National Trust, Nymans, letter of 21 May 1897, S/97/01.

6 Nicholson, p. 164.

7 Ditto, pp. 15–16.

8 Martin Postle, 'Hidden Lives: Linley Sambourne and the Female Model', in exh. cat., *Public Artist: Private Passions*, Royal Borough of Kensington and Chelsea and *The British Art Journal*, 2001, p. 25.

9 Mary Ann Roberts, 'Edward Linley Sambourne', *History of Photography*, XVII, no. 2, Summer 1993, p. 208.

10 See note 8.

11 Alison Smith, 'A "Valuable Adjunct": The Role of Photography in the Art of Linley Sambourne', in *Public Artist: Private Passions*, p. 16.

12 Sarah Grand, *The Heavenly Twins*, London (Heinemann), 1894, p. 132.

13 *Illustrated London News*, 28 January 1893, p. 121.

14 F. Anstey, *A Long Retrospect*, Oxford (Oxford University Press), 1936, pp. 163–64.

15 Ditto, p. 162.

16 Ditto, p. 165.

17 M.H. Spielmann, *The History of Punch*, London (Cassell), 1895, p. 89.

18 R.G.G. Price, *A History of Punch*, London (Collins), 1957, p. 50.

19 A. à Beckett, *The à Becketts of Punch*, London (Constable), p. 252.

20 John Rylands Library, Manchester, Spielmann Collection: Misc. Letters, letter of 9 April 1891, 1302 [R. 110250]. I am grateful to Frankie Morris for bringing this letter to my attention.

21 Harry Furniss, 'Round the *Punch* Table, III', *Tit Bits*, 13 June 1914, p. 426.

22 Ditto.

23 Ditto.

24 Letter of 22 November 1895, Kensington Library, ST/1/3/108.

25 Letter of 13 April 1883 from an unidentified correspondent, formerly collection of Anne, Countess of Rosse.

26 M.H. Spielmann, 'Our Graphic Humorists: Linley Sambourne', *Magazine of Art*, 1893, p. 329.

27 Letter of 4 July 1893, Kensington Library, ST/1/4/2/7.

28 Diary of Mary Seton Watts, Watts Gallery Archive, Compton, Surrey.

29 Spielmann, 'Our Graphic Humorists', p. 332.

30 Giulia Bartrum, *Albrecht Dürer and his Legacy*, London (British Museum Press), 2003, p. 188.

31 Smith, p. 14.

32 Ditto, p. 13.

33 *Magazine of Art*, 1892, p. 21.

34 Ditto, p. 23.

35 Ditto.

36 Ditto, pp. 23–24.

37 Ditto, p. 22.

38 Ditto, p. 24.

39 Ditto, p. 42.

40 Ditto, p. 43.

41 Ditto.

42 Ditto, pp. 43–44.

43 Spielmann, 'Our Graphic Humourists', p. 331.

44 *Magazine of Art,* 1892, p. 45.

45 Ditto, p. 46.

46 Ditto.

47 Undated letter, *Punch* archive.

48 *The Letters of Rudyard Kipling*, ed. Thomas Pinney, Basingstoke (Macmillan), 1990, vol. II, p. 357.

49 Nymans, letter of 13 June 1900 to Maud Messel, S/oo/20.

50 Ditto.

51 Nymans, letter of 8 June 1900 to Maud Messel, S/oo/19.

52 I am grateful to Mary Anne Goley for giving me this information about Sambourne's relationship with Alexander.

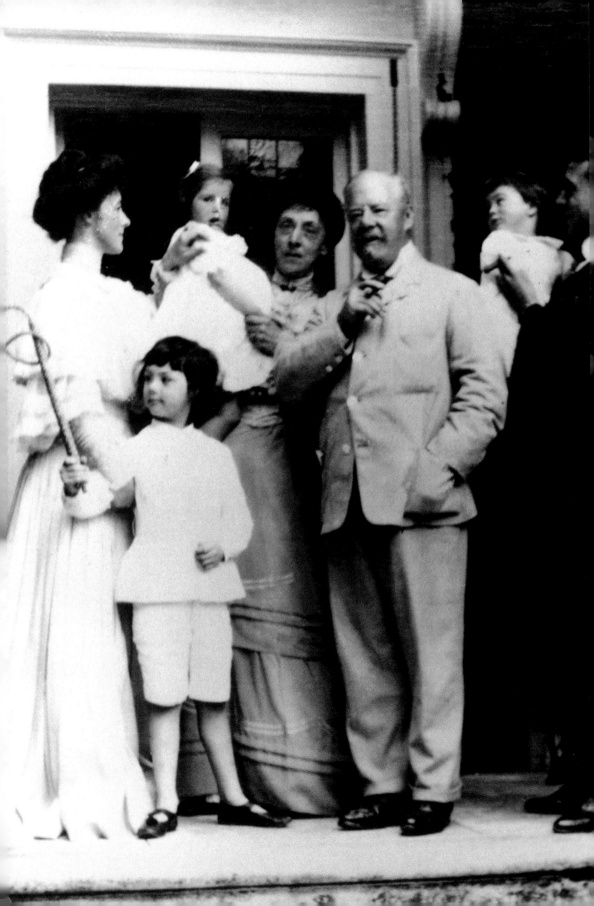

Chapter 7

The First Cartoonist

The Victorians, unlike their twenty-first century successors, celebrated the coming of a new century on the correct day, 1 January 1901. In Sambourne's fine 'quadruple' page cartoon for the 'Almanack', *The Dawn*, the Twentieth Century appears as a young woman, striding ahead with a staff labelled 'Science' and a star in her hair (fig. 98). Father Time and Mr Punch show her the route forward. As Toby turns the pages of the 1901 diary, the nineteenth century fades away. Volumes of *Punch*, dating back to the first numbers of 1841, are piled up behind him.

For Sambourne the dawn of the new year meant a double celebration, for this was the day on which he replaced John Tenniel as chief cartoonist. Tenniel had joined *Punch* in 1850, when Mark Lemon was editor and Thackeray still on the staff. The main political cartoon had been his responsibility since 1862 and, for many people, Tenniel *was Punch*.

There had been general rejoicing when Tenniel was knighted in 1893, and, on 5 December 1900, the staff planned to present him with a silver tobacco box engraved with designs, including one by Sambourne, to mark his half century on the paper. By mischance, Tenniel, who rarely missed a *Punch* dinner, was unwell, and, unaware of the special occasion, failed to appear. His colleagues took the present to Tenniel's home, but Sambourne, who had taken an overnight train from Scotland in order to attend, did not accompany them. Irritated, he returned to the north on the mail train: "No Tenniel, no F.C.B. [Burnand] & dragged up 350 miles" (D. 5.12.00).

Fig. 97 The Sambourne and Messel families at Balcombe House (from left, maud Messel, Linley Messel, Anne Messel, Marion Sambourne, Linley Sabourne, Oliver Messel, Leonard Messel)

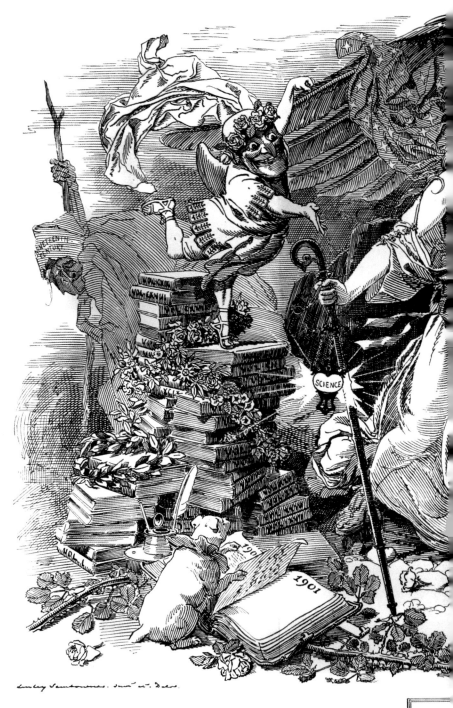

Fig. 98 *The Dawn, Punch*, Almanack 1901

Tenniel, whose eyesight was worsening, confided a week later that he was "no good" and that he planned to retire at the end of the year (D. 12.12.00). This may help to explain his anxiety at the public dinner given in his honour on 12 June 1901, with Arthur Balfour, soon to become Prime Minister, in the chair. Tenniel reportedly spent weeks preparing, but when he rose to speak was so overcome that he failed to deliver more than the opening words. His audience, moved by the speaker's emotion, were not in the least dismayed, but Tenniel never forgave himself.

The choice of Tenniel's successor was a matter of considerable importance for the magazine's future. Sambourne had been his deputy since 1878 and naturally anticipated taking over the position of first cartoonist. That this was not a foregone conclusion emerged at a meeting of the paper's writers, at which at least one dissenting voice was heard. Owen Seaman, a talented writer of light verse who had joined the staff in 1897, told Sambourne what had happened, but without naming the speaker. There may have been a feeling that, were Sambourne to replace Tenniel, an opportunity to move forward would be lost, and that a younger and more inventive man should be appointed.

A majority of the staff and management must have supported the safe choice, however, and Sambourne duly became first cartoonist, nearly thirty-four years after contributing his first cartoon to *Punch*. He noted, with some asperity, that 1 January 1901 was a "dull day" and that no congratulations arrived from friends or associates. The diary gives no indication of elation at his promotion and, if Sambourne felt excited, he kept it to himself. The truth of this long-awaited change in circumstances may have been as prosaic as the diary would have us believe. It was work as usual.

On 2 January Tenniel attended his last *Punch* dinner as principal cartoonist, although he continued to be an occasional guest. Sambourne found his predecessor's farewell speech "very touching", although he noted that Tenniel failed to refer to his successor. As usual, the two men travelled part of the way home together. On Thursday 3 and on Friday 4 January, his fifty-seventh birthday, a day so dark that it was hard to work, Sambourne proceeded with the appointed subject, war. His birthdays almost always passed without notice, presumably by his own wish, although he occasionally sounds aggrieved at the neglect. When the cartoon was published, on 9 January, it had the title *Urgent* and showed Lord Kitchener and

John Bull appealing for more men and horses in order to achieve a rapid victory in the campaign against the Boers in South Africa. The press now reported the change of chief cartoonist, and Sambourne counted ten articles on the subject. Letters of congratulation duly began to arrive. This was an altogether more cheerful time, and he rejoiced in a particularly good shooting expedition with William Knox D'Arcy at Bylaugh Park, East Dereham, ending the day with a bag of forty-seven pheasants, one hare, one duck and a partridge.

The timing of Sambourne's elevation gave him an unexpected opportunity to impress the magazine's readers. Queen Victoria became ill in January 1901 and died on Tuesday 22 after a reign of sixty-three years. A major national event, this was a moment when the public was bound to note the absence of Tenniel and to look for an indication of the character of his successor. Sambourne had been asked by a neighbour, Douglas Sladen, the journalist, popular novelist and founder of *Who's Who*, to address the New Vagabonds Club on the occasion of his promotion. In this emergency, however, he had to ask for a postponement in order to work on a memorial cartoon. Sambourne and Burnand decided on the format together and the artist worked "harder than ever in life", in a state of acute nervous excitement, night and day, missing the *Punch* dinner as he devised and completed the drawing (D. 25.1.01).

The double-page cartoon *Requiescat!* shows the countries of the Empire as mourning women, with their flags behind them and a wreath, marked with the name 'Victoria', in the foreground (P. 30.1.01; fig. 99). Such a symbolic tribute brought out the best in Sambourne, and the stylized female figures make up a dark, elegant and dignified design. A few years before, in 1896, he had responded with similar effect to a commission to commemorate Frederic Leighton in the *Art Journal*. On that occasion he submitted a fine drawing of a woman in classically draped black, her hand over her face, a wreath and palette on the ground before her and Burlington House, with flag at half mast, behind.

The *Punch* number marking the death of the Queen included a group of earlier cartoons illustrating different phases of her reign. Sambourne was represented by three examples, his 13 January 1877 salute to the Empress of India, *Kaiser-I-Hind*; *The Two Jubilees* (on the Queen's golden jubilee) of 7 January 1888; and *The Water Babies and the Royal Godmother* from 28 February 1891, with the Queen launching naval vessels.

Fig. 99 *"Requiescat", Punch,*
30 January 1901

"Requiescat!"

Summoned early to the *Punch* dinner on 30 January, the day on which the Queen Victoria special number appeared, Sambourne found that Burnand had called him in, not for the anticipated confrontation, but for a long chat. At the dinner, Sambourne gleefully followed Arthur à Beckett's lead in attacking Leonard Raven Hill's cartoon. A week before, Raven Hill, who had joined the table on 2 January, had published a drawing showing the owner of a steaming and violently palpitating motor-car attacking the vehicle with a hay rake, while telling passers-

by not to be alarmed: "It will be all right as soon as I've discovered the what-d'ye-call-it". Motor-cars were new and exciting in 1901, but either the subject or the style bothered à Beckett and Sambourne. Sambourne himself was meanwhile basking in the praise of his colleagues at the round table, and, best of all, Philip Agnew took the opportunity to congratulate him warmly on the memorial drawing.

No sooner was this first hurdle achieved, with considerable success all round, than Sambourne was called upon for *God Save the King*, a drawing of Mr Punch bowing deeply to Edward VII (P. 6.2.01). A week later he drew the new King and Queen Alexandra at the State Opening of Parliament (P. 13.2.01). The Memorial drawing was sold at once, to an unnamed buyer, and Sir James Whitehead, the former Lord Mayor, bought that of the King.

A year later a cartoon was needed for the coronation and, after Sambourne had spent many days working on it, Burnand presented the special number of *Punch* to the King in person. However, Edward VII suddenly developed appendicitis, necessitating the 'pulling' of the celebratory edition. Sambourne eventually completed a second coronation drawing in time for the re-scheduled ceremony. In *Empire and Peace* the new king, crowned and seated on the throne, is flanked by two symbolic female figures, the sword of Empire and the lily of Peace forming an arch above his head (P. 13.8.02).

Sambourne's appointment as principal cartoonist, which was to last until his death, brought him no immediate rise in salary. He had to argue his case with Lawrence Bradbury and Philip Agnew at a sticky interview on 5 February and was eventually granted £120 a year more. Sambourne needed the money as the leases on the Barr Estate property would come to an end in 1902, reducing his income by £650 a year. There are references in his diary to meetings with members of the Barr family and these may have been attempts to stave off the inevitable.

From the time of his promotion, Sambourne began to register increasing dismay with the direction which *Punch* was taking. "Depressed & bitter about the affairs of the paper" and "getting more & more disgusted" are just two of his reactions to the weekly dinners of 1902 (D. 4.6.02; 18.6.02). He remained a 'regular' but these meetings were no longer a pleasure to him. Changes in the layout brought further aggravation. Sambourne was understandably "annoyed" when told that the Index would, in future, appear without his traditional heading and conclusion. The management decided to cut down his contribution to the 'Almanack'

from a double to a single page, presumably paying him half. More broadly, Sambourne began to feel resentment at the subjects chosen for him. "Got horrid subject, [Sir William] Harcourt as Knight …. Protested" (D. 2.3.04). On this occasion, events proved that Sambourne was right: "[Francis] Gould [the cartoonist for *The Westminster Gazette*] came out with The Old Crusader like my cartoon for next week" (D. 5.3.04).

In 1905 Sambourne was given a cheque for less than his usual earnings. This discrepancy was adjusted, but, not entirely satisfied, he continued to discuss the matter with Lawrence Bradbury. It is noticeable that the proprietors (and sometimes the rest of the staff) often congratulated Sambourne on particularly good drawings, possibly to try and retain a harmonious relationship with the increasingly disgruntled chief cartoonist. They did not always achieve their aim, however. On 18 June 1902 Sambourne noted in his diary: "Not one single word said about my drawing for Coronation number. Lots of praise of Phil May & Raven Hill". This followed a sour remark in January "L.B. [Bradbury] in inordinate praise of Phil May" (D. 21.1.02).

The magazine was passing through a troubled period. The staff as a whole struggled to cope with the dictatorial behaviour of Frank Burnand and Sambourne's difficulties with his old friend's 'worry letters' continued until 1906. As early as 1891, writing to M.H. Spielmann, who was planning a history of *Punch*, Sambourne explained that there would be no cartoon of his in the next week: "It is all (between you & I) F.C.B. and his methods. I could easily have done my cartoon a little before if the slightest trouble is taken to try & get a subject."[1] His New Year cartoon for 1904, of a young top-hatted New Year, 'whose precocious tastes are already modelled on those of the Old Gourmand', asking Father Time, dressed as a waiter, 'Now, Old Man, what have you got to give me?' (P. 6.1.04), did not, for some unexplained reason, find favour with the editor or with William Bradbury. Sambourne received a 'worry letter' "saying New Year's cut all wrong" and two days later he left the *Punch* dinner early "owing to B., FCB grumbling at New Year cartoon" (D. 4 and 6. 1. 04).

It was generally felt that the editor was too often away from the office and from the weekly dinners, and that he rated his own pleasure above the paper's welfare. Sambourne, a *bon viveur* himself but careful to come to every possible Wednesday dinner, noted that Burnand was absent from the *Punch* table for a whole month in the early autumn of 1904. These absences meant that Burnand left

too much to his deputies. When Sambourne first became chief cartoonist Arthur
à Beckett was playing this role. However, à Beckett, furious at being replaced by
Owen Seaman, attended his last dinner in June 1902 and spent the remaining years
of his life writing his memoirs and a history of his family's association with *Punch*.
Seaman, Cambridge-educated like Burnand, Guthrie and Rudolph Lehmann, was
a careful administrator. Sambourne says little about Seaman in his diary and is
more concerned with the increasing influence of Rudolph Lehmann, a former
editor of the *Daily News*. Lehmann, whose first contributions to *Punch* date from
1889, had considerable success with his parodies of contemporary fiction, 'Mr
Punch's Prize Novels'.

The artists on the paper also continued to change. Among the cartoonists
Sambourne was now the only survivor of the generation which had included
Tenniel, Keene and Du Maurier. On the whole the new men made up a good
team and, like Tenniel before him, Sambourne could rely on the support of a
large group of artists, some working on commission and not attached to the
table. He got on well with Bernard Partridge, who now took over the position of
second cartoonist. A former actor, Partridge was a protégé of George Du Maurier
and of Anstey Guthrie, whose books he had illustrated. He had begun to con-
tribute to the magazine in 1891 and joined the staff a year later. Promotion gave
Partridge, essentially a social cartoonist, an ever-increasing load of political
work. Edward Tennyson Reed, whose cartoons had been appearing since 1889,
followed Furniss on 'The Essence of Parliament', but was best known for his hi-
larious series of 'Prehistoric Peeps', where ancient peoples are shown in modern
situations. In one a group of dismayed and skin-clad ancient Britons watch as
a large flotilla of prehistoric sea creatures swims just off the beach. The caption
reads 'No Bathing to-day!' (P. 24.2.94). This was a time when archaeological and
geological discoveries were eagerly followed by the public, and Reed, with con-
siderable historical accuracy, drew upon museum displays for his humour. F.H.
Townsend became Art Editor in 1905 and it was said that the proprietors ap-
pointed him without Burnand's knowledge. Sambourne, evidently annoyed, was
very anxious to correct Spielmann's statement that Townsend sat next to the
editor at the dinner table. Sambourne insisted that, like Tenniel before him, he
took this seat, not Townsend, "who has sat at the table just about as many weeks
as I have years".[2]

From the evidence of Sambourne's diary, it would seem that, for all his annoyance at the "inordinate" praise of May's work, he felt a certain affection for the improvident, talented and doomed Phil May. A delicate, sprite-like man, May wore away his strength in constant activity. He worked in Australia for three years and then, on his return to London, rapidly made his name with a wonderful series of low-life drawings. A contributor to *Punch* from 1893, May joined 'the table' in 1895, remaining there until his death only eight years later at the early age of thirty-nine. Sambourne frequently refers to May's drinking problems and to his debts, but without moral censure. He regularly notes that May was late for the *Punch* dinner and that, when he came, he would tell long-drawn-out funny stories. May was famously generous, one cause of his financial difficulties, and in December 1896 he overwhelmed Sambourne with the gift of a silver cigarette-case. His death was announced at the dinner on 5 August 1903.

Phil May's minimalist style was very different from Sambourne's own, but they shared a responsiveness to line. James Thorpe believes that Sambourne was the chief influence on the younger artist: "May used the same parallel lines of shading, following the surface planes. At first he did not join the lines as skilfully as his master, but he gradually simplified this method, using a flatter and simpler tone throughout, so that one is less conscious of the means used to produce the effect. He once told Raven-Hill, 'All I know I got from Sambourne'."[3]

Sambourne's problems came, not from his fellow artists, but from the writers and the management. In 1907 he had an argument with Lawrence Bradbury about "my Almanack drawings and also his inaneness about my cartoon" (D. 23.10.07). Lehmann, in a tone which Sambourne found "offensive", mocked his older colleague's taste in clothes – perhaps irritated by the horsy effect (D. 6.1.04). This was symptomatic of a continuing friction, and Lehmann is sometimes described in Sambourne's diaries as "aggressive", a word previously reserved for Harry Furniss (D. 16.1.01; 22.10.02). In his history of the magazine, Richard Price describes Lehmann, a political Liberal among an increasingly Conservative staff, as a "combination of ability and casualness, of fervour and inertia … a hot-tempered, generous man".[4] On one occasion, the chief cartoonist lost his temper and told Lehmann that he did not have to take his orders: "Told R.L. to his face he took too much on himself & wasn't editor" (P. 25.5.04). Sambourne was once more objecting to the subject chosen for him, Joseph Chamberlain as a gun. He was pleased,

however, when Lehmann praised his work and, away from the table, the two men were friendly. Sambourne dined more than once at the Lehmanns' house at Bourne End, near the Thames in Buckinghamshire and, in 1903, he noted Lehmann's two little daughters with their deep voices and their pretty governess. In later life, Rosamond Lehmann became a famous novelist, and her sister Beatrix an acclaimed actress.

Henry Lucy also annoyed Sambourne with a slighting remark on the cartoonist's lack of personal knowledge of Austen Chamberlain, son of Joseph and Chancellor of the Exchequer in the Conservative administration. Presumably this was a return to the old issue of Sambourne's not drawing from life, the problem which had brought the cartoonist's association with 'The Essence of Parliament' to an end in 1881.

Bradbury and Agnew were ungenerous in refusing to raise Sambourne's salary after his promotion, but, in truth, there was little real change in the nature of his work. If anything it became slightly easier, as the subject of his cartoon was almost invariably decided at the Wednesday evening dinner, giving him two days to complete it. His task was to contribute a single drawing on the central issue of the week, and, although there are occasional gaps, he rarely compensated for these with a second drawing. The cartoons were generally larger than before and appeared on a central page of the magazine rather than just inside the title page. Sambourne occasionally notes that he himself chose the subject of the cartoon, or that he argued a case for a particular treatment. Generally speaking, however, the particular political event to be highlighted was decided by the staff in committee. This makes it very hard to estimate how far Sambourne endorsed the views which he was expressing. A study of the cartoons gives one a clear sense of the general political atmosphere, and of *Punch's* response to it, but does not tell one a great deal about Sambourne's own position.

There were always cartoons featuring the rivalries between particular political factions. Lord Salisbury, the Conservative leader, was Prime Minister when Sambourne was promoted, and his nephew, Arthur Balfour, a major force in the government, took over in 1902. Balfour's indecision over questions of free trade and protectionism and the internal divisions and eventual decline of the Liberal party were major issues of these years. Henry Campbell-Bannerman, the Liberal leader, who replaced the Conservative Balfour in 1905, aroused far less interest in

Punch than the Liberal Unionist Joseph Chamberlain, who had split the Liberal party over his opposition to Home Rule for Ireland. Sambourne, who had been called upon to caricature Chamberlain in the 1890s, continued to draw him until the end of his career. Chamberlain, having served for a time with the Conservatives, broke with them in 1903 in support of the campaign for imperial trade preference. Sambourne declared himself a Conservative Unionist, making him, like Chamberlain, an opponent of Home Rule, but the paper's bias was apparently the other way. When he met Chamberlain in person at Henry Lucy's in 1901, they had an "interesting talk … about pyramids & theatres" (D. 30.4.01).

Events overseas

Sambourne was often requested to provide cartoons on events overseas. One such was the second Boer War in South Africa, a contentious subject on which he had already been working before taking over from Tenniel. In 1880 the Boers, the Afrikaner farming community of Dutch descent, had risen against the British imperial power, gaining independence for the Transvaal in 1881. The second war began in 1899 when the Boers attacked Natal, defeating the traditional tactics of the British army by employing guerrilla warfare. At home, it was taken for granted that a small, largely untrained, force would be easily beaten by the professionals. Complacency was shattered when the army sent to relieve the besieged garrisons in Ladysmith, Kimberley and Mafeking was heavily defeated. 'Black week', in December 1899, was a devastating blow to confidence in British military strength. However, Sambourne's cartoon for 13 December 1899 warns the Boers not to underestimate the British infantry. Entitled *Disillusioned!*, it has a double caption: 'What they thought Tommy was. And what they find he is.' On the left of the drawing a bullet explodes overhead. Three slightly ridiculous British soldiers react by respectively falling over, standing hesitantly with a gun and running away. On the right, in the 'real' scene, one soldier advances with his bayonet held high while his companion lies, wounded or dead, beside him.

Sambourne's diary for January 1900 notes that rumours of Sir Redvers Buller's defeat at Spion Kop were circulating. Soon after, on 14 March, he had a chance to return to an old favourite, Napoleon. An exiled Boer General, Piet Cronje, the besieger of Mafeking, is shown on St Helena, saluting the ghost of the French emperor with the words: 'Same enemy, Sire! Same result!' The relief of the garrison

LEFT
Fig. 100 Photograph for *At Last*, taken 1 March 1900, Otley, the groom, on the left and a fireman

RIGHT
Fig. 101 *At Last, Punch,* 7 March 1900

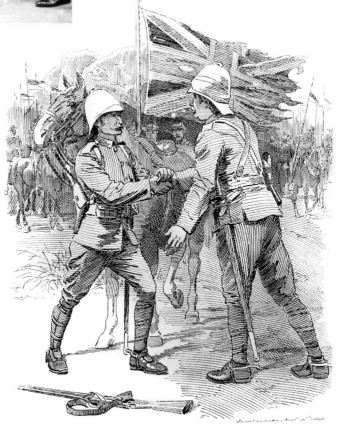

AT LAST!

Sir George White. "I HOPED TO HAVE MET YOU BEFORE, SIR REDVERS."
Sir Redvers Buller, V.C. "COULDN'T HELP IT, GENERAL. HAD SO MANY ENGAGEMENTS!"

at Ladysmith was marked with a cartoon entitled *At Last* (fig. 101). The caption reflected public amazement that Buller could have taken so long to reach the beleaguered stronghold. Sir George White, the defender of Ladysmith, greets him with: 'I hoped to have met you before, Sir Redvers', to which he receives the reply: 'Couldn't help it, General. Had so many engagements!' (P. 7.3.00).

The Boer siege of Mafeking was well reported in the press from the accounts of Lady Sarah Wilson, the *Daily Mail*'s correspondent, who was trapped inside the town. Huge celebrations in London greeted the news that Mafeking had been relieved and Sambourne heard joyful shouts from the streets of Kensington at midnight on 18 May 1900. Paula Krebs argues that such enthusiasm was largely the result of a mood of anticipation generated by the press and that Mafeking Night "made jingoism safe for the middle classes by blurring the distinction" between jingoism, previously seen as working class "over-enthusiasm for the empire", and patriotism.[5] If so, *Punch* played its part. Sambourne's Mafeking cartoon saluted the Queen on her birthday, with Mr Punch standing on a chair, and with women from the different parts of the empire raising their arms in triumph (P. 23.5.00). A number of Sambourne's drawings register *Punch*'s dismay at the handling of the war, with profiteering at home, unsuccessful attempts to broker a peace deal in Paris and ongoing guerrilla warfare in South Africa itself. In *A Vain Appeal*, Peace, represented as a white angel, is faced by a blackguardly Boer soldier, preparing to brutally whip her (P. 27.3.01).

Not everybody hated the Boers. There were calls for an end to the system of concentration camps, where Boer women and children were incarcerated. More people died in the camps as a result of malnutrition and poor sanitation than were killed in the field. Campbell-Bannerman expressed his party's opposition to the camps and his personal horror at their inhumanity. Sambourne drew him as a bagpiper in a cartoon of 26 June 1901, *Piping Times of Peace*.

Public opinion was divided on the issue, and *Punch* pilloried those who were seen as Boer sympathizers. A later Boer War cartoon, *Her Worst Enemy*, shows a trombone-playing 'Pro Boer' attacking and silencing a figure of Peace (P. 11.12.01). Rumours of a ceasefire in April and May 1902 meant that Sambourne was constantly caught wondering whether to change his cartoon. On 30 April the dilemma was placed in the foreground, as he showed Peace and War casting dice. Two weeks later, his title was *Almost Settled!* (P. 14.5.02). When the news finally broke on 1 June,

Sambourne was at Sir Alfred Hickman's dinner table after a game of tennis: "News of Peace came in whilst at dessert". The cartoon on 4 June was duly headed *Cease Fire!* with Peace blowing a trumpet.

The war had personal consequences for Sambourne. He noted with sadness that Captain Earle, whom he had met at Tressady in September 1899, was killed at the Modder River in the following December. Marion's brother, Edgar Herapath, was badly wounded in the ankle in 1900. Sambourne had done his best to promote Edgar's army career in September 1885 with a letter to Field Marshall Viscount Wolseley. This was shortly after Garnet Wolseley's return from the Nile campaign and his unsuccessful attempt to save the life of General Gordon at Khartoum. Sambourne's letter followed closely on Edgar's marriage to Sophy Fletcher and was clearly intended to help the newly married man to an improvement in salary. Wolseley replied telling Sambourne that Captain Herapath was likely to be appointed as an adjutant for the fourth battalion of his regiment. Sambourne was also offering to sell horses to the army, an offer which Wolseley turned down. He did, however, promise to forward Sambourne's comments on his brother-in-law to the Lincolnshire Regiment. Sambourne's correspondence with Wolseley was generally concerned with tickets for military reviews and volunteer march-pasts, but on this occasion his appeal for patronage apparently bore fruit.

A few years later, Sambourne was called upon to provide a commentary on the Russo-Japanese war, which broke out in 1905 following the Japanese attack on Russian warships in the harbour of the strategically placed Port Arthur (which the Russians had themselves seized in 1898 during the first Russo-Japanese war). Like many artists of the time, Sambourne was fascinated by Japanese artefacts and prints. On visits to Frederic Leighton's house or to his daughter and son-in-law, he talks of looking through volumes of Japanese prints or studying ivories. *The Darling of the Gods*, performed at His Majesty's Theatre in 1904, struck him as a "poor play" with "splendid Japanese Scenery" (D. 20.2.04), and he bought a number of Japanese vases at a sale in Campden Hill Road in the same year. From the late 1880s the wallpaper in the drawing room at 18 Stafford Terrace was Japanese. Imitating Spanish leather it was supplied by an English firm with a factory in Japan, Rottman & Co.

Punch was pro-Japanese, and Sambourne, who had retained a sense of the ruthless autocracy of the Russians from his 1890 visit, was no exception. He presumably shared the magazine's belief that Czar Nicholas II should make

concessions to his people in the aftermath of the disastrous Bloody Sunday rising of January 1905, when troops fired on a procession in St Petersburg. The defeats in the Japanese war, together with poverty and lack of parliamentary representation, were, *Punch* believed, the underlying causes of that revolution.

Sambourne's political cartoons, like Tenniel's, were often anthropomorphic. The old national stereotypes were retained and he made particular use of birds in his designs. He began to go to the Zoo more frequently, often photographing the bears which traditionally represented Russia. In June 1904, for example, he took eighteen photographs for use in a cartoon depicting the struggle between the Russians and the Japanese over the planting of a Russian flag on an ice floe. On this particular occasion, Sambourne's own shots turned out badly but "the Keeper took three which were the most useful to me" (D. 9.6.04). One result was *Melting*, a cartoon of a bear on ice at Port Arthur. In *The Jolly Rogers* the Russian bear (or merchant seaman) becomes a pirate, hoisting the skull and crossbones (P. 15.6.04; 27.7.04). Nearly two months later Sambourne was back at the Zoo taking photographs of "lions, eagles, bears etc. All thro' bars. Melancholy Bear waving his paw" (D. 31.7.04). On other visits, he photographed a range of animals, among them lemurs, ostriches, orang-outangs, kangaroos, a baby giraffe, an elephant and a jackal.

Sambourne's more imaginative work was to be found, as before, in his drawings for the Almanack (fig. 102) and, until they were discontinued, in the heading and tailpiece of the Index. Douglas Sladen paid tribute to Sambourne, stressing his superiority to Tenniel as a decorative artist:

> In all his long service, Sir John never gave us anything better than the noble Paolo Veronese decorativeness of the cartoon in this year's 'Punch's Almanach', 'The Object Lesson', and that admirable cartoon of 'History repeats itself'[26 Feb 1902], which appeared a fortnight ago, in which a stately ghost of Dryden was saying to the most lifelike picture of Lord Kitchener I ever saw. 'Our trouble now is but to make them dare'.[6]

Photographs and models

Sambourne did not change his working practices with his promotion. He continued to take photographs of family, friends and staff. The groom, George Otley, proved to be a particular success as a model, appearing in numerous roles and

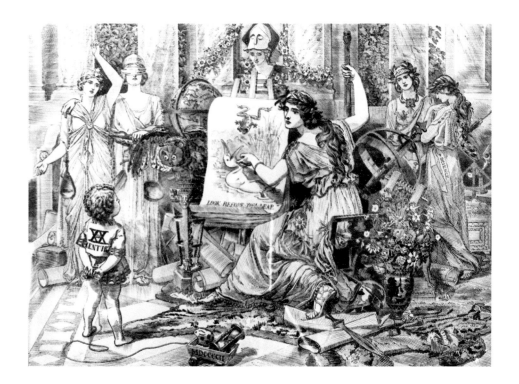

Fig. 102 Original drawing for *Punch* 'Almanack' of 1902, Linley Sambourne House

seeming to enjoy the activity as much as his master. Otley, however, had his faults, and Marion was much dismayed when she saw him brutally lashing their horse, the Mare, in 1902. Sambourne considered having Otley charged with the offence. Alcohol was Otley's vice, and he was intermittently drunk on duty. In June 1903 he was inebriated when he collected his employers from the Royal Academy Soirée and again, although he declared that he was sober, after Hilda Messel's wedding the next day. Finally, in February 1906, Otley was so drunk when on his way to pick up the Sambournes from a dinner party that he crashed into a cab, causing considerable damage to both vehicles. Sambourne received a solicitor's letter with a claim for £20.00 from the cab owner and Otley left on 27 February. Upton, who appears in many of Sambourne's last cartoon photographs, replaced him.

Sambourne's sessions at the Camera Club continued until August 1905, when it vacated its premises. He removed his equipment, but delayed sending it to the Photographic Association in Conduit Street until November 1906. He then

continued to photograph models in the new setting until he became ill in 1909.

With the passage of time, Sambourne had become increasingly preoccupied with his filing system. In the later years of his career, if no other work had to be done, he would tidy his equipment and sort his photographic prints and sketches. Stafford Terrace is not an enormous house and, given the shortage of space and the pressure of Fridays, there must have been a need for order as well as for easy access to whatever he needed. At the same time the artist evidently felt a keen pleasure in the activity of filing his photographs. John Ruskin embarked on periodic ordering when under strain and this process may have been therapeutic for Sambourne, a way of relaxing after his efforts to meet the deadline. Or was it just an excuse for delaying a return to work, while cultivating the illusion that he was achieving something? Was he setting up the conditions in which to begin on a book illustration or a private drawing, or was he finding some means of not beginning on either?

With a characteristic sense of order where his photographs were concerned, Sambourne had begun in the 1890s to list the dates on which each individual sat to him, with terse evaluations of the success of the session. Not all the cartoons were drawn from new photographs. He would sometimes take existing photographs out of his files, as he did with a print of Hetty Pettigrew in December 1904. An 1895 shot of Mrs Madge King served for the mourning figure on the left of his Gladstone memorial card of 1898 (fig. 103). Sambourne retained some interest in his models. After his sessions with her in the mid 1890s, he believed Mrs King and her daughter to be dead. To his surprise, she wrote to him in October 1900 and Sambourne duly photographed her again in 1901.

Maud Easton, who may not have been a professional model, was very tall with long legs, exactly what Sambourne needed for his drawings. After she had ceased sitting to him, he occasionally heard news of her. In May 1901 Sir Kenneth Mackenzie told him that Maud had been nineteen when she posed for Sambourne in 1891, and that now, a decade later, she had recently married. "Very interesting," was the artist's response (D. 2.5.01). He talked of Maud again, to Mr Simmonds, at a dinner given by the Messels three weeks later.

Martin Postle and Shirley Nicholson agree that Sambourne had a particularly close, and probably sexual, relationship with a favourite model known only as M. Reid. He "made detailed graphs of all his previous sessions … with notations such as 'First', 'Best', 'Double' and 'Climax'".[7] These may have been evaluations of the

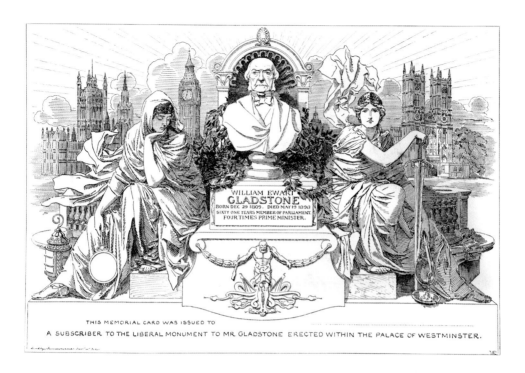

Fig. 103 Gladstone Memorial Card, 1898, Madge King on the left

success of his photography, but it is notable that he took this model to tea at Liberty's in 1901 and also corresponded with her during his autumn visit to Scotland. Letters were delivered to the Camera Club, rather than to his home. As Postle points out, she appears in his list of sittings as M. Reid, but, "elsewhere Sambourne refers to Miss Reid only by her initials, indicating perhaps that he wished to keep her identity secret".[8]

A revealing glimpse of Sambourne's friendships with his models comes in a letter posted to Ethel Warwick in March 1906. Ethel, a favourite with James Whistler and Herbert Draper, worked for artists in the Kensington area and posed for Sambourne between July 1900 and July 1901 and again in March and August 1905 (fig. 104). In November 1903 he had "Strange Dreams" of her (D. 19.11.03). The letter, like two earlier ones, was returned to the sender with the note "gone away". (One fell into Marion's hands, causing a domestic dissension.) In the surviving letter, Sambourne, addressing his correspondent as "Miss Ethel", asked affectionately whether she had found an engagement, presumably as an

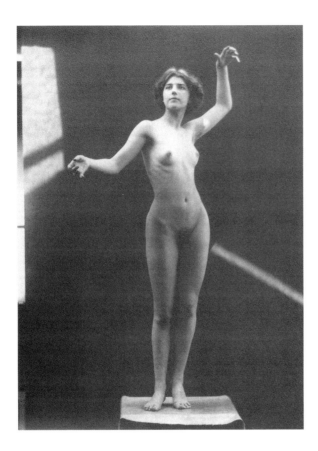

ABOVE
Fig. 104 Ethel Warwick posing, 1900

RIGHT
Fig. 105 *A Row in the parrot-House*, *Punch*, 17 May 1899

actress. Her stage debut had come in 1900 when she appeared in *The Corsican Brothers* by Dion Boucicault and after this she continued to work as both model and actress. Then, in 1906, she married the actor Edmund Waller. They travelled extensively, which may explain the return of Sambourne's letters. Sambourne did see Ethel again, on the stage, in 1908 and 1909.

Other commissions

Private work continued to be a source of income. When he sold the original drawings for his cartoons, the purchasers frequently requested that he write messages on them. Among the buyers was Lionel de Rothschild, who asked for the double-page drawing of the Russian Bear on melting ice at Port Arthur. Margot Asquith, the wife of the Chancellor of the Exchequer, requested the drawing of *A Row in the Parrot-House*, which Sambourne, in an interview with a journalist, declared to be his "best-remembered example of the comic spirit". The cartoon shows Rosebery and Harcourt as

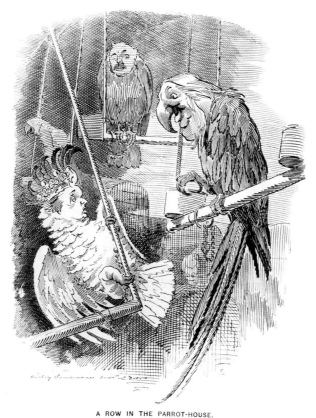

A ROW IN THE PARROT-HOUSE.

The Campbell-Bannerman Bird, "What a Noise they're making! I can hardly hear myself shriek!"

parrots. Harcourt hectors the cowering Rosebery while Campbell-Bannerman, as a third bird, complains: 'What a noise they're making! I can hardly hear myself shriek!' (P. 17.5.99; fig. 104). Sambourne explained that the idea for the cartoon had been his own, and that he "took a lot of trouble over the drawing, first going to the Zoo to make some studies of the birds".9 A number of people asked to buy the drawing and Margot Asquith was unlucky. It was sold to the first comer, a canon of Winchester Cathedral.

Sambourne continued to sell through the Fine Art Society in Bond Street, but the 1893 exhibition had represented the zenith of his public success as a draughtsman. A later Fine Art Society show, in July 1897, was shared with the illustrator of Elizabeth Gaskell, Hugh Thomson, but Sambourne was disappointed with the results. He was even more depressed in June 1903 when, at a special *Punch* show held in the Woodbury Gallery, he failed to make a single sale.

Sambourne's *Punch* contract did not prevent him from working for other journals and employers. In 1909 Gordon Selfridge asked him to design an

advertisement for his Oxford Street store, part of a group of thirty-two such advertisements, many of them supplied by *Punch* artists. Cunard Line commissioned a drawing in November 1904 and Sambourne decided to incorporate a quotation from Edgar Allan Poe, 'As sure as there is a sea' (D. 16.11.04). In January and February 1900, he was hard at work on a drawing of Joan of Arc for Mr Gillott. This work, for which he was paid £105, caused him a good deal of anxiety: "Much pushed & bothered with it", "took out the head for 4th time" (D. 17.2.00). So large was the design that it had to be sent by rail rather than post.

One casualty of the numerous commercial commissions was the still unfinished illustrated edition of Hans Christian Andersen's stories. Sambourne records a meeting with Frederick Macmillan on 23 March 1908, which he found "satisfactory" but Macmillan was never to have his complete volume. After Sambourne's death he had to content himself with publishing *Three Tales of Hans Andersen*. The text, illustrated with the twenty-two completed drawings, appeared in a handsome blue cloth binding with gold lettering and vignette.

Turn of the century

Times were changing. There were new features at 18 Stafford Terrace. Electric light, fitted in 1896, was a mixed blessing. It helped with late evening work, but there were frequent breakdowns and the costs were alarming. The telephone was installed in February 1909 and inaugurated with a call to Maud. Sambourne first travelled in a 'motor' in 1898, on a journey to Guildford. In a later diary entry he dates his first ride in a motor car to an outing from Ballechin in Scotland in August 1901, possibly distinguishing between different kinds of vehicle. In the same month he was very worried when Marion and Maud joined a party "for a most dangerous ride on a strange motor car" (D. 4.8.01). By then Sambourne had already drawn a cartoon featuring a car, *Difficult Steering*, with Lord Salisbury and Arthur Balfour trying to circumvent a mass of political obstacles in their path (P. 20.2.01). Leonard Messel bought a Panhard in 1902 and the Sambournes soon became used to travelling with his vehicle and chauffeur. The painter Hubert von Herkomer wrote in 1903 to congratulate the artist on a cartoon, *The Race of Death!*, in which Death hurtles down a mountain path (P. 3.6.03; fig. 106). The occasion was a road race from Paris to Madrid, cancelled at Bordeaux after many accidents, one fatal, had occurred. Herkomer regretted that Sambourne had not used a racing car as a model.

PUNCH, OR THE LONDON CHARIVARI.—June 3, 1903.

THE RACE OF DEATH!

Fig. 106 *The Race of Death!*, *Punch*, 3 June 1903

A keen motorist himself, he pointed out that the drawing showed, not a "lethal vehicle" but "a nice respectable car that gives [a] respectable motorist endless pleasure and real health".[10]

Sambourne's first journey up to town in a motor bus was in May 1905, and he returned from Hyde Park Corner in what he calls a motor cab (a taxi) for the first time in September 1906. *Punch* published a number of cartoons on the new modes of transport, complaining that cars went too fast, and that they disturbed riders, cyclists and pedestrians, complaints which Sambourne echoes in his diary. The Sambournes never bought a car, and could not have afforded one. Instead, they maintained a brougham, a horse and the stable in Phillimore Place. Shirley Nicholson is right to be puzzled by this decision: "Linley no longer rode, and even the bicycle was beginning to lose its charm, but he refused to consider selling the horses or making economies in this department and nothing Marion said would change his mind."[11] After her husband's death, Marion promptly parted with the stable to Mr Gwyer, who planned to convert it into a garage (a structure which her husband would have called a motor house).

Sambourne did make a late attempt to return to horse riding. He looked at various horses in the early part of 1909, and then chose a cob mare, Jenetta, paying £45 for her. He began to take morning rides in the Park and surrounding area once again, carrying his camera and snapping scenes and passers by. In April Jenetta was taken down to Ramsgate for him. On one occasion, when there were no staff in the stable, it took him three quarters of an hour to mount her and the mare bit his hand in the process. Then, on 23 July, she stumbled behind the Albert Hall, causing her "severely shaken" rider to fall to the ground. Some "kind labourers" helped him, but he seems not to have ridden again and she was sold for £20 in January 1910.

The underground railway – with its unpleasantly smoky steam train – reached Kensington in the 1860s. Sambourne occasionally used it to take him to the City and the *Punch* dinner. This was an old-fashioned cut-and-cover railway, but the 'twopenny tube', running in a metal casing of its own and at a fixed price of twopence, came into operation in 1900. Almost a decade before, when the idea of an electric underground railway was first mooted, Sambourne had drawn a cartoon, *The Young Spark and the Old Flame*, which shows the steam railway, swathed in smoke, growling at the 'Flashy Young Upstart' as Lady London stands between them (P. 15.11.90; fig. 107). On 4 July 1900, *Punch* featured a Sambourne

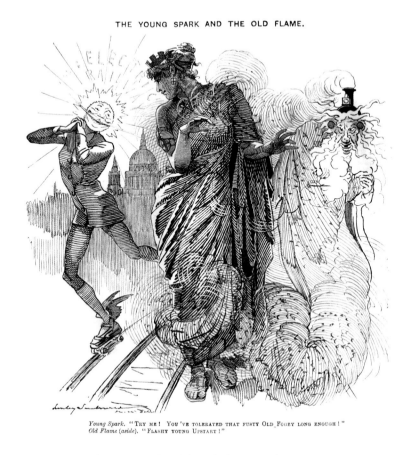

THE YOUNG SPARK AND THE OLD FLAME.

Young Spark. "TRY ME! YOU'VE TOLERATED THAT FUSTY OLD FOGEY LONG ENOUGH!"
Old Flame (aside). "FLASHY YOUNG UPSTART!"

Fig. 107 *The Young Spark and the Old Flame, Punch*, 15 November 1890

cartoon on a similar theme, *Notice to Quit*, marking the opening by the Prince of Wales of the Centre of London Electric Railway (later the Central Line). A demonic steam locomotive is put to flight by the Fairy Electra, who tells him, 'Now they've seen *me*, I fancy your days are numbered'. Sambourne's first diary reference to the 'tube' comes on 3 December 1900, when, with Marion, he saw Roy to the station. He himself took a ride five days later and noted: "Twopenny Tube for the 1st time". He was soon making use of the underground railway to visit Maud on the northern side of Hyde Park and to reach the Oxford Street area. Eventually he was travelling to Holborn and Bank, sometimes returning late in the evening and saving the cab fare.

The biograph, a pioneering form of cinema, was another technical innovation. In the early 1900s Sambourne regularly records seeing short films at the Palace

Theatre. These included newsreel material and he enjoyed coverage of the Boer War and of the political situation in Russia. More fantastically, the subject of one piece was a fight between spiders and scorpions.

Virginia Woolf placed the beginning of Modernism at the Post-Impressionist exhibition in the autumn of 1910, a time which Sambourne did not live to see. For all his regular visits to Varnishing Days and Private Views at the Royal Academy, he rarely remarks on developments in the art world. True to his belief in accuracy of detail, he believed that painters in the Impressionist style were inherently lazy and the notes on pictures which he had enjoyed at exhibitions and galleries refer almost exclusively to established artists or to Old Masters. The striking portrait of James McNeill Whistler by Giovanni Boldini greatly pleased him at a Grosvenor Gallery private view in 1903. It had won a medal at the Paris International Exhibition in 1900, which he attended, but he appears to have seen it for the first time at the Grosvenor. Boldini shows Whistler seated, but turning away from the angle of the chair to look straight out at the viewer, his hair tangled and his hand raised to his brow. He is in evening dress, but his coat, hat and umbrella are held in front of him, and there is a general effect of *déshabillé*.

Sambourne continued to have a special interest in the eighteenth century, and was delighted by the eighteenth-century French and English portraits shown in an exhibition at the Guildhall in 1902. The annual Royal Academy cartoons in *Punch* were now the work of younger artists but he occasionally parodied Old Master paintings seen on holiday like Velázquez's *Don Baltasar Carlos on Horseback*, from the Prado in Madrid, and Rembrandt's *Anatomy Lesson*, from the Mauritshuis in the Hague (P. 30.5.06; 7.11.06).

Coming closer to his own date, he parodied three popular paintings by John Millais in late cartoons. A *Punch* reader suggested *The Huguenot* (1852; Makins Collection), where a young woman appeals to her Protestant lover to save himself from the Massacre of St Bartholemew, as the basis for a commentary on Ireland trying to persuade Campbell Bannerman to support Home Rule. *Bubbles* (1886; private collection) was an obvious choice for a cartoon on American soap manufacture, and *The Princes in the Tower* (1878; Royal Holloway College) inspired a humorous design showing Augustine Birrell and Reginald McKenna as the two princes awaiting the arrival of the Prime Minister, 'Uncle Arthur' Balfour (P. 20.12.05; 31.10.06; 5.2.08; fig. 108).

PUNCH, OR THE LONDON CHARIVARI.—February 5, 1908.

Fig. 108 *The Victims*, *Punch*, 5 February 1908. Based upon the painting *The Princes in the Tower* by John Everett Millais.

THE VICTIMS.

(After "The Princes in the Tower," by Sir John Millais.)

AUGUSTINE BIRRELL *(apprehensively)*. "I SAY, REGGIE, HERE COMES UNCLE ARTHUR."
REGINALD McKENNA *(with modest assurance)*. "I DON'T MIND. IT'LL TAKE HIM ALL HIS TIME TO SMOTHER *ME*."

Edward Burne Jones's *Briar Rose* (1870–90; Buscot Park), a painting of the Sleeping Beauty, appeared on the title page for Volume CXXI of *Punch* with Mr Punch as the knight trying to break through the briars, and the caption: 'The Legend of the War Office Red (Tape) Briar Rose' (P. 3.7.01). Sambourne knew the Hendersons of Buscot and must have been familiar with the sequence of paintings which hung there. His passion for accuracy made him send for a shoot of a briar rose and a branch with thorns from his daughter's garden in Sussex. Such drawings were, however, now exceptions from the regular run of his work.

One contemporary work which Sambourne could not miss was *Physical Energy* by the recently deceased George Frederic Watts, a huge statue of a young man on a rearing horse which was set up in Kensington Gardens in September 1907 on an axis with the Albert Memorial. Sambourne first saw Watts's statue six months after

its arrival, when walking through the Gardens with Marion on 2 February 1908. Watts, a Kensington resident, had contributed a drawing to Marion Sambourne's fan in 1882, and his praise for Sambourne's draughtsmanship has already been quoted, but it is hard to trace any personal relationship between the two artists. A number of letters, written late in Watts's life, congratulate the younger man on his work and invite him round for a cup of tea, but there is no evidence in the diaries that Sambourne saw Watts except on his annual round of studios before the opening of the Academy exhibitions. Possibly he found the older artist, with his strong social conscience, too intimidating. They met and shook hands in July 1902, when Sambourne was a guest at a dinner to mark the institution of the Order of Merit, of which Watts was among the earliest recipients. In her letter of thanks for Sambourne's letter of condolence on Watts's death in 1904, his widow, Mary, wrote: "Your work was always an abiding pleasure to him – he used to say how rarely he found what he liked to call 'great style', in any work but yours".[12]

It would be a mistake to assume that Sambourne was completely unaware of changing patterns of taste. He was familiar with the work of a number of the women painters who were making a reputation at the Grosvenor and elsewhere. Louise Jopling was a good friend, and he knew Lucy Kemp Welch well enough to dream of a "girl painter" like her (D. 15.9.00). At Varnishing Day in 1901 he particularly noted meeting Kate Perugini, Dickens's daughter and a successful portraitist who was known for her studies of children. She was the sister of one of Sambourne's friends, the lawyer Henry Dickens, and the Sambournes frequently met Kate and her husband, the painter Carlo Perugini, and Dickens's sister-in-law Georgina Hogarth.

Family and social life

In many respects, Sambourne's life in the first years of the twentieth century continued much as usual. After Maud's marriage, her parents often stayed with her at her country home. For a time the Messels rented a house in Sussex, and then, in 1900, they bought 'Glovers' at Charlwood. Two years later they moved to the Georgian Balcombe House (see fig. 97, p. 248). It was probably from the more "picturesque" Glovers that Sambourne sent an undated letter to the officers of the Royal Society for the Protection of Birds, telling them: "This country house of my daughter's is a Paradise for Birds, and there is a Robin now in the room so tame that he has come through two other rooms to get here." A small sketch of the robin

Fig. 109 Linley Sambourne's grandchildren, Anne left, Oliver centre, Linley right

was included in the letter, its "scarlet breast being indicated with the red ink so often called in to ornament and emphasize his correspondence".[13] Sussex would now replace Ramsgate as a setting for his autumn work on the 'Almanack'. He could walk in the surrounding area, enjoy good food and pass his evenings in the company of fellow guests. Both houses were near enough to the Messel family home at Nymans for him to take part in its dinners and shooting parties. As he had from Ramsgate, Sambourne would go up to London for the *Punch* dinner on Wednesdays, usually returning to the country on Saturday morning.

For Maud, whose father had always worked from home, this was a new world. When they were in the country, her husband, like a modern commuter, would travel to the city by train from the nearby station, returning in the evening. Lennie's success in the family stockbroking business meant that Maud was able to relieve her mother of financial anxieties. He proved a model son-in-law, pleased that Marion could provide company for Maud, and happy to take his father-in-law on holiday. Maud remained as dependant upon her mother as Marion herself had been on hers, and, sadly, Maud also inherited something of Marion's tendency to ill health, fuelled by hypochondria. When he was old enough, little Linley would join his grandfather on walks or visits to the

pantomime. Two further grandchildren soon followed him, Anne, born in 1902, and Oliver (the future designer) in 1904. Coming from a well-to-do family, they were well supplied with supporting staff but their grandparents were nevertheless very welcome. Before long, Sambourne was photographing the children, sometimes singly, sometimes in groups (fig. 109). "Dear little Ann [*sic*]" was his special favourite and he greatly enjoyed her visits to 18 Stafford Terrace. In old age she could still recall the fun she had with her grandfather.

> It was a house of perpetual motion, sometimes guests and relations, but often models coming to and from grandpapa, and now and then the little figure of the artist himself in his black and white plaid suit bounced down – with great gold watch in hand, to make it tinkle for children. My task was to sit at a little table making Christmas presents until the procession of tea was brought up – leaving my grandmother to entertain callers.[14]

Roy, meanwhile, remained at home. With the help of his brother-in-law he became a trainee at the Stock Exchange and then worked as a jobber. He did not set up in business on his own until after his father's death. Sambourne rated Roy's success as "not very brilliant" (D. 28.7.01), but Roy made his "first money on Stock Exchange", £10, in January 1902 (D. 25.1.02). Though never very gifted in the money markets, nor much enjoying his work (he complained bitterly to his father in January 1904), Roy was to remain in the City. Like Lennie, he joined the Territorial Army, but left when the two men went to America on business for two months at the end of 1901. The plan was that Roy would learn a good deal from this journey and that he would make valuable contacts.

Roy must, in fact, have spent a good deal of his time in the theatre, of which, like his father, he was a lifelong *aficionado*. His mother was dismayed when her daughter and son-in-law reported seeing him in a box at a London performance "with women! Could not recognise him of course. Perhaps Lin will see at last Roy is not the innocent child he seems to think him".[15] Roy was swept away in 1898 when a young American actress, Edna May, opened in *The Belle of New York*. He met her in Oxford in 1899, while he was still an undergraduate, and became a member of her circle of admirers. Edna, who had left a husband behind in America, seems not to have been greatly attracted by Roy, and, with her mother as a chaperone, she made a particular

Fig. 110 Roy Sambourne, 1906

point of maintaining her respectability. Their friendship, however, lasted for the rest of Roy's life. Not long before Roy left Oxford, where Marion thought that he was "too much" in the "theatrical set", he tried to defend Edna against the parental strictures, telling them: "I should not like to displease Papa or cause him or you sorrow in any way, but he is wrong about Edna May, who although a burlesque actress and living apart from her husband is as *good* and as *ladylike* as anyone I have *ever* met."[16]

Sambourne himself was in the audience for a number of Edna's performances, including *The Belle of New York,* which he saw at the Shaftesbury Theatre with Marion in 1899. He notes that Roy saw the play on three occasions, but this was no doubt an underestimate. Sambourne thought Edna's next play, *An American Beauty,* produced at the same theatre a year later, "the greatest rubbish I ever listened to" (D. 22.5.00). He was in the audience when she fainted at the end of the last act of *The Girl from Up There* in 1901 and saw her in *La Poupée* at the Prince of Wales Theatre in May 1904.

Roy had wealthy friends from Eton and Oxford days, with whom he often spent his evenings and weekends, and who would pay his expenses, but his bills occasionally landed in his father's hands, drawing out expressions of dismay and annoyance. On the whole, however, Sambourne put little pressure on his son, less, it would seem, than his mother. There are regular references in Sambourne's diary to Roy's arguing with Marion at the lunch or dinner table, perhaps about his career. His father, by contrast, kept in touch (when they were apart) with long and informative letters, only occasionally reminding Roy to try to succeed in business, to take care of his health, not to eat and drink too much, and to keep regular hours.

As chief cartoonist for *Punch,* Sambourne's social position was further elevated. He was already becoming well known and was invited to royal levées at

Buckingham Palace and St James's Palace, a garden party at Windsor Castle, conversaziones at the Royal Society, Foreign Office receptions, dinners at City companies and at the Mansion House. The aristocracy included him on their lists. In July 1902 he was at Hatfield House in Hertfordshire for Lord Salisbury's garden party, then, in June 1906, at Stafford House for a reception given by a great hostess of the day, Millicent, Duchess of Sutherland. In July 1900 he attended a dinner at the Royal College of Surgeons, where the Prime Minister, Lord Salisbury, and the former Prime Minister, Lord Rosebery, were the guests of honour. Sambourne, who had designed the invitation and the menu, received many congratulations on his drawings and was later paid £52. 10.00.

The New Vagabonds Club dinner in his honour, delayed at the time of Queen Victoria's death, was held at the Holborn Restaurant on 23 February 1901, with the novelist Israel Zangwill in the Chair. Douglas Sladen then invited Sambourne to be guest of honour at a dinner at the Authors Club, on 10 March 1902. In his speech, Sambourne described himself as like an author, telling stories. A copy of Sladen's welcoming address survives, paying tribute to the cartoonist as *"the Flaxman of comedy and journalism,* one of the greatest masters of line-drawing that this country has ever seen". Sladen, a good friend of M.H. Spielmann, referred to the restrictions which Burnand placed upon his staff: "I do not think that Mr Sambourne was allowed to exercise a frank pencil, though it seems difficult to conceive that any editor should be so blind to the interests of his paper as to deny a free rein to a genius like Mr Sambourne – *the greatest comic genius in the history of British Black and White."* Before proposing the toast at the end of his speech, Sladen once more turned to the subject of Burnand, with a reference to the "the mean way the Punch artists say that the jokes are Mr Burnand's".[17]

In 1901, in a return to the family home-town, Sambourne was invited to a dinner given by the Sheffield Press Club in the Cutlers' Hall with the Duke of Norfolk as chief guest. Roy was his companion on this occasion and they stayed with the Linley Howldens, who must have been distant relatives. Like the Linleys, the Howldens were a Sheffield manufacturing family. In 1901 and 1902 Herbert Linley Howlden and his wife rented Renishaw Hall in Derbyshire, the seat of Sir George Sitwell. The Sambourne family made three visits to them during that time. Renishaw is close to Sheffield, and, after the dinner, father and son made their way to the Hall with their host. Roy was housed in a bedroom reputedly haunted

by the ghost of a drowned man. Disturbed by "ghost wringing hands, noises, owls etc.", he spent the rest of the night in his father's room (D. 19.4.01).

Next day, Sambourne, delighted by Renishaw, took many photographs: "Lovely tapestries, furniture, pictures, bronzes" (D. 20–21. 4. 01). Ever practical, he noted that it was insured for £50,000. On the previous day, father and son had taken the opportunity to visit Aunt Elizabeth Linley, who lived in Sheffield. Eighty-four years old, she looked much younger. Now they made an expedition to the scenes of Sambourne's childhood, looking around Norton Church, Chantrey's Cottage, Bolehill and Jordanthorpe.

A few weeks later Sambourne returned to Renishaw for a weekend visit, bringing Marion with him and taking her on the same nostalgic round. On this occasion, he shot at rooks with fellow guests, among them his uncle, Arthur Linley. In March 1902, Roy joined his parents for the third expedition to Renishaw. Linley and Marion managed to sleep soundly although they were housed close to the haunted room. Sambourne photographed extensively in Sheffield and then relaxed by playing golf. The whole party visited Welbeck Abbey, the home of the Duke of Portland, and Hardwick Hall, the great Elizabethan House belonging to the Duke of Devonshire. The tapestries at Hardwick caught Sambourne's eye, together with a painting of the Duchess of Devonshire.

The Sambournes reciprocated this hospitality in the following April by inviting the Howldens to Stafford Terrace for dinner and taking them on to see a comedy by Anthony Hope, *Pilkerton's Peerage*, at the Garrick Theatre. Sambourne ruefully noted that his guests did not seem to enjoy their post-theatre supper at the Savoy. There was little further contact between the two families until Howlden and his son and daughter called at Stafford Terrace in February 1909.

At the Varnishing Day for the Royal Academy exhibition of 1901, an occasion for artists to study each other's work, Sambourne looked very carefully at John Singer Sargent's *Sir George Sitwell, Lady Ida Sitwell and Family*. Sargent had not painted the Sitwell family at Renishaw, but Sir George had arranged for the Brussels tapestry of *The Triumph of Justice* by Louis de Vos and the Chippendale sideboard to be taken to the artist's studio in Chelsea. The tapestry and the sideboard are a prominent feature of the group portrait and Sambourne recognized both. A year later, dining with the leading doctor, Sir Henry Thompson, he talked at length with Sargent about Sir George Sitwell. The painter must have had a good deal to say. Sir George

had interfered at every stage of what proved to be a very difficult commission. Sargent painted the Sitwells with their three children, Edith, Osbert and Sacheverell, and the sittings feature in the autobiographies of the first two. This was what would now be called a dysfunctional family. In the portrait the relationship between husband and wife is reflected in the unusual distance between them, and the painting aroused a good deal of critical discussion. Sambourne was an indirect beneficiary of Lady Ida's extravagance, evidently a factor in the leasing of Renishaw to the Howldens. Given Sambourne's family connection with Sheffield, the visits to Renishaw must have been particularly enjoyable. He could not fail to be gratified that he was now not only an honoured participant at a Sheffield civic dinner but also a guest at a local country house.

None of this increasing fame, however, brought the one benefit for which Sambourne was hoping. Among the few really revealing statements in his diary are his notes, just before the announcement of the sovereign's honours list, that he now knew that there would be nothing for him. If Tenniel, Burnand and Lucy, together with Francis Gould, the cartoonist of the *Westminster Gazette*, were knighted, why not Sambourne? It is impossible to tell Sambourne's reactions in 1902 when Burnand received his knighthood. He duly congratulated his old friend, but was it a bitter pill to swallow? He was careful to note honours of any kind whenever he mentioned friends and acquaintances in his diary. The way in which he rigorously refers to the knighthoods of close friends like Burnand and Lockyer produces an oddly pedantic effect, a reflection of his own preoccupation with the subject.

There was talk of the election of Sambourne or Tenniel to the Royal Academy, but neither gained the honour. An obituarist at the time of Sambourne's death quoted a telling statement from *Men and Women of the Time*: "It is singular that although Mr Sambourne was the doyen of English caricaturists, and as such maintained the ancient and highly honourable traditions of a typically English art, he never received recognition from any Academy."[18] Agitation for black-and-white artists to be elected continued through the later years of the nineteenth and into the twentieth century. When her husband dined with Frederic Leighton, Marion wished "it meant A.R.A. for him!"[19] In the summer of 1903 *The Times* and the *Quarterly Review* became involved in calls for reform. The Academy, it was pointed out, was run by painters and sculptors, who regarded alternative branches of the arts as unimportant. It was suggested that the Associate membership of the

Academy should be widened, and that a separate exhibition for drawings, engravings and applied art should be held.

Sambourne corresponded on the subject with Edward Poynter, who had succeeded Frederic Leighton and John Millais (both of whom died in 1896) as President of the Royal Academy, but Poynter refused to be drawn into a discussion. Sambourne did not like Poynter, identifying him as an opponent to change. The diary entry for 4 November 1896, the day of Poynter's election as President, tells of the "great excitement and terrible disappointment". That Sambourne was among the disappointed is clear from a red ink note which he added later: "E. J. Poynter elected President of the R.A. D—him."

Sambourne's position on *Punch*, and his reputation as a cheerful companion, increased his popularity as a guest on short cruises, a popular form of entertainment among friends of the wealthy. Frank Burnand noted that, when in company, Sambourne talked neither of himself nor of his work, and this lack of egoism must have been an added bonus. Some expeditions were family outings, organized by Hamilton Fletcher, others were 'men-only' gatherings of like-minded figures. In 1900, Sambourne was on board the *SS Arcadian* making the journey from Gravesend Estuary to Southampton. He noted the presence of a number of MPs, including his old friend John Penn, together with Arthur Wing Pinero, the playwright, and his own *Punch* colleagues Burnand and Lucy. Similar cruises took him from the Irish Channel to Dover on the *SS Minnewater*, on the *SS Barbican* to Ireland and on the *SS Sabrina* from the Isle of Wight to Weymouth. Sambourne's remarkable drawing of Gladstone relaxing on the deck, the frontispiece to Henry Lucy's *The Log of the Tantallon Castle*, actually recorded a voyage from which the artist was absent, but he had no lack of experience to draw upon (fig. III). He still made occasional Sunday journeys to Calais, and travelled from Holyhead to Dublin for lunch, a risky undertaking considering the unpredictability of the Irish Sea.

Shooting expeditions, if anything, increased in number. Sambourne's letters to his daughter frequently cancel existing arrangements in favour of tempting invitations. He would now shoot four or five times a year, sometimes as a guest of his brother-in-law Hamilton Fletcher, whose large houses continued to provide holiday destinations for all the Sambournes. Vernon Watney gave up Tressady in favour of Loch Luichart, Rossshire, and Sambourne reports his last visit to Rogart in April 1902. William Knox D'Arcy, Sambourne's host at the time of his promotion in 1901,

BOUND FOR THE BALTIC.

invited him to shooting parties at Bylaugh Park in Norfolk. They had met in Rotten Row in the late 1880s and were fellow members of the Garrick. D'Arcy, who made a fortune mining for gold, later became an important figure in the development of the oil industry in what is now Iran. Close to the time of his meeting with Sambourne he had commissioned the *Holy Grail* tapestries (designed by Edward Burne Jones) from William Morris. D'Arcy's wife, Nina Boucicault, was a cousin of Sambourne's friend, the theatre manager Dion Boucicault.

As he grew older, Sambourne became less willing to kill certain animals. He saved a shrew mouse on one occasion and rescued a rabbit from a gin trap (finding this method of capture unsporting), to the intense irritation of at least one onlooker.

LEFT
Fig. 111 *Bound for the Baltic*, Gladstone, from *The Log of the Tantallon Castle* by Henry Lucy, 1896

RIGHT
Fig. 112 Title page, *Punch*, Volume 115, 1898. Sambourne imagines Mr Punch in Egypt

After their honeymoon, and with the exception of the Russian expedition, Linley and Marion Sambourne rarely travelled further than Paris, where they continued to take short holidays. Then, in the last years of Sambourne's life, they began to venture farther afield. A spring Mediterranean cruise in 1905 took them from Marseilles on *SS Orient*, visiting Corfu, Olympia, Athens, Smyrna, Constantinople, Alexandria, Cairo, Malta and Sicily. That this journey was not an entire success is evident from the couple's diaries. The weather was bad and Linley was upset when he discovered that his new camera had been damaged on the way out. Marion thought the boat crowded and uncomfortable in comparison with the private yachts to which they had become accustomed. Compensations were to be found in the Greek museums and their time in Constantinople lived up to expectations, with extensive sightseeing and two visits to the British Embassy. The camera began to behave, and Sambourne took many photographs in Egypt. Throughout the journey he enjoyed the company of Lord Mount Edgcumbe, a fellow photographer.

Marion was persuaded to join him in crossing the North Sea to visit Holland for ten days with Maud and Lennie in April 1906. Writing to Roy about this holiday, his

father expressed his pleasure at a new mode of travel, the motor tour: "We have had a delightful trip & far more enjoyable than I expected. We have been motoring all over the place."[20] They were based in The Hague, at the Hôtel des Indes. Sambourne greatly appreciated his visits to the Mauritshuis, studying the paintings of Rembrandt with particular pleasure. A tram ride took him to the Mesdag Museum, which specialized in nineteenth-century Dutch and French paintings. His favourite work in the museum was Jozef Israels's *Alone in the World,* which shows a widower beside the body of his dead wife. On a visit to the Rijksmuseum in Amsterdam he found Rembrandt's famous *Night Watch* a disappointment. While Lennie and Maud went to a private view, Linley and Marion walked for two hours through the old town. On motor expeditions, to Delft, Haarlem, Marken, Volendam and Edam, Sambourne seized the opportunity to take photographs of these picturesque towns. Mary Ann Roberts sees these as among his best camerawork, as he "began looking for narrative possibilities in a picture The photographs taken in Holland reveal Sambourne's well-known sociability in that he was able to photograph strangers without being intrusive, and to engage their co-operation".[21]

Sambourne had to return from Holland by himself for the *Punch* dinner, but, after completing the week's cartoon, he returned to Flushing on Saturday and enjoyed a Sunday outing to Domburg and Middleburg before crossing back to England overnight. He must have acquired a taste for the Low Countries, as he spent three days in Ostend in July. Perhaps remembering the rough sea which she had encountered on the way to Holland, Marion did not accompany him, and Sambourne spent his time walking on the beach, taking photographs, and enjoying the hotel facilities.

Of all these journeys, Sambourne derived most pleasure from his visit to Spain in March 1907, in company with his daughter and son-in-law. Marion, who had been seriously ill, remained at home. The Prado in Madrid was a revelation, and he wrote in his diary: "went to the Prado & saw Pictures. Magnificent Velasquez, Don Balthazar. Pair Portraits. The Surrender of Breda. Many of Goya's. Portraits King Charles 4 etc. An Albert Durer of himself. Moro Portrait of Queen Mary. Portrait of Charles 5th by Titian. Death of the Virgin by Mantegna" (D. 23.3.07). "All the pictures I know so well but the originals far surpass anything I have seen."[22]

Velázquez was very popular with artists of Sambourne's acquaintance, such as John Millais and John Singer Sargent. Dürer, of course, was a favourite of his own.

He was less enthusiastic at a bull fight, where he saw four bulls killed and felt "seedy", whether out of sympathy for the bulls or because of the "bright glare & cold wind" is not clear (D.24.3.07).

The party spent Easter Week in Seville. Sambourne enjoyed the religious processions and looking round the churches but, predictably, he let the rest of the party go to High Mass in the Cathedral without him. The bull fight in Seville was more to his taste than that in Madrid, although numerous bulls and horses were killed, and one matador was seriously injured. Sambourne admired the Murillos in the art gallery, and took numerous photographs in the streets. Visiting Dumfries in 1908 he found that the white houses with bars at the upstairs windows reminded him of Seville. After Seville came Cordoba, Malaga and Granada. "Cordova is delightful & the Mosque Cathedral quite as wonderful in its way as the St Sophia at Constantinople."[23] Begging gypsies were one problem, and Maud was afraid of bandit attacks when they drove along the seashore, but this was otherwise a happy time with sightseeing, visiting gardens and shopping. Sambourne told Marion that Maud was "very well. Lennie is up one minute & down the next. But he's always so".[24]

Sambourne had planned to return home by sea, but gale-force winds made him change his mind. The party, who had been in Algeciras, enjoying a restful time at the Hotel Reina Cristina, "as good as the Carlton and on the sea shore",[25] made their way back to Madrid through the picturesque hill-town of Ronda. "Frightful rain and gale here am thankful decided to return overland", Sambourne told Roy.[26] They made a day trip to Toledo, and, in his daughter's words, "he would not have missed it for anything The Dad was quite angry that the guide-books had *written* such libellous reports, & kept up a torrent of abuse about their want of taste."[27] Unlike today's tourists to Toledo, however, the party seem to have ignored the paintings of El Greco. Although Lennie settled the bills, Sambourne's letters to his wife are full of lists of expenses, whether of hotel fees, meals or general expenditure. His time in Granada was spoilt by his anxiety about a £218 estimate for the repair of the drains at 18 Stafford Terrace, and, from that point on, the letters to Marion are as much about drainage as they are about Andalusia.

Schoolgirls

As with his Dutch photographs, Sambourne made up volumes of his Spanish prints, not for publication, but for his own delight. Photography and his collection

of prints continued to be a major interest, almost an obsession. Sambourne took photographs on holiday, on his visits to the country, and in the 1900s he began photographing schoolgirls in the street, an activity which became an important element in his regular morning walks from Stafford Terrace. By the middle-class standards of the day Sambourne was an early riser. His diary tells us that he was up at around 8.45 and that he set off (apparently without breakfast) either on foot or on his bicycle for the round of the local streets. The morning cycle rides, which gradually became more infrequent, took him further afield, often down the Earl's Court Road, and his brief return to horse riding in 1909 took him back to Hyde Park and Rotten Row.

The ostensible reason for Sambourne's morning walks was that he was giving the dogs their exercise. Campden Hill was a frequent destination, although, on his more distant expeditions, the dogs occasionally ran alongside his bicycle. One dog, a terrier named Rags, was particularly undisciplined both in and out of the house. Officially the dog belonged to Roy, given to him on the visit to the Howldens in 1902. Rags was in the habit of attacking cats, a fact which Sambourne notes laconically and with some pride: "Rags got hold of a sandy cat in Phillimore Gardens. Surly workman" (D. 6.1.04). On one occasion, after Rags had recently seized a small kitten, he was put onto a lead, but Sambourne was roused to anger when a carter protected a cat by lashing out at his two dogs, Rags and Rick. In 1903 Rags and Rick nearly killed a cat in Stafford Terrace itself and, in the following year, they succeeded in doing so opposite Kensington High School. (Rick was killed by a car in 1908, two months before another Sambourne dog, Bogey, met the same fate).

These were not the only instances of Rags's violence. Cats were his usual prey, but he sometimes got into dog-fights, and a road sweeper whom he attacked threw a broom at him. Rags did not always have his own way and, in 1905, he was lucky to survive an attack by a bull terrier. Sambourne or his groom would find themselves at the Police Station answering complaints about the dog. Tiring of this, Sambourne tried to part with Rags, but Roy objected and the dog remained at Stafford Terrace. In the end, however, in December 1908, after some years of alarming cats and passers-by, Rags bit the household maid, Marie, and was put down the next day. He was replaced by Taxy, a handsome fox terrier bought by Lennie in the Leadenhall Market. Like Rags, Taxy had a taste for chasing cats and was not an ideal companion for city walking. Recalcitrant in crossing the road, he got into a

fight with a dog in June 1909, retiring "bitten and beaten" (D. 28.6.09). Then, in September, Sambourne temporarily lost the dog in the Earl's Court Road, an incident which left the owner feeling old and ill.

Sambourne was an early walker, but, even at that time, a number of beggars had to be avoided. A German band played in Kensington High Street, a serious annoyance to Sambourne, who greatly disliked street musicians. Attempts to reduce the noise had continued through the Victorian period and those who, like artists and writers, worked from home were among the chief protesters. Sambourne would have known that his much-admired predecessor John Leech had been obsessed with the problem and that some attributed Leech's death to an excess of anxiety brought on by the overwhelming noise of street organs. An act of the 1860s had given householders some means of reducing the nuisance, but had not obliterated it. In 1896 a leading article in *The Times*, once again arguing for the suppression of these wandering performers, stimulated a debate to which Sambourne contributed a letter. On the whole, the correspondents felt as he did, but an American woman responded by rejoicing in this unique opportunity for poor children to hear music. Sambourne must have registered his disagreement, but his letter was not published.

Another hazard was the "old woman" from the workhouse, who swept the crossings. As we know from Jo in Dickens's *Bleak House*, crossing sweepers were a feature of street life. At a time when women wore long skirts it was of particular importance to clear the horse droppings and mud. O.W., as Sambourne called her, started work early in the morning and would solicit alms from him when he came by on foot. He tried to dodge her, noting his small triumphs in his diary, but she was not always in the same place and would sometimes appear unexpectedly. If cornered, often in Holland Walk, he would give her sixpence or some smaller sum, and, at Christmas, when generosity was the order of the day, she took away a shilling.

Sambourne's response to the irritating approaches of beggars is typical of middle-class men at the time. By walking around the neighbourhood as he did, he laid himself open to their advances and was wise to take evasive action whenever he could. In the centre of London, prostitutes were a menace, with the Strand and the Haymarket particularly notorious for streetwalkers. Sambourne met a more ambiguous figure in the Haymarket in June 1900: "Spoken to by respectable middle

aged woman Gave her 6d. Starving" (D. 3o.6.oo). In the following year a woman followed him to the gate of his home at one in the morning: "Cheek", was his outraged response (D. 1.3.o1). Suburban Stafford Terrace was evidently not fair game.

Infinitely more welcome was the sight of young girls walking along the pavements. Some were schoolgirls, others young women from the less prosperous North Kensington or Earl's Court areas, on their way to work in shops like Barker's, the large department store which had opened in Kensington High Street. While the schoolgirls were comfortably off, well dressed and educated, the shop girls, as we learn from Katherine Mansfield's early short story (1908), *The Tiredness of Rosabel*, were frequently ill nourished, exploited by their employers, and living on a pittance. They were always in danger from male predators, who thought them easy prey.

Sambourne gave both groups of girls private names, noting whether or not he met 'C', 'Chumps' and 'Essex V'. Among other invented titles were 'Aphrodite', 'Lady Diana', 'Little Composure' and 'Little Princess'. Sometimes Sambourne discovered the girls' identities. Lady Diana and her sister, for example, were the daughters of a letter-cutter called Edwards. In term time Sambourne deliberately haunted the approaches to the local girls' schools. His two regular routes both took him past the Kensington High School for Girls, established in Lytham House, St Alban's Grove. When on his bicycle, he would set out from there into the Earl's Court Road. When on foot, he would usually make his way north up Campden Hill and then turn into Norland Square for the Notting Hill High School for Girls. These were pioneering days for female education, and many girls of good families attended these schools. There were other local schools, the Kensington Board (or state) School and, at a distance, St Paul's School for Girls, but it was these two High Schools which regularly drew Sambourne.

Sometimes he was genuinely looking for models for cartoons. On one occasion, with his sharp eye for potential sitters, he tipped a boy a shilling to give him a girl's address. Cycling through Fulham in 1901, he saw a little girl who would have been the just the thing he was looking for, had the drawing not already been completed. Sambourne notes that he photographed a schoolgirl outside Kensington Board School in April 1901, and by this date he was very conscious of the beginnings and ends of the terms. However, judging from the dates of the 'schoolgirl' photographs, it was not until 1905 that he began to snap them regularly.

Fig. 113 Photograph of schoolgirls in Kensington

They often walked past in pairs without an adult chaperone, and he took the photographs with a right-angled 'detective' camera purchased in September 1905. This took the form of a pair of binoculars and the shots were taken at a right-angle to the apparent sightline. Sambourne had problems with this camera at Hampton Court in 1906, but told the palace guards, who were satisfied with the explanation, that he was simply carrying binoculars. In May 1908, more disturbingly, he noticed the presence of two mysterious policemen while he was snapping girls.

This activity may carry overtones of paedophilia, but the resulting photographs are among Sambourne's most attractive. With their wide hats, long skirts, plaited hair and satchels, these girls have a remarkable freshness and charm. The shots are lively and natural in comparison with the forced poses of many of the studio plates. Unlike the often drab and routine nude shots taken in the studio, these are elegant, evoking the lost world of Edwardian girlhood. Taken in the open air, they are also less disturbing than the print of the Sambournes' housemaid, photographed sur-reptitiously as she slept in her bed at 6.30 in the morning.

It would be hard to believe that the shop or schoolgirls did not notice the man on the bicycle or walking with the badly behaved dog. Very occasionally, Sambourne notes that a smile passed between them or that a girl would hurry on or double back, perceiving him as a threat. From the evidence of the diary he did not draw the schoolgirls into conversation, although this occasionally happened with the girls from the shops. That someone was aware of the activity is clear from a letter written to him by the headmistress of Kensington High School, who told Sambourne that he was seriously disturbing her pupils and asked him to desist.

For the twenty-first-century viewer, these photographs pose a problem. In many ways the images seem innocent, and they belong to an age very different from our own. In no sense are the photographs pornographic. On the other hand, there was a degree of compulsiveness in Sambourne's behaviour. It is hard to resist the sense that both Rags and he were in search of prey. Brief as they may be, his diary entries show that he was always looking around him and was disappointed if the favourite of the moment failed to appear. Those photographs which he selected and placed in an album are all of particularly attractive girls, calling to mind the frequent re-marks in his diary on good-looking young women spotted on the bus, in the theatre or in the street. Sambourne's own privately educated daughter, Maud, had not attended a local school, but the question arises whether, had she done so, her father would have been happy for someone else to snap her in the morning light.

Sambourne would develop these photographs fairly rapidly and would then assess the quality of the prints in his diary. He cannot possibly have needed more than a tiny fraction for his work, but this is also true of the photographs taken at the Camera Club. To some extent these images, rapidly and surreptitiously made, were ephemeral material. They were a challenge to his powers as a photographer, an attempt to capture life as it was happening.

Final years

As the years went by, Sambourne became more irritable. In a less regulated society, it was not uncommon for passengers to dispute the payment for a cab journey, or for clients to consider themselves overcharged for one commodity or another. Sambourne's diary records a number of these incidents, together with a brief sum-mary of his own response. He began to take offence when waiters, porters, bus

conductors, cab drivers or shop assistants failed to treat him with the respect he expected. He was furious, for example, when a labourer put down a pile of gravel just behind his horse, Marquis, risking an accident. On a more mundane level, he reported an argument with the staff at the Garrick Club about the cost of the milk for his son's cup of tea. 'Annoyed' becomes a common word in his diary, 'disgusted' another. It is possible that he was simply recording a decline in deference, and that waiting staff and transport workers were becoming less obsequious. However, his own tolerance was decreasing and his problems with the *Punch* management were exacerbated by this increasing shortness of temper.

Something of Sambourne's mood can be gauged from a series of letters to M.H. Spielmann, the historian of *Punch*. In January 1910, near the end of his life, Sambourne told him: "I can't say I'm in love with the change in *Punch*. Did *you* write the criticisms on *Punch* advertised in The Times for the 50 years issue if so *my* name is singularly absent, though all my confreres of the same rank are mentioned."[28]

With age, his health began to fail. He had been losing teeth for some time, and first wore a denture in December 1901. After nearly a fortnight he found it "not quite so uncomfortable but horrid all the same" (D. 31.12.01). He gave up liqueurs and brandy, possibly temporarily, in 1903, and in the following year he complained of a pain in his chest while on a strenuous day's shooting. A little later, he was taken ill at the *Punch* dinner and had to leave early. The old problem with his nostril recurred in 1904 and again in 1907. There were periods when he tried to abandon smoking.

1906 proved to be a traumatic year for more than one reason. In January 1906 the *Punch* management decided to fire Burnand from the editorship. Burnand had discussed the possibility of retirement with Sambourne in July 1905, but had told him that he had no financial reserves and could not afford to leave *Punch*. Without letting either Burnand or Sambourne know, the proprietors had offered the editorship to Henry Lucy in 1897, but Lucy, loyal to Burnand, had declined. Sambourne first learnt of Burnand's dismissal on 12 February, when his old friend suddenly arrived at 18 Stafford Terrace in a distressed state and telling a "somewhat rambling pitiful yarn" (D. 12.2.06). Sambourne, a natural hoarder, responded, after his visitor had gone, by tearing up all Burnand's letters of instructions for cartoons for the last four years. He may have been protecting his friend by destroying in-criminating evidence, or, more likely, expressing a sense of relief. On 14 February

Burnand presided over his last *Punch* dinner as editor, a gruelling occasion. On the following day, he published a letter expressing his disgust with the proprietors. As a result they decreed that, unlike Tenniel, Burnand was not to attend any future dinners. Sambourne was in a very difficult position. He relied on *Punch* for his own income, but Burnand was an old friend who was being badly treated. Anxious to avoid taking sides, Sambourne declared his intention of keeping out of this "deplorable quarrel if possible" (D. 19.2.06). Lehmann may have expected to be made editor but, in the event, Burnand was replaced by Owen Seaman. Whatever loyalty Sambourne may have felt for his old friend, Seaman proved to be a far easier editor to work with. Some consolation for Burnand came at a Reform Club dinner on 16 March, organized in his honour by Rudolph Lehmann. A second dinner was held at the Garrick Club on 10 June 1906, when the critic and playwright Joseph Comyns Carr gave a speech. Sambourne was prevailed upon to perform his best known act, 'The Gnome King'. According to Henry Lucy, this was reserved for "exceptionally festive occasions" and was a "character of fire and fury he had somewhere seen at a penny show. Its due presentation, involving much violent physical exertion, must have been trying to the performer, following as it did close upon participation in a bountiful meal. A little judicious egging on generally found Sammy ready to oblige." An affectionate drawing by Bernard Partridge shows him in full flow, his arms thrown wide and his feet off the ground (fig. 114). Lucy also recalled that Sambourne invented "imaginary personages" and then related "circumstantial stories and conversations attributed to them. One Major Punkah, long time resident in India, was most prolific in his exuberant fancy."[29]

At the time when the Burnand drama was unfolding, Sambourne was facing a further difficulty. From time to time dealers proposed purchasing groups of his drawings, sales which brought in a lower price per drawing than individual arrangements but which cleared a number of works at one time. When Mr H. Waterbury of 180 Fleet Street called on 27 February 1904, he bought eight drawings for ten guineas each. On Wednesday 10 January 1906, Charles Wilde, whom Sambourne had known as a bookseller in Notting Hill nearly thirty years before, called at Stafford Terrace, smelling of drink. He explained that he wanted to buy a large group of drawings for a rich American client. On Saturday morning, after the completion of the week's cartoon, Sambourne showed Wilde one hundred and thirty drawings, some dating back as far as 1888, others more recent, but

MR. LINLEY SAMBOURNE.
"Sammy" tells the story of "The Gnome King."
DRAWN BY BERNARD PARTRIDGE.

Fig. 114 Bernard Partridge, *Mr. Linley Sambourne. "Sammy" tells the story of "The Gnome King."*

pointed out that the best ones had already been sold. It is not clear how many drawings Wilde bought on this occasion, but he called again on January 24 and three days later offered £200 for a second cache. When he came to collect them on Monday 29 January, after a number of postponements, he brought an associate with him. It was the associate who counted the drawings and took them away in two parcels. Sambourne refused to take a cheque and was paid £200 in cash, money which he promptly handed over to Marion.

Wilde paid one further call, and then, to Sambourne's dismay, Roy came in late on the evening of Friday 2 February, just as his parents were taking their dinner after the completion of the cartoon. He broke the news that a sale by auction of Sambourne's drawings on 5 March had been announced in the *Times*. Wilde had been deceiving him: "Frightfully depressed & annoyed. Stayed down till 1.15am when M came down & fetched me up to bed. Slept uneasily." Sambourne was still gloomy when he woke: "Never felt more depressed & seedy in my life" (D. 2–3.2.06).

On the following Sunday the auction and Burnand's forthcoming retirement were the topics of discussion at a family dinner when Maud, Roy and Lennie were present. The evening evidently raised Sambourne's spirits, but he sank into gloom again when Wilde called a few days later trying to reassure him about the sale with a lengthy explanation: "Don't believe a word he says …. A d-d humbug" (D. 6.2.06). Sambourne subsequently noticed that some drawings and letters of his were on sale in a shop in Pall Mall, but it is not known whether Wilde was responsible. No such anxieties assailed Sambourne about the exhibitions at the Fine Art Society, nor the private sales of individual drawings. Putting his cartoons onto the market was not in itself a problem. It would seem, however, that it was not 'done' to auction drawings, and Sambourne may have feared that he himself would be portrayed as the vendor. He hastened to write to Spielmann to explain that he had played no part in this disgraceful episode and gave the same explanation to *Punch* colleagues.

The year was to end badly. On Christmas Eve Marion had an operation connected with kidney problems. The shock was terrible to her husband: "The greatest blow I have had during my married life. Miserable and wretched" (D. 23.12.06). Recuperating from what was a very serious illness, Marion spent long periods away, and life at Stafford Terrace was not back to normal for more than a year. By that time her husband was frequently complaining of a cough, which

worsened when London was foggy, and the words "very tired" recur in his diary. In the autumn of 1908 he drank only water at the *Punch* dinner, telling Roy at the same time that Dr Parker (the physician recommended by Maud) had told him not to continue shooting. In 1909 he once again tried to give up smoking. The cough remained a serious problem, especially at night, and, although bromide brought a temporary improvement, he had increasing problems with sleeping. The diagnosis was a heart problem. A masseur called for the first time in January 1909, and these visits became a regular event. In the same month Sambourne was well enough to spend some time at the Granville Hotel in Ramsgate, which, once again, failed to improve his condition. An expedition to William Powell Frith's ninetieth birthday party in January 1909 can scarcely have raised Sambourne's spirits, as his old friend did not recognize him and looked very ill. Tenniel was also unwell and Arthur à Beckett died in January 1909 following an operation for the amputation of a leg. There were occasional outings on fine days, drives in Lennie's car to Hampstead, Richmond and Hampton Court. By May Sambourne had recovered sufficiently to play six sets of tennis on Sir Alfred Hickman's court.

The Sambournes tried various health resorts – Bournemouth in the early part of 1909 and Homburg, from which they travelled to Frankfurt to watch a Zeppelin take off, in the summer. However, Sambourne became seriously ill in the autumn. He was at the *Punch* dinner on 6 October and found it a "tiresome late sitting". Hints that he should draw Edward VII in his next cartoon disturbed him: "Made up mind to resign sooner than draw His Majesty. Mistake to touch it." He finished his last 'Almanack' drawing on 27 October and his last *Punch* drawing on 29 October. Pleased with the subject, Sambourne decided that he would go ahead with this final "cut", although he felt ill and exhausted. *A Pleasure Deferred* shows Guy Fawkes, as the budget, telling the 'House of Lords Flunkey' that he wants to blow them up. A line beneath explains that: 'The Commons propose to finish with the Budget Bill on Guy Fawkes Day. The Lords are to consider it on the twenty-second' (P. 3.11.09; fig. 115). The image of Guy Fawkes was taken from a photograph of the cartoonist himself, dating back to 1889.

During the months which followed, Sambourne struggled to keep up his diary, which records the ups and downs of his health. He carefully reports the problems with his bowels, presumably a result of his sedentary condition, and the dietary changes (including sour milk) which were recommended. Marion wrote in her

diary of his fits of gloom and depression. In November he was in Brighton, at the King's Hotel. From there he wrote to Bernard Partridge explaining that he was bequeathing a precious possession to him:

> I have left you if you care to have them all my photographic notes & references for work. They may be useful to you & successors. Pass them on when the time comes. Good luck to dear old *Punch* & you all. I hope I may be spared a few more years notwithstanding …. I have directed negatives shall be destroyed. But all photographs for work to you.[30]

Sambourne would have been dismayed to learn that the photographs were sold by Partridge's widow, who was in straitened circumstances, after his successor's death in 1945, but would have been correspondingly delighted that his own daughter, Maud Messel, bought them back at auction.

In a letter written to Spielmann in March 1910, Marion told him how much her husband missed *Punch*: "His whole being was so wrapped up in his work" that he "feels his great weakness most acutely".[31] Sambourne seemed to be recovering in

LEFT
Fig. 115 Sambourne at his desk,
c. 1910

RIGHT
Fig. 116 *A Pleasure Deferred,*
Punch, 3 November 1909,
Sambourne's last *Punch*
cartoon

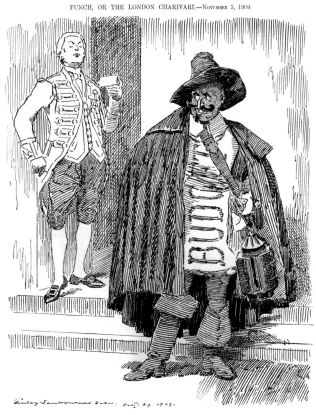

PUNCH, OR THE LONDON CHARIVARI.—November 3, 1909.

A PLEASURE DEFERRED.

The Budget (*as* Guy Fawkes). "THEIR LORDSHIPS NOT AT HOME? THEN I'LL CALL AGAIN."
House of Lords Flunkey. "ANY MESSAGE?"
The Budget (*as* Guy Fawkes). "NO, NO! I JUST WANT TO BLOW THEM UP."
[The Commons propose to finish with the Budget Bill on Guy Fawkes Day. The Lords are to consider it on the twenty-second.]

the early part of 1910 and he visited Ramsgate. He was able to attend the *Punch*
table occasionally. Travelling with his nurse, Marie, he would stay only a short time
but, by April, he had become a regular participant once more. The last appearance
noted in his diary was on 25 May, when there was a full turn-out to welcome a new
man, A.A. Milne, later to become famous as the creator of Winnie the Pooh. Henry
Lucy gives a touching account:

> Up to the last he clung to old associations. At a time when old friends
> mournfully recognised that he was stricken by the hand of Death, he
> insisted upon coming to the dinner. He took his old place at the right hand

of the Editor, listening with wistful face to the cheery conversation. He was not able to stand the excitement more than an hour, and left before – dinner finished – the business of the evening dealing with the cartoon of the following week commenced. He was among the most well-beloved of the brotherhood, bearing among them the affectionate diminutive of 'Sammy'.[32]

Soon after this last *Punch* dinner, Sambourne's health took a turn for the worse. He was confined to his bed and out of his mind. Marion endured terrible suspense, made worse by the practical problems of household expenses, which her husband had always handled. In her diary Marion recorded the last hours on 2 August when he briefly recognized his family: "My darling looked so happy all afternoon, smiled at us & kissed us & seemed to see friends, his whole face lighted up".[33] He lost consciousness again and died the next morning. Lucy noted that there "was something pathetically appropriate in the circumstance that Linley Sambourne died at the dawn of a Wednesday morning ... a day of the week whose evening has, for more than half a century, found Mr Punch and his young men seated round the hospitable board". Phil May and John Tenniel "also died on a Wednesday".[34]

Sambourne's funeral was at St Mary Abbot's Church in Kensington. He had left no instructions, so the hymns and readings must have been chosen by his widow and children. As was the frequent practice at the time, neither Marion nor Maud was present in the church, although there were women in the congregation. Roy and Lennie led the mourners. A great many friends and relatives attended, together with a group of *Punch* staff. The wreath "In affectionate remembrance from his colleagues of the *Punch* table" caught the eye of the journalists, as did that from his grandchildren. According to *The Star*, there was "scarcely a dry eye to be seen, and especially was this so towards the close, when a near relative of the deceased, a lady, was carried out in a state of collapse". Outside was a group of young girls in red shawls and carrying flowers, with some poor schoolchildren "carrying a few flowers in their tiny hands".[35]

Shortly before his death Sambourne had taken the decision to be cremated and this ceremony took place at Golders Green. (George Du Maurier had also chosen cremation and John Tenniel was an early advocate for the practice.) The ashes were then interred at St Peter's, Thanet, where Sambourne and Marion had married. Marion's grave is now beside his.

NOTES

1 Letter of 10 January 1891, *Punch* archive.

2 Letter of 15 February 1906, ditto.

3 James Thorpe, *Phil May*, London (Art and Technis), 1948, p. 33.

4 R.G.G. Price, *A History of Punch*, London (Collins), 1957, p. 141.

5 Paula Krebs, *Gender, Race and the Writing of Empire: Public Discourse and the Boer War*, Cambridge (Cambridge University Press), 1999, p. 2.

6 Douglas Sladen, manuscript draft of speech to the Authors' Club dinner, 10 March 1902, Richmond-on-Thames reference library.

7 Martin Postle, 'Hidden Lives: Linley Sambourne and the Female Model', in exh. cat., *Public Artist: Private Passions*, Royal Borough of Kensington and Chelsea and *The British Art Journal*, 2001, p. 21.

8 Ditto, p. 27.

9 'Our Graphic Humorists', *Strand Magazine*, XXIII, 1902, p. 82.

10 Kensington Library, letter of 4 June 1903, ST/1/4/820.

11 Shirley Nicholson, *A Victorian Household*, London (Barrie & Jenkins), 1998, p. 191.

12 Kensington Library, undated letter, ST/1/4/870.

13 *Bird Notes and News* (Royal Society for the Protection of Birds), IV, no. 3, 29 September 1910, p. 1.

14 *Linley Sambourne House*, London (The Victorian Society), 1980, p. 2.

15 Nicholson, p. 177.

16 Ditto, pp. 175 and 177.

17 See note 6.

18 *Staffordshire Sentinel*, 3 August 1910.

19 Nicholson, p. 114.

20 Kensington Library, letter of 22 April 1906, ST/1/2/1338.

21 Mary Anne Roberts, 'Edward Linley Sambourne (1844–1910)', *History of Photography*, XVII, no. 2, Summer 1993, p. 212.

22 Kensington Library, letter of 23 March 1907, ST/1/2/861.

23 Ditto, letter of 3 April 1907, ST/1/2/878.

24 Ditto, letter of 2 April 1907, ST/1/2/876.

25 Ditto, letter to Roy Sambourne of 15 April 1907, ST/1/2/1338.

26 Ditto, of 16 April 1907, ST/1/2/1337.

27 Ditto, letter from Maud Sambourne to Marion Sambourne of 20 April 1907, ST/2/2/791.

28 Letter of 10 January 1910, *Punch* archive.

29 Henry Lucy, *Nearing Jordan*, London (Smith Elder), 1916, p. 110.

30 Letter of 7 November 1909, formerly collection of Anne, Countess of Rosse.

31 Leonee Ormond, 'Linley Sambourne', *Nineteenth Century*, IV, no. 4, Winter 1978, p. 87.

32 Lucy, p. 109.

33 Nicholson, p. 207.

34 Lucy, pp. 108–09.

35 *The Star*, 6 August 1910.

Coda

Marion Sambourne lived for only four years after the death of her husband, dying on the eve of the First World War in August 1914. Roy remained at 18 Stafford Terrace, although he was away for long periods during the war. When peace returned he went back to his life in the City. Roy maintained a bachelor existence, making no important changes in the house, although he occasionally attempted to file the papers crammed into every drawer and cupboard. His sister, Maud, living on the other side of the Park, was, like her brother, committed to preserving her father's creation. Her daughter, Anne, believed that Maud paid many of the household bills. Comfortably off, and with homes of her own, Maud was under no pressure to sell 18 Stafford Terrace when she inherited the property on Roy's death in 1946.

In the fourteen years before her own death in 1960, Maud kept the house as it was, a courageous decision in a period committed to denigrating and destroying all Victorian buildings and artefacts. Anne Messel had married Ronald Armstrong-Jones in 1925. They separated in 1933 and, in 1935, she married the 6th Earl of Rosse. Increasingly fascinated by the Victorian period and by her grandparents' house in particular, Anne gave a number of receptions there, drawing attention to the exceptional quality of the interior.

On 5 November 1957 Lady Rosse hosted the remarkable gathering of like minds which led to the foundation of the Victorian Society, dedicated to preserving the architecture and artefacts of the Victorian age. Among her guests were the poet and champion of Victorian architecture John Betjeman; the architectural historians Nikolaus Pevsner, Christopher Hussey and Mark Girouard; the artist John Piper; the designer Norman Fowler; the pioneering historian of Victorian art William Gaunt; the cartoonist Osbert Lancaster; and Thackeray's grand-daughter Belinda Norman Butler. Among those present who had known Linley Sambourne were Anne Rosse herself, her brother, Oliver Messel, and Rosamond Lehmann, one of

the small girls whom Sambourne had noticed at her father's home on the Thames. Four months later, on 25 February 1958, the Victorian Society was officially instituted in the drawing room of 18 Stafford Terrace. Several of the same supporters were present, including Betjeman and Pevsner.

Anne Rosse and her husband decided to make 18 Stafford Terrace their London home. As she explained it, "The challenge came in 1960 with my mother's death, and by then the ties had become too strong to sever".[1] Lord and Lady Rosse lived in the house for twenty years. Some changes were made, including an extension to the bathroom, but the main rooms remained largely the same. Some of the wallpaper, altered by Sambourne himself in 1880s and 1890s, reverted to the William Morris patterns with which the house had originally been decorated. Visiting scholars, including the present writer, were warmly welcomed and given access to this time-capsule of Victorian taste.

In her anxiety that the house should be preserved, Lady Rosse considered a number of alternatives. She concluded that it would be best secured through ownership by a public body rather than by creating a private trust. Influential supporters made out a strong case for keeping the interior and furnishings intact. In 1980 Lady Rosse sold 18 Stafford Terrace to the Greater London Council, who made the purchase with the help of the Land Fund. In a tribute to its own origins, the Victorian Society leased the building and took over the relevant expenses. The Society opened the house to the public, working with a large and dedicated group of volunteers. The association of the Victorian Society with the house continued until December 2000. When the GLC was disbanded in 1989, the Royal Borough of Kensington and Chelsea took over the house. A major restoration was carried out from 2000 to 2003, at which time the archive was removed to Kensington Library.

Maud Messel and Anne Rosse (fig. 117) are the heroines of the survival of 18 Stafford Terrace, with some of the credit going to Roy Sambourne. Anne Rosse always spoke with warmth of her mother's romantic attachment to the home of her childhood, an attachment which passed from mother to daughter. To visit Lady Rosse in her house, and to hear her memories of the past, was an unforgettable experience.

Several of Linley Sambourne's descendants have inherited his artistic talents. Maud's gifts as a draughtsman have been mentioned, and her second son, Oliver Messel, was one of the leading theatre designers of his generation. Anne Rosse's

Fig. 117 Anne, Countess of Rosse at the official handover to the Greater London Council

eldest son, Lord Snowdon, follows in his grandfather's footsteps as a photographer, and Lord Snowdon's son, Viscount Linley, is a prominent designer of furniture.

Linley Sambourne would have been proud to think that later generations have enjoyed his creation. He would also have been aware of a certain irony. While the substantial homes of his painter neighbours and friends have been altered, re-decorated and stripped of their furniture, Sambourne's simple terrace house has survived with its decoration and contents largely intact. His longing to receive proper recognition and to become an Academician was never satisfied, but, in a strange way, the black-and-white artist has finally triumphed.

NOTE

1 Foreword by Anne, Countess of Rosse, in Simon Jervis and Leonee Ormond, *Linley Sambourne House*, London (The Victorian Society), 1987, p. 2.

Index